W9-BPN-147

OTTO PÄCHT

VAN EYCK

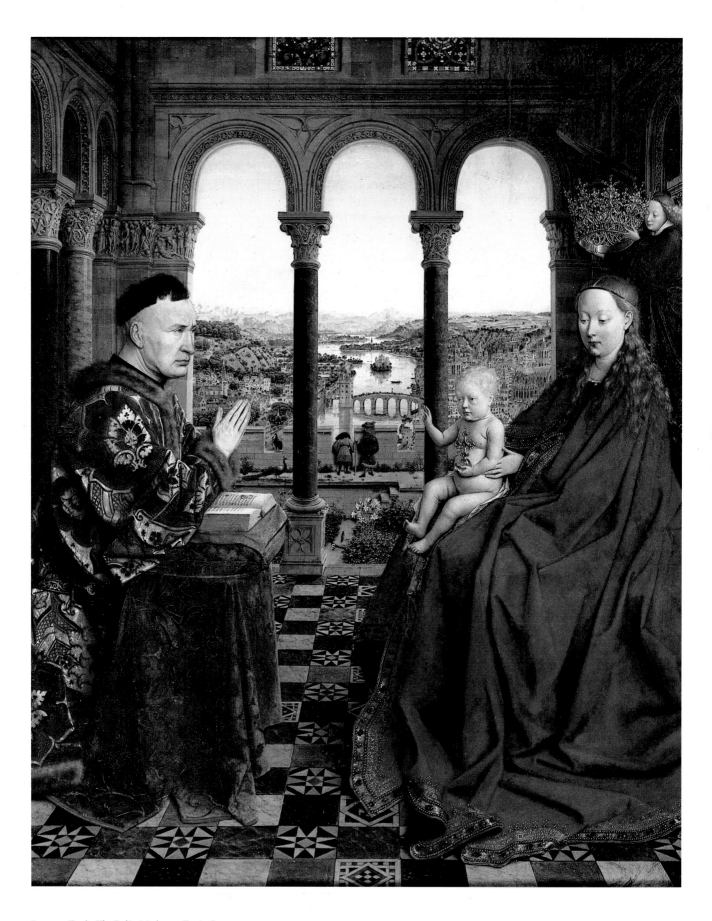

Jan van Eyck, *The Rolin Madonna*. Paris, Louvre

OTTO PÄCHT

VAN EYCK
AND THE FOUNDERS OF
EARLY NETHERLANDISH
PAINTING

Foreword by Artur Rosenauer
Edited by Maria Schmidt-Dengler

Translated by David Britt

HARVEY MILLER PUBLISHERS

HARVEY MILLER PUBLISHERS
Knightsbridge House · 197 Knightsbridge · London SW7 1RB · England

An Imprint of G+B Arts International

Originally published in German as *Van Eyck*
Die Begründer der altniederländischen Malerei
edited by Maria Schmidt-Dengler, by Prestel-Verlag, München, 1989
First English translation published by Harvey Miller, London, 1994

Designed by Michael Pächt

British Library Cataloguing in Publication Data

Pächt, Otto
 Van Eyck : And the Founders of Early
 Netherlandish Painting
 I. Title II. Schmidt-Dengler, Maria
 II. Britt, David
 759.9492

 ISBN 1-872501-81-8

Cover Illustration:
Jan van Eyck,
Giovanni Arnolfini and Jeanne Cenami (detail),
London, National Gallery

Composition by Jan Keller, London
Origination by Karl Dörfel Reproduktionsgesellschaft mbH, Munich (colour)
and Brend'Amour, Simhart & Co., Munich
Printed and bound by Passavia Druckerei GmbH, Passau, Germany

Contents

Foreword

Otto Pächt gave two courses of lectures on the origins of Netherlandish painting during his tenure as Professor of Art History in Vienna. The first was in the winter semester of 1965-66, as part of a two-semester course, in the second half of which he covered later developments in Netherlandish painting from Rogier van der Weyden to Hugo van der Goes, Hans Memling, and Gerard David. In the summer semester of 1972 he lectured on the early period once more, under the title 'The Founders of Netherlandish Painting'. For this he used the script of the earlier lectures, which he altered and expanded with pasted-over slips and inserts. The present publication is based on this reworked text.

Pächt's lectures are legendary. Seldom has a lecturer attracted such a wide audience of fascinated listeners. He presented living research in brilliant and often idiosyncratic formulations, with an authority that stemmed from intimate familiarity with the work, from profound scholarship, and from total commitment.

Otto Pächt probably never worked so intensively on any theme as he did on the art of the brothers Van Eyck. Even in the last days of his life, in hospital, he was studying offprints of articles on Early Netherlandish painting; and three days before his death I had a conversation with him about the Ghent Altarpiece. Pächt's interest in the Van Eycks probably dated from the late 1920s; it was, in other words, only a few years after the death of Max Dvořák—whose lectures he had attended—that he began to concern himself with the issues raised by the art of the Van Eycks and by Netherlandish painting in general.

At the beginning of this century, with his essay 'Das Rätsel der Kunst der Brüder van Eyck' ('The Enigma of the Art of the Brothers Van Eyck'), Max Dvořák broke new ground for scholarship and made the question of the origins of Netherlandish painting into one of the great themes of the Viennese School of art history. Others, besides Pächt, who worked in this field included Ludwig Baldass and Charles de Tolnay. (Dvořák's monumental essay of 1904 was published in Munich in 1925.)

The fact that Pächt's own earliest publications on the Van Eycks—his magnificent reviews of the books by Ludwig Baldass and Erwin Panofsky—did not appear until the 1950s is a typical reflection of his thoroughness. All his publications were founded upon long and intensive research.

It was no easy matter to induce Pächt to consent to the publication of any of his lectures. In the case of the present text, this reluctance may well have stemmed from the tension between his demand for perfection and the awareness that, where the Van Eycks are concerned, it is virtually impossible to progress beyond hypotheses. At times he came close to agreeing to publication, only to draw back at the last moment.

Pächt always hoped to get closer to a solution of the Van Eyck problem by drawing on a wider store of source material. He was convinced that, in spite of the iconoclastic outrages and other catastrophes of the intervening centuries, no major pictorial idea had been entirely lost. In a notebook, he once called for 'the historical scene to be viewed, as a matter of principle, against a wider horizon. Above all, in examining the

truly creative masters, we must not confine ourselves to what has been preserved in the original but must seek to gain an idea of what has been lost, by using secondary sources, copy drawings, workshop replicas and paraphrases, partial copies, and sometimes much later echoes. All this is very often no less significant, and of no less evolutionary importance, than the material that happens to survive in the original'.

A major interest of Pächt's, and a major part of his work in his last years, consisted in the retrieval of those lost pictorial inventions. Among his papers at his death was a series of files in which he had collected a rich store of picture material on the antecedents and the influence of lost Van Eyck compositions (including a *St Michael*, a *St Christopher*, *Crucifixions*, the *Carrying of the Cross*, and the *Passage of the Red Sea*). Some of these thematic categories are accompanied by brief texts that reveal something of his ideas and intentions. In the concluding pages of the present book, Pächt points in the direction that he intended to take, when he compares and contrasts the two *Epiphany* drawings with each other, and the *Mystic Marriage of St Catherine* from the Hours of Turin with a drawing in Nuremberg based on an early work by Jan van Eyck.

As an art historian, Pächt was so staunch a partisan of his own discipline that he was reluctant to take a lead from any other. This is evident from his approach to the Brussels laboratory report on the Ghent Altarpiece: as when he points out that the investigating commission would only have had to compare the crown at the feet of the Almighty with that of the *Madonna of Chancellor Rolin* to be relieved of any doubt as to its authenticity. But there are cases in which science has proved to be right, as with the *Man with Pink*, which dendrochronological examination has shown to have been painted no earlier than the last third of the fifteenth century.

Pächt was as reluctant to put his trust in iconology as he was to rely on science. He was one of the first, in his Panofsky review of 1956, to take issue with the iconological method. The scepticism that he expresses in that article is also plainly conveyed in this book. To him, the new realism in art was not a mask behind which a symbolic religious content concealed itself: on the contrary, as he shows from the example of the Master of Flémalle's *Madonna with a Firescreen*, it was the materialization, the reification of symbolic signs.

Panofsky's stupendous learning gives rise, in his *Early Netherlandish Painting*, to numerous digressions that enrich our knowledge but often relegate artistic problems to the background. Pächt's text is less richly orchestrated than Panofsky's, but it is more coherent. He always keeps his eye on the work as a work. He is less concerned with such issues as the incorporation of learned theological ideas within the picture, or the reflection of social history, than with the presentation of one of the great events in the history of western art: the discovery of new formal possibilities by the Master of Flémalle and the Van Eyck brothers; the transition from the medieval thought-image (as Julius von Schlosser called it) to the recognition and acceptance of reality as seen. This recognition, in all its facets and varieties, was to remain the central concern of European painting well into the nineteenth century.

The following sentence is entirely characteristic of Pächt's attitude: 'We are dealing with a phase of transition between the anonymous history of art and the history of artists; and as in other cases this makes investigation not easier but harder, because less clear-cut' (p. 197). Nothing, not even our possession of biographical knowledge, must distort our view of the work of art.

Pächt seeks access to the genesis of Netherlandish painting through the use of his eyes. His capacity for subtle observation and analysis of stylistic phenomena, which often allows us to see familiar things with new eyes, goes hand in hand with a strict

and logical conception of stylistic evolution, often handled with great rigour. Pächt excludes the Ince Hall *Madonna* from the Jan van Eyck canon because it does not seem to fit into the course of his evolution, even though there might well be other explanations for this anomaly. It may be that Baldass is right, after all, when he credits Jan with the capacity to paint in more than one style.

Whatever the case, the sharpness and exactitude with which Pächt defines the various formal resources of Early Netherlandish painting is vastly instructive. Never before has the early Van Eyck style (i.e., that of Hubert?) been so clearly distinguished from that of the mature Jan: 'Among the most momentous transitions of all, and at the same time one of the most elusive, is the stylistic shift from Hubert to Jan: for it primarily affects the way of seeing, not what is seen. It is only with Jan that the viewpoint becomes a fixed one, and painting becomes passive contemplation' (p. 170). What counts is that we can clearly distinguish between two different formal approaches: whether Jan is behind one and Hubert behind the other comes to seem almost secondary.

This is an art history in which the prime objective is the visual grasp and understanding of the work of art. Fascinatingly, it combines an outstanding degree of specialized expertise with a strong instinct to grasp the essential. One has only to look at the passage in which he compares the *Lucca Madonna* with the *Madonna* by Jacquemart de Hesdin: in it, he goes far beyond the two works under discussion into a realm of first principles that affords basic insights into the possibilities of painting. Pächt induces his reader to see with precision, and to do justice to the individuality of the work of art; and in this respect this book may be seen, over and above its specific purpose, as a school of seeing.

Pächt would not have been the conscious adherent of the Viennese School that he was, if the evolutionary position of the Master of Flémalle and the Van Eycks had not been a central issue in his mind. This book is clearly not a monograph but an evolutionary historical investigation of the genesis of Early Netherlandish painting. Pächt is concerned to 'to interpret a revolutionary genesis in terms of organic evolution' (p. 30).

In this connection, it is instructive to compare him with Dvořák. Dvořák rolls back the historical background of the Van Eycks' art in a panoramic view that stretches away into the fourteenth century; he presents their work in an evolutionary context. Pächt is more concrete, taking the description and analysis of the works as his starting-point and only then displaying the threads that link it with tradition: as, for example, in the digression on the late medieval interior that he includes in his discussion of the Mérode Altarpiece.

Pächt had no hesitation in standing up for what he thought was right; but he was wary of leaping to hasty conclusions: 'Our only concern at present must be to work out an inner stylistic—and thereby also chronological—ordering of the Van Eyck material, which will enable us to distinguish fact from hypothesis and identify those open questions that would remain unanswered even if we knew exactly where to apply the external labels: Hubert, or Jan, or XY' (p. 79).

The very last pages of this book, in which Pächt weighs his observations against each other, make it clear how keenly aware he was of the hypothetical nature of his conclusions. In his review of Baldass's Van Eyck monograph, he had warned against treating the history of art as a mathematical problem amenable to resolution without an element of uncertainty.

Pächt never became rigid in his opinions; even in his old age, he continued to regard art-historical research as in a state of flux. The problem, raised in the present

text, as to whether Hand G of the Turin Hours is to be identified with Hubert van Eyck, was a constant preoccupation in the last years of his life. (Dvořák and Baldass both regarded Hand G as an artistic personality quite distinct from either Hubert or Jan.) A good example of the way in which Pächt constantly went on working and thinking about his subject is provided by a comparison between the passage on the *Crucifixions* and his later notes on the same theme. In the body of the text he proposes a sequence that runs New York—Hours of Turin/Cà d'Oro—Berlin; in his notes, he revises this to separate the New York and Berlin *Crucifixions*, as works by Hubert, from the versions in Turin and at Cà d'Oro, which he sees as echoes of a single early work by Jan. He emphasizes the 'discontinuity of the landscape background', in which he detects 'a total revolution in artistic vision', and concludes: 'It is hard to imagine this shift taking place as part of the evolution of a single artistic personality' (see note 86 below).

A careful reading of the text reveals inconsistencies, here and there, of which one was not aware as a listener to the lectures. This reflects the fact that Pächt worked on Van Eyck for decades on end; the inconsistencies may well represent different geological strata, as it were, of his knowledge. To take one example: the rigorous evolutionary sequence in which he presents the Eyckian *Madonnas* is more like the Pächt of the early articles in *Kritische Berichte* than it is like the cautious sceptic who warned his readers against hasty evolutionary constructs in the epilogue to his essay on Hugo van der Goes (1969): 'Genuine solutions are not the product of cogitation: they must grow, organically, out of new insights'.

A number of inconsistencies arise from the fact that the optical impression tends to be richer, more complex, and at times more confusing, than even the subtlest theory or evolutionary conception. We are reminded of Pächt's own dictum: 'In the history of art I am convinced that truth is as follows: in the beginning was the eye, and not the word'. And so his observation that 'the stillness of Jan's art' influenced the work of Petrus Christus and Gerard David—precisely those North Netherlandish painters in whom he finds echoes of the Master of the Hours of Turin—does not seem to support his own view that Jan and the Master of the Hours of Turin were two distinct artistic personalities. But contradictions of this kind contribute to the richness of the text.

One can only regret that Pächt did not consign to paper his reactions to such major, later studies as the essay by Charles Sterling or the book by Hans Belting. The views of both authors are more or less diametrically opposed to his. In the miniatures of the Hours of Turin, both follow Friedländer and Panofsky in detecting the hand of the young Jan van Eyck. Sterling differs radically from Pächt in regarding Hubert as the master from whom Jan derived his monumental figures. Belting, for his part, seeks to explain the differences between the Turin miniatures and the mature work of Jan in terms of the difference between the genres of the miniature and the easel painting, and to trace Jan's evolution from an illuminator to a panel painter.

Perhaps this book will lead others to reformulate the questions and to reconsider the issues. In all probability, the debate over the 'Enigma of the Art of the Brothers Van Eyck' will never be laid to rest. Pächt, for one, certainly has not resolved it: but he has taught us to see the works more clearly, and to understand the problem better.

Artur Rosenauer

I. Introduction

With the triumph of the Gothic, all Europe acknowledged the artistic hegemony of France. The artistic dialect of the Île de France was now an international language: in artistic terms, England, Germany, Spain and even—to a degree—Italy had become provinces of France. As early as the fourteenth century, however, decentralizing forces began to make themselves felt. It was a time when a social and cultural shift of the utmost magnitude was in progress. No longer were the most important artistic commissions bestowed by the Church: its position was being usurped by secular patronage. Though vast churches and monasteries were still being built and decorated, the artistic avant-garde was no longer to be found in the masons' lodges of the cathedrals but in the workshops that were employed by secular rulers to maintain the decorum of courtly life. Nor did all the best talents gravitate to the court of the kings of France: in the second half of the fourteenth century, the four brothers of Charles V, the dukes of Anjou, Orléans, Berry and Burgundy, struck up a peaceful rivalry with him by creating new metropolitan centres of their own, in which the pulse of artistic life soon beat faster than it did in Paris, with its vast burden of tradition.

A visitor to those artistic colonies, at the courts of Angers, Orléans, Bourges and Dijon, might have been surprised to observe that most of those who worked there did not have French as their mother-tongue. In the household accounts and other records of those princely courts, foreign names predominate, whether it be Melchior Broederlam from Ypres in Flanders, André Beauneveu from Valenciennes, Claus Sluter and his nephew Claus de Werve from Haarlem, Henri Bellechose from Brabant, Jacques de Baerze and Jean de Marville from the Meuse country, or Jean Maelwael (Malouel) and his nephews the Limbourg brothers, from Guelders. In short, the magnificent flowering of art at the princely courts of the period around 1400 was largely the work of Flemings, Walloons and Dutchmen.

This courtly art was famously cosmopolitan. It formed one branch of the 'International Gothic', that uniquely standardized artistic idiom that prevailed in every leading artistic centre in Europe, from Bohemia to Catalonia, from England to Lombardy. No wonder Netherlandish artists blended so readily into the French milieu without entirely losing their own identity; the hallmark of the age was its internationalism. Their work fitted perfectly into the French tradition, because it was in any case no more than a variant of French art.

In the following generation, however, Netherlandish talents found an adequate outlet at home, and in place of a dialect of French they created a native Netherlandish language of art. The Limbourg brothers, although Netherlanders by origin, represented the French courtly style, and indeed a strongly Italianate form of it; by contrast, though the Master of Flémalle and Jan van Eyck worked for Burgundy and for the Burgundian court—and indeed in Burgundy itself—it would never occur to anyone to regard them as exponents of French art.

The oldest description of the Ghent Altarpiece stems from a humanist of Nuremberg, one Hieronymus Münzer, who toured the Netherlands in 1495 and recorded his

impressions in a notebook. He wrote, among other things: 'And all this is painted with such wondrous ingenuity and skill that you would suppose this to be, not merely a painting, but the whole art of painting'.[1] He had previously listed the subjects represented, describing the *Adoration of the Lamb* as the *Eight Beatitudes*, in which he presumably took his cue from the erudite and—as we should now call it—iconological commentary given him by the cleric who showed him the altar. The comment that he hastened to add seems to amount to this: What, he maintains, is unique about this work is not what is shown, but how it is shown; all is painted in such a way that you see not one painting but every aspect of the art itself. It sounds like an anticipation of the idea of Art for Art's Sake. At all events, we can only say, with the benefit of hindsight, that Münzer had hit the nail on the head.

The period immediately preceding the completion of the Ghent Altarpiece in 1432 had brought with it a totally new kind of painting, and a new definition of the painted image—the same definition that subsequently became so ingrained in us that, until the advent of extreme modernism, it was wrongly considered to be the only possible one. Furthermore, and crucially, a new beauty had been discovered, one liberated from ideological trammels, not rooted in metaphysical values and religious ideals but extracted as directly as possible from what is seen: visible, coloured phenomena. This was *Ars nova*, a new art, as contemporaries were quick to realize—even abroad, even in Italy, where, in spite of the utterly different aesthetic of native art, Netherlandish painters soon found patrons, and a Netherlandish painting soon became one of the objects most sought after by collectors. Just as the incomparable art of a Greek sculptor is evident from a torso or a fragment of marble, a scrap of Early Netherlandish painting no more than a few centimetres square is instantly identified by the unique- *Plate 12* ness of its workmanship even before we have seen the composition or recognized the subject.

The earliest school of art history, that of Italy, had an extremely simple answer— even before Vasari—to the question of the nature of the *Ars nova* of Eyckian painting. It was a basically materialistic explanation, and it went like this: Jan van Eyck was the inventor of oil painting. In other words, a technical innovation prompted the refound- ing of the art, and called into existence what we now think of as painting. This thesis already seemed untenable to Gotthold Lessing, that great debunker of historical myths. He discovered that medieval treatises on painting, such as that of Theophilus Presbyter, already mention the mixing of pigments with oil, and concluded that Jan van Eyck had no claim to 'the invention for which his name has enjoyed such fame, these two hundred years and more'. Lessing's essay, 'On the Antiquity of Oil Painting', concludes with these prophetic words: 'In ancient churches, who knows how many paintings we might yet discover that are demonstrably older than 1400 and would nevertheless prove to be true oil paintings, if only it were possible and permissible to apply reliable tests!'[2]

With the application of ever-improving scientific methods of analysis to late medieval painting technique, Lessing's scepticism has been entirely vindicated: it has been shown that drying oils were in use as painting media before Van Eyck, and that Vasari's tale of Jan's invention of oil painting is, at best, a gross oversimplification of the facts. Stylistic analysts of the strictest observance had long since come to regard it as no more than a pious legend, an example of the anecdotal interpretation of history. Early in the present century there was, however, one attempt to rehabilitate this ancient art-historical legend; this was in E. Berger's *Beiträge zur Entwicklungs- Geschichte der Maltechnik*, in which he claimed that the secret of the Eyckian painting technique lay in the use of an oil tempera, which had made it possible to apply

pigment and varnishes in multiple layers.[3] This argument, too, failed to carry conviction, especially as the author was unable to refer to one practical test carried out on a major work of the *Ars nova*.

Then came the Second World War, and evacuation left the Ghent Altarpiece in such a precarious state that thorough restoration was a vital necessity; and so, at last, it was possible to put the question to the work itself. But, after the restoration commission had examined and restored every one of the twenty panels with the most modern technical and chemical equipment, all that it was able to say in its report about the medium used was that it was drying oil with an additional ingredient x. As to the nature of ingredient x, there was nothing to be said.[4] In one respect, at least, the old legend seems to have been quite right: Jan van Eyck took his secret with him to the grave.

In their eagerness to repudiate any attempt to ascribe so historic a departure as Early Netherlandish painting to a mere technical innovation, stylistic historians failed to realize that they had tipped out the baby with the bathwater: they had missed their chance of a critical engagement with the one concrete, incontrovertible fact that had first prompted the legend of the Van Eycks as the inventors of oil painting. This fact is the unique brilliance of the paint surface of a Van Eyck painting, and of Early Netherlandish paintings in general. Vasari saw and pointed out the decisive factor: Jan van Eyck, he said, used his oil and pigment mixture to obtain a very strong tempera that, once dry, not only suffered no damage from water but gave the colours such brilliance that they glowed by themselves, without a varnish (*che gli dava lustro da per sè, senza vernice*).[5] Luminous colours, then: a clue as to the purpose of those mysterious technical aids, and the consequences that sprang from them.

In other words, the crucial event was not the invention of oil painting but a cognitive breakthrough: the realization that light and shade are coefficients of every coloured phenomenon. It has long been realized that in the whole of medieval painting not one figure casts a shadow. The mid nineteenth-century Italian painter who restored Giotto's frescoes in the Bardi Chapel, and who—as we can now see— filled in some very considerable lacunae, did not know this. And so, until recently, the scenes of the burial and subsequent miraculous apparition of St Francis displayed heavy cast shadows, and art historians hailed them as the first occurrence of this phenomenon in art since antiquity. Some years ago the paintings were de-restored, and the shadows turned out to be the work of the restorer, who had unwittingly given Giotto the credit for overcoming the absence of shadows in medieval art.

It has since become clear that it was Masaccio in Italy, and simultaneously the founders of Early Netherlandish painting in the North, who made cast shadows obligatory in painting; clearly, it was a discovery whose time had come. One of Masaccio's frescoes in the Brancacci Chapel shows the scene from the Acts of the Apostles in which St Peter heals cripples with his shadow as he walks past. It has rightly been pointed out that 'earlier painting would not have been able to make sense *96; Plate 21* of this incident'.[6] In the *Annunciation* on the exterior of the Ghent Altarpiece, the floor within the painting is crossed by triangular shadows that could only be cast by the mouldings that separate the individual panels of the altarpiece. Here the source of the cast shadow is not depicted; it lies outside the world of the painting. What is depicted is merely its shadow, its optical concomitant.

Shadow complements light. At the same historical moment when artists embarked on the depiction of cast shadow, they could no longer avoid showing its counterpart, light: and vice versa. For the first time since antiquity, things ceased to be visible in their own right: they became visible because a certain light fell upon them. For the

eye, at least, they existed purely by the grace of light. Thenceforward, the state of the lighting in any scene had to be shown as part of the scene. This is not to say that previous painting had taken no cognizance of light and shade as purely objective motifs. One wall of the undercroft of San Francesco in Assisi, painted by the Sienese artist Pietro Lorenzetti, contains an early example of *trompe-l'oeil*: a painted bench that casts a shadow on the wall. Shadow is evoked, by way of exception, in order to delude us into believing that this is a real object, not a painting. If the artist had wanted the bench to be seen as part of a painting, he would not have thought it necessary to show its shadow. Just as shadow is shown in this one instance at Assisi, there is just one fourteenth-century Florentine painting, the *Angels Appearing to the Shepherds* of Taddeo Gaddi, in which a phenomenon of light appears. Again by way of exception, and in order to perform a specific narrative function, the yellow on the shepherds' garments is not the local colour of the material but a reflected light, which impinges little on the rest of the depicted world. In the *Ars nova* of the fifteenth century, by contrast, all colour is lit colour.

By comparison with Early Netherlandish paintings, even the most highly coloured works of the preceding period, or of contemporary Italy, seem dull or pale. This is because their colours are not saturated with light, not generated by light; because, in Vasari's words, they have no *lustro da per sè*. If a painter of the Gothic age wanted to depict radiance, the brilliance of sunshine, he resorted to gold: and this is not really a colour at all but a reflective substance. Shortly before the Van Eyck brothers came on the scene, the Boucicaut Master, the best-known Parisian manuscript illuminator of his day, painted a *Flight into Egypt* in which the rising sun is a giant, metallic, golden orb, emitting an array of sunbeams. These beams emanate from the sun, but they affect nothing; they illuminate nothing, and, accordingly, they cast no shadows. The colouring of the scene remains neutral.

The light source in Jan van Eyck's *Madonna in a Church* is outside the painting; but inside the painting we are constantly finding unmistakable evidence of its effect. We do not see where the light comes from, but we see the play of reflected light in the gold and jewels of the crown, in the golden border of Mary's mantle, and in the glint of her golden hair. We cannot miss the dappled light on the window reveals and screen walls, or the pools of sunlight on the nave floor, all of which exemplify the transmutation of colour under the influence of light. For light colours stand out, and intermittent patches of brightness attract the eye. *Plate 5*

If the lighting effect had been restricted to the individual phenomena just mentioned, it would remain a basically episodic feature, like the depiction of reflected celestial light in Taddeo Gaddi's fresco. But everything that appears around these islands of reflected light in the painting is also primarily seen in terms of light. We do not see the fabric of the church in its intrinsic stone colour but in half-shadow, an entirely specific lighting situation. Interior space is shown as partial protection from sunlight, and chiaroscuro as the colouring proper to an interior. A pictorial imagination that operated in such terms might well retain the religious conceptions of the Middle Ages; but it had entirely overturned, by implication, the medieval hierarchy of values.

Clearly, then, the central problem of Eyckian painting was that of making the ubiquity of light palpable through colour. A thing did not possess one specific colour, for all time, on which certain factors of brightness and darkness might subsequently superimpose themselves. Colour was now to be interpreted as a constantly varying capacity for the reflection of light. All colour must now acquire something of the quality previously unique to gold, in its function as a symbol of light: the capacity to

generate an intrinsic radiance. If colour was to be made to glow as the light struck the surface of the painting, then its substance itself, the consistency of the paint, would have to be changed. And this, it would seem, was achieved by an admixture of ingredients with a fat content, emulsions, and no doubt also transparent glazes.

The jewel-like, sparkling quality of Van Eyck paintings has often been remarked upon, and it has often been said that oil painting, so called, was an attempt to rival the transparency and the light-filled quality of the stained glass in Gothic cathedrals. There is some truth in this, even if only on a metaphorical level. It was not a matter of reproducing the transparent colour of Gothic windows by imitating the effect of light refracted through colour. The true point of comparison lies in the transparency of the coloured material itself, the response of the new colours to light: their capacity to use the real light that shines on the painting as part of the impression of light that emerges from the painting. The paint through which the depicted radiance—the light that belongs to the pictorial world—is made concrete does not merely simulate light: it gives off a light of its own. It glows—and that is why we are involuntarily reminded of the phenomenon of refraction in precious stones. This continues to apply in those parts of the painting that do not depict jewels, stained-glass windows, or anything of the sort. The Van Eycks did not so much invent oil painting as make the transition to a painting in which the colours are luminous in themselves and are brought to life by light. The light of the real world does some of the painting.

It is symptomatic of the new situation that it made the use of gold into something of an anomaly. In medieval painting, gold stood for the transcendental light. In the guise of haloes and nimbi, the attributes of sanctity, and in aureoles, crowns of rays and gold grounds, it cut across a pictorial world that was otherwise neutral in terms of light. In fact, the only light in medieval painting *was* the transcendental light, as manifested in the luminous substance of gold; light as a part of the depicted world, as something to be depicted, was unknown. But as soon as light was absorbed into the varied colours that served representational purposes, gold inevitably came to be regarded as an intrusion, and gold leaf was avoided as much as possible. Significantly, Alberti wrote in his treatise *Della pittura*, which appeared in 1435: 'It sometimes occurs that the man who uses much gold in his paintings supposes himself to be thereby endowing them with sublimity [*maestà*]; I find nothing to praise in this...The artist garners more admiration and praise if he imitates the gleam of gold by means of colours'.[7]

The modern-minded Alberti's theoretical demand was better satisfied by his Netherlandish contemporaries than by his own compatriots, many of whom long continued to put golden nimbi into their altarpieces. If anything, the Italians were more bothered by the flatness of the nimbus than by its gold substance, and they fitted it into spatial depth by perspective foreshortening, as if it had been a solid object. In Eyckian painting, the effect of gold is achieved with infinite skill through the subtlest gradations of yellow tones, and nimbi are eschewed on principle. An appropriate setting for the Madonna or a saint is provided by a sparkling golden crown, a brocaded canopy, or the interior of a church.

Artists with a less rigorously logical cast of mind either made the nimbus itself transparent or broke up its solid disc into separate, and usually inconspicuous, rays or beams. At the very start of this process, the Master of Flémalle hit upon a singular

Plate 1 solution: he seated the Madonna in front of an enormous firescreen, in such a way that this round, flat, straw-coloured object could stand in for the nimbus; he thus turned an object in real space into a surrogate—a distinctly prosaic one—for a transcendental symbol that refused to fit into the modern visual world.

On occasion, the Van Eycks and the Master of Flémalle used the beam halo, an alternative convention of celestial aura which, unlike the nimbus, had survived the Middle Ages with its visionary quality intact. Thus, for instance, the Dove of the Holy Ghost, above the Lamb on the Ghent Altarpiece, is ringed with an aureole of rays; but in this case the image of a natural celestial phenomenon is introduced in the guise of the rainbow aura, a device neglected by painters since the making of the Vienna Genesis. The heads of the three monumental figures in the Ghent *Deësis* are haloed not so much by the rays of light around them as by the gilt interiors of the stepped niches in which they are enthroned. These replace the abstract symbolism of the nimbus to provide a truly majestic setting for the head. As with the Master of Flémalle's firescreen—though less prosaically—the sacred has been translated into natural terms.

The appearance of the Master of Flémalle, so early in our account of the foundation of Early Netherlandish painting, shows that this was not founded by any one artist, let alone as the consequence of a single technical breakthrough; nor, even, was it the achievement of those two brothers, Hubert the elder and Jan the younger, who are named in an inscription as the artists of the Ghent Altarpiece. At least three painters must share the credit; and of them only one, Jan van Eyck, is a biographically definable personality.

The awareness that, alongside the Van Eyck brothers, the anonymous artist known as the Master of Flémalle was a member of the founding generation is a recent one; for this artist owes his foothold in history to modern stylistic criticism alone. When the connoisseurs and critics of the Romantic and post-Romantic age first undertook to group and attribute the Flemish Primitive material, they assigned the works that now bear his name to Rogier van der Weyden (or Rogelet de la Pasture, as his French-speaking compatriots called him), an artist born in Tournai and active in Brussels as town painter (*der stad scildere*),[8] whose sixteenth-century reputation, in both North and South, was excelled only by that of Jan van Eyck. Only gradually did it dawn upon scholars, around the turn of the century, that they had compressed two quite distinct artistic personalities into one. The painter who emerged from the consequent differentiation process was dubbed, for want of a better name, the Master of Flémalle; this was because some of his works, the fragments of a monumental altarpiece, were believed to come from the abbey of Flémalle, near Liège—a provenance that turned out to be wholly imaginary.

The realization that the unknown painter termed the Master of Flémalle was an individual distinct from Rogier did not immediately clarify his true historical position. Having been born, as it were, from Rogier's rib, he was at first understandably supposed to be his pupil. Soon, however, it became evident that the true relationship was exactly the reverse: that the Master of Flémalle was Rogier's teacher, and therefore—or so it was assumed—the master under whom Rogier had served his apprenticeship.

It was apparent from documents in the Tournai archives that one Rogelet de la Pasture entered the workshop of the painter Robert Campin as a journeyman in 1427 and became a master in 1432. It was known from other sources that Campin was forty-seven years old in 1422, which would make him sixty-nine at his death in 1444; he thus belonged to the same generation as Jacopo della Quercia, Lorenzo Ghiberti and Masolino. The birth dates of the Van Eyck brothers are unknown. A document was found that made it possible to identify the handiwork of one of Campin's journeymen: a colleague, so to speak, of Rogier's during his early years in Tournai. This document records a commission given in 1434 by the abbey of Saint-Vaast, in

2 Arras, to the painter Jacques Daret, for an altarpiece of which four panels have survived. This would seem to put us on a firm footing at last. For in their style and composition these paintings by Daret turn out to bear a close relation to a number of youthful works by Rogier; furthermore, Daret's and Rogier's compositional ideas point to the same source of inspiration; and this common source is clearly the art of that painter we name the Master of Flémalle. What could be more logical than to suppose that the Master of Flémalle was none other than the man proven to have been Daret's and Rogier's master: Robert Campin of Tournai?

So plausible a hypothesis would long since have been universally accepted, had it not been for another item of documentary evidence from Tournai, according to which, in 1426—before Rogelet de la Pasture entered Campin's workshop—the town council voted a testimonial gift of wine, a *vin d'honneur*, to one Maistre Rogier de la Pasture. If this Maistre Rogier, whom the document does not expressly identify as a painter,

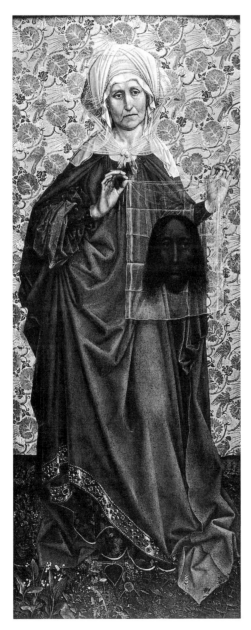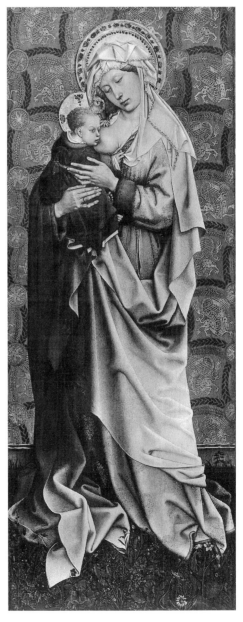

1
Master of Flémalle,
St Veronica and *Madonna*.
Frankfurt am Main,
Städelsches Kunstinstitut

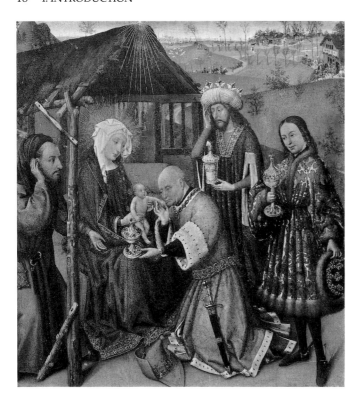

2
Jacques Daret,
Adoration of the Magi.
Berlin, Staatliche Museen
Preussischer Kulturbesitz

was the Rogier who subsequently rose to artistic fame, then he cannot have been the same person as Campin's journeyman of the following year; and then the Campin theory collapses, or else requires to be laboriously shored up.

Additionally, the identification of the Master of Flémalle as a painter from Tournai is cast into doubt by the provenances of his paintings. The only known provenances point not to Tournai but to Bruges and, in one case, to Malines: to Flanders, that is, and not to Tournai, then a French city, far to the south. Bruges was the home of the Master's most monumental work, of which only a fragment survives: the great altarpiece of the *Deposition*, almost five metres wide and the ancestor of all Netherlandish *Depositions* right down to Rubens and Rembrandt. Is it possible that in Bruges, a city with a very rigid guild system, so vast a commission could have been given to a painter from Tournai? It is not mere indolence or conservatism that induces a number of writers, myself included, to stay with the old and established, if makeshift, designation of 'Master of Flémalle'.

There is another difficulty that cannot merely be passed over in silence. The man who has been identified by modern stylistic analysis as the joint founder of Netherlandish painting bears a name that finds no mention whatever in the literature. Carel van Mander, the Northern Vasari, who tried to record oral traditions wherever he could, makes no mention of an artist called Robert Campin. Campin must have been even more rapidly and more completely forgotten than Hubert van Eyck. For, strange as it may seem, the history of Early Netherlandish art—as told in the early antiquarian and annalistic literature both North and South of the Alps—contains no mention of either; it knows only the name of Jan van Eyck.

On the one hand, therefore, there is total silence within the literary tradition; on the other there is the evidence of stylistic criticism, which has concluded from visual analysis of the material that the foundation of modern painting was the work of two elder masters, besides Jan van Eyck, and that he was only the most developed, the

most uncompromising, and the maturest representative of the new artistic gospel. So blatant a conflict of evidence has given rise to much heart-searching; and there have been repeated attempts to get rid of the problem by simply denying the existence of the two elder masters. The inscription on the Ghent Altarpiece, which refers to Hubert as *maior quo nemo repertus* ('than whom no greater has been found'), and to Jan as *arte secundus* ('second in art'), was accordingly dismissed as a later invention, a forgery on the part of some sixteenth-century local patriot; and, when this was exploded by the findings of the restorers in 1950, it was asserted that the wording of the original inscription, preserved only in part, had been deliberately altered by a subsequent restorer. Hubert, it was said, did not begin the Altarpiece, and the stylistic inconsistencies were explained by supposing that Jan stopped work to travel to Portugal in the service of the Duke of Burgundy, and that he changed his style before he started again. Similarly, the Master of Flémalle was disposed of by converting his entire *oeuvre*, with its admittedly earlier style, into the youthful work of the unforgotten and always celebrated Rogier van der Weyden.

I feel it necessary to draw attention to this highly problematic situation at the very outset, in order to avoid the impression that my personal historical interpretation forms part of any established canon. Max Dvořák's celebrated study of 'The Enigma of the Art of the Brothers Van Eyck', published in 1903, was the first systematic attempt to show that the *Ars nova* was not a creation *ex nihilo*.[9] It is not the least virtue of a proposed solution to a problem of scholarship that it throws up new questions that were not clearly seen before, even if it does so without answering the old questions. It might well be said of Dvořák's magisterial essay that it casts up more enigmas than the author thought he had solved; but therein lies its value. It is time to give up looking for solutions that will leave no questions unanswered. To seek for such solutions tends to be fatal to the seeker's capacity for alert self-criticism. I would rather work towards a more open style of research and interpretation: still, of course, constantly enquiring into the meaning of all that takes place within one's objects of study, but at the same time accepting their multiple meanings and never treating one's own answers as definitive.

In the treasury of Ghent Cathedral—a former collegiate church, elevated to cathedral status only in 1559—there is a *rouleau nécrologique*, a funerary roll, from the powerful abbey of St Bavo (St-Bavon or St Baaf), which Emperor Charles V caused to be demolished in 1540 to make way for fortifications, and which transferred its patron saint to the nearby church that is now the cathedral. This roll is one of the few surviving relics of the custom whereby, on the death of an abbot, a monk was sent round from monastery to monastery, often over a wide area, with a roll of parchment on which he collected the signatures of those who wished to join in prayer for the deceased abbot's soul. For palaeographers, such funerary rolls are of incomparable value as records of how people were writing, and where, in one specific year.

3 Unusually, the St Bavo funerary roll, which dates from 1406, is prefaced by a title miniature, which shows an abbot kneeling before the throne of the patron saint, St Bavo. At the feet of the saint, who is attended by three other patron saints of Ghent, lies the body of the abbot's deceased predecessor.

The miniature is badly worn, as one would expect with a much-travelled document; but its style and its Netherlandish identity are clearly evident. The squat proportions of the figures reappear in a late fourteenth-century miniature from the
5 Hours of Turin, and even earlier in the well-known pen and wash drawing in the Gelre Armorial in Brussels, which is known to date from no later than 1380 or thereabouts.

As we pass from the treasury of St Bavo to the chapel endowed by Justice Jodocus

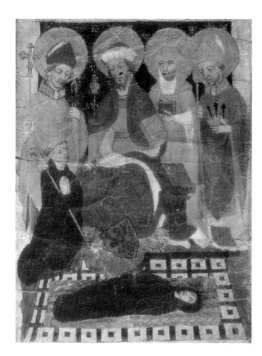

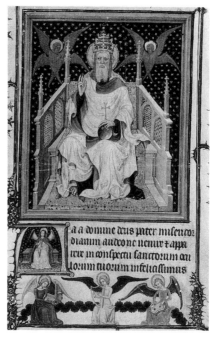

3
Funerary Roll of St Bavo.
Ghent, St Bavo

4
Hours of Turin,
God the Father.
Paris, Louvre

Vijd and his wife, we observe how artists in Ghent were painting some twenty years later; and we find ourselves in another world. True, the illuminator of the 1406 funerary roll cannot have been among the most modern painters of this time; and of course it is misleading to compare a modest miniature with an spectacular example of monumental painting. But the gulf remains equally wide if we take one of the many available opportunities to compare works where the roles are reversed, and the product of the new style is the more modest work, both in size and in function.

The Hours of Turin, from which we have already extracted one miniature as a stylistic parallel to the Ghent funerary roll, is the work of several generations of artists; and one page presents us with a large miniature in the pre-Eyckian style, representing God the Father enthroned, and a small historiated initial in the Eyckian style, depict- *4* ing a harp-playing angel. It looks very much as if the later artist has set out to demonstrate, by a contrary example, how to create the illusion of spatial depth even on a tiny surface, and how to convey the seated posture by integrating the seat spatially with the human figure that rests upon it: something that is not achieved by simply framing the figure between the sides of the throne. Indeed, he has yielded to the temptation of correcting his predecessor in one detail of the principal image itself, by transforming what would certainly have looked like a flat disc into a transparent, vitreous, spherical orb.

Between 1406, the date of the St Bavo roll, and the 1420s, when work began on the Ghent Altarpiece, an undeniable revolution took place in painting. Suddenly—as happens inside the small initial—the picture plane became transparent: that is to say, it became the surface onto which the pictorial world behind it was projected. To find out how this transformation took place—for this is the origin of the *Ars nova* in painting—we must first look in some detail at the laws and principles of the older and remoter artistic vision that was superseded and abolished by the Eyckian optic. Prompted by the juxtaposition of old and new representations of essentially the same subject on one page of the Hours of Turin, we shall compare the old and the new forms of artistic vision by citing a pair of their most distinguished representatives.

5
Gelre Armorial.
Brussels, Bibliothèque Royale,
MS 15652–56, fol. 26

My choice falls on two versions of the enthroned Madonna, both representing the same iconographic type. The earlier version forms part of a frontispiece diptych for a Book of Hours made for that celebrated bibliophile and collector, the Duke of Berry, probably by one of his court artists, Jacquemart de Hesdin. On the right-hand page is

6 Mary, enthroned with the child Jesus; the Duke, commended to her notice by his patron saints, kneels at a prie-dieu on the left. Jan van Eyck painted his version of this

7; Plate 6 subject, a panel, in the 1430s. Here, too, the Madonna is an enthroned figure; once more, she is suckling her Child. Both representations thus belong to a humanized Madonna type, the so-called *Maria lactans*, which emerged in the fourteenth century to displace the idealized Queen of Heaven of the High Gothic. In accord with this humanization of the imagery, and as a necessary corollary to it, both works seem to lay great stress on physical roundness and three-dimensionality. There are, however, considerable differences between the two.

Jacquemart de Hesdin's *Madonna* is painted in grisaille, grey on grey, on a stone throne, against a red background thronged with angels. This angelic wallpaper is as uniformly red as the Madonna figure is grey—although in her case the monochrome is relieved by a faint flesh tone and a touch of brown in the hair. If the Duke of Berry were not also shown in grisaille, one would be tempted to suppose that he was adoring a stone sculpture of the Madonna. There does in fact exist an almost identical

8 *Madonna* sculpture, an ivory statuette. In this, the Madonna's seated posture is more convincingly rendered than in the miniature, in which we are given no information as to the exact placing of the knees and lap, or the precise spatial relationship between the enthroned figure and the surface she is sitting on. But, then, any viewer who had grown up with the style of the age would have been unlikely to ask any such question. He would have had no time to reflect on the spatial organization of the figure before finding his eye caught up in the compositional movement, a kind of *serpentinata*, that leads upwards from the ground in gentle swings from side to side.

The path prepared for the eye, which largely follows the long folds of the drapery, meets its strongest upward impetus at the centre, in the climbing action of the Child:

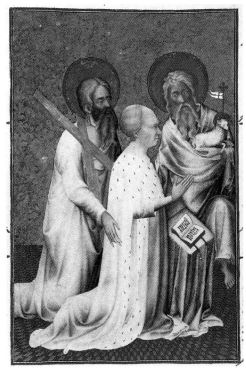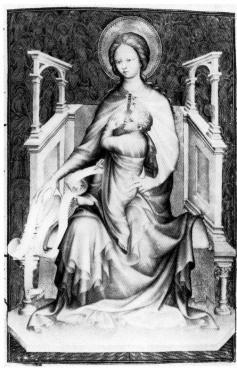

6
Jacquemart de Hesdin,
Très Belles Heures.
Brussels, Bibliothèque Royale,
MS 11060–61, fols. 10v, 11

that is, in the suggestion of a bodily movement. Here, at the critical point of the composition, the dynamic is at its strongest. The clambering Child masks the lap of the seated female figure, just where we ought to be able to discern both a change of direction and a sense of pictorial recession. In depicting her arms, too, the artist similarly avoids an effect of depth by outlining them with laterally directed curves that merge without a break into the endless melodic flow of the drapery. The supreme law in his eyes, as with all exponents of the 'soft' style of International Gothic, is continuity of form: the line that never ends, or rather the form that never ends; for this is not an art of linear strokes. The lines have volume; the movement flows, as if along pipes, so that every form continues without break or termination not only in the direction of its motion but also laterally, swelling into roundness as it gradually recedes into depth. Logically enough, Jacquemart's figures are set apart from their surroundings, not by even a trace of outline drawing, but solely through distinctions of colour. A total absence of demarcating contours is among their most conspicuous properties.

The effect of continuity of form is based on the principle that the eye is never permitted to lift itself away from the object but clings, as it were, to the surfaces. In its constant motion, the eye makes up the form as it goes along; it is as if the artist were not only seeing his subject but shaping it at the same time. This helps to explain the interchangeability of media: as the ivory statuette shows, it is possible to realize the selfsame artistic idea, down to the last detail, in three dimensions. These are the workings of an iconic imagination for which seeing a three-dimensional form with the eye and tracing it with the fingertips are one and the same.

If we now look at Jan van Eyck's *Lucca Madonna*, we at once observe a whole series 7; Plate 6 of strongly marked differences. The sides of the Madonna's throne have, as it were, converted themselves into the walls of a chamber, by which Mary is enclosed; one side seems to have taken the form of a window, and the other that of a matching niche.

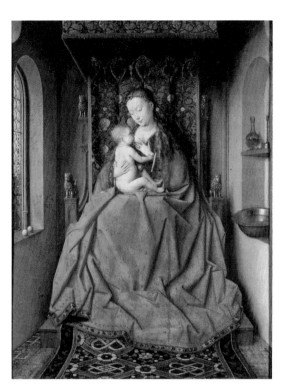

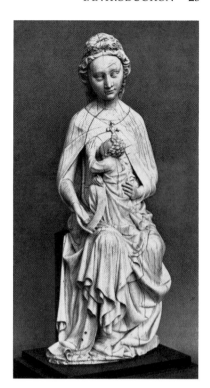

7
Jan van Eyck,
Lucca Madonna.
Frankfurt am Main,
Städelsches Kunstinstitut

8
Virgin and Child.
Paris, Louvre

Instead of an almost monochrome imitation of statuary, we have a colourful image, its focal figure nestling within a shell, an interior, that is impossible to peel away. Jan's composition could—just—be converted into a relief, but only by sacrificing its most essential formative qualities. In the *Lucca Madonna*, light and colour are constitutive factors, not afterthoughts.

It is particularly instructive to observe the changed approach to the depiction of the seated figure. The figure of Mary is now spatially integrated with the form of her throne. The change of direction in the figure necessitated by the seated posture is unmistakably signalled by a sharp horizontal break at knee level. The Child does not provide a transition from the lower to the upper part of the body, but is clearly resting on the shelf formed by the lap. We see nothing of the seat of the throne itself, or of its steps; but we deduce from the fall of the drapery that some solid obstacle beneath has forced a change in the direction of the folds. The mass of folds cascades towards us and spreads out to the same degree as do the divergent perspectival lines.

The Madonna figure as a whole forms a kind of pyramid; and we notice that a diminutive thorax forms the apex of a vast expanse of skirt. The torso seems unconscionably small; and yet the diminution is fully accounted for by perspectival foreshortening. Optically, it is approximately correct. The effect is surprising, because there is no transition between the knee area and parts further away from us. In projection, the torso seems planted directly on the knees, with the whole thigh area omitted: it is almost as surprising as one of those optically correct but implausible photographs in which a close-up foot looks twice as big as the person's head. Half a century ago, when it was calculated that the Van Eycks had a defective command of perspectival representation, this curious effect would probably have been ascribed to their less than perfect naturalism; but the truth is just the opposite. The abrupt juxtaposition of knee and torso catches our eye and strikes us as disturbing, almost as unnatural; but, if the scene is observed from a viewpoint at lap level, the (presum-

ably horizontal) thighs do become invisible, and in the projection the knees and the torso do become neighbours.

If Jan van Eyck had inserted something of the thigh area, which of course he knew all about, he would have had to shift the chosen viewpoint and let his eye wander. He was clearly not prepared to do anything of the sort. We realize that the seemingly abrupt juxtaposition, the discontinuity in objective rendering, springs from the immobility of his viewpoint, his stilled gaze.[9a] This absoluteness of contemplation means that the picture plane becomes transparent: it turns into a projection screen.

The withdrawal of the eye from the object of perception; the immobilization of all those motor energies of looking that had so recently been inseparable from the pictorial imagination; the abandonment, on principle, of the tactile exploration of things seen; the establishment of an art of pure contemplation, passive descrying: therein lies the revolutionary and, one may safely say, the Copernican crisis that has gone down in the history of painting as the achievement of the Van Eycks. Painting— the descriptive art, *schilderkunst*, as the Netherlanders call it—is thus reduced to an eye-witness account, often rigidly excluding even such prior knowledge of the object as is part and parcel of the normal act of seeing. This is why in Netherlandish painting—as the cases of Hieronymus Bosch and Pieter Brueghel show—the discovery of the world goes hand in hand with its transformation into something wholly weird and uncanny. This is an art that professes to add nothing whatever to what is optically perceived. Naturalism, we might call it; and yet this is no mere offprint of nature. It is pure art, because it relies on the utopian fiction that, in the act of perception, a human being can become all eye.

The newly entrenched passivity of the artist's eye had a number of momentous consequences. The first and most important of these was that, in the art of the Netherlands, painting and sculpture would never again be equal partners. It was now axiomatic that painting was a passive act of registering and observing, and all formative intervention was banned. The result was that painting acquired a total dominance, far more extreme even than the Venetian preference for painted over sculptural creation. In the fifteenth century—although the Netherlands had recently produced one of the greatest sculptors of all time, in the person of the Haarlem-born Claus Sluter—we know the names of more than a dozen great Netherlandish painters, but not of one eminent sculptor in stone or in wood.

The following historical facts are equally revealing. When, in the 1390s, a Duke of Burgundy commissioned altarpieces for the newly founded Chartreuse de Champmol, the central feature—and thus the principal image—was a woodcarving, the work of one Jacques de Baerze; only the exteriors of the shutters were painted, by Broederlam of Ypres. Similarly, until far on in the sixteenth century, all the important altarpieces in Germany, including Mathias Grünewald's Isenheim Altarpiece, consist of carved wooden tabernacles with painted shutters. And yet in the Netherlands, after the Ghent Altarpiece, there is not one major altar without a central painting. It was sculpture that now found itself relegated to the exterior, the reverse, of the polyptych, and even then only in the form of illusionist grisailles, painted to show sculptural images as the constituents of a stony, inanimate world. These images of sculpture are far more solid, vigorous and firm than the painted 'soft' style figures intended to represent living beings. Even so, the painter has denied himself any credit for giving form to the objects that he shows: he presents them as if he had found them ready-made, and as if he were simply depicting or reproducing a solid sculptural substance.

One consequence of this characteristic passivity in the painting of the *Ars nova*

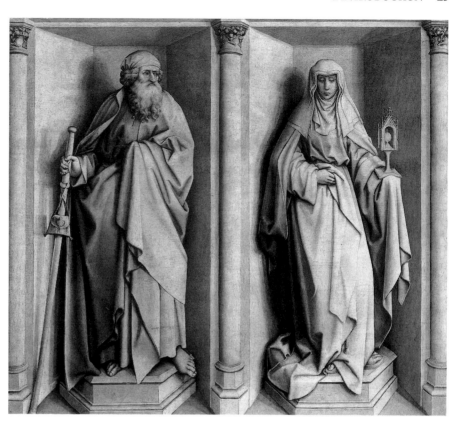

9
Master of Flémalle,
St James the Greater and St Clare.
Madrid, Prado

deserves mention because it underlines the true nature of the change that was taking place. When, for whatever reason, a medieval painter wanted to reproduce a work of past art, and to show it as such, he automatically and involuntarily translated it into the style of his own time: he unwittingly modernized it, because he could not help involving himself in the making of the object; he was incapable of just copying, but had to adapt it to suit his own taste. In their paintings, the Van Eycks and the Master of Flémalle were the first artists to leave intact the style of existing works of art, thus enabling us to place the style of the thing depicted, as distinct from the style of the depiction. John the Baptist prophesies with reference to a book in which the writing is adorned with an unmistakably Late Romanesque initial: he has opened a Roman-

10 esque bible at the Book of Isaiah. In a late work of the Master of Flémalle, dated 1438, the wall of the chamber in which the donor kneels is adorned with a *Madonna* that

11 can unhesitatingly be ascribed on formal grounds to the third quarter of the fourteenth century. In both cases we are confronted with faithful and authentic reproductions of the artistic impulse of a different age.

These were the first portraits of works of art, in the same sense in which the art of the same period faithfully and authentically portrayed the human face. Here, perhaps, lies the true, inner connection between visual passivity and the truth of what is seen. This was the specific historical moment at which copying, too, became possible.

The stilling of the eye, which we see as the decisive Eyckian innovation, was bound to raise entirely novel representational problems when applied to the composition of so complex an ensemble as the Ghent Altarpiece; and it looks as if its creators realized this only as their work proceeded. To immobilize the eye implies, first of all, that everything shown within a single frame must be seen from one angle of sight: must refer, that is, to a single viewpoint. But what if the altarpiece as a whole consists of a

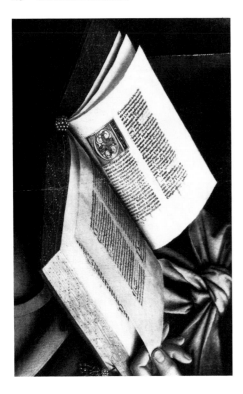

10
Ghent Altarpiece (detail),
St John the Baptist, Book
(rotated through 90 degrees)

11
Master of Flémalle,
Werl Altarpiece (detail).
Madrid, Prado

number of images, each with its own frame, arranged in several tiers? Is there to be one viewpoint for all of them, or is the viewer to be permitted—or rather compelled— to alter his standpoint from one image to the next? It is abundantly clear that the planner of the Ghent Altarpiece, who was most probably Hubert van Eyck, did not intend a single viewpoint for the whole work; or should we rather say that the issue had not yet been raised? Modern critics—and among them a number of noted exponents of our own supposedly historical discipline—have found the constant shifts of viewpoint within the Altarpiece so distracting that they have leapt to the conclusion that the whole thing was a composite, made up of a number of separately designed, smaller altarpieces: an assumption that can be shown to be untenable on iconographic grounds alone. They fail to realize that the constantly shifting viewpoint is only one symptom of the oft-observed and much-debated stylistic inconsistencies that also exist within the Ghent Altarpiece.

In evolutionary terms, this tells us that the issue of unifying the viewpoint came to a head only at the time, in the late 1420s, when Jan took over the task of completing the Altarpiece. Many, including the author of the report of the Brussels restoration commission, speak of Jan's contribution and achievement as an attempt to bring the various disparate components into harmony.[10] In a sense, however, what Jan did was rather the opposite: some of his portions of the Altarpiece address the viewer so directly, almost aggressively, and make him so keenly aware of the one and only viewpoint, that the visual discrepancies between adjacent scenes become all the more conspicuous.

No truly medieval art ever took account of the observer's viewpoint. Its works were created *ad maiorem Dei gloriam*, for the greater glory of God; often, indeed, they were set up in locations where only the eye of God could see them. On the Ghent Altarpiece, by contrast, there are two panels, the celebrated representations of our First Parents on the insides of the shutters, in which Adam and Eve are shown from

Plate 25

Plate 26 a low viewpoint, so that we look up at them. If these panels were placed at the observer's eye-level, perhaps in the lower tier of this two-tier altarpiece, this rendering would become anomalous. Once we see the sole of Adam's foot, we are inevitably put in mind of an observer placed below him. And so, in every painting thereafter, there was to be one more person present than the painting itself showed.

This is true of every image that is even remotely perspectival; and in some of his paintings Jan van Eyck made the fact verbally explicit. He usually signed his work *Plate 10* with the words *Johannes van Eyck me fecit*, 'Jan van Eyck made me'. But once, in the *Plate 11* portrait of the newly-wed Arnolfini couple, he wrote on the painting: *Johannes van Eyck fuit hic*, 'Jan van Eyck was here'. This is the painter testifying to his own presence at the scene: he says, in fact, *testis fui*, 'I was a witness'. In a celebrated study, Panofsky deduced from this, in anecdotal and symbolic vein, that the painter had acted as a legal witness to a wedding celebrated in private (*in camera caritatis*).[11] Doubt has since been cast on the possibility of such a civil wedding in the fifteenth century; as a result—and probably rightly—a large question mark has been attached to Panofsky's ingenious hypothesis. In any event, all we know for certain is that Jan was an eyewitness, not that he was a legal witness. Not content with his inscription, Jan also found another way to commemorate his presence in the bridal chamber. This was an inspiration of genius: the observer, though outside the painting, is made visible within it. The viewer's eye reflects the couple in the chamber; conversely, the inanimate eye of a mirror captures Jan's own figure, outside the pictorial space and in real space. The mirror looks at the viewer; the miniature reflection in it turns the room, though seen frontally, into a space that is known from all round.

Nor is the Arnolfini mirror image Jan van Eyck's only self-portrait. In the *Madonna*
12 *of Canon van der Paele*, the shield that St George carries slung on his back reflects, quite recognizably in spite of the half-shadow, the figure of a man in contemporary costume who is presumably watching from the nave of the church as the scene of the donor's presentation takes place in the apse. This figure can only be the painter himself, who has recorded the scene, and who uses this half-concealed detail to confess his indiscretion. Many post-medieval paintings rely for their suggestive power on fostering in the viewer the illusion of being present at the event depicted; and where the participants in an event are to be thought of as solitary or unobserved, this of course gives rise to an inner contradiction: if we are to suppose that no one was present, the painter cannot expect us to make an exception for him. Jan van Eyck seems to have taken a different view: he must have felt that even the theme of 'A Donor Contemplating the Divine' might be made more credible if he were to let us know that he had seen the scene with his own eyes, surreptitiously revealing himself as an eyewitness.

As we have already stressed, the awareness that both seen and painted reality hinge on a subjective viewpoint—an awareness that we regard as one of the fundamental innovations of the Netherlandish *Ars nova*—is an achievement that cannot have been consolidated until the final phase of work on the Ghent Altarpiece, that is to say around 1430, and in the person of Jan van Eyck. For otherwise the many uncertainties and imprecisions of spatial vision within this multipartite work—one of the few aspects of it on which Eyckian scholarship speaks with one voice—would be incomprehensible.

When I say that the decisive factor was the new, viewer-oriented nature of painting, I do not wish to be misconstrued as implying that—for example—a low viewpoint was never used before Jan van Eyck. It is well known that Giotto, in the Arena Chapel, flanked the choir niche with painted, fictive architecture that presupposes a viewpoint located on the central axis of the chapel and makes sense only when we occupy this

12
Jan van Eyck,
Paele Madonna (detail).
Bruges, Groeningemuseum

13
Limbourg Brothers,
Très Riches Heures,
Procession of St Gregory (detail).
Chantilly, Musée Condé, MS 65

position and look up. Like the Ghent figures of Adam and Eve, Giotto's fictive chapels instruct us as to where we should stand in order to look at them. It is less well known that the five legendary scenes in the predella of Simone Martini's panel of *The Coronation of Robert of Anjou by St Louis of Toulouse*, painted in Naples in 1317, are all based on a single, central viewpoint: the first move towards a centralized perspectival construction. A borderline case is Simone's dedication fresco above the entrance to the chapel of St Martin in Assisi, in which the visitor looks upward into a tabernacle-like architectural setting. Here, the low viewpoint applies only to the architectural space and not to the figures that occupy it, which are shown normally, just as if they were down on the viewer's level and directly facing him. The low viewpoint remains an isolated detail of the spatial setting: the view of the whole is unaffected.

Nor was Jan van Eyck the first to paint figures seen from below, *di sotto in sù*. The Brussels restoration commission published an infrared photograph of Adam's feet, proving that there had been a change in the composition at this point; they interpreted this to mean that Adam's right foot, in profile, was originally the only one visible, and that the foreshortened foot that we see from beneath must have been an after-thought.[12] However, this interpretation is hard to reconcile with the fact that the Adam figure on the Ghent Altarpiece, in its present and final form, already exists in a miniature by the Limbourg brothers that must have been painted before 1416: and that there the low viewpoint is accounted for by the fact that the figure is a work of architectural sculpture, set so high up on a building that the supporting console partly masks the feet.

There can be no doubt, in my view, that Jan's *Adam* and *Eve* stand in direct line of succession to those depicted by the Limbourgs. Not that Jan was necessarily inspired by the miniature in the *Très Riches Heures*: his immediate source is more likely to have been something on a monumental scale. I would, however, be inclined to suppose that the Limbourg works involved were representations of statues. It would make

sense to find a low viewpoint first adopted in the case of figures incorporated in architecture. Low viewpoints in the rendering of architecture had existed, as we have seen, in the Italian trecento; and so this would be one more example of the Limbourgs' function as purveyors of Italian pictorial ideas. What Jan did was to transpose the low viewpoint, as applied to statues, onto a pair of living figures—albeit figures who stand in niches as if they were statues.

One final point. Quite deliberately, I have been speaking in terms of the relation of the work to the viewer, and have avoided the word 'perspective'. Jan did not construct his pictorial spaces according to mathematical rules; he had no idea of the necessity of making all the orthogonals meet at a single vanishing point; they do so only in the work of his successor, Petrus Christus. No tidings of the *costruzione legittima* had reached him, and he can have known nothing of the visual pyramid.

Attempts have been made to reconstruct the so-called perspective of his paintings; and in the case of the Arnolfini portrait, for instance, the lines of the floor and of the upper parts of the side walls are found to converge on different points, respectively below and above the circular mirror in the far wall. The room seen in the mirror is another space in perspectival recession, and by rights not only ought the receding lines in the floor to meet those of the upper part but both ought to meet those of the reflected space at a single point. Nothing of the sort takes place. The same goes for *Plate 13* the pictorial space of the *Madonna of Canon van der Paele*, which was painted two years later, in 1436. Once more, the painting fails the mathematical test. Once more the vanishing points of the orthogonals of the lower and upper parts do not coincide, and one can speak of an area of convergence lying on the central axis but not of a point of convergence.

Only in the third quarter of the fifteenth century do we find Netherlandish works—paintings by Petrus Christus and by Dirck Bouts—in which the composition is based on unitary perspective, in obedience to the law of the single vanishing point. The first author to scrutinize the work of the Early Netherlandish masters for evidence of their knowledge of the rules of perspective was dismayed to discover that the first perfect perspectival construction was the work of Petrus Christus, a follower of the Van Eycks. So reluctant was he to accept that this pioneer achievement, as he called it, was the work of a Van Eyck pupil—a star of the second magnitude—that he postulated the existence of lost, late works by Jan van Eyck in which the decisive step of unifying perspective must have been taken.[13] He did this rather than draw the only possible conclusion from the absence of unified perspective constructions in Jan van Eyck: namely that the laws of artistic optics are not identical with those of natural optics, and that the solving of technical and mathematical problems does not necessarily make a spatial illusion any more convincing. The space in which Petrus Christus' *Madonna* sits is more correctly rendered than is that of the apse in the *Paele Madonna*; and that of the spacious, loggia-like interior in Bouts's *Last Supper* is more correct than that of the Arnolfinis' bridal chamber; but that does not make them any more true.

Unless we work it out mathematically, we are not aware that these interiors are organized around two viewpoints instead of one; we have the impression that we are beholding the scene from a single, immovable standpoint. And this is what I mean by the new relation to the viewer, which also includes the rendering of a specific lighting situation. The newly-weds are presented just as an eyewitness (*Johannes de Eyck fuit hic*) found them in their own home; but this is not to be thought of as a snapshot of a momentary scene. Panofsky's interpretation of the painting as a private nuptial ceremony is erroneous, not only because it conflicts with what we know of the customs of the period, but because it runs the risk of misleading us into introducing

14
Perspectival construction
of the Arnolfini portrait
(after Kern)

a narrative element. For Jan van Eyck, the stilling of the viewer's, and the painter's, eye goes hand in hand with the total stillness of the subject painted. Momentariness, in the sense of the capturing of a momentary event, has no place in this painting: this is a secular image of timelessness. The London painting is an early—though, as we shall see, not the earliest—example of the betrothal portrait. At the same time, it is a cross between a portrait and a still-life: a still-life with human figures, seen in their capacity as the most important of natural objects.

If we seek to comprehend what took place between the Ghent funerary roll of 1406 and the Van Eyck brothers' Ghent Altarpiece (begun before 1426), then it is no use merely taking the emergence of the new painting as an accomplished fact: we must start by making the effort to interpret revolutionary genesis in terms of organic evolution. We need to recognize, from the outset, that this upheaval occupied a wider stage than the regional one of the Netherlands—and, at the same time, that this particular historic process marked the coming-of-age of Netherlandish art.

Paradoxically, the emancipation of the Netherlandish artistic genius, the emergence of a highly individual artistic scene that was as vast in productiveness as it was small in area, coincides with the loss of the region's political independence. At the very time when the Netherlanders attained artistic autonomy, they came under foreign political overlordship: a fact that ought to serve as a warning against equating events in one sphere of life with those of another.

It needs to be realized, once and for all, that the physical setting in which Early Netherlandish art history took its course does not coincide with the territory of the two states, those of Belgium and Holland, that now occupy the area around the estuaries of the Meuse, the Scheldt and the Rhine, between the Ardennes and the North Sea. For one thing, the present-day French provinces of Flanders and Artois need to be added; for another, the greater part of what is now Holland took no part in the artistic development that concerns us here. Liège, with its environs, formed an important ecclesiastical centre and an independent state in its own right. But the most important political factor of all, particularly in relation to the structure of artistic patronage, was the link with Burgundy.

In 1384 the County of Flanders fell by inheritance to the dukes of Burgundy, a cadet line of the house of Valois; and, notably under the rule of Duke Philip the Good, the so-called *grand-duc de l'occident*, this new Burgundian state rapidly began to absorb its neighbours. Brabant, Hainault, Limburg and Zeeland were annexed, one after the other. Dijon remained the political centre of the state, but the artists who served the court were no longer to be found living there (or in the alternative ducal seat of Lille). The cultural centre of gravity had decisively shifted northward. By the fifteenth century, the state was Burgundian but its art, and especially its painting, was Netherlandish.

The elite of the artists employed by the Burgundian court now stayed put in their own native cities; and the resulting contact with their own social milieu had its own artistic and cultural consequences. Thanks to the high degree of local autonomy maintained by the prosperous Flemish cities against the feudal state, this was one of the most progressive societies in the whole of Europe, comparable only with the contemporary city-states of Tuscany. And, as in Tuscany, the new self-confidence of the inhabitants, and of the now dominant bourgeoisie, found physical expression in the look of the cities themselves: the tall belfries of the immense town halls often lend a stronger accent to the urban skyline than the towers of churches or cathedrals. Finally, as a symptom of the new relation between art and society, there emerged a specific, secular genre of painting, that of the justice picture or *gerechtigheidsbeeld*, as

indispensable to the interior of a Flemish town hall as was the high altar to a church.

However, it is no use looking to the great painters who are the glory of Flemish art for an exact reflection of their own daily lives, or of the social milieu in which they worked. Jan van Eyck is regarded as the founder of the bourgeois portrait, as the Master of Flémalle is regarded as the founder of the bourgeois interior; but Jan held the position of court painter, first to the Count of Holland, then to Philip the Good, with the title of *varlet de chambre*, yeoman of the bedchamber. Rogier van der Weyden, on the other hand, was *portrater der stad van Brussel*, city painter of Brussels; and yet the core of his work is essentially backward-looking, a last revival of medieval sacred art; his portrait style is aristocratic.[14] For the rest, anyone who has encountered the miracle of Eyckian painting will surely dismiss as absurd the notion that it was intended to satisfy the aesthetic demands of a bourgeois culture.

There is only one feature of Jan's art for which it is tempting—not to say vital—to seek a sociological explanation. If we survey Jan's authenticated work, and hold in view for a moment the thematic range covered by his paintings, we make a surprising discovery. In the work of the man whose eye discovered the phenomenal world in all its inexhaustible multiplicity, there are just three groups of iconographic themes. First, the Madonna on her throne, either alone or accompanied by saints and by the individuals under their protection: a kind of *sacra conversazione*. Second, a silent encounter between two figures whose relationship is either purely spiritual—as when a mortal individual addresses his homage to the Divine in a never-ending act of piety—or emerges from a dramatic exchange, as in a series of *Annunciations* in which Mary and the angel appear rapt in silent contemplation rather than overtly concerned with the act of annunciation itself, which takes place only in gestures. The third category is the portrait, the rendering of the human face in total repose. What all three types have in common is their total absence of movement, their uncompromising uneventfulness. All convey a state of being. Jan's paintings transport us to a still-life world in which nothing ever happens.

At this point, an objector might well ask how this assertion is to be squared with the narrative manner of the main panel of the Ghent Altarpiece, the *Adoration of the Lamb*; for there the vision in the Book of Revelation, of the Adoration of the Lamb by the Communion of Saints, is represented by a concentric movement of crowds of people in procession towards the altar of the Lamb. This invites a question: to what extent was Jan responsible for the painting as we see it in its final form today? Can he be made responsible for the design of the composition? I shall keep my own view on this matter for later, in the lectures devoted specifically to the Van Eycks; but this much I will say now.

Since the publication of the report on the restoration work carried out in 1950–51, there has been no room for doubt that the original design was altered. What is in doubt is only the extent of the alterations, and whether Jan was correcting himself or correcting his elder brother Hubert. A number of changes of detail have been established by X-ray and infrared photography; nevertheless, apart from the *Annunciation* scene on the exterior, we have learnt nothing to suggest that the original overall plan differed very markedly from the present arrangement: nothing, in fact, to help clarify those anomalies in the iconography of the Ghent Altarpiece over which scholars have for so long been racking their brains. There has been fierce controversy on problems more apparent than real; and yet one notable iconographic oddity has barely been mentioned.

The centre of the upper register of the interior of the triptych is occupied by the three large figures of the *Deësis*, all of whom are shown seated. It is normal in such

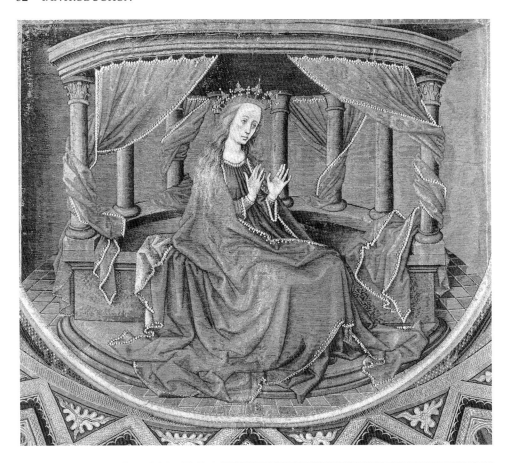

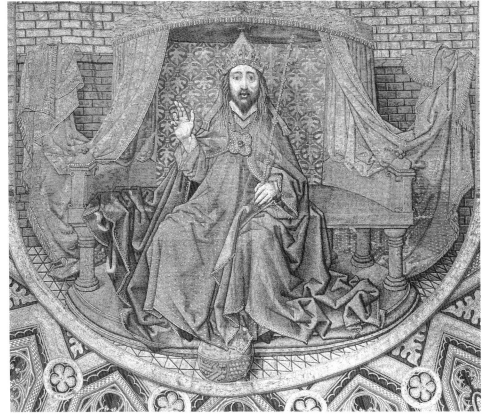

15
The Virgin Mary, Christ, St John.
Details of three copes
from the treasury
of the Order of the Golden Fleece.
Vienna, Schatzkammer

cases for the Virgin and St John the Baptist, who flank the *Majestas Domini* or *Rex regum*—the Majesty of the Lord or King of Kings, as the Almighty is called in this context—to adopt the posture of suppliants; but in Ghent neither of them does so. John's pointing gesture is a visual equivalent of his words, *Ecce Agnus Dei*, 'Behold the Lamb of God'; but it directs the eye to the Almighty himself, the First Person of the Trinity, rather than to the Lamb, who is to be seen in the panel beneath. Mary, meanwhile, is reading a book: the activity proper to a Virgin Annunciate.

There exists a paraphrase of the Ghent Altarpiece—or, to be precise, a paraphrase of its image of the Communion of Saints—that goes some way towards clarifying this enigmatic image of the Virgin Mary reading. This is to be found in the Paramenta, or ecclesiastical ornaments, of the Burgundian Order of the Golden Fleece, now in the Schatzkammer in Vienna: a body of work that is as important as it is little known. The three persons of the *Deësis* are depicted on three copes or pluvials; and this time Mary, quite appropriately, has her hands raised in a gesture of intercession. The choice is ours: we must suppose either that the designer of the cope had the completed Ghent Altarpiece in front of him and changed the reading figure back into an interceding one in order to fit her into the traditional iconography of the *Deësis*, or—a bold conjecture—that he is reproducing an older version of the subject, the original version, that of Hubert van Eyck. This is a highly complex question, for the cartoon for this painted textile was certainly drawn in the style of the Master of Flémalle, if not by him in person.

One thing is clear, however, or so I believe: the motif of the Virgin reading was introduced by an artist who sought to isolate his figures, insulate them from the

context of action, turn them in upon themselves. All this suits no one's artistic character better than it does that of Jan van Eyck; it confirms what we have said of his aversion to depicting an event.

Does this criterion of uneventfulness also apply to his youthful works? We know too little of his early period to be sure. But even in his youth he can hardly have been much of a storyteller; for in that case subsequent Early Netherlandish painting would show traces of the influence of a narrative religious art bearing an Eyckian stamp; and no such traces are to be found. Jan lived in Bruges in the 1430s, and the great painters of that city who came to him learned a great deal from him; but when they were commissioned to paint scenes from the life of the Virgin, or from the Passion narrative, or from biblical or hagiographic legend, they regularly drew their inspiration from a completely different pictorial tradition. Clearly, for this branch of religious art—still the artists' bread and butter—there were no precedents in Jan's work.

The inescapable conclusion is this: that Jan painted only what was congenial to his own stylistic concerns; that he was one of the earliest artists, if not the earliest, to specialize in a particular area of his art. An Italian counterpart would be Pisanello, who has left us just one painting on a biblical theme (also an *Annunciation*, as it happens). That Jan van Eyck could afford the indulgence of specializing in this way—that he could demand a say in the choice of subjects—is an astonishing privilege, in the context of his time, that would be hard to explain except by supposing that his office as court painter allowed him a considerable degree of independence. Here it may safely be said that between the patronage of the late medieval feudal state and the recognition of the artist's autonomy there exists a relationship of cause and effect.

II. The Master of Flémalle

The art of Jan van Eyck stands clearly apart from what went before; its genesis grows more enigmatic, and evolutionary continuity becomes still harder to establish. Any-one who sets out—as we intend to do—to trace the antecedents and the origins of the *Ars nova* in painting is well advised to try his luck first, not with the Van Eycks, but in the more traditional strain of Early Netherlandish painting: and this means with the painter who stands at the beginning of that strain, the prototype of all those painters whose task it was to satisfy a regular religious and secular demand: the Master of Flémalle, the undoubted founder of Early Netherlandish narrative painting.

For the chronology of this artist, only one certain point of reference exists: the date 1438 on the shutters of a triptych, of which the central panel has not survived, and which was painted in that year for one *minister henricus Werlis magister Coloniensis* (Father Provincial Heinrich von Werl, Professor at Cologne). If we then try to establish a chronology of the Flémalle Master's work on stylistic criteria, it soon becomes apparent that this Werl Altarpiece must be a late work. A number of other paintings, which show affinities with the monumental style of Burgundian painting around 1400, must be regarded as early works. It is understandable on purely historical grounds that the art of the new dominions of the dukes of Burgundy was in contact with that of the old Burgundian capital, Dijon; especially since, as I have said, the creators of the Burgundian style, such as Sluter, Beaumetz, Broederlam and Malouel, almost all had Netherlandish blood in their veins and were the compatriots of those who were breaking new ground in the new artistic centres. For the history of art, it is significant in another sense that the vital stimulus came from Dijon and not from Paris. Dijon, with its flourishing school of panel painters—not book illuminators—was also the home of a new school of large-scale sculpture with a new sense of solid physicality: both in painting and in sculpture, this was the contemporary centre that had produced the strongest three-dimensional impulses.

The monumental corporeality of Burgundian painting could never have existed without that of the Italian trecento; and, of all the Northern schools, the Burgundian was the most strongly saturated with Italian influences in the years round 1400. From Malouel and his circle, the Master of Flémalle must have learned to compose devo-tional paintings with a quasi-scenic character, extracting dramatic feeling from the interaction of physical beings, and from the attunement of their states of motion and repose.

In Malouel's tondo of the *Pietà*—or, to be more precise, of the 'Male *Pietà*'—the picture plane is occupied by a tight nexus of figures who are bound together not only physically but emotionally, by a shared expression of anguished feeling. The corner-stone of the composition is the limp, helpless body of the dead Saviour, just taken down from the cross, with blood still flowing from the wound in his side. In its collapse, Christ's body sags away from us into pictorial space and leaves the main axis of the tondo, which it would otherwise have occupied, partly vacant. The limpness of Christ's body causes the painting to sink in the centre and become hollow;

this is a composition with a weak centre. But the consequent slow, sliding motion serves to fit Christ and all the other figures neatly within the circular form of the panel. The body is caught up and held from behind by God the Father, while from the other direction Mary, followed by John, starts forward as if to support her dead son. Opposite Mary, angels try to lend a hand, forming into a semicircle that stretches round from behind God the Father's back to Christ's right knee. Sustaining, commiserating, lamenting, all the figures close in upon the dead Christ with a literally concentric motion. The round shape of the painting emerges organically from the nature of the action; it is the necessary result of a play of forces internal to the picture. At the same time, the endless flux of the circular motion suspends the workings of gravity and reconciles the considerable mass of the bodies with the unreality of the gold-grounded pictorial space.

Iconographically, Malouel's tondo is very complex, a subtle superimposition, intersection, interpolation, interpenetration of a number of related pictorial ideas. One motivic source is the Deposition; for the body of Christ, presented to Mary by God the Father, corresponds to the crucified body taken down by Joseph of Arimathaea and sliding into the arms of the Mother of God. The dove between the heads of the

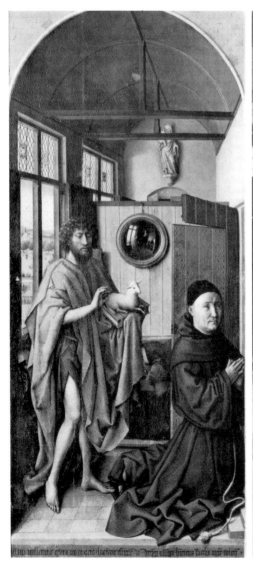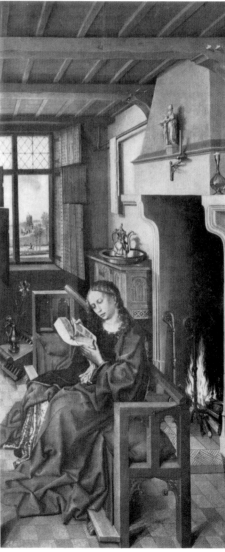

16
Master of Flémalle,
Werl Altarpiece.
Madrid, Prado

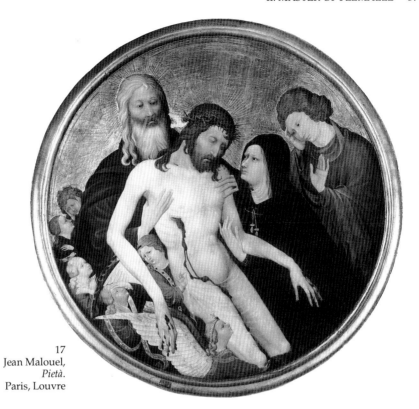

17
Jean Malouel,
Pietà.
Paris, Louvre

Father and the Son shows that the idea of the Trinity, the Mercy Seat, has also been involved; and that a historical and a purely symbolic idea have been blended together. To put it another way, Malouel's tondo uses the historical iconography of the Passion to renew the image of the Trinity.

This is not all. The three-quarters view of Christ, whose legs seem already to be half swallowed up in the grave, and the presence of grieving angels who seek to arouse our commiseration, evoke echoes of the *Imago Pietatis*, the Lamentation over the Dead Christ: a pictorial idea into which the artist has inserted from the *Pietà* the grieving figures of Mary and the disciple whom Jesus loved. The motif of Mary embracing her dead Son for the last time, which is thus alluded to, belongs in narrative terms rather to the Entombment than to the preceding scene of the Deposition; and this blurring of the distinctions between successive events tends to reinforce the sense of timelessness. Above all, it intensifies the devotional character of this subject, generally referred to in contemporary inventories as the *Pitié de Notre Seigneur*, 'Male *Pietà*', or *Nood Gods*.

Malouel's *Pitié de Notre Seigneur* comes from the Chartreuse de Champmol, in Dijon, endowed by Duke Philip the Bold, whose arms are on the reverse of the tondo. The monastery church was dedicated to the Trinity, which of course explains the thematic content of this work, and of a second, different representation of the Trinity from the same source, also now in the Louvre. This is a panel depicting the legend and martyrdom of St Denis or Dionysius. The iconographic combination of the Trinity with St Denis derives from the occasion when (as the *Golden Legend* tells us) Denis underwent martyrdom *in confessione trinitatis*, confessing the Trinity.[15] The idea of this panel, which was begun and planned by Malouel but probably completed by Henri Bellechose, was the conflation of the imagery of Trinity, Crucifixion and Martyrdom, the link being supplied by the motif of the crucified Christ, derived from the type of Trinity image known as the Mercy Seat. The combination of the traditional Mercy Seat

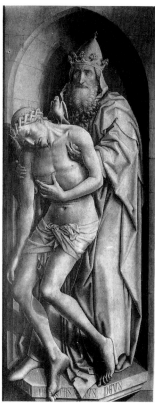

18
Master of Flémalle (copy),
Pietà of the Father.
Louvain, St Peter,
Musée de l'Art sacral

19
Master of Flémalle,
Pietà of the Father.
Frankfurt am Main,
Städelsches Kunstinstitut

imagery with that of the Crucifixion means that in this image a massive Golgotha cross is seen rammed into the earth, rather than reduced to the proportions of a portable crucifix. Interpolated above the cross, the Ancient of Days bears the features of Joseph of Arimathaea. Similarly, a little later, Masaccio visualized the Trinity as a Crucifixion surmounted by the head and shoulders of God the Father.

The Master of Flémalle reverts to this same thematic area; but he draws a clear distinction between his Trinity, which is a timeless vision, and his Deposition, which is an image of a historical event. The composition of his that comes closest to the Burgundian *Pitié de Notre Seigneur* type is one that we know only from copies. It deviates from the Burgundian type in a number of significant ways. Mary and John have been omitted, and the role of mourning for the dead Saviour has devolved upon a group of angels, who surround the Father and Son on all sides and assist the Almighty in supporting the lifeless body of his Son. The representation has thus been rendered timeless. A second and even more potent element of timelessness is the reshaping of the Christ figure himself: in place of the Christ newly taken down from the cross, with blood still flowing from his wounds, this is the Man of Sorrows: although dead, he points to his wounds and displays them to us. *18*

Strangely, while its devotional character is emphasized by this imposition of time-lessness, the image has simultaneously been localized. In Malouel's tondo, the laws of gravity are suspended; the figures enter the picture from somewhere undefined; there is nothing for them to stand on. In the Master of Flémalle's composition, there is still no telling where the figures stand, but the lower edge of the painting coincides with the floor of the pictorial space, a stretch of turf on which the angel on the right has taken a seat. This is a devotional image that has come right down to earth.

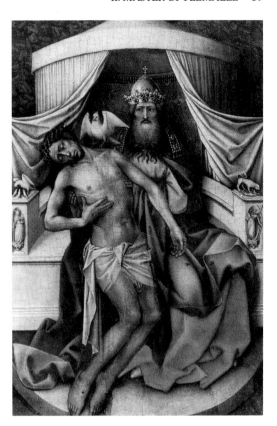

20
Master of Flémalle,
Pietà of the Father.
St Petersburg, Hermitage

The angel on the grass is, however, the only figure who does keep his feet on the ground. The posture of the Father, for instance, seems to suggest a seated position, but the tight interlocking of the figures blocks our view and prevents us from deciding whether to imagine a throne for the Almighty, or where it might stand. In two variants of this composition, both by the Master of Flémalle, the localizing tendency has affected the principal figures themselves: the painter ceases to evade the choice between hovering, sitting and standing and has God the Father seated on his celestial throne in one case and standing in a niche in the other.

19 The grisaille painting in Frankfurt, formerly the exterior of one shutter of an altarpiece, is an illusionistic image of a standing statuary group. The Man of Sorrows—that is, the Redeemer pointing to the wound in his side and thus appealing directly to the viewer's compassion—is a variant of the *Ecce Homo* that first emerged in the fourteenth century, mostly in the sculptural form of a standing figure who confronts the viewer open-eyed, demanding sympathy. With the amalgamation of the *Pitié de Notre Seigneur* idea with that of the Man of Sorrows, God the Father has also become a free-standing figure, exhibiting his dead Son for us to worship. We see that it is no accident that the Master of Flémalle's grisaille is a fictive sculpture: it has sculptural origins.

20 The localizing tendency is differently expressed in a further version of the subject by the Master of Flémalle, in which God the Father is seated. Here, as might be expected, the painter takes as his point of departure the image of the Mercy Seat, which he revises by replacing the crucifix in the lap of God the Father, where it looks like a devotional object, while at the same time showing Christ as the Man of Sorrows: that is, on the same scale as the Father himself. It is only thus, by absorbing the Mercy

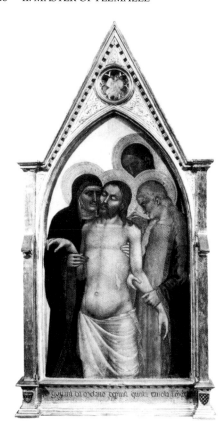

21
Giovanni da Milano,
Pietà.
Florence, Accademia

Seat type into the 'Male *Pietà'*, that the latter becomes a formal—and not merely a conceptual—counterpart to the feminine form of *Pietà*: a *Pitié de Notre Seigneur*.

When the Master of Flémalle took up the pictorial formula of the Mercy Seat, the physiognomy of God the Father in this type of image underwent a significant change. The Flémalle type of God the Father is no longer a deified Joseph of Arimathaea but a *Majestas* figure, crowned with the papal tiara, whose omnipotence is symbolized by the orb that he carries, and whom the early artists of the Eyckian circle liked to set beneath a baldachin representative of the sky. The Master of Flémalle's canopy has the unusual feature that its sides are swept back like curtains; a motif that probably echoes the venerable Early Christian convention that gathered curtains stand for revelation, the unveiling of the Divine Mystery to the devout believer. The same curtain motif is associated with the Man of Sorrows in an early fifteenth-century French relief and in a small panel painting by Jan van Eyck's pupil, Petrus Christus. Wherever it appears, it serves to emphasize the devotional and mystical nature of the image.

The irrationality of the conception of these images of Divine Mercy stands in marked contrast to the literalism of their execution, the sober, unsparing objectivity with which the supernatural is made visible to the bodily eye. The refined, aristocratic, delicately modelled, gently unfolding physique of Malouel's Christ, all sensuous spirituality, gives way in the Master of Flémalle's paintings to a coarser, fleshier, bonier, more muscular type. It is as if everything depended on creating the illusion of the tactile reality of what is depicted; as if the viewer were some kind of Doubting Thomas, demanding to be convinced of the truth of martyrdom by the evidence of his own sense of touch.

The new and, so to speak, palpable solidity of the Master of Flémalle's figures derives from two very different stylistic roots. The first is Italian. His dependence on Burgundian painting, as just observed in the Lamentation and *Pitié de Notre Seigneur* themes, is proof in itself that there is an Italian strain in his art. The ancestry of the devotional images that concern us here can be traced back, by way of Burgundian painting, to such works as the *Lamentation* of Giovanni da Milano. And this is true not only in thematic but also in formal terms: the volumetric quality of Italian trecento figures helped the North to transcend the linearity of the Gothic.

The second source of the Master of Flémalle's massively down-to-earth figures lay in large-scale sculpture. We have seen that in Western Europe the emergence of the *Ars nova* invested painting with a hegemony among the arts; in the altarpiece, it so completely usurped the role of sculpture as to retain no more than a surrogate for it in the shape of fictive grisaille sculpture on the exteriors of the shutters. Painting displaced sculpture, but learned greatly from it in the process, especially in the creation of a figurative world that was conceived in three dimensions from the start, rather than assembled out of flat forms and inflated to three dimensions as an afterthought.

Shortly before the *Ars nova* was born in Netherlandish painting, Gothic sculpture had enjoyed a new flowering in Burgundy with the work of Claus Sluter, an artist from Holland, who endowed it with a monumentality and an emotive, dramatic eloquence far beyond even that of the age of the cathedrals. It has been suggested that something of the new-found, voluminous intensity of sculpture reappears in the solidly built figures of the Master of Flémalle, or—shall we say—in the prophets in the Van Eycks' *Adoration of the Lamb*, with their massive blocks of drapery. It is tempting to suppose that Sluter's draped figures, with their strong sense of the pull of gravity, gave Netherlandish painters a feeling for solid structural and for internal distribution of weight. On a closer look, however, despite the shared sense of solidity and consistency, few concrete formal affinities are to be found. Individual motifs—

22
Claus Sluter,
Philip the Bold.
Dijon, Chartreuse
de Champmol, portal

23
Gepa.
Naumburg, Cathedral,
west choir

such as the mantle that is caught up in front, curtain-like, to reveal its lining—may well have been borrowed from Burgundian sculpture; but for sculptural precedents for the structure of Netherlandish draped figures we must look elsewhere. It is, however, worth considering whether Sluter's portrait likenesses might have been one source of the individualized portraiture of the Master of Flémalle and of the Van Eycks.

22

Sluter is hard to fit in anywhere; he is a world in himself. He worked in the age of the so-called 'soft' style, with its flowing masses of drapery that rise from the ground and fall back in gentle curves; but there is much in him, including the extraordinary massiveness of his figures, that seems to stem from the previous generation, that of Peter Parler, to which he belonged. By contrast, the Master of Flémalle and Jan van Eyck belong to an age of angular, discontinuous forms. The substance of the draperies looks brittle, or at least crumpled. The figure stands out sharply from the ground, and its drapery folds tend to change direction with a sharp kink. The form is no longer governed by the spontaneous movement of the drapery but is the result of the encounter in space between substances of varying degrees of hardness: the result, that is, of a play of forces beneath the surface. Every individual form is only the effect of an unseen cause; and so it demands to be perceived as the exterior of an entity that exists in spatial depth. Star-shaped fold patterns, for instance, reflect tensions such as those set up by the projection of a knee, or by the catching of a loose fold between the arm and the body. Bodily movement and spatial position thus directly impinge on the surface of the draperies.

Once before in medieval art, there had been a figurative convention organized around the vertical axis of the side facing the viewer and the axis of depth of the body; and that was in the statuary of the thirteenth century. In the monumental sculpture of that period there is a set of characteristics that seem to anticipate the typical qualities of Early Netherlandish figure types: the tendency to block-like self-containment; draperies with deep, sharp creases; a surface full of angular discontinuities that reveal the encounters between solid underlying forms. Also related is the way in which High Gothic sculpture creates a local sculptural emphasis by holding the integument clear of the body to take on a life of its own; as in those statues that raise one arm, as if in self-defence, to hold up the mantle like a shield or wall in front of the body. For all its inner affinity with the sculpture of antiquity, the classic sculpture of the Gothic period manifests a relationship between drapery and body that is fundamentally different from that of Greek and Roman sculpture. It is rare to find the draped form giving any indication of the shape of the body beneath or behind it. There is still a relationship between body and garment; nothing else could account for the discontinuities of external form. However, that form is not created by a flexible substance—like the diaphanous draperies of antiquity—that clings to a firmer substance, revealing and tracing the organic forms of the body beneath. On the contrary, it expresses a clash of forces within a confined space: the drag and thrust of the conflict between bodily energies and the inertia of lifeless matter.

23

The way in which the painting of the 1430s draws upon the sculpture of the late thirteenth century is an instance of the historical phenomenon of time-lag between different arts. The painters who were striving to conquer the third dimension may well have recognized that a true sense of three-dimensionality had already existed in art, albeit in the representation of filled rather than vacant space, and not in painting but in sculpture; and so they took instruction from sculpture. Rather as the painters of the Early and High Renaissance found matter for the new-found solidity of their figures, and a pattern for their articulation, by studying antique sculpture,

so in the North the early fifteenth-century painters found that High Gothic free-standing sculpture supplied them with figures that would carry conviction as inhabitants of a three-dimensional pictorial space. It was the achievement of Netherlandish painting to transform sculptural figures, inhabitants of the built space of an architectural structure, into beings who can be imagined as organic components of a living space.

We see this transfer process at work when we start to look for the origins of one of the earliest scenic images in the work of the Master of Flémalle. It soon becomes apparent that this Netherlandish painter has drawn inspiration from sculpture not only in the design of the individual figures but also in the grouping of the scene as a whole; what is more, the sculpture involved was probably a contemporary one. An *Plate 2* entirely unknown triptych came to light [1942] and was immediately recognized as an early work by the Master of Flémalle. It was in the collection of Count Seilern, in London. This complete small altarpiece, which shuts to reveal the unusual exterior form of a pair of arches, has as its central panel an *Entombment*, and on the wing panels the preceding and following moments of the Passion cycle: *Golgotha* on the left and the *Resurrection* on the right. The shutters, partly (though not exclusively) because of their tall, narrow shape, have a pictorial space completely distinct from that of the central panel. In both, we see a terrain viewed from above, winding towards the top of the frame: a space in which the flattening influence of the wallpaper landscape of International Gothic has clearly not yet been overcome. This is the same transitional style that is also found in a number of early Eyckian compositions, such as the *104* *Annunciation* in the Metropolitan Museum in New York or the *Three Women at the* *Plate 20* *Sepulchre* in the Museum Boymans-van Beuningen in Rotterdam. All these are characterized by a very high horizon line and a setting that drops away obliquely.

By contrast, the central scene takes place on a stage that is seen more from the front than from above, although it is shallow: it stretches hardly farther back than the end of the sarcophagus. The altered view is reflected by the altered design of the figures. The participants in the *Entombment* rise up close to the near edge of the pictorial stage (those in the *Resurrection* are much smaller, as if they were further from the viewer's eye). On a narrow foreground strip are the kneeling figures of two women, both of whom are viewed from behind and therefore automatically draw our gaze into the picture. If the painter had shown these two figures standing, they would also, as the closest to us, have been the largest, and would have overlapped and partly masked those beyond them. Their kneeling posture makes it possible for us to look over their heads at the principal action in the middle ground. It is only beyond this zone, dominated by the horizontal form of Christ as he is laid in the tomb, that we encounter standing figures; these form a wall, as it were, to shut off the painting in depth. The setting of the painting itself is not a landscape background or an indication of atmosphere: it is—one is tempted to add 'still'—a gold leaf ground with a relief pattern. In front of this embossed gold wallpaper, the figures in their stepped arrangement create the pictorial space by their own unaided efforts, rather as a sculptural group in the round might do.

The Master of Flémalle's painting of the *Entombment* is best thought of as a substitute for a sculptural representation of the same subject, a monumental *Saint-Sépulcre* in the round, of the kind that was among the most popular features of churches and chapels in fifteenth-century Lorraine and Burgundy. The panel is a two-dimensional version of an architectural setting for sculpture. The niche, with its vault, explains the paired arch shape of the frame. For that is basically what the central panel of the Seilern Triptych represents: a painted *Saint-Sépulcre* niche.

24
Simone Martini,
Entombment.
Berlin, Staatliche Museen
Preussischer Kulturbesitz

In art, the *Saint-Sépulcre* idea already had a history behind it. Around the year 1000, a vacant chest-tomb in one of the lateral niches of an ambulatory, or in a chapel, came to be used as the *scenarium* or setting for a dramatized Easter liturgy, and later for a Passion play; in the High Gothic age, this led to the idea of peopling this empty stage with sculptural figures, in such a way that the sarcophagus containing the body of Christ was fronted by the sleeping guards, while the three Maries were positioned behind it. Two separate scenes in the mystery play, the crucified Christ in the tomb and the women who find the tomb empty, were thus anomalously combined to create a sepulchral monument.

By the late fourteenth century, however, there was a growing and imperious demand to see each episode of sacred history in isolation, as part of a distinct sequence; the ahistorical imagery of the *Saint-Sépulcre* was no longer adequate, and a more eventful version of the subject was called for. Meanwhile, the iconography of the Entombment had also been transformed in Italian painting, and in the Sienese trecento in particular. Powerful motifs of lamentation and weeping—*compassio*—lent the scene so strong an emotional charge that it evolved from a subsidiary episode into one of the climactic moments of the whole Passion drama. It was this scene, combining the Entombment and the Lamentation, that found its way in the early 1400s into the Burgundian *Saint-Sépulcre* niches, which thenceforth served to commemorate the Entombment instead of the Resurrection.

It is possible that this development also owed something to the mystery plays, in which the Entombment was enacted in dumb show, thus coming half-way to a purely optical presentation. In any case, sculptors now provided stone figures to act out the Passion play in its traditional setting, the niche of the Holy Sepulchre. The earliest dated work of this kind known to us belongs to the second decade of the fifteenth century, but the conception dates back at least to the time of Sluter, as is proved by the *Saint-Sépulcre* that recently came to light at Mainvault, in Hainault.

In none of the Burgundian sculptural groups is the tomb surrounded by figures on all sides. The figures merely hint at actions: they are statues arranged in parallel rows around a cavity. The Master of Flémalle's version is an iconographic and stylistic blend of two separate traditional versions of the Entombment: the sculptural *Saint-Sépulcre* and the painted Lamentation-cum-Entombment. From the former—the *tableau vivant* or rather the set piece—the Netherlandish painter derived his non-illusionistic, wax-work-like conception of space; and from the Entombment tradition in painting he derived the way in which the actors in the drama are linked within the picture.

In the *Saint-Sépulcre* groups, Christ's body lies on the lid of the sarcophagus, ready for embalming, and all concerned—most often including even Mary, supported by John—maintain what, in the circumstances, is an entirely implausible composure. In the Master of Flémalle's painting, the coffin is open. Christ is being lowered into it, and this prompts Mary to bend over her dead Son for an impulsive last embrace. This is a far more 'instantaneous' version of the action than anything in the *Saint-Sépulcre* groups; however, there are other factors—even aside from the patterned ground—that are out of character with a purely narrative account of a historic event. For one thing, angels participate in the scene, exhibiting the Instruments of the Passion and flanking the act of Entombment itself. Every figure has its entirely individual function in the scene: not one gesture is repeated. Most significantly, the three Maries play their parts at three distinct points of the narrative; the addition of St Veronica is a unique departure from iconographic convention.

The most significant change affects the body of Christ himself. In the Burgundian sculptural groups, as in trecento painting, the dead man, the passive participant in the drama, is seen from the side. This is a disadvantageous view, if the central figure

25
Entombment from Mainvault.
Ath (Hainault), Musée Athois

is to be the focus of emotional expression. Thus, the Christ figure in the *Entombment* painted in Avignon by Simone Martini is not only physically but expressively mute; and the attendant figures are all the noisier and busier. It is their anguished reactions to the event that appeal to the *compassio* of the viewer and worshipper. The Master of Flémalle succeeds in staging the physical act of the Entombment in such a way that Christ's body is turned to present its full width, parallel to the picture plane, while the head and arm hang limp. As in devotional paintings of the *Pietà* or of the Mercy Seat, this is an *ostentatio*, a displaying of the Passion of Christ. Significantly, there is a move in this direction in the Netherlandish *Saint-Sépulcre* carving just mentioned, which predates the work by the Master of Flémalle: except that in the sculpture Christ is still laid out on a bier instead of being lowered into the grave.

The *Pietà* and the Mercy Seat are by definition devotional pictorial types. What is new about the Master of Flémalle's *Entombment*—and the particular achievement of this artist—is that he makes it possible for a painting of a specific event to become devotional: the devotional meaning emerges without strain from the logic and from the mechanics of the visible action. To bring religious ideas home to the viewer, the painter no longer needs to invoke the supernatural; he takes his stand on natural causation. The essence of artistic illusion now lies in visibly reconciling empiricism with faith.

The pictorial transposition achieved in the Seilern Triptych—the translation of the *Saint-Sépulcre* group into the language of painting—had momentous consequences. This early work by the Master of Flémalle became the ancestor of a series of major monumental compositions by his pupil, Rogier van der Weyden, which made a deep and immediate impact on contemporaries, and which marked a new departure for

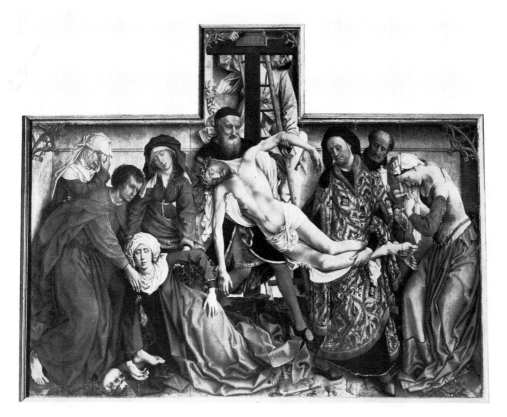

26
Rogier van der Weyden,
Deposition.
Madrid, Prado

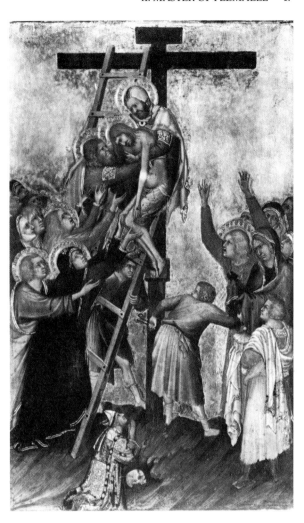

27
Simone Martini,
Deposition.
Antwerp, Koninklijk Museum
voor Schone Kunsten

the religious painting of the North. Rogier applied his master's principles to new themes in two paintings, a *Deposition* and a *Bearing of the Body to the Sepulchre*. Of these, only the *Deposition* has survived in the original.

In place of the illusion of a sepulchral niche, Rogier has attempted to convey that of an altar shrine, carved in wood or otherwise sculptured. The Master of Flémalle's unspecific, patterned background gives way to the sharply delimiting spatial reality of a box shrine. The arrangement of the figures slightly in depth is replaced by a new foreground emphasis and a frontal composition based on a single wall of figures. This newly direct, head-on approach to the worshipper stirs his sympathies with an almost aggressive immediacy. Joseph of Arimathaea, holding the Saviour in his arms after taking him down from the cross, displays him very much as God the Father does in the *Pitié de Notre Seigneur*. The direct address to the viewer is not restricted to this single motif: the central expressive movement carries along the single layer of the pictorial space, so that outward event and emotive gesture coalesce in a single dynamic.

26 This celebrated *Deposition* of Rogier's, once in Louvain and now in the Prado, is indebted to the Master of Flémalle's Seilern Triptych of the *Entombment* only for the idea of the shrine: the main source of inspiration for its figurative composition was another work by the Master of Flémalle, now lost, which shared the theme of Rogier's

panel and was on a similarly monumental scale. A fragment of the right wing of this triptych, which once adorned a church in Bruges, has been preserved; but its overall composition is known to us only from smaller copies.

This was not the first time that the Deposition, usually a transitional episode, had been promoted to be the central scene of the Passion cycle in place of the Crucifixion itself. In twelfth- and thirteenth-century Italy, for instance, there were woodcarvings of Deposition groups in which the *ostentatio* or display of Christ's sufferings could be handled with greater freedom than in the Crucifixion itself, where the artistic innovator had to contend with a weightier burden of tradition. The most significant monument of this new iconography of the Deposition is Simone Martini's Avignon altarpiece, which soon found its way to Burgundy, whence it exerted a powerful influence on French art. In Simone's version, the Dead Christ is lowered from the cross not for burial but in order to slide into the arms of his Mother, who awaits him with yearning. Mary is not the only one who stretches out her arms to the Son whose sufferings are now at an end: the other Maries do the same; and, in order to balance their movements symmetrically, the artist makes one woman on the other side, probably Mary Magdalene, throw her arms in the air. The whole scene is pervaded by a single, unison cry of lamentation.

27

When we turn from Martini's powerfully emotive image to the Master of Flémalle's composition, we find to our surprise that this harmonious unity of physical action and emotional response seems to have been abandoned. The practical business of bringing the body down from the cross occupies the right-hand half of the panel, while the left is reserved for those whose participation in the drama is a purely emotional one. In Martini's painting, everything seems to converge on the impending reunion between Mother and Son; by contrast, the Master of Flémalle's composition is dominated by a shrill dissonance. The body slumps abruptly to the right, and every detail—the dangling left arm, the drooping head—illustrates the total loss of strength, as the lifeless mass surrenders to the force of gravity. On the left, meanwhile, Mary

28, 29

28
Master of Flémalle (copy), *Deposition*. Liverpool, National Museums and Galleries on Merseyside

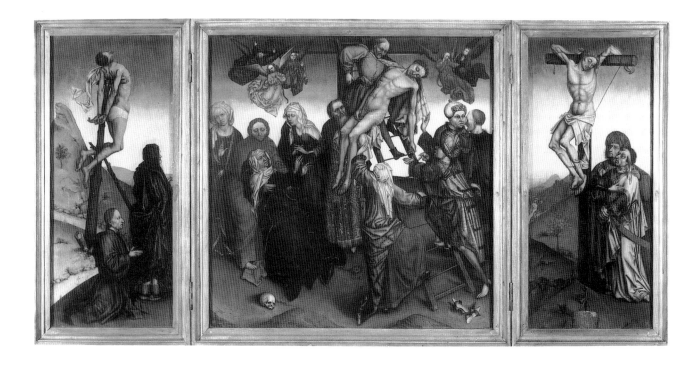

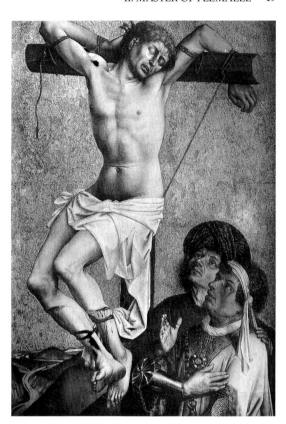

29
Master of Flémalle,
Deposition (fragment).
Frankfurt am Main,
Städelsches Kunstinstitut

swoons into John's arms, her hands still outstretched to her dead Son. These two movements, caused by the loss of vital power on one side and the loss of consciousness on the other, widen the distance between Mother and Son before our very eyes. The longed-for last embrace can never happen. This separation is the tragic accent that sets its imprint on the whole scene. It sounds the keynote for the forming of every detail: the broken line in the draperies, the angular movement of the limbs, the zigzag of the outlines. Discontinuity is raised to the status of a motif in itself.

The stage on which the event takes place has a considerable rake, so that we still to some extent look down on it. This looks less unnatural than it does in paintings of the preceding period, because so much of the ground is covered by the tightly packed figure composition, and also because the sinking movement harmonizes with the way in which the ground falls away. The spatial structure of the figure composition is a kind of pyramid, one side of which is formed by the ladder that rises from the right foreground corner to the top of the cross. According to the strict rules of perspective, this movement ought to be not only upward but away from us into depth; as it is, however, we have the impression that the figure composition looms towards us at the top. Which, of course, makes it all the easier to suppose that the body is slipping downward. This forward tilt of the picture plane makes the body impossible to hold, and it slides out of control. When Rogier took over the theme of the Deposition, he reinterpreted and rationalized the Master of Flémalle's composition: in his version, the action takes place in a single slice of space, parallel to the surface.

The Master of Flémalle packs the surface of his painting with massive forms, not all of which occupy equivalent positions in space: this means that, in the projection, forms with differing spatial content fit closely together on the picture plane. Wherever

a part of the surface is left empty of human figures, small-scale forms such as flying angels, a skull, even a pair of pattens, are inserted as fillers. Clearly, the artist feels impelled to cover the whole surface, as far as possible, with an even density of forms; he abhors a vacuum. This *horror vacui* is one of the most characteristic traits of the Flémalle style, both in open-air scenes—not that there is very much that is open about them—and in interiors.

Horror vacui is the agoraphobic fear of empty space. In the present context it signifies the denial of any pictorial space unoccupied by material substance. But, if this repression of the void is so characteristic of the Master of Flémalle, is it not curious, even paradoxical, that this very same artist was also the creator, or at least the part-initiator, of the entirely new pictorial genre of the interior? I say paradoxical: for does not the very idea of an interior presuppose the existence of a void, a space free of solid matter?

To clarify this, we shall need to look into the prehistory of the late medieval interior. First, however, I must give my reasons for asserting, as I do, that the *Annunciation* on the Mérode Altarpiece can rightly be regarded as the first true modern interior. There

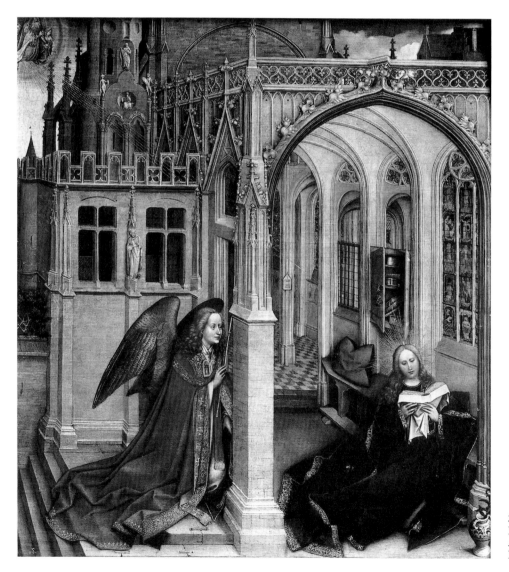

30
Master of Flémalle,
Annunciation.
Madrid, Prado

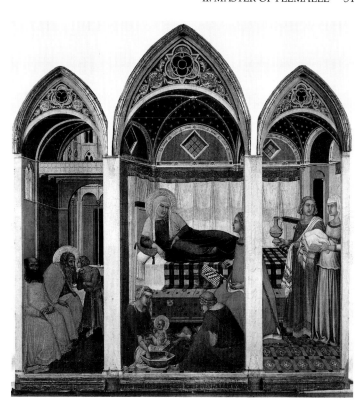

31
Pietro Lorenzetti,
Nativity of the Virgin.
Siena, Opera del Duomo

30 are other *Annunciations* by the Master of Flémalle that retain the older method of showing an indoor scene, as a view into a building of which we can also see the exterior. We are therefore safe in assuming, at the very least, that the decisive step was taken, and the solution to the problem of the interior found, during his lifetime; and it is probable on other grounds that it was he and no other who found that solution.

Plate 16 He was certainly not alone among his contemporaries in looking for it; this is proved by some of the Hours of Turin miniatures, which belong to the Eyckian circle,
Plate 17 and which represent a no less important contribution—indeed an alternative solution to the problem. But in that case the end in view, and indeed the artistic lineage, were different. The sources of the spatial conception of the *Birth of St John the Baptist* in the Hours of Turin lie in Sienese trecento painting, notably in the settings devised by the
31 Lorenzetti brothers for indoor scenes. These show a marked tendency to reduce the visible exterior of the building to a minimum and to make it into a frame for the scene itself, in which they concentrate entirely on the character of interior space. What particularly fosters the illusion of an interior in these works is the introduction of a new proportional relationship between the figure and its surroundings. The medieval primacy of the figure, with the setting pared down to an attribute or accessory, has been markedly reduced. For the first time, living rooms, halls and chancels are shown lofty and spacious enough to make it credible that people can live and move about inside them. Spaciousness, in turn, means respect for the intervals between the figures: that is, space free of solid matter.

He was certainly not alone among his contemporaries in looking for it; this is
The Lorenzettis paid for the relative airiness of their architectural settings—by comparison with those of Giotto and his Florentine School—with a marked loss of substance and solidity. And as the reduction of the size of the figures brought with it a loss of physical presence, there was a lack of the common denominator that would

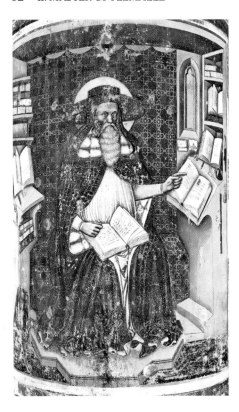

32
Tommaso da Modena,
St Jerome.
Treviso, S. Niccolò

33
Petrarch, *De viris illustribus,
Petrarch in his Study*.
Darmstadt, Hessische
Landesbibliothek
Hs. 101

have made it possible to set figure and setting in a clear spatial relationship to each other. Correct relative proportions alone were no solution to the problem of convincingly integrating the figure with its spatial setting.

Other trecento painters—notably Giovanni da Milano and other North Italians—developed approaches that had more of a future. In one *Annunciation* scene, Giovanni da Milano shows us an interior that is still cramped and box-like but constructed in *36* almost perfect centralized perspective. We see virtually nothing of the exterior: only a plain fillet that stands for the cross-section of walls, floor and ceiling. Interior space in this work is something like a hollow cube, sliced in half, the internal void of a stereometric solid of whose outer surface we learn nothing. A hollow body, we would call it; but in representational terms it is a typically Italian concept, in that the void itself is firmly circumscribed and presented to us as material, physical fact. This, in turn, has the advantage that the box is clearly defined as the space containing the solid presence of the figures. It was on this Italian pictorial type that the most important Parisian manuscript painter, the Boucicaut Master, based his often astonishingly advanced interior settings.

Also in Northern Italy, there existed another, and quite different, approach to the same problem of the interior. The principal exemplars in this case were Tommaso da Modena's paintings of Dominican saints—especially his *St Jerome in his Cell*, in *32* Treviso—and the same artist's *Petrarch in his Study*, which formerly adorned the Sala Virorum Illustrium at Palazzo Carrara, in Padua, and of which the best idea may now be gained from a miniature in Darmstadt. All these are images of scholars, in which *33* the box-like interior has a realistic justification: scholars do tend to work in cramped dens, and such little space as their rooms afford is cluttered with books, writing implements, chests and all manner of odds and ends. Bookworms seem to have a

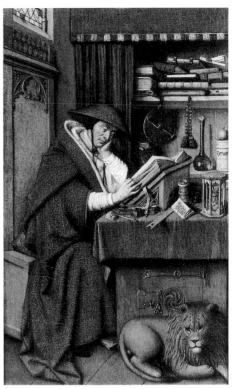

34
Bible Moralisée,
St Jerome.
Paris, Bibliothèque Nationale
MS fr. 166

35
Petrus Christus
after Jan van Eyck,
St Jerome.
Detroit, Institute of Arts

rooted dislike of empty space, and so the chief visual point made by this kind of image is not the void itself but its furnishings and other contents.

The creators of these North Italian images of scholarship seem to have instinctively realized that two things are necessary to create the spatial illusion of an interior: the sense of the three-dimensionality of a space built for human occupation, and its interior atmosphere, which is evoked by the depiction of the objects that furnish the space. For a theme such as that of the scholar in his cell, where the setting is the human subject's home ground—the space in which he leads his life—rather than the location for any particular event, they saw that the second factor, the nature of the room's contents, is incomparably the more important of the two; and that the painter must pursue the specific interior atmosphere by all possible means, even at the expense of clear spatial structure.

The result was the almost effortless removal of one of the major obstacles to a complete illusion of interior space: the predominance of the human figure. This was eliminated not by reducing human stature—as in Siena—but by integrating the occupant and his four-footed companions with his own inanimate chattels, and thus making him a part of the furniture: one item in a volumetric still-life. The ideal theme for this kind of illusion of interior space is, of course, that of St Jerome in his cell, and it is an open question whether Petrarch in his Paduan study was a secularized St Jerome, or whether the poet-scholar in his den was actually a source for the theme of 'Jerome Enclosed'.

The same Paduan School that created the image of the scholarly recluse also tried its hand at depicting the Virgin Mary in her own domestic setting. In the Oratorio di San Michele, in Padua, there is an *Annunciation* fresco attributed to one Jacopo da Verona. This attempts to create the atmosphere of an interior by means similar to those

36
Giovanni da Milano,
Annunciation (part of a small altarpiece).
Rome, Galleria Nazionale, Palazzo Barberini

employed in *Petrarch in his Study*: that is, by filling Mary's chamber with a variety of furnishings and household effects. Domestic animals are included as *staffage*—one of which, a cat, was Petrarch's favourite pet and would have been better left in his study. The illusion does not quite come off, largely because of the clash between the strong three-dimensionality of Mary's plump figure and the almost anachronistic flatness of the tiled floor. Even so, this Paduan fresco of the Virgin's chamber is the most secularized *Annunciation* scene that we know of before the Mérode Altarpiece.

The image of the scholar in his study, as represented by St Jerome, must have been a familiar one in France by the end of the fourteenth century. One example, which probably once existed as a free-standing enamel (*émail en ronde-bosse*), is recorded in a large drawing used as the frontispiece of a Bible copied for a Duke of Burgundy in 1402. Here we look into a Gothic shrine of goldsmith's work to find the Father of the Church seated in a Carthusian cell.

It was not long, however, before Northern artists revived the cluttered North Italian interior in a purer form; and the end result was an Eyckian *St Jerome* that has survived only in a version by Jan's pupil Petrus Christus. The creator of the original, presumably Jan van Eyck, had such confidence in the suggestive power of his spatial inventory, with its profusion of detail, that he dared to leave out a part of the enclosure; and so he created the first interior that shows only a section, a 'detail', of the space. The scene is totally still. There has been a decisive advance in the spatial integration of the human figure with its setting; and this has been done, paradoxically enough, by standing on its head the relationship between animate and inanimate matter. Eyckian painting lets the domestic detail, the inanimate minutiae of the image, speak out—one is tempted to say 'shout'—while the living beings simultaneously fall silent. The Saint is deep in his reading, lost to the world; and even the lion of his legend is no longer permitted to display the thorn in his paw, but must sit still and turn into a drowsy household pet. The legend has become a volumetric still-life.

After this detour by way of the scholar's den, we now return to the home of the Virgin Mary, as seen in the *Annunciation* scene of the Mérode Altarpiece. This digression ought to help us to make out the differences—only some of which are

34

35

37

Plate 3

thematic—between an Eyckian and a Flémallian interior. Mary's living room, in the Master of Flémalle's version, is not a 'detail' of a space: it is a complete interior with the near wall removed, rather like those in the miniatures of the Boucicaut Master. However, it lacks the bareness of those Boucicaut settings; it is, as they say, comfortably appointed, with all those things that create the illusion of a cosy atmosphere: one suited to the tastes of the stay-at-home North, by contrast with the more outdoor, public life of Southerners. The interior atmosphere is thus taken into account; and although Mary's room is not exactly crammed with furnishings and effects, Joseph's neighbouring workshop is every bit as cluttered and as stiflingly cramped as Jerome's study.

There is just one thing more that sets Mary's chamber in the Mérode Altarpiece apart from its precedents in the work of the Boucicaut Master and permits us to describe it as a true interior. The last vestige of the outside view, the framing strip, has disappeared, and the picture plane slices through the room just on the near side of a pair of consoles that belong to the interior space. We thus see only what a person inside the room itself would see. The success of the illusion of interior space depends ultimately—as the Master of Flémalle must have intuitively realized—on transpor-

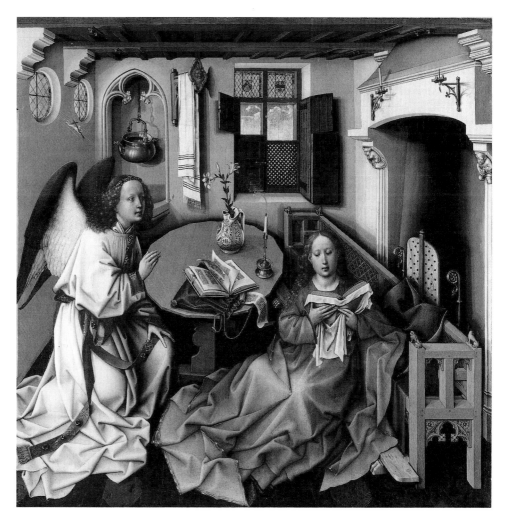

37
Master of Flémalle,
Mérode Altarpiece.
New York, Metropolitan
Museum of Art, Cloisters

ting the viewer into the position of those within the pictorial space itself, who cannot see beyond their own four walls. The scene, the process in the living room, has to be brought home to us as it would be experienced by an occupant of the house—or by the painter of the newly-wed Arnolfinis, who recorded his own presence, his status as an eyewitness, in the words *Johannes de Eyck fuit hic*.

In the interior of the Eyckian *St Jerome in his Study*, as in that of the workshop of Joseph by the Master of Flémalle, and as in the Mérode Altarpiece *Annunciation* itself, the accessories divert the eye from the central action and invite us to dwell on inessentials. This striking fact seems to announce a momentous change in perception of the function and demands of religious art; and this is a change for which the literature of the subject furnishes us with two diametrically opposed explanations.

35

Plate 3

Earlier writers tended to regard it as a symptom of a secularization process that culminated in such works as the market still-lifes of Pieter Aertsen, in which the religious theme turned into a mere pretext for depicting everyday objects that had yet to establish themselves as suitable subjects in their own right. This historical approach lapsed into near-oblivion when a school of iconographical scholarship that terms itself iconology achieved great success with a symbolic mode of interpretation.

According to this school, the minute particularization of settings and household contents by the Early Netherlandish painters, their whole new vision of reality, was a mere façade; the new, sensuous-seeming realism was only a disguise for profound religious ideas, and for symbolic concepts based on theological speculation. Behind the modest and unassuming objects of this pictorial world—or so we are invited to believe—there lies a profound religious programme which it is for us to discover and to explore. Netherlandish realism is presented as a new and secret language of Christian worship that we must decode. So far from being the secularization of religion, it is the sanctification of nature.

We shall have cause to return to this attempt at symbolic interpretation at a later stage; but first, to get our feet on the ground, we had better try to clarify the formal structure—the stylistic *raison d'être*—of the new world of objects that had now entered into art.

Gabriel would have no wings, if he were not thought of as a messenger who has descended from the heights of Heaven to enter Mary's modest room and to salute the chosen vessel of divine grace. In the Mérode Altarpiece *Annunciation*, however, there is no sign of the distance he has travelled, or of the moment of his arrival and entry. The angel has dropped onto one knee and is almost as motionless as the Virgin, who sits on the floor, totally absorbed in her book. Artfully expanded, Mary's form spreads to fill the space between the table and the bench; by contrast, Gabriel is tightly confined between the wall and the table. There is no room for movement whatever; this is the same *horror vacui* as in the *Entombment* of the Seilern Triptych. And yet, if we make the effort to trace our perceptual experience back to its root, we are surprised to find that it is not the room that is crammed full but the surface of the painting that is tightly packed with forms from top to bottom and from side to side.

Plate 2

If we try to reconstruct the ground plan of Mary's chamber, it turns out that there is empty space between the Angel and the Virgin; it is only the projection of the table onto the picture plane that interposes itself and fills the void. Again, between the Angel's head and the ceiling beams there would be a considerable space; but the painting contrives to suggest that if Gabriel stood up he would knock his head on a kettle that hangs, not above his head at all, but in an alcove in the far wall. Connections are thus established between things that are juxtaposed in projection but not in three-dimensional reality. The surface of the painting is actually filled as a result of

the projection, with contours neatly fitted into each other to cover the entire picture plane with an uninterrupted mosaic made up of the outlines of figures and objects.

Not only the spaceless painting of the Middle Ages but also the new Netherlandish painting, with its illusion of space, still creates a surface pattern; now, however, this surface is essentially a projection screen. Everything we see is projected form, and as such is ambivalent: 'Every projection of an object has an illusive, spatial value; but the outline of that object simultaneously acquires a purely planar value. For example, a circular table-top can be projected onto the picture plane as an oval'.[16] We have before us a pictorial world that is organized according to two entirely distinct principles: henceforth, the art of composition consists in coordinating and marrying the separate requirements of two-dimensional organization and spatial illusion.

The first phase of Early Netherlandish art was long thought of as a transition from a purely empirical—and therefore imperfect—knowledge of perspective to an exact one; and artists were judged by the errors and the faults of drawing into which their want of skill was thought to have betrayed them. That is, works of art were approached as if pictorial composition were primarily a technical matter, and not primarily an aesthetic one at all. We have now come to see that defects in perspective may have perfectly good reasons behind them, and that they reflect the primacy of two-dimensional organization over the demands of spatial illusion, with which it has been in constant conflict ever since the picture plane first became a projection screen. To take an extreme case: a picture might be perspectively quite correct and yet, for want of a good pictorial pattern, aesthetically inadequate and indeed false. If all that mattered in an interior, for instance, were a clear indication of the floor-plan, it would still be quite possible, even with a correct projection, for it to present unwarrantable masking or impenetrable clutter in one place and yawning emptiness in another.

The paintings of the Master of Flémalle are marked by an approximately even distribution of formal constituents, and at the same time by an endeavour to fit the outlines of discrete objects into each other as neatly as possible across the surface of the picture. Of course, this kind of ubiquitous, seamless integration of planar forms does not emerge spontaneously as a result of the projection process: it appears only if the pictorial imagination has adopted the plane of projection as its starting-point in elaborating the form of the work. To retrace this procedure requires us to undertake a thought experiment, taking the relationship normally implied by the term 'projection' and reversing it: that is, not starting out from the ground plan of the pictorial space, with its three-dimensional concomitants, but starting out from the plane of projection and treating it like a focusing-screen on which we see a configuration of variously formed patches that are then projected back into the imagined space behind the screen, where they coalesce into objects and animate beings. This 'back-to-front' projection looks like a highly paradoxical assumption; and of course it must not be thought of as a literal technique. But as a hypothesis it may be of some help in identifying the pictorial structures of Early Netherlandish art, and in clarifying some features of it that will not fit into any interpretation confined to the factor of spatial illusion.

Once we realize that an Early Netherlandish painting is based on two separate reference systems, it is clear at once that these are not equal in importance. In the Master of Flémalle, a highly developed sense of the planar organization of projected form goes hand in hand with an astounding insensitivity to the spatial separation of the contours that he fits into his pictorial pattern. The curve of the table edge, which is the foreshortened outline of an orthogonal surface, runs parallel to that of the Virgin's side, which is vertical. It is impossible to resist the impression that the

table-top has been tilted downward, in defiance of spatial logic, solely in order to improve the fit between neighbouring outlines. Our eyes perceive this adaptation as a visual distortion.

Contrary to all expectations, wherever there is a conflict between the two organizational principles of pictorial pattern and spatial illusion, it is planar organization that prevails, and three-dimensional organization becomes secondary. For a number of reasons, some of which will be discussed later, this primacy of two-dimensional organization should be regarded as an aesthetic compulsion that cannot—or perhaps we should say cannot *yet*—be countered by greater optical experience of the external world. For the moment, bear this in mind: for all the forms in the picture, the locus of aesthetic unity is the picture plane, not the pictorial space.

Visual distortions, in the first phase of Early Netherlandish painting, are not confined to individual objects. Very often, the upper half of the painting is seen in a normal, horizontal view, while the lower half—and often more than half—is viewed from above. This happens, for instance, in the landscape of the *Adoration of the Lamb* *Plate 24* on the Ghent Altarpiece; and it is well known that Dvořák, in his still extremely important study of the Van Eycks, took this very fact as his criterion for distinguishing between the hands of Hubert and Jan van Eyck in that work: he regarded the undeniable shift of viewpoint as the mark of a stylistic discontinuity.[17] But the same change of viewpoint is equally evident in the *Annunciation* scene of the Mérode Altarpiece, where it has never occurred to anyone to detect a stylistic change, let alone a discontinuity. 'What is more, even the high viewpoint in the lower half of the Master of Flémalle's *Annunciation* is not consistent: the figure of Mary, seen slightly from above, is juxtaposed with that of the Angel, who is seen sideways-on. It would thus remain a highly inadequate description of Netherlandish pictorial organization to say that it combines a level view in the upper half of the painting with a downward view in the lower half'.[18]

To clarify the way in which the Master of Flémalle organizes his painting, we shall once more reverse our habitual way of looking. Instead of supposing that everything converges with increasing distance and becomes foreshortened, imagine perspective as a process whereby the forms spread out and diverge as they grow nearer. Towards us—in accordance with perspective—the bench and the table thus grow wider apart, thus making room for the Virgin to sit on the floor in between. Her upper torso fits in frontally, while the mass of body and garments below armpit level expands outwards and downwards. The strongest sculptural accent lies at the points where the knees seem pushed forward against the draperies, which they stretch. All this seems to be based on the curious notion that a disproportionately large area of the picture surface is available for the projection of objects in the near layers of space, so that the forms of things have to be stretched sideways in order to avoid breaking contact with adjacent projected forms—with the consequence that we gain the impression of a visual distortion.

There is more to it than this. 'According to the laws of natural optics, things on the horizon and in the distance appear flat and devoid of sculptural relief; they merge to form a unified *veduta*, a spectacle. Where natural visual experience leads us to expect a flat effect, there is no need for the relief of the projected form to be artificially brought out. In the upper part of the painting, everything is consequently more "natural"; there the motif fits into the composition more readily, because it already is more planar: there, from a Netherlandish point of view, nature lends itself more readily to artistic treatment'.[19] There, too, no new form has to be invented in the course of translating nature from three dimensions to two.

A better and less forced compromise between the two demands—the planar coherence of projected forms, as against a convincing spatial illusion—was to be one of the most urgent priorities in the course of the evolutionary changes that ensued. The later works of the Master of Flémalle himself, such as the Werl Altarpiece (dated 1438), show how to resolve the conflict that arises when every form must be the servant of two masters: without disrupting the surface organization, all the details of the scene—and especially those of the figure and of its spatial shell or enclosure—are plausibly integrated into the space. The Mary of the Mérode Altarpiece sits beneath the window and next to the bench; the St Barbara of the Werl Altarpiece sits in front of the window and on the bench. Although the later interior contains far more detail than the earlier—a little table with a vase of flowers is inserted between window and bench, and a washstand between window and fireplace—the surface of the picture seems far less crowded; there is more air in the room. The format, too, sets the room and its occupant in a more natural relation to each other; but this is no longer, as in trecento painting, simply a question of relative scale: it also depends on the plausible fitting together of spatial volumes.

In the Mérode Altarpiece, the conflict between plane and space, which underlies the surface continuity of the pictorial pattern, has yet to be resolved; especially as the artist sets out to achieve the greatest possible sculptural roundness in every individual object. The colour reinforces the additive character still more. The dominant principle is that of local colouring, and neighbouring objects are sharply distinguished by their different colours. But the recognition of space has confronted the art of colour with an entirely new problem. The effects of the medieval hierarchy of visibility still linger, according to which the human figure is sharply distinguished from inanimate nature—that is, from its surroundings—not only in size but also in colour: bright colours are reserved for figures, and all the rest is confined to pale and neutral tones. In the Mérode Altarpiece *Annunciation* there are, apart from the figures, few and relatively small passages in bright colours: the red metal of the towel rail, the green pouch belonging to the book, and the blue cushion and cover of the bench. All the rest is painted in various tones of grey and brown, with which the tones of the brass utensils also harmonize. But since the furniture is projected in exactly the same way as the forms of the figures, the neutral and unassertive colours of the objects in the middle and background press forward to the picture plane; and one of them, the table top, actually occupies the centre of the painting.

We can probably form no conception, today, of the sheer audacity involved in putting in the centre not only a large piece of still-life but a piece of neutral colour. This was the moment when black and white, which Alberti in his treatise on painting did not even recognize as true colours,[20] and their close relative, brown—all of which operate primarily through tones of light and dark—first asserted their claim to equality of status with the brighter colours.

In the two wing panels—that is, at the periphery of the work, where innovations tended to make their first appearance, subverting traditional censorship and self-censorship—the Master of Flémalle went one stage further still. Although the wing panel on the left shows an open-air scene and the one on the right shows an interior, in both cases bright colour has similarly been forced onto the defensive. The donors on the left, husband and wife, are clad in black, with only a single strip of dark brown: soberly dressed, we might say. Joseph's gown, on the right, is a plummy brown, with an admixture of blue as well as red: colours that appear in pure form only in his turban-like headgear and in the sleeves of his undergarment. This heightened brown in the right-hand wing panel generates no contrast with the tonality of the room; and

this is set off from the distant view by an illusion of interior space created more by chiaroscuro contrasts and cast shadows than by anything we see of its bounding walls. The Master of Flémalle has discovered that certain qualities of light and of lighting suffice in themselves to convey that a scene is an interior.

This brings us to light and its reverse, shadow; omnipresent in the central panel as well as the wings of the Mérode triptych, they had been barely detectable in the painting of the immediately preceding period. In Mary's chamber, we are to assume that the light comes from at least two directions, from the far wall and from the left; these two light sources overlap to some extent, creating penumbral cast shadows. Light and shadow are no longer simply aids to modelling: they supply the new, unifying factor that makes a disembodied but optically effective connection between pattern and ground. Long before Netherlandish paintings acquired a single view-point, they were constructed around a specific lighting situation. This countered— and far outweighed—the risk that the picture might disintegrate into an additive pattern of scattered forms.

The form of the object tends to be relativized by its lighting. Colour, and bright colour in particular, remains identified with the object and extends no further than the ambit of its form; at the same time, however, what seem to be objects—the shadows that replicate real objects—appear on the plane of projection alongside the objects themselves; and this, of course, blurs the distinction between what Is and what Seems. The object and its shadow, or its mirror image, relate to a common light source, which is mostly thought of as located outside the painting itself, and to which every detail within pictorial space is referred. Even in later art, where pictorial organization has been brought into line with the laws of linear perspective, the strongest guarantee of pictorial unity remains a precise definition and individualization of the state of the lighting.

Bright and dull colours are equally subject to the laws of lighting; and this in itself tends to undermine the medieval dualism whereby figures are brightly coloured and the inanimate world is confined to more neutral tones. Lighting shows up colourful objects; but it also counters what would otherwise be the total dominance of bright colours in the overall pattern. In medieval painting, bright colours not only pick out the figures by contrast with everything else but define the expressive value of the individual figure according to hue. The blue of the Madonna's mantle has virtually no representational function, only a symbolic one: blue is the colour of Heaven and also of humility. In compositional terms it operates as a flat area of colour, divorced from the figure; and yet it makes a definitive statement about the inward, spiritual identity of that figure.

With the new, realistic approach to the process of representation, colour has a new requirement to satisfy. It must help to identify the objecthood, the three-dimensional identity, of the object that it colours: it must, for instance, convey the texture of the material of Mary's gown. The Master of Flémalle is fond of fur-lined garments; and in the St Petersburg painting of the *Madonna at a Fireplace*, in a room that has not only a source of light but a source of warmth, Mary's skirt is turned back to give us a view of its cosy fur lining. The red of her mantle, by the nature of its colour, introduces another note of warmth. This is a good example of the cooperation between two different kinds of colour effect in the service of a specific mood.

The compositional use of colour in the St Petersburg painting perhaps gives us a clue to the interpretation of the curious choice of colours in the Mérode Altarpiece. In this *Annunciation*, in defiance of the centuries-old custom of showing Mary in the blue of humility, she appears entirely dressed in red. Her mantle and her dress are the same *38*

colour, the former being hemmed with a narrow band of gold. Only the cushion and the cover of the bench on which she leans are dark blue. Red, with its elemental associations with blood and fire, could be used in the Middle Ages as the colour of sovereignty, or as a symbol of the sufferings of Christ and of the martyrs. Not inconceivably, the red costume of this Virgin Annunciate might be intended as a premonition of the Passion of Christ, to mark her out as the future *Mater dolorosa*. There is a *Lamentation* by Rogier van der Weyden in which Mary is dressed in red. But we should also consider whether this departure from traditional colour symbolism might not be the first sign of a growing indifference to the medieval canon of colour.

If we put this to the test by looking at the response of the Master of Flémalle's immediate successors—and particularly his great pupil, Rogier van der Weyden—to this innovation, it turns out that in their *Annunciation* scenes they went straight back to traditional colour symbolism, though they continued to make use of red effects in other ways. In Rogier's *Annunciations*, Mary's blue is set off by the red of a counterpane or tester. It is as if the St Petersburg Mary's red mantle had detached itself and taken on a life of its own as a glowing contrast to Mary's deep blue.

It had long been traditional to dress the Angel of the Annunciation in red. Simone Martini had been the first to put him into a gold-patterned white robe. In the New Testament, angels are mostly described as white-clad youths; according to St John, the two angels whom the women found in Christ's tomb were in white. White as the colour of purity and innocence was entirely appropriate for Gabriel; indeed, it is surprising that red, symbolically so inappropriate, had become so firmly established as the colour for angelic garments, no doubt because it automatically suggested itself as a complement to Mary's blue. On the Mérode Altarpiece, the Master of Flémalle

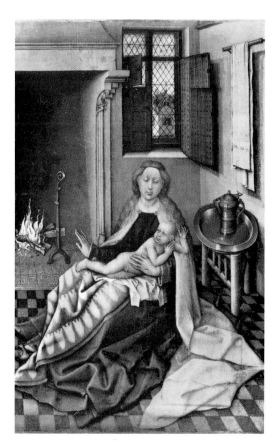

38
Master of Flémalle,
Madonna at a Fireplace.
St Petersburg, Hermitage

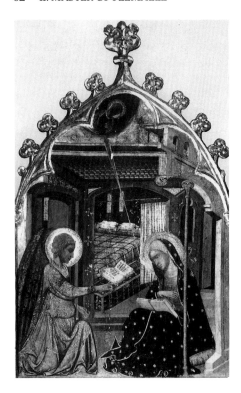

39
Cardona Altarpiece,
Annunciation.
Barcelona,
Museo de Bellas Artes

replaces this red-blue contrast by balancing one area of very warm colour against another of very cold colour. Bluish shadows, reinforced by the blue bands of the girdle and cuffs, give the angel's robe an icy tone. The warm-cold polarity is carried to an extreme, albeit mainly in terms of warm and cold light.

What is depicted is an event; but there is not a trace of bodily movement. And yet the painting does not entirely lack a sense of time, and thus of a specific occasion. In the colouring, a clear sequence runs from left to right: brilliance diminishes, and, conversely, warmth increases. A progression from light to dark, and from cold to warm, follows the direction of the angel's movement as he approaches Mary: it is an unequivocally directional, optical movement. It does not set the figures in motion, but it conducts the eye.

With this, we finally touch on the quality that sets this painting apart from its sources. If we enquire as to what new motifs the Master of Flémalle has created, we come to the surprising conclusion that, with a single exception, he took all his pictorial ideas—even the Virgin's pose, seated on the floor and reading—from his predecessors. It was the Sienese trecento painters who first transferred the idea of the *Madonna humilitatis* to the Virgin Annunciate and had her sit close to the earth, on the floor; but they did not otherwise interfere with the traditional iconography of the Annunciation as a dialogue. It remained an inviolable rule that Mary's gesture and posture should convey that she has been surprised while engrossed in some activity, whether spinning or reading. We are intended to notice her response to the angel's message: either her initial consternation—the Gospel's *turbata est*,[21] 'she was troubled'—or her humble acceptance of her mission. In the *Annunciation* scene of a Catalan altarpiece, 39 clearly based on a lost Italian original, Mary sits on the floor, just as she does in the Mérode Altarpiece, with her book open on her knees so that she—and not only, in the usual way, the viewer—can read it. But between the two figures, on a chest just inside the bedroom door in the background, is a second open book, this time displayed so

that we, the viewers, can read in it Mary's answer: *Ecce ancilla domini*, 'Behold the handmaid of the Lord'. The Catalan Mary still mildly demurs, one hand before her breast; but this has become the merest hint of an answer, barely perceptible; the book has interposed itself to speak for her.

In the Mérode Altarpiece, Mary has fallen altogether mute; she is so deeply engrossed in her book that we cannot even tell whether she has heard the message at all, let alone what her reaction might be. A profound silence reigns in the room; the wonder is that an angel has walked in and Mary has remained quite oblivious of his presence.

Deeply impressed though they were by this composition, the Master of Flémalle's pupils and successors could not accept its drastic neutralization of the protagonist's response. In all their numerous paraphrases and reworkings of the piece, they kept the motif of the Virgin seated on the floor with a book—the typical pose of the *Madonna humilitatis*—but reintroduced the gesture with which she responds to the Angelic Salutation. The change was a compromise with tradition, and an implied criticism of a rash innovation that had transgressed the bounds of religious acceptability.

The English language has a phrase that is much used in the specialist literature to characterize the radical this-worldliness of the art of the Master of Flémalle: the phrase is 'down-to-earth realism'. (It has no precise equivalent in German: *erdgebunden*, 'earthbound', or the like fails to convey the same dynamism.) As anyone with any insight must have realized, down-to-earth realism called into question the very

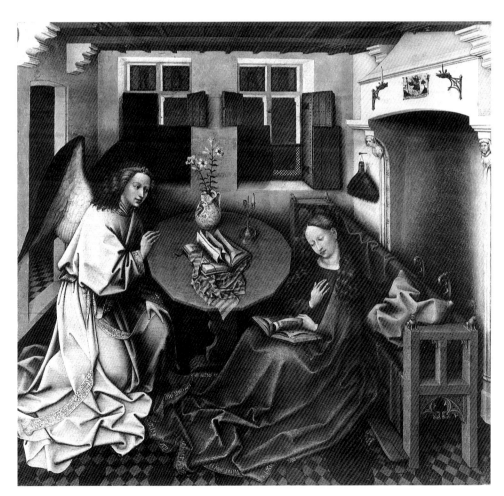

40
After the Master of Flémalle,
Annunciation.
Brussels, Musée des Beaux-Arts

existence of religious art. How far was it possible, or permissible, to naturalize the miraculous and the supernatural, which is the be-all and the end-all of religious art? Surely, every visualization of a miraculous event as a palpable reality was a perilous rationalization of the irrational, an unseemly reduction of the mysteries of faith to the level of so-called common sense. To replace a Virgin who responds to the Angel's message by one who remains devoutly absorbed in her reading automatically neutralizes the expressive content; and does this not ultimately make the painting itself mute, and cause it to abdicate as an intermediary between the doctrines of the faith and the viewer?

This complex of questions has never been precisely formulated in detail; but there is one school of primarily iconographic scholarship—styling itself iconology, the study of significant content—that claims to have found an answer. This answer, which in spite of its oddness many find convincing, runs as follows. The new realism is superficial; it is a mask, behind which a profound religious symbolism conceals itself. All these everyday objects in a living room or in a carpenter's shop—the candle, the towel, the ewer, the mousetrap, the fireplace—are ciphers, cryptograms in a secret language of which we are initially unaware; this seemingly ingenuous rendering of reality is something that we can understand only by decoding it as a symbolic structure.

It is an basic tenet of the iconological creed that the new realism, with the detailed view of reality that it affords, is underpinned and governed right down to the last detail by a preconceived and minutely worked-out iconographic programme. We find a mousetrap in Joseph's workshop, not merely because a joiner makes such things, but because it stands for the *muscipula diaboli*, the Devil's mousetrap, whereby Satan was outwitted through the Redeemer's incarnation in human form and—in particular—through Mary's betrothal to the elderly Joseph himself: a match that the Devil could never have guessed would lead to the birth of the Son of God.[22] Whether the iconologists suppose that the naive and untutored viewer is intended to be as totally foxed by the Master of Flémalle's veiled symbolism as the Devil was by the Incarnation, I have never been able to make out.

If the iconologists are to be believed, Christian art not only began with a secret language but ended with one. When the paintings in the Catacombs were done, Christianity was a banned sect, or at any rate an underground movement, unable to publish the truths of its new doctrine of salvation; Christians dared only hint at them under the pictorial camouflage of innocuous genre and decorative motifs. The devotee who had been initiated into the mysteries of the cult would know that the peacock or the phoenix stood for immortality, and grape vines for the paradise of the blessed; while the profane eye of his pagan contemporaries saw no more in all this than the customary motifs of classical interior decor. If we think back to this example of an art that really set out to reveal and to conceal at the same time, and which had good cause to rely on a secret language, we are impelled to ask what cause could have led a late medieval artist to conceal the specifically religious character of his image. What was new about this new art—and, in religious terms, what was suspect—was the surface realism itself: not the What but the How. It is implausible, to put it mildly, that artists would have sought to justify their realism, by which—for unexplained reasons—they set such store, by shoring it up with an ideological infrastructure. A creative process incorporating any such *ex post facto* spiritualization is simply impossible to conceive.

Let us for a moment take literally the quotation, *spiritualia sub metaphoris corporalium*, 'corporeal metaphors of things spiritual', which Panofsky adduces by way of defining the essence of late medieval realism.[23] When the Master of Flémalle inserted

Plate 1 a firescreen just where people were used to seeing a halo, he certainly had no intention of using this all-too-prosaic everyday object to disguise something spiritual. To speak of disguised symbolism in this case would be justified only if there were proof of the intention to conceal the sanctity of the Virgin, of which her nimbus was the outward and visible sign. In fact, however, everyone who sees the firescreen immediately thinks of a halo; there can be no intention of concealment. It might perhaps be said that, in substituting a palpable object for a symbolic sign, the Master of Flémalle is trying to evoke the idea of a 'sacred being' by association; this, of course, presupposes the viewer's prior knowledge of the form and significance of the nimbus. In a pictorial world purged of supernatural phenomena, the artist assigns the accessory function of the nimbus to a similarly shaped object taken from the world of experience. This transformation is, I think, very readily understood as a symptom of radical secularization and systematic demythologization; and as such it entirely concurs with other, simultaneous tendencies.

What is true is that artists tended to avoid any over-demonstrative display of symbolic motifs, to avoid overt symbolic language, to refrain from forcing symbols down people's throats, and where possible to let the viewer come upon the miraculous as something contained by chance, as it were, within the everyday. And so, in a *104* Van Eyck *Annunciation*, the obligatory vase of lilies—the lily being one of the most familiar symbols of the purity and innocence of the Virgin Mary—can just be glimpsed in a corner behind the door-jamb. The lily vase is incorporated in the setting—tucked away from the picture plane, where it would look like nothing so much as an exhibit set up for the viewer's benefit.

Nothing, perhaps, is more characteristic of this process of bringing symbolism down to earth, converting signs into objects, than the Master of Flémalle's propensity, shared by the Van Eycks, for taking the sacred types of Christian iconography (the symbols of the mysteries of the faith) and presenting them in miniature form as the figurative decoration of the scenes in which sacred narratives are enacted: as images within images, obtruding themselves as little as possible. In the *Madonna of Chancellor* *51* *Rolin*, the loggia in which the Chancellor worships the Madonna has capitals adorned *Frontispiece* with Old Testament scenes, from the Fall to Abraham. Again, in one of the Master of Flémalle's representations of the Trinity, the throne of the Father is adorned with diminutive figures of the Church and the Synagogue, and with the symbols of Redemption and Resurrection: the pelican, and the lioness who breathes on her stillborn young to bring them to life. The inanimate architectural ornament thus supplies a commentary on the principal theme, which is presented—one is tempted to say performed—by living figures. One metaphorical expression finds palpable reality in the localized setting itself: God sits enthroned beneath the Canopy of Heaven.

In one early work by the Master of Flémalle, the *Betrothal of the Virgin* in the Prado, the artist has gone beyond signalling his message to the mind through symbols: he has had the inspired idea of making it palpable to the senses not only in the architectural detailing but in the structure of the setting itself. To make this phenomenon more easily comprehensible we need to take a wider perspective.

The novel element in the fourteenth-century attitude to religious themes is often characterized as a 'humanization of sacred history': trecento art attempted to think its way into the narrative by empathy, and to appeal to the devout viewer's capacity for compassionate self-identification. The Man of Sorrows, the *Pietà*, the *Madonna humilitatis*, are the creations with which the pictorial imagination of that age has enriched Christian art.

41
Master of Flémalle,
Betrothal of the Virgin.
Madrid, Prado

This age of empathy represents only one tendency and one episode within the wider transmission of the common religious inheritance. With the advent of the Master of Flémalle, the fifteenth century marked an entirely new phase and a fresh start. The emphasis now lay on the immediacy, the sense of presence, with which biblical facts were evoked. This was something more than a generalized process of 'humanization': it took scenes remote in place and time and almost literally brought them home to the viewer, into his own life, his own age and his own milieu. Legendary events were depicted as if they had just happened, or were still happening, at the moment when the painter recorded them, and in the places best known to him and to his public: Christ in Flanders.

And so it became both possible and necessary to bring into the picture the living room of a Flemish bourgeois house, or the interior of a Gothic church or chapel, or the wide expanse of a polder landscape. Biblical figures were costumed in contemporary fashions, occasionally enriched with borrowings from the contemporary Turkish and Arab world in order to suggest the character of the biblical Orient (*ex oriente lux*, 'light from the East'). With this in mind—that the distant past may be brought to life by appealing to the viewer's own visual habits—the Master of Flémalle, in his *Betrothal of the Virgin*, sought to clarify the opposition between the Old and New Dispensations by contrasting an obsolete architectural style with that of his own day.

There seems to have been a universal tendency to associate centrally planned Romanesque structures with exoticism, paganism, and the pre-Christian Orient: among the conclusive evidence of this is an illustration in a manuscript of St Augus-

tine's *City of God* in which one group of people point to a Romanesque building (they are identified by an inscription as *les payens*, the pagans) and another group, *les chrétiens*, point to a Gothic church.[24] In the Master of Flémalle's *Betrothal of the Virgin*, the miracle of Joseph's staff, which springs into leaf, takes place in a Romanesque circular temple, open at the front; the Betrothal itself takes place before a Gothic portal. The artist also has a vivid metaphor for the fact that Mary's Betrothal is only the first instant in the genesis of the new Church: the Gothic portal, in front of which the Betrothal scene takes place, is the first, fragmentary section of a cathedral that is still under construction—starting, oddly, with the façade.

In this case, what we see certainly is a corporeal metaphor of things spiritual: it requires to be understood parabolically, as something more than just a 'Scene Before an Unfinished Portal'. But it hardly makes sense to interpret this use of symbolism as an attempt to conceal and keep secret the true meaning: on the contrary, to liken the relation between Old and New Dispensations with that between an old and a new style is a way to make something absolutely evident to the eye; it is an attempt to make background knowledge into foreground experience, for all who see the painting. This has nothing to do with a secret language, decipherable only by initiates.

If artistic truth is to rest on palpable reality and a natural logic of vision, as it does in the world of the Master of Flémalle, does this mean that certain religious themes in which the supersensory lies at the very heart of the matter—the Virgin Birth, say, or the Resurrection—can no longer be shown in art? Does the depiction of the miraculous, an indispensable component of Christian art, become an insoluble problem? The answer is to be found in the Master of Flémalle's handling of one of these *Plate 4* vexatious themes. In his *Nativity of Christ*, which comes from the Chartreuse in Dijon and is still in Dijon to this day—a painting that set its mark on the treatment of this subject throughout fifteenth-century North European art—he has placed the mystery

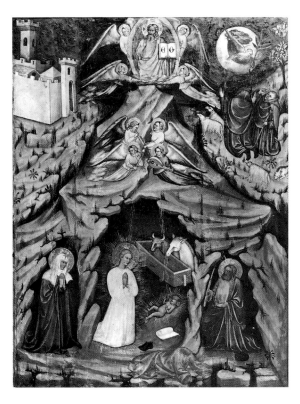

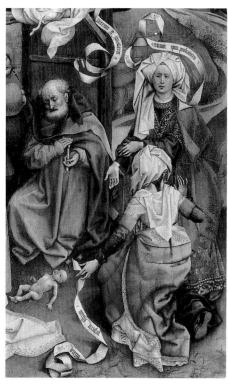

42
Nativity.
Pisa, Museo Civico

43
Master of Flémalle,
Nativity (detail).
Dijon, Musée
des Beaux-Arts

of the Virgin Birth at the very centre of his image in a way unknown since the art of Early Christian times. As then, the motif of the midwife who doubts Mary's virginity is not an episode but a principal element in the drama.

Taken in isolation, none of the iconographic motifs in the Master of Flémalle's *Nativity* is a new creation. Mary's kneeling posture; her worship of the Child; Joseph arriving with a candle to signify the Holy Night of Christmas; the two midwives; even the realistic stage set of a diagonally placed, thatched, tumbledown shed with the shepherds packed into the opening of a stable door to look at the Child: all this exists in the painting of the years up to and around 1400.

There are some grounds for supposing that a number of these features, notably the kneeling Mary and Joseph's candle, derive from one of the visions of St Bridget of Sweden, who lived in the fourteenth century; indeed, attempts have been made to make her solely responsible for all late medieval changes in the iconography of the Nativity. Some caution is called for; most of the innovations ascribed to St Bridget have literary and iconographic precedents that antedate her visions.

We know that St Bridget had a vision in 1370, in which the Madonna instructed her to make a pilgrimage to the Holy Land in order to visit the Holy Places. There, on the spot, it would be revealed to her exactly how the Mysteries of the Faith had taken place, and what happened at the Virgin Birth.

As is well known, the Church of the Nativity in Bethlehem had a crypt in which pilgrims were shown the cave where the boy Jesus first saw the light of day, or rather night. Consequently, the art of Eastern Christianity—unlike that of the West, in which since Early Christian times a stable roof had been shown above the crib to localize the scene—regularly sited Mary's confinement in a cave. Italian art, notably in Siena and later in Venice, had followed suit, in the *maniera greca* of the duecento. Giotto, for his part, went back to the western tradition: his Virgin and Child lie beneath a stable roof. Even so, the—so to speak—authentic oriental version of the setting of the Nativity was well known in Italy by the time the Swedish visionary returned there from the Holy Land and published her Bethlehem experiences in her *Revelationes*. There are Tuscan paintings, inspired by this account, that follow her text in showing a rocky 42 cave in a hillside that is pierced—in a departure from the eastern iconography of the Nativity—by one main opening and two smaller openings. In one of these subsidiary caves, the visionary saint herself is to be seen kneeling in prayer; in the other is St Joseph with a candle. In the central cave, the Virgin herself kneels in adoration before her Child.

In her account of her vision, St Bridget tells how Mary, when her time was upon her, went into the cave with Joseph, who carried a candle, and laid aside her white mantle and her shoes; and that Joseph withdrew when the crucial moment came. There can thus be no doubt that the Tuscan painter intended to reproduce Bridget's vision as faithfully as possible; we must remember, however, that the form of the vision itself partly derived from pre-existent iconographic traditions. Comparing the text with the Tuscan image, we notice that Mary's discarded mantle is brightly coloured and not (as in the text) white, although her *tunica* is white. This departure from the text is entirely comprehensible in compositional terms, as it makes Mary in her adoration into a figure of radiant whiteness; it was in fact the only innovation that established itself in the iconographic tradition.

The iconography of St Bridget, or parts of it, migrated North, or rather West, into the Franco-Flemish area and into North-western Germany. Sometimes the cave is adopted, sometimes the motif of Joseph with a candle; always, Mary appears kneeling in prayer, in a white or bluish-white dress. The dressing of Mary in white, the colour

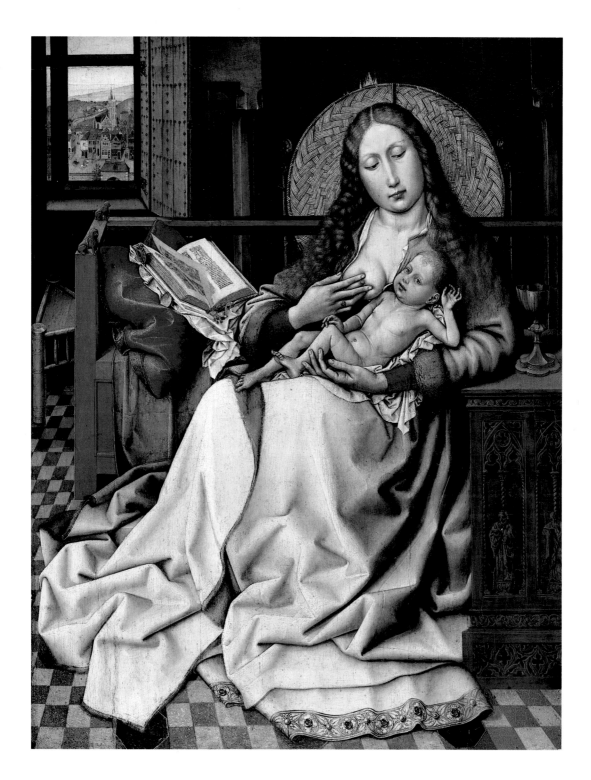

1 Master of Flémalle, *Madonna with a Firescreen*. London, National Gallery

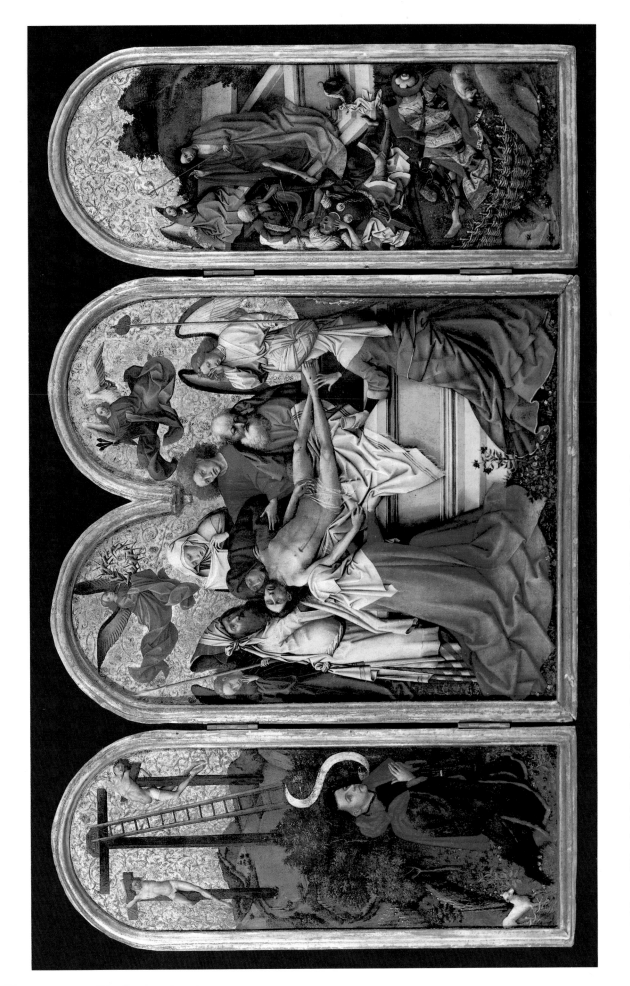

2 Master of Flémalle, *Seilern Triptych*. London, Courtauld Institute Galleries (Princes Gate Collection)

3 Master of Flémalle, *Mérode Altarpiece*. New York, The Metropolitan Museum of Art, The Cloisters Collection

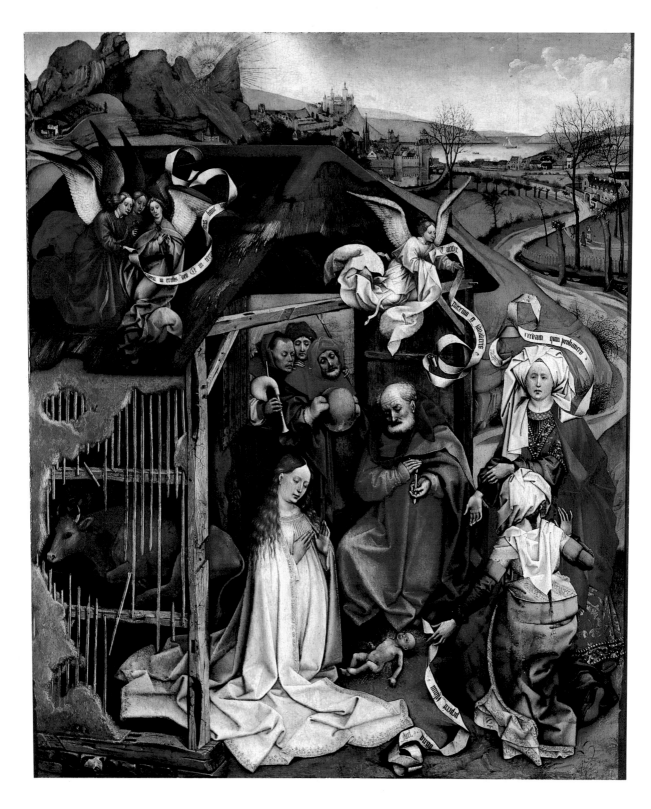

4 Master of Flémalle, *Nativity*. Dijon, Musée des Beaux-Arts

of innocence, in allusion to the Mystery of the Virgin Birth, is the sole lasting contribution made by this literary source. Not one other feature of it succeeded in establishing itself; and this has inspired Panofsky to the following significant generalization: 'A literary source may modify but hardly ever breaks an established representational tradition unless the impact of the written word is reinforced by that of a visual experience'.[25]

The Master of Flémalle has taken an extremely high-handed line with the iconography of St Bridget's visions. He has adopted the motif of St Joseph's candle, but not the cave that it was intended to illuminate. The motivation thus disappears, and the candle becomes a mere index of the state of the light and the time of day (or night), complemented by the sunrise over the mountains on the skyline. The long shadows of the willows in the background confirm that this is daybreak.

The Master of Flémalle's *Nativity* exhibits a number of other unusual features that have nothing whatever to do with the iconography of St Bridget. By enlarging the cast, the artist contrives to shift the emphasis almost imperceptibly away from Mary's act of adoration, towards the boy Child to whom she has just given birth, and towards the core and religious significance of the legend. The crucial factor here is the stress on the revival of the midwife episode, which transforms a lyrical narrative into drama.

Spatially, and in their actions, all those present concentrate on the newborn Child, who occupies the gap between the figures on the ground. We see none of their eyes; for all are gazing down at this one spot on the ground—all, with one exception, that of the unbelieving midwife, Salome, to whom the other midwife, kneeling with her back to us, looks upward. All the characters are on their knees, again with the exception of the unbelieving Salome. But there is one thing in her pose that directs our gaze towards the Child: her right hand, hanging limp, towards which the left hand points.

The literary source of the midwife episode is well known: it lies in the apocryphal Infancy Gospels,[26] in which we are told how one of the midwives loudly proclaims the miracle of the Virgin Birth, while the other, Salome by name, expresses her doubts in the following words: 'If I make not trial and prove her nature I will not believe that a virgin hath brought forth'. Whereupon her hand withers. Then an angel appears and counsels her to touch the Child; then her hand will become whole again. And so it proves. The Mystery of the Nativity has been confirmed and attested by the first miracle of healing.

Although the popular medieval *Golden Legend* incorporated this episode unchanged, the trecento artists and their North European disciples seem to have had little notion of its doxological significance; they introduced it as a mere genre motif. It was left for the Master of Flémalle to restore it to its original prominence. He shows the dialogue between the believing Zelomi and the unbelieving Salome and the intervention of the angel; and his mute image is made to speak, through the scrolls tossed out by the figures. Reduced to three lines, these amount to a script for the scene as performed in the nativity plays of contemporary liturgical drama. This is the only instance in the Master of Flémalle's work where lettering on scrolls—sign language— intervenes in his sensuous rendering of the world. It is therefore worth seriously considering whether this work might not be (as Emile Mâle suggested) an allusion to, or rather an evocation of, an important scene in a mystery play.[27] It makes contact with the realm of sound, because that is where the symbolic content of the scene is made manifest. Once again, all this is the utter antithesis of secretiveness and disguise.

The mystery of the Virgin Birth is thus emphatically brought home to the viewer; Mary is clad in the only possible symbolic colour, which is white; and yet at first sight

43

44
Master of Flémalle,
Betrothal of the Virgin (detail).
Madrid, Prado

the look of the Christ Child himself, the literal and conceptual centre of the whole painting, is decidedly disconcerting. In medieval and later painting alike, we are used to seeing a well-developed Child, not this ugly, embryonic creature. We are forced to conclude that the Master of Flémalle has once more remained true to his principle of projecting biblical events into the world of everyday experience, and has not shrunk from depicting the Child as a pitiful, flailing, helpless newborn baby and not as a toddler. Perhaps the artist thought that it would make Salome's unbelief all the more credible if she were confronted with the all-too-human infirmities of the Christ Child. No such blatantly naturalistic Christ Child is to be found elsewhere, even in the work of the Master of Flémalle. (In fact, no other *Nativity* by him is extant.)

The simplest explanation, once more, is that the artist simply took the word 'newborn' literally, and indeed that he based this rendering on a life study, recorded with positively scientific objectivity, and in all probability the first of its kind. Previously, the observation of nature had operated only on the periphery, as a regenerative factor in the decor surrounding the pictorial narrative; here it has dethroned the ideal type of the central figure. This is certainly not the only case where a study from life is to be seen close to the central focus of a painting by the Master of Flémalle. The toothless old man in the Madrid *Betrothal of the Virgin*; the broad, fleshy oval of Mary's face in the London *Madonna with a Firescreen*; and the standing *Madonna* and *St Veronica* in Frankfurt, all look like portraits.

44

Plate 1

It becomes all the easier to believe in this empirical underpinning of the Master of Flémalle's religious compositions when we recall that he has left a number of portraits of sitters whom we cannot now identify, but whom he must have 'drawn from the life' in the truest sense of the word. In individual cases, the characters in this painter's biblical legends also turn out to be portraits of his contemporaries; this was a custom that was maintained throughout the fifteenth century. In this connection, it is possible to trace how the individual, first-hand record gradually evolves into a type and finally settles down into a generalized, formulaic part of the scene.

'Portraiture in the modern sense of the term—that is, the artist's attempt to capture the unique and contingent reality of a human physiognomy, to see in it the essence of the sitter's character, and to use as unprejudiced a record as possible, a life study of

45
Boccaccio, *Des Femmes nobles,*
Marcia Paints Her Own Portrait.
Paris, Bibliothèque Nationale,
MS fr. 12420, fol. 101v

some kind, to liberate himself from the tyranny of the generalized stylistic formula and the traditional simile—portraiture in this sense seems to have begun in the mid fourteenth century, with portraits of ruling princes. Or, at least, the portraits of a French King (John the Good, died 1364) and of an Austrian Duke (Rudolf the Founder, died 1365) are the earliest paintings in which the portrait is freed from all sacred and funerary associations. Only slightly later, the series of busts by Peter Parler, in Prague Cathedral, includes portraits of ecclesiastical dignitaries, architects and other persons involved in the building of the Cathedral'.[28]

In general, at this early stage in the development of post-medieval portraiture, what we find is not so much a record of reality as a tendency towards portrait likeness. Perhaps this is best thought of as follows: the work is still based on a standard type, but this is then checked back, as it were, against the individual sitter and corrected to give a closer likeness. In particular, the artist adds to it those 'salient' features that help us to tell one individual apart from another. The odder those features are, the truer to life the image appears: it is the deviations from the norm that are recorded as characteristic.

All this changed in the courtly style of the end of the fourteenth century, with its unprecedented flowering of secular art in which princely patrons entered into a new relationship with artists. The portraits of the previous generation tell us that this or that ruler had a long nose, or that he wore his hair in a particular way; but we have

6 likenesses of Philip the Bold and of the Duke of Berry that go far beyond the mere intention to portray. In particular, anyone who has seen the carved likenesses of Berry,

22 or above all Sluter's *Philip the Bold*—sculpture was ahead of painting in this respect— will feel confident of recognizing these men anywhere, not by any salient features but because these portraits convey the total impression of an individual physiognomy. Plainly, artists had now realized that a portrait likeness is not an additive tally of salient features but springs from the uniqueness of the relationship between the details. And this could not have happened without direct study of nature.

Copying from life, and not just working up impressions from memory, had now become customary among artists; and we have incontrovertible proof of this in a

45 miniature from a text by Boccaccio. It shows the painter Marcia engaged in portraying

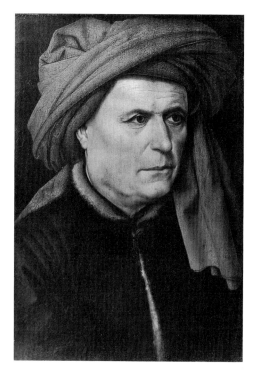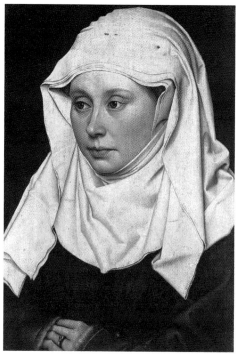

46
Master of Flémalle,
Portraits of a Man and a Woman.
London, National Gallery

herself with the aid of a little mirror that she holds in her left hand while painting with her right. By the time this miniature was painted—it is dated 1402—it was possible to produce a panel painting purely as a portrait: that is to say, without reference to devotional, funerary, dynastic or courtly requirements.

The only painted portrait of the period around 1400 of which we can gain a fairly good impression, albeit from a late copy, is of John the Fearless, Duke of Burgundy; it probably formed one half of a diptych in which the Duke paid homage to a half-length image of the Madonna on the other wing.[29] It is thus precisely analogous to those carved busts of rulers (of Philip the Bold by Sluter and those of the Duke of Berry), whose heads are based on life studies or sketches, but whose overall iconography is still confined to the religious donor type.

Among the autonomous portraits known to us, those of the Master of Flémalle hold pride of place, alongside those of Jan van Eyck. The Master of Flémalle's sitters all look like members of the bourgeoisie, and the style has little in common with the courtly portrait. They are always close-ups, in which the frame cuts in so close to the head, or head-and-shoulders, as to recall the *horror vacui* of the Master of Flémalle's subject pictures. The whole pictorial field seems to be crammed with solid sculptural form. In the pair of portraits in the National Gallery in London, the head-dresses, with their layers of material, serve as extensions of the solidity of the skull; in the portrait of a well-fleshed man in Berlin, the sitter's looming physical presence fills out the pictorial field without any assistance from his costume.

Everything, including the lighting, is subordinated to the elaboration of tactile, sculptural values. Panofsky has accurately pointed out that the light regularly falls on the side of the face that is turned towards us, so that in a portrait diptych the husband is lit from the left, the wife from the right.[30] This means that in these works, as in trecento painting, light is used as an aid to modelling; which is not the case with Van Eyck. In order to make the head emerge as a form in the round, the pose is consistently a three-quarter profile; the shaded and foreshortened half of the face

47

46

48

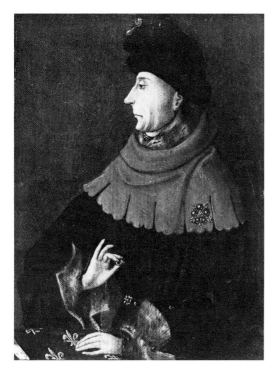
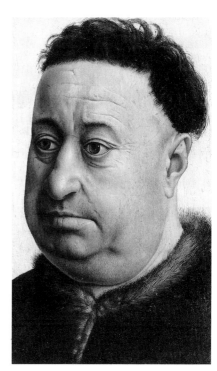

47
John the Fearless,
(sixteenth-century copy).
Paris, Louvre

48
Master of Flémalle,
Robert de Masmines.
Berlin, Staatliche Museen
Preussischer Kulturbesitz

tends to be backed with a portion of headgear by way of colour contrast. In court portrait painting, the profile pose, inherited from the medal, had hitherto prevailed; here, by contrast, the framing headgear eases the junction between solid form and surface, and the head itself is conceived in three dimensions.

The Master of Flémalle's portraiture contains examples both of the head framed to include only a small section of neck and chest and of the extended head-and-shoulders portrait, which enables him to include the hands. The sitter's posture is not part of the subject of the picture. 'Framing' or 'detail' is not really the right way to describe the design of such a work: it is no more a detail of a full-length figure than a medal is, or the head-reliquary of a saint. In the reliquary, the bust section is designed purely as a plinth; similarly, in the London *Portrait of a Woman*, the horizontally placed arms are meant as a base and an inner frame. They make the chosen 'detail' into an artistic whole.

This contributes to the impression of utter calm that is pursued in the same painting by other means. To allow the eye to trace the relief of the surface of the face, in all its rises and falls, down to the minutest details, and thus to describe the physical uniqueness of the individual human face, firstly the subject must be seen at very close quarters, in extreme close-up; and secondly, in order to permit so thorough a scrutiny, she must keep still. The people in the Master of Flémalle's portraits are motionless, and by the same token they do not look at anything in particular. They gaze ahead, rapt in thought. What is portrayed is the state of being looked at, not that of looking. The Master of Flémalle's portraits are still-lifes of the human face. This tallies with their reserved, inexpressive quality: for a still-life is psychologically mute. These people, whose outward appearance is recorded in every detail and with often merciless objectivity, tell us nothing about their inner life: they are still waters. As an objective eyewitness and an incorruptible reporter, the painter denies himself all interpretation of the visual facts.

Whether the portraiture of the Master of Flémalle implies the prior existence of the

Eyckian portrait; or whether, on the contrary, Van Eyck was inspired by the Master of Flémalle: this is a question that we can consider only when we have gained some understanding of Eyckian portraiture itself. This will involve us in studying not only Jan van Eyck and the problem of the chronology of his works but also the art of Hubert van Eyck, Jan's (presumably) elder brother: something that has remained even more of an unknown quantity than that of the Master of Flémalle, whose name is uncertain, but whose artistic personality is known.

III. Jan van Eyck

When we turn from the art of the Master of Flémalle to that of the brothers Van Eyck, we are on shakier ground. We may take it as established that the *Ars nova* of painting had two roots, one Flémallian and one Eyckian. But as soon as we begin to explore the growth and advancement of Eyckian art, and its evolutionary aspect in particular, we are liable to become enmeshed in a dense thicket of conjectures. The state of Eyckian studies is the exact opposite of that of Flémalle studies. There, we have a stylistically well-defined *oeuvre*, but no documented name for the artist, only a hypothetical one: that of Robert Campin—which is, incidentally, more hypothetical than is dreamt of in the conventional wisdom of art history. Here, on the other hand, in Eyckian territory, we have no less than two celebrated names, those of Hubert and Jan van Eyck; but only the younger has an authenticated *oeuvre*. The elder and, in evolutionary terms, naturally the more interesting artist has none. To paraphrase Pirandello: in one case we have characters in search of an author, and in the other we have an author in search of characters.

A scholarly discipline worthy of the name can proceed only by drawing conclusions from the known to the unknown; and what is known in this case is the late work of Jan van Eyck, or rather the style of the last part of his life, which ended in 1441. The Ghent Altarpiece, completed in 1432, is a composite work, on which, before Jan, the Great Unknown 'X' was engaged; and for that Great Unknown, an inscription on the work itself offers us the name of Hubert van Eyck, who died in 1426.

It seems so simple: just insert the known factor, Jan, into the equation, and ascribe to Hubert everything in the Ghent Altarpiece that does not match Jan's style. However, art history has never succeeded in carrying through this process of elimination, although for generations on end its greatest specialists and its acutest brains have devoted themselves to the question. Even the thorough physical restoration and X-ray and infrared examination of the Altarpiece in 1950–51 did not uncover the secret; although they did come up with facts that undermined a vast edifice of scholarly speculation. We now know very much more than we did before about the visible surface of the painting, and about its stratification, the sequence of paint layers beneath the surface; in the last resort, however, we can still interpret the physical data and observations of detail—whether old or new—only by applying the criteria of stylistic analysis.

I have no intention of offering a new interpretation that can claim to solve all the problems; indeed, I regard that as an entirely misconceived notion. Our only concern at present must be to work out an inner stylistic—and thereby also chronological—ordering of the Van Eyck material, which will enable us to distinguish fact from hypothesis and identify those open questions that would remain unanswered even if we knew exactly where to apply the external labels: Hubert, or Jan, or XY.

In his pioneer study of 'The Enigma of the Art of the Brothers Van Eyck', Dvořák made it his principal objective to find the demarcation line in the Ghent Altarpiece that divides Hubert's contribution from that of Jan.[31] In doing so, limited by the state

of knowledge in his own day, he oversimplified the problem. Dvořák's unsuccessful attempt to find a solution helped to stimulate the subsequent research that has converted his single enigma into a whole set of enigmas. To name only the most important issues, we must now not only look for what may be by Hubert in the Ghent Altarpiece, but try to ascertain whether his hand is to be detected in any other work, and also what Jan's early style looked like before he came to Ghent. Each time, we find ourselves having to build a bridge back into the past. It is worth starting out with a brief summary of the most significant biographical data, together with other documented facts.

We first hear of Jan van Eyck, a native of Maastricht or of Maaseyck in Limburg, in 1422 and 1425, when he was working in The Hague as court painter to John of Bavaria, Count of Holland and Prince-Bishop of Liège. In 1425 he took service with Philip the Good, Duke of Burgundy, whose *peintre et varlet de chambre* he remained until his death; he was a close and trusted servant, always treated with notable consideration and respect. In 1442, the year after his death, his body was moved from the parvis of St Donatian in Bruges into the church itself and interred close to the font; the church records speak of him as *solemnissmus pictor*, a most distinguished painter.[32]

In 1425 he moved from Bruges to Lille, where the Duke held court when he was in Flanders, and he finally settled in Bruges only in 1430. Among his earliest admirers were the rich Italian merchants of Bruges, the Arnolfini, Giustiniani and Lomellini families, who commissioned portraits of themselves and other work from him, thus establishing his fame in Italy during his own lifetime. They thus laid the foundations of the legend, which was to be codified by Vasari, of Jan van Eyck as the sole founder of the Netherlandish school of painting. Understandably, the name by which they knew him, and under which they promoted his fame, was that of John of Bruges, Johannes de Brugis. Raphael's father wrote: '*A Brugia fu fra glialtri piu lodati / El gran Iannes…*': 'Among the painters lauded most at Bruges was the great Iannes'.[33]

All of this is in marked contradiction to the message inscribed on the frame of the Ghent Altarpiece, which reserves the highest superlative for Hubert van Eyck (*Hubertus de Eyck. Maior quo nemo repertus…*), and dismisses Jan as second best with the words *arte secundus*. No wonder that attempts have been made to impugn the authenticity of the inscription, and to dismiss it as an inept forgery perpetrated by the patriotic local antiquary who first published it early in the seventeenth century. The hope that after the Brussels laboratory examination no one would ever again question its genuineness has proved unfounded. Ink continues to flow in the attempt to prove that behind the inscription we see today, allegedly restored in the sixteenth century, there is an older one that makes no mention of the name of Hubert.

There is nothing that cannot be ingeniously explained away—not even the earliest recorded mention of the Altarpiece by a traveller, the physician and humanist from Nuremberg who wrote in 1495 that the painter of the work lay buried before the Altarpiece itself.[34] Such is the obduracy of the sceptics that they reject even the epitaph from that very location that was first recorded in the mid sixteenth century as bearing the name Hubert and the date of death 1426. They remain unmoved by the discovery of the tombstone itself, which still exists, albeit in a poor state of repair and minus the inscription, which was originally held by a skeleton. Its wording was recorded as follows: 'I was called Hubert van Eyck; now food for worms, formerly famed, in paintings highly honoured'.[35] At the end of the fourteenth century, as Emile Mâle has shown,[36] the traditional tomb effigies portraying the deceased as they had been in life (albeit stiff and mute) began to be replaced by the macabre figures known as *transis*: disintegrating cadavers or skeletons, designed to proclaim the transience of all earthly

49

49
The tombstone of Hubert van Eyck.
Ghent, St Bavo

things. It was common for a skeleton to apostrophize the passer-by, as if from the depths of the tomb, with the words 'I was as you are'.[37]

Those who take the view that Hubert's stature as an artist, or even his existence as a man, is a pious fabrication on the part of patriotic sixteenth-century local antiquarians and humanists, regard the tombstone itself as a fraud perpetrated by those same people; but scholars now consider that it is a perfect stylistic match for the funerary art of the early fifteenth century. By some miracle, those later Ghentish humanists seem to have been *au fait* with all the latest conclusions of modern iconographical research. Joking apart, this makes it all the more imperative to take the stylistic evidence of this stupendous work itself as our ultimate authority in deciding whether Hubert van Eyck is a myth or a historical fact.

We must begin, as I said, with the known works of Jan; and this means the paintings of the last decade of his life. A suitable starting point is the *Madonna of Canon van der Paele*; clearly intended for a chapel endowed by the Canon in his own church of St Donatian in Bruges in 1434, this work was completed in 1436. As an iconographic type, it is a Netherlandish equivalent of the Italian *sacra conversazione*, and its precedents and evolutionary sources lie in Italy. There, in the second half of the fourteenth century, painters had begun to show the donor, who traditionally appears under the protection of a patron saint, not as a diminutive figure who might be one of the saint's attributes, but on very much the same scale as the Deity, or Mother of God, before whose throne he kneels. In Lombard and Paduan painting in particular, secular dignitaries take part in life-size encounters with the Divine. Similar innovations had been attempted in thirteenth-century sculpture, without ever gaining lasting acceptance.

In Northern painting, it was only the Italian precedent that induced artists to bring mortals face to face with the Divine; and, initially, at least, this privilege was reserved for mortals of exalted rank. And so the Dukes of Berry and Burgundy—with all the marks of their outward appearance intact, physically formed (or rather deformed) as people of advancing years generally are—may be seen on their knees before the heavenly throne in miniatures, panel paintings and, notably, also carvings, where the

equal presence of the figures is particularly striking. However, in pursuance of the unchallenged conventions of ceremonial stagecraft, the supremacy of the Divine is maintained throughout by the use of an elevated throne or other device to assure a dominant position.

The situation for Netherlandish painters became critical at the moment when a pictorial world took shape in which it was necessary to assign all the persons present, whether mortal or immortal, to a clear location. Where and how can mortals be in a position to intercede with the Deity? An ideal, antique architecture, such as the Italians devised for such occasions—providing a firm spatial setting, and yet wholly pertaining to a higher sphere, remote from everyday life—could never satisfy the empirical bent of the Netherlandish pictorial imagination.

Two alternative solutions offered themselves. The first, favoured by the Master of Flémalle, was to settle Our Lady into a bourgeois dwelling-house to which the suppliant donors, escorted by their patron saints, gained admittance through side doors. As always with this artist, the celestial, the sacred and the miraculous are projected into the Here and Now of domesticity. The second alternative, adopted by Jan van Eyck, was to set the scene in God's House, thus ensuring that it retained all the solemnity of sacred space, as manifested in the terrestrial enclaves of the Divine.

The Madonna sits enthroned in a Romanesque apse. Stone-built, and backed by a *Plate 13* rich brocade canopy, her throne has steps covered with an oriental carpet. Like the Master of Flémalle, the artist has indicated a means of access to the sanctuary from outside; however, instead of using prosaic doors, the saints and their charges seem to have entered through the arcades of the ambulatory. The gesture with which Van Eyck's saint commends the donor to the Deity is far less conventional than it is with the Master of Flémalle: the donor's name-saint, St George, almost seems to step forward as he doffs his helmet and stretches out his left hand to present his kneeling protégé to the Madonna and Child: an unusually spontaneous gesture for Jan.

As the new handling of space came to be applied to the *sacra conversazione*, new problems of representation began to emerge. Conflict arose over the relative sizes of the figures, as dictated by a naturalistic rendering of space on one hand and by the hierarchic requirements of spiritual rank on the other. In a composition in central perspective, the principal figure, the object of adoration, is removed into the distance and inevitably seems smaller than the attendant figures to either side, who are closer to the near picture plane. In the *Paele Madonna*, the throne is elevated to ensure that the Madonna—although she is seated and although, being further away from the front edge, she appears smaller—is isocephalous with the lateral figures.

The half-round of the apse plays its own part in making a gradual and uninterrupted transition between centre and sides, as also between depth and foreground. The whole composition has the coherence of a greatly expanded throne niche. The interior does not end at the upper edge of the picture but must be thought of as going up much higher, so that in objective terms this is a detail, a section of a larger whole. However, the horizontal line of the canopy cuts off the image precisely at the upper edge of the painting; in formal terms, therefore, the pictorial space is just as much a self-contained whole as if ceiling beams had been visible at the top.

If we set out to define the evolutionary relationship between the *Paele Madonna* and the undated *Lucca Madonna*, already analysed, we can find an unforced filiation only *Plate 6* by supposing that the *Lucca Madonna*, with its conversion of the throne structure into a room space, was the starting-point from which the artist derived the more spacious apse in which the Madonna's throne is enabled to set itself more firmly back from the picture plane.

Plate 7

In its turn—and even without the date of 1437, now revealed by the removal of the frame—the Dresden Triptych would have to be assigned to a still more advanced stylistic phase. For this is a work that shows greater spatial depth in every respect. The central figure has been moved to the far end of a perspectival system designed in the shape of a church nave; she therefore appears small and distant. The space has also grown in height: the whole of the baldachin has been brought back within the picture, so that the incompleteness of the space is freely admitted. In exactly the same way, at the lower edge, the end of the carpet has been shifted up into the picture. Both patterns are then extended in a vertical direction by very similar ones.

Horizontally, the space extends into the wings of the triptych, which have been reinterpreted as aisles: the lateral panels present themselves as lateral spaces. The saints who occupy these spaces in the capacity of patrons stand close to the edge in such a position as to be, once more, isocephalous with the seated central figure. The frame cuts in rather close to the two standing figures; but above their heads there is plenty of space, stretching up into the vault.

The figures look rather small in the tall space, and—let it be said—less solid than the massive figures in the *Paele Madonna*. It was this Gothic daintiness that led many scholars, before the date of 1437 became known, to place this among Jan van Eyck's early works. The fact is, however, that in 1437 or thereabouts there was something of a back-to-the-Gothic movement, which is clearly evident in the Master of Flémalle's

16
50

Werl Altarpiece, dated 1438, and even more in the same artist's *Madonna in Glory* in Aix. There was a tendency to move away from the cubic mass, the almost ponderous weight, of the *Paele Madonna*—which is still comparatively close to the monumental, sculptural quality of the *Deësis* on the Ghent Altarpiece—and to revert to intimate

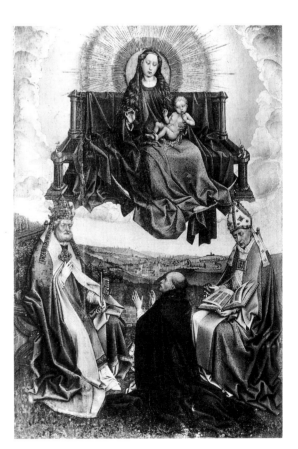

50
Master of Flémalle,
Madonna in Glory.
Aix-en-Provence,
Musée Granet

proportions, beginning with the format of the panel itself. In Jan van Eyck's work, this new genre of 'cabinet pictures' culminates in the *Madonna at the Fountain*, of 1439, with its intense concentration on a small space that is meant to be interpreted as the walled paradise, the 'garden enclosed', the *hortus conclusus*.

Plate 15

We have been concentrating mainly on the relationship between figure and space; let us now see whether the evolutionary sequence that I have just outlined holds good in the other principal departments of pictorial design. The pyramidal figure compositions of the *Paele* and *Lucca Madonnas* have much in common, but there are also a number of unmistakable differences, which can only partly be explained in terms of overall design. In both Madonnas, the torso is so projected as to join the horizontal of the seated figure's lap without any transition. In the *Lucca Madonna*, this horizontal serves as the base that supports the Child, who is seen in profile, entirely enclosed within the triangular outline of the Virgin's upper body and similarly parallel to the picture plane. The Child of the *Paele Madonna* is seen frontally, with his torso and head turned aside to give a three-quarter view: a much more complicated pose, organized in depth and with some foreshortening in the legs. Like the Mother's lap, the Child's legs are flexed, crossing the edge marked by the knee-line. This same arrangement of the Child's legs reappears in the Dresden Triptych, except that the head is not turned to one side, so that the relative positions of Mother and Child in depth are more explicit.

There can surely be no doubt: the *Lucca Madonna* is the earliest of these three versions of the enthroned Madonna, and must date from the early 1430s. From the *Lucca Madonna* to the Dresden Triptych, the space available to the Virgin Mary expands from a narrow cell to a spatial enclosure that is a comparatively loose fit around the nuclear space. At the same time, the spatial shell emerges more strongly in terms of colour; for, as a result of perspective diminution, the area of bright colour is considerably reduced and that of neutral greys and browns is increased. If the Madonna is still able to dominate in colour terms, this is because she is dressed in red. Red is a colour that tends to advance rather than recede; and so in this case it directly counters the effect of the spatial position of the coloured object.

There are two other *Madonnas* that display close links with those just mentioned, both in motif and in composition, and which thus demand to be placed in terms of the evolutionary sequence I have just established: these are the *Madonna of Chancellor Rolin* and the so-called *Ince Hall Madonna*.

51, 54

Frontispiece

The *Madonna of Chancellor Rolin* is not a centralized composition: it is a face-to-face encounter between a seated and a kneeling figure, although only the kneeling Chancellor is aligned parallel to the picture plane. Mary and the Child Jesus are in three-quarter profile, seen slightly obliquely; and so no eye contact takes place within the painting. Since the Madonna is seen almost laterally, a pyramidal form is created without any abrupt transitions between closer and more remote areas within the figure. The arcaded space does not confine the figures too closely; and this, together with the upper windows—cut off just above the sill, as in the Dresden Triptych, to reveal the pictorial space to be a section of a much taller loggia—mean that the *Rolin Madonna* must not be dated too early: say around the mid 1430s.

The setting of the *Rolin Madonna* is not, of course, an interior of the kind that we have previously encountered. It represents an entirely original and unprecedented formula. For Jan van Eyck, the problem of depicting an interior was never simply that of delimiting a known spatial quantity on every side. For him, the crucial distinction between interior and exterior lay in the quality of the light, and of the specific directional lighting. And so, if the effect of an interior depended on conveying the

specific quality of interior light, it became unnecessary to show all four of the walls that shut off the scene from the world outside: a portion of the room was enough. And so Jan, like the Master of Flémalle, has a number of interiors in which the walls are pierced by windows that indicate the direction of the light and thus account for the specific degree of dimness in the interior. But Jan goes one step further. In his *Rolin Madonna*, he has built the whole painting around the contrast between interior and open-air light, and has given us the visual sensation that one has when one looks from a dimly lit interior, with patches of semi-darkness, into a brilliantly sunlit outside world. For centuries, no one had dared to show an interior otherwise than by opening up one side of a hollow solid, which thus never ceased to be a part of the external world. Interior space was always seen from the outside looking in. Jan van Eyck has reversed this arrangement. He opens up his interior space, right in the centre of the picture, with airy arched openings, and thus allows us to share in the experience of being indoors, in half-light, and looking out into the sunshine. Exterior space is seen from the inside looking out.

While Chancellor Rolin, with no patron saint to escort him into the Madonna's palace, kneels mutely before her in eternal adoration, our gaze travels along the

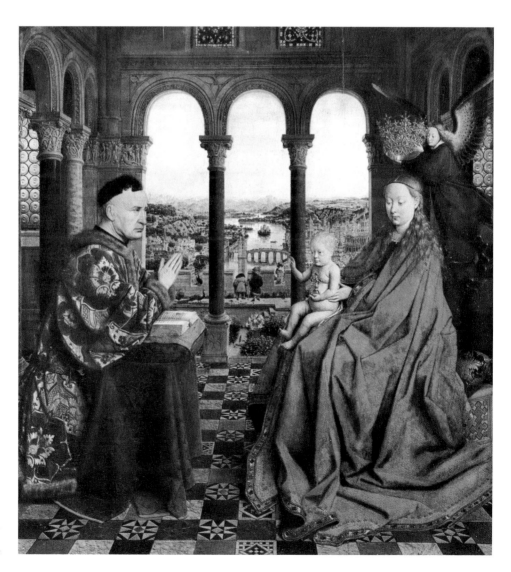

51
Jan van Eyck,
Rolin Madonna.
Paris, Louvre

52
Jan van Eyck,
St Barbara (detail).
Antwerp, Koninklijk
Museum voor Schone Kunsten

central axis, traverses the foreground stage between the two massive figures, makes its way under the arches onto a sort of roof garden or terrace and thence plunges across the infinite spaces of a river valley to the far-off mountains on the skyline. Twice along the way, it takes a leap from one zone of depth to another. In front of the second leap, two diminutive men, personifications of our own visual experience, gaze out from the terrace into space. The other and more important discontinuity within the pictorial universe is the transition from interior to exterior space. The open arcade gives the *Rolin Madonna* a picture within a picture, a distant view embedded in a spatial close-up; the whole is united and unified in the viewer's act of optical perception and embraced within a single visual trajectory. As seen from a window, the outer world fits perfectly into the artist's planar projection of inner space.

51

Frontispiece

In the landscapes of the Master of Flémalle, and in his early works above all, the scene stretches uninterruptedly from the foreground into the distance, mostly in a serpentine ascent. In the *Rolin Madonna*, the layers of space are so arrayed in depth that the middle ground is omitted altogether. The naturalistic explanation that Van Eyck offers for this is the real disparity in height between the foreground stage and the area deeper within the pictorial space. The Madonna's palace stands higher than the roof garden; the terrace is higher than the valley. By lowering the ground level as he proceeds further into the painting, Jan thus counteracts the tendency for a landscape projected in perspective to appear to slope upwards.

This spatial discontinuity is the same phenomenon that we encountered in analysing the spatial construction of the seated figure in the *Lucca Madonna*. The cause is the same in both cases: the stilling of the gaze, the imposed passivity of vision. It is only when the eye no longer traces the objective forms of things, no longer helps to mould them, but only encounters them as a pure observer, that the inexhaustible variety of the world of appearances reveals itself to the painter's microscopic eye. A form cannot now be invented: it can only be discovered, out there in the real world. Pictorial design and nature study are one and the same.

The discontinuity of pictorial space, and the suppression of the middle ground, reappear in those works of Jan's mature and late style that are set entirely in the open air, as is the case with the *St Barbara* in Antwerp, a partly coloured brush drawing. The saint sits on raised ground, beyond which we must be looking straight into the distance: for the human figures just behind Barbara are minute. The low-lying landscape gives the impression of an infinite expanse. This makes the tower all the more vast: a giant to the diminutive figures at its foot, it seems inconceivably tall even in relation to the close-up figure of St Barbara; especially as it is still only half built.

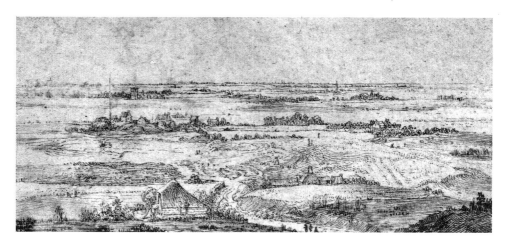

53
Hendrik Goltzius,
Dune Landscape near Haarlem.
Rotterdam,
Museum Boymans-van Beuningen

Van Eyck's Tower of St Barbara is an excellent example of the reinstatement of a saint's conventional attribute in the world of palpable reality. As a realistic surrogate for a halo, it is a parallel, in a sense, to the Master of Flémalle's firescreen nimbus— although of course it is an incomparably more significant pictorial element in its own right. For the virgin martyr now enters upon a new symbiosis with her own former attribute: her figure, seated on the ground with her voluminous skirts spread around her, becomes a podium for the tower, which in a sense stands on her shoulders as it soars into the heavens, thereby converting the horizontal format of the scene into a vertical one.

Plate 1

In the landscape background of the Antwerp St Barbara, Jan van Eyck has anticipated a view of landscape that was to assert itself two hundred years later as an separate pictorial type: the panorama of a low-lying plain, as first seen in 1600 or so in a number of drawings by Hendrik Goltzius, and then again in mid century in drawings and etchings by Rembrandt. On the right-hand side of the St Barbara, in particular, we already see the stratification of the flat surface that became the essence of later lowland landscapes, in which field boundaries, dips in the ground, and bushy hollows supply an objective pretext to insert a rapid succession of horizontals, parallel to the picture plane, and thus to suggest a maximum of spatial recession while minimizing the need for uncommunicative, purely formal indications. However, the seventeenth-century landscape begins only at the third level of Jan van Eyck's discontinuous view: it is Jan's distant prospect, treated as a subject in its own right.

52
Plate 14

53

The second work closely related to our evolutionary sequence is the so-called *Ince Hall Madonna*,[38] regarded until recently as a dated original by Jan van Eyck. It bears an inscription in Roman capitals, painted to either side of the brocade canopy, to the effect that the painting was completed by Jan van Eyck in Bruges in 1433. However, the form of the lettering, and the way in which the inscription is applied, are so out of keeping with Jan's customary way of doing things that it was long assumed to have been copied onto the panel from the lost original frame. Some years ago the painting, which few specialists knew at first hand, was transported to London and Brussels for technical examination, and it emerged that this supposedly spurious inscription formed part of the original paint layer; and that, in those passages—such as the Madonna's head—where weaknesses had been ascribed to overpainting, the paint was intact. In short, the investigators came to the probably irrefutable conclusion that this is not an original Van Eyck but a fairly close and amazingly well-painted copy of a lost work of which a number of other copies and paraphrases are known. If we now

54

look at the *Ince Hall Madonna* in evolutionary terms, we are therefore seeking to define the place of its lost original in the evolution of Van Eyck's Madonnas.

On careful scrutiny, the *Ince Hall Madonna* presents us with an anomaly. As in the *Lucca Madonna* or the Dresden Triptych, the Madonna sits beneath a brocade canopy; but she is not on a throne. She sits on the floor, like a *Madonna humilitatis*. This posture perfectly suits those Madonnas who inhabit the plain bourgeois interiors of the Master of Flémalle; but it is hardly appropriate under a magnificent baldachin that immediately reminds us of the Queen of Heaven.

Once more, as in the early *Madonnas* of the Master of Flémalle, it is hard to determine exactly how and where in space the Madonna is sitting. The figure rests upon the floor in a pyramidal mound of drapery folds. In the *Ince Hall Madonna* there is no trace of the discontinuous style of the *Lucca Madonna*, with its clear, stepwise transition from one spatial layer to another (as apparent, notably, in the lap with its shelf-like edge). On the contrary, the artist adroitly turns the seated figure a little to one side, in order to maintain continuity of form on the picture plane from head to foot and through all the gradations of spatial depth. The opening of the Madonna's mantle traces a gentle curve from her head to the floor, taking in her left arm and the legs and napkin of the Child. The critical points of the lap angles of both Mother and Child are concealed by the Madonna's hand and by the book, so that the downward linear flow is not interrupted. The right-hand half of her mantle makes the same sickle-like basic form as the left-hand half of the mantle of the Flémalle Master's St Petersburg *Madonna*: a form that is read almost entirely from top to bottom rather than from far to near. The curving movement that runs through the figure continues upwards in the flamboyant curves of the brocade pattern, thus reinforcing still more the planar character of the composition. The Madonna and Child are superimposed, like a bas-relief, on a patterned ground.

The spatial relationship between the central figure and the furniture and objects around her is also left entirely vague. In the *Lucca Madonna*, the wash-basin and the carafe are quite clearly placed one above the other on two shelves, the position of which can be defined in relation to the throne. In the *Ince Hall Madonna*, the basin ought to be on the floor in front of the cupboard, but it looks as if it were directly underneath it. There is just one respect in which the rendering of the interior in the *Ince Hall Madonna* is not defective, and indeed even excels that of the Arnolfini double portrait of 1434: and that is in the lighting: the superb way in which it captures the half-light of a space only partly illuminated from one side. These are effects that seem to anticipate the achievements of Jan Vermeer and Pieter de Hooch.

All this enables us to draw a number of conclusions: some certain, others more tentative. It is, I think, certain that the *Ince Hall Madonna* belongs at the beginning of the evolutionary sequence of Jan van Eyck's work; or, better, that the original was conceived at a time when Jan had not yet taken the decisive step of stilling the gaze, which led to the discontinuous spatial form and the blockish, angular style. Whether this momentous decision should be dated before or after 1432, the year in which the Ghent Altarpiece was completed, clearly depends on what credence we should give to the date of 1433 appended to the signature, which as written is certainly not authentic. Be that as it may, even before we have properly worked our way into the pictorial world of the Ghent Altarpiece, we can venture to assert that as a pictorial invention the *Ince Hall Madonna* is certainly not contemporary with the Mary in the Ghent Altarpiece *Deësis*, whose three-dimensional structure is if anything overarticulated by the layered swag of folds that lies in her lap and by the horizontals of the arm and the book above it. Its chronological place is with the diffuse sprawl of the Maries

7

Plate 6

38

Plate 11

Folding Plate

37

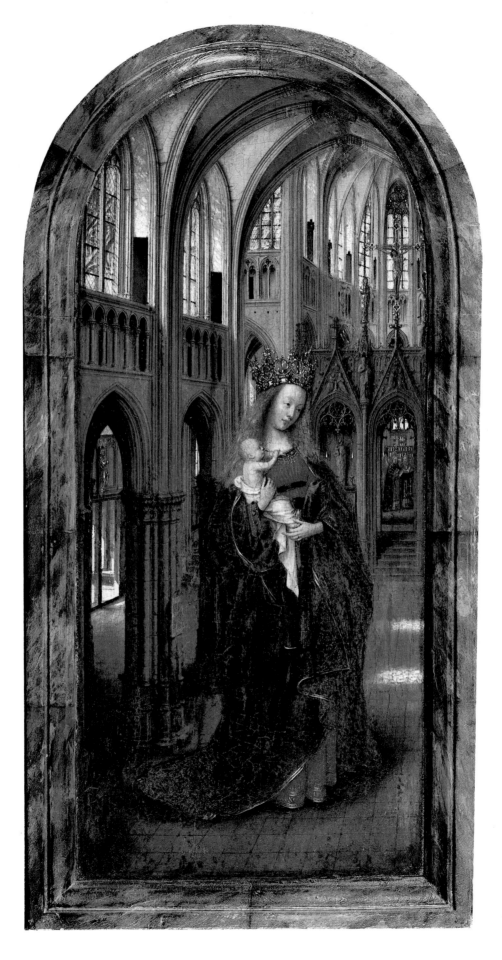

5 Jan van Eyck, *Madonna in a Church*. Berlin, Staatliche Museen Preussischer Kulturbesitz

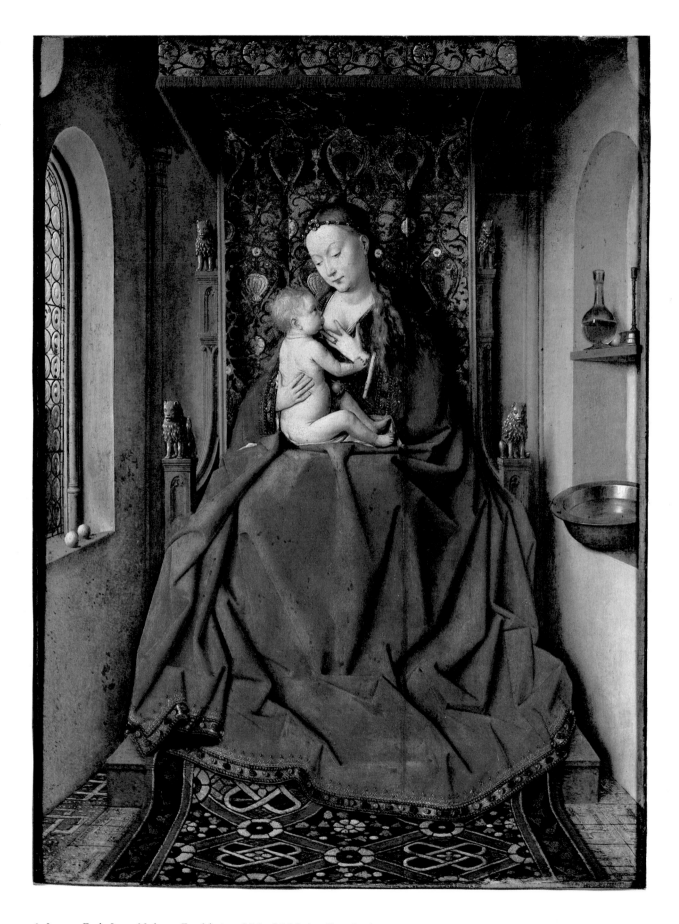

6 Jan van Eyck, *Lucca Madonna*. Frankfurt am Main, Städelsches Kunstinstitut

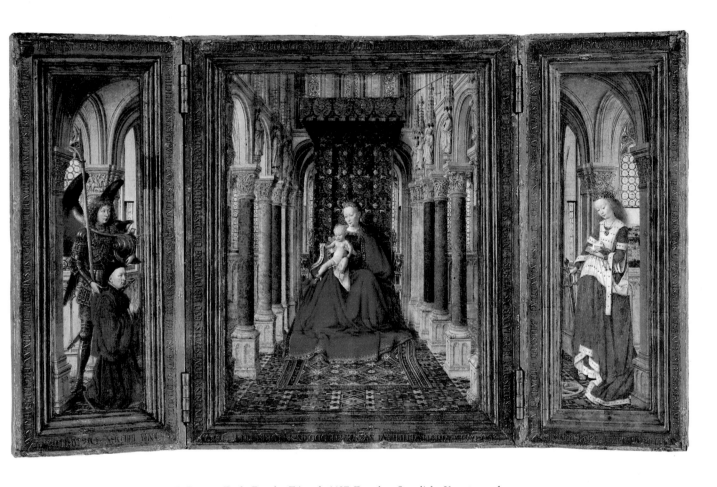

7 Jan van Eyck, *Dresden Triptych*, 1437. Dresden, Staatliche Kunstsammlungen

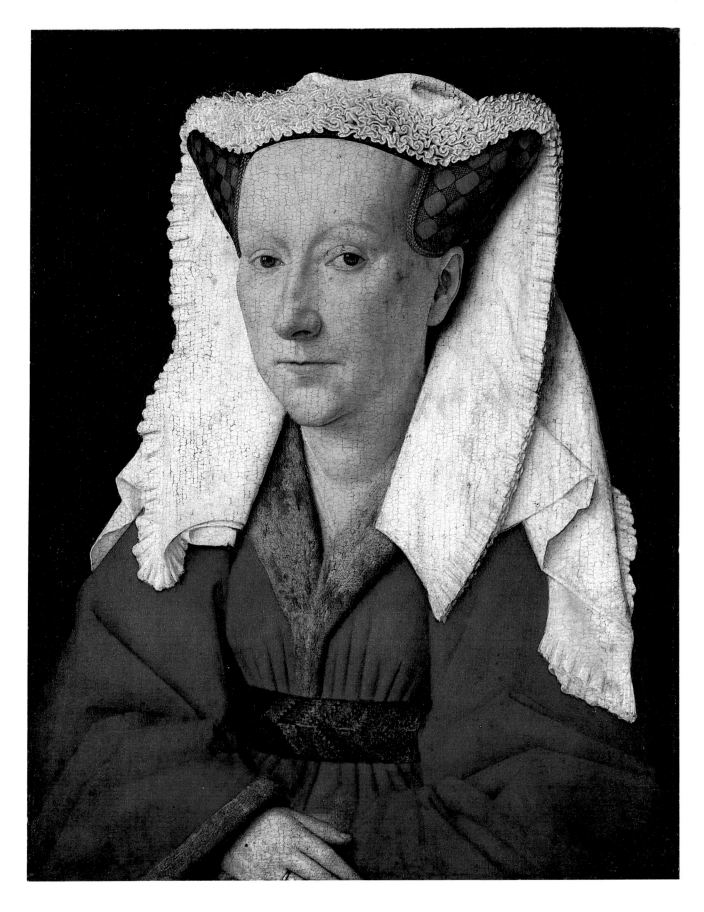

8 Jan van Eyck, *Margareta van Eyck*, 1439. Bruges, Groeningemuseum

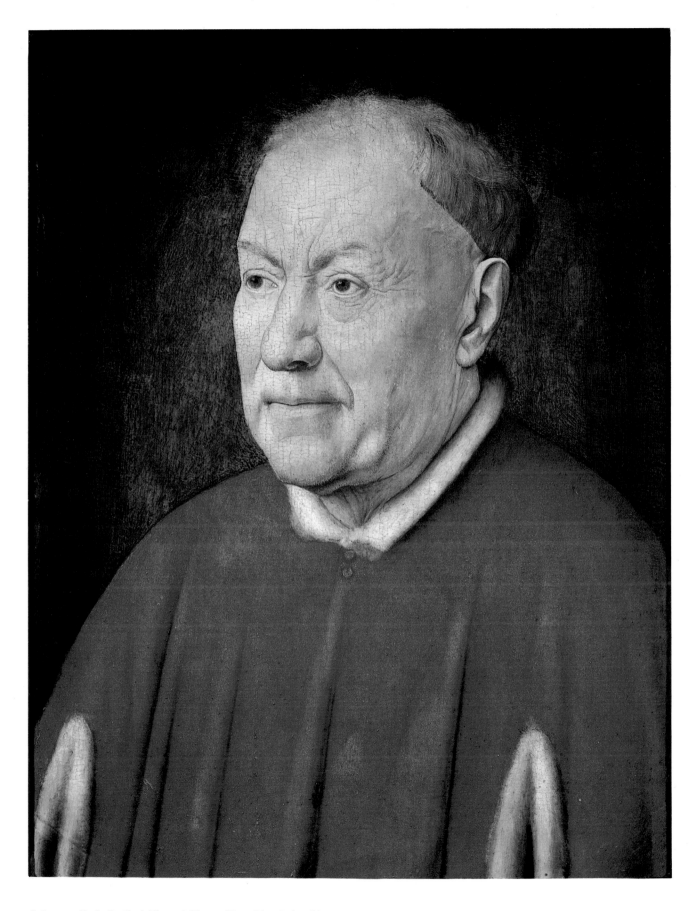

9 Jan van Eyck, *Cardinal Albergati*. Vienna, Kunsthistorisches Museum

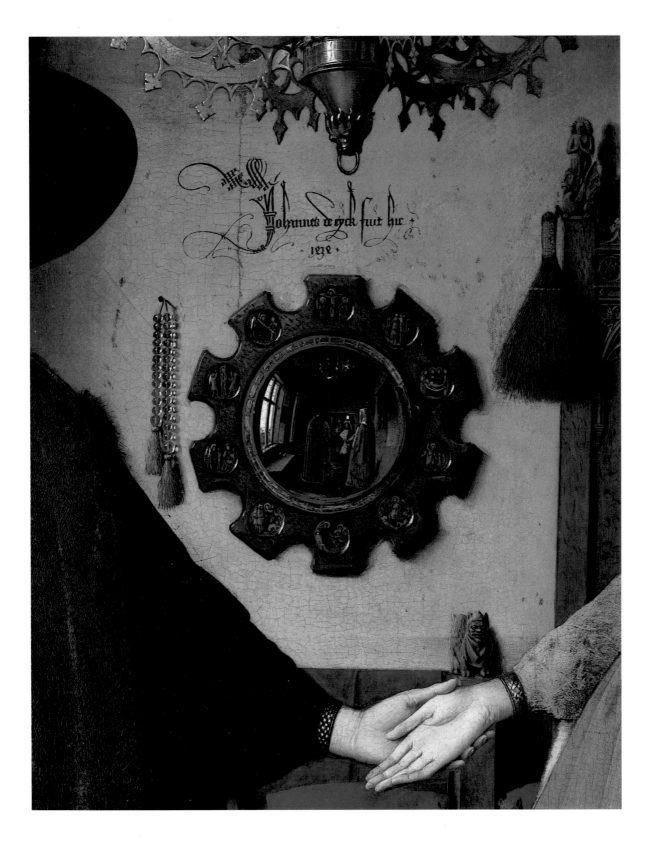

10 Jan van Eyck, *Giovanni Arnolfini and Jeanne Cenami* (detail). London, National Gallery

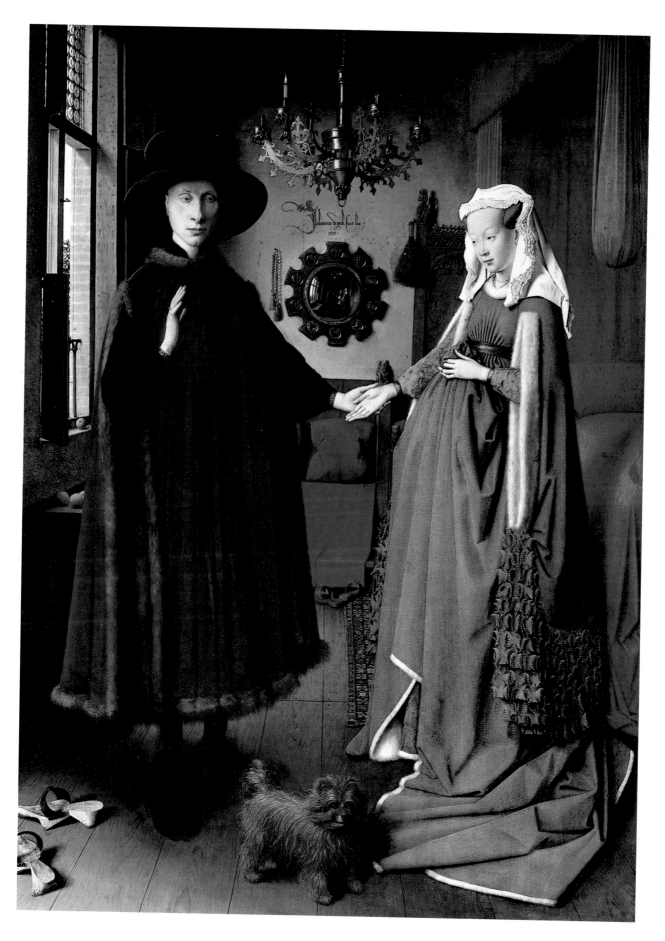

11 Jan van Eyck, *Giovanni Arnolfini and Jeanne Cenami*, 1434. London, National Gallery

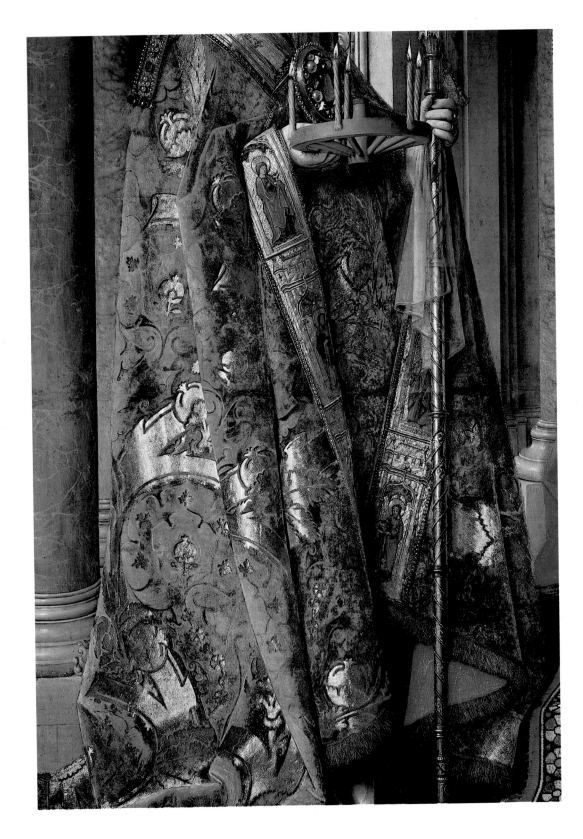

12 Jan van Eyck, *The Paele Madonna* (detail). Bruges, Groeningemuseum

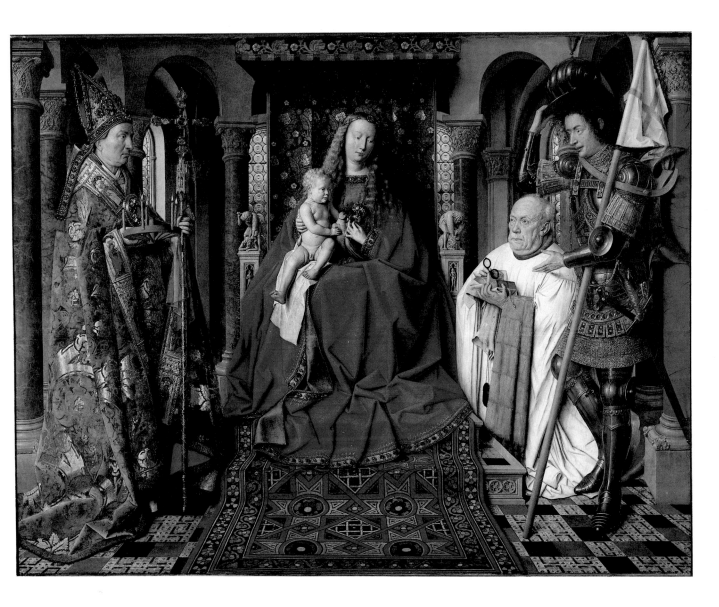

13 Jan van Eyck, *The Paele Madonna*, 1436. Bruges, Groeningemuseum

14 Jan van Eyck, *St Barbara*, 1437. Antwerp, Koninklijk Museum voor Schone Kunsten

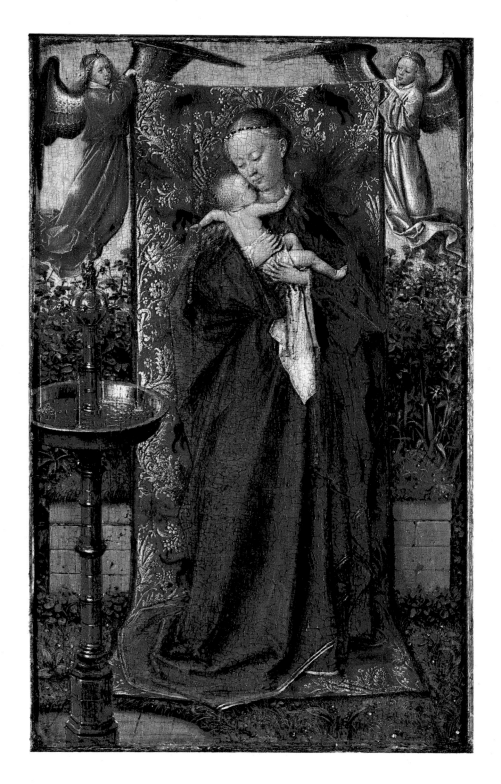

15 Jan van Eyck, *Madonna at the Fountain*. Antwerp, Koninklijk Museum voor Schone Kunsten

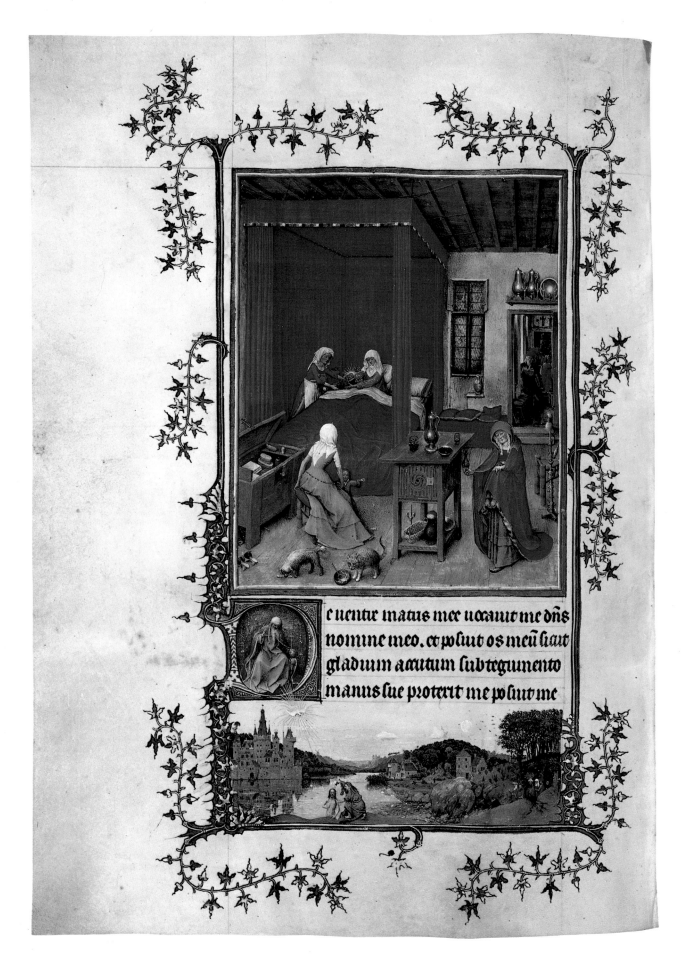

ce uentre matus mee uocauut me dñs
nomine meo. et poluit os meũ siaut
gladuum acutum sub tegumento
manus sue proterit me posuit me

16 Hours of Turin, *Birth of St John the Baptist*. Turin, Museo Civico, fol. 93v

17 Hours of Turin, *Requiem Mass*. Turin, Museo Civico, fol. 116

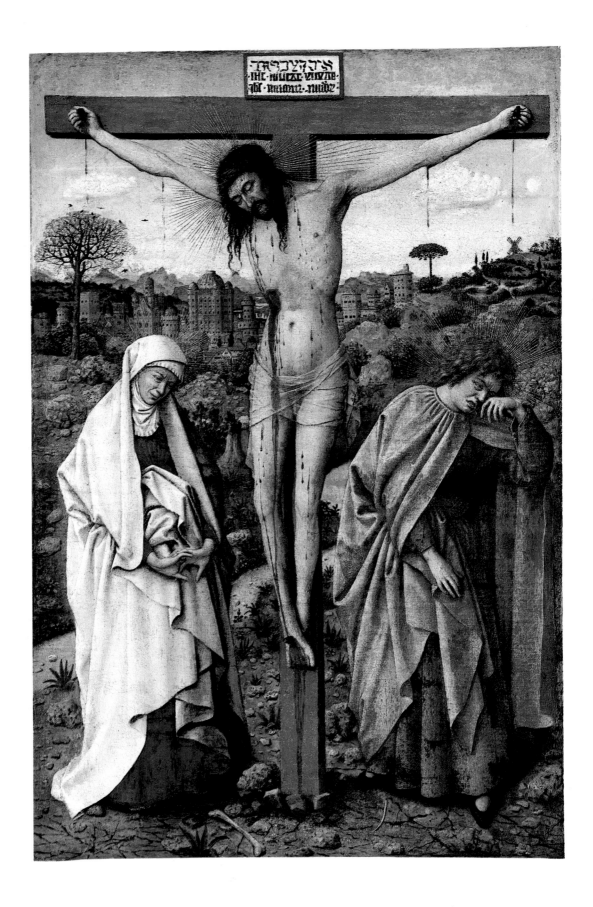

18 Hubert van Eyck (?), *Crucifixion*. Berlin, Staatliche Museen Preussischer Kulturbesitz

19 Master of the Hours of Turin (Hubert van Eyck?), *Crucifixion* and *Last Judgement*. New York, The Metropolitan Museum of Art, Fletcher Fund

20 Hubert van Eyck (?), *The Three Women at the Sepulchre*. Rotterdam, Museum Boymans-van Beuningen

Plate 3
38
of the Mérode Altarpiece and the *Madonna with a Fireplace*, both of which are commonly assigned to the 1420s.

That this is entirely a matter of the relation between date and style, rather than one of motivic content (the solemnity of the throne in a monumental painting as against the intimate scene of a private devotional painting), can be verified by a concrete example. In the work of the Master of Flémalle, there is one *Madonna* that belongs to the type of the bourgeois *Madonna humilitatis* in thematic and motivic content while conforming in spatial composition and figure construction to the discontinuous, cubic style. The *Madonna with a Firescreen* in London still sits in front of, and not on, her bench; but Virgin, bench, and window are all arranged parallel to the picture plane. In the figure of this Madonna herself, as in the *Lucca Madonna*, the orthogonal shelf of the lap is completely suppressed: the pyramid of the upper part of the body rests directly on the knee section. Here, at the same time, the Master of Flémalle reduces the interior to a 'detail' of the room in a more complete manner than in any other interior of the period: neither of the side walls is visible, and the impression of an interior is defined by the layered organization of space and not by the structure of the spatial shell itself.

Plate 1

The *Ince Hall Madonna* represents the stage of stylistic evolution that finds its classic form in the *Madonnas* of the Mérode Altarpiece and St Petersburg; conversely, the Master of Flémalle, in his London painting, gives his own version of the discontinuous, block-like style that marked Eyckian painting at least from the *Deësis* of the Ghent Altarpiece onward.

We have hitherto left aside one of the most important of all Jan van Eyck's interiors, a work that is both signed and dated: the Arnolfini double portrait of 1434. We have done so principally because this is a work of secular art and a milestone in the evolution of Eyckian portraiture; and it is to this aspect of Eyckian painting that we now turn.

Plate 11

The Arnolfini portrait has not been spared the attentions of the symbolic interpreters. It has always been regarded as a commemoration of a wedding or of a betrothal, but Panofsky, with characteristic ingenuity, takes this a considerable step further and interprets it as a commemoration of a private, non-Church wedding. The two people whose presence is revealed by the mirror thus become the witnesses to the union. Here again, as in the *Annunciation* of the Mérode Altarpiece, none of the countless unobtrusive genre details is there by chance: all are supposed to have a meaning relative to the marriage ceremony. This interpretation has met with vigorous objections, both theological and art-historical: a private wedding of this kind would, we are told, have been entirely inconceivable at the period in question.[39]

I believe that both sides in the controversy are missing the essential artistic point. The full-length pose does indeed fit into a tradition of betrothal or marriage portraiture, of which a few earlier and later representatives are still extant. To set the portraits in the nuptial chamber must surely have been Jan's own idea; a localized, individual space makes for more of a commemorative image than a neutral and therefore timeless setting ever could. Specific space equals specific time. The interior is constructed in accordance with centralized perspective, as in so many of the Van Eyck *Madonnas*—except that in this case the perspectival recession does not end at the rear wall, as it does elsewhere, but is continued in the miniature space reflected in the mirror. The walls of the room give the figures more air than the alcove-like setting of the throne in the *Lucca Madonna*, largely because the space between and beside the figures is pierced. On the left it opens through a window onto the outside world; on the right

7
Plate 6

it opens into the spatial recess of a four-poster bed, the far side of which we imagine but cannot see; and in the centre it opens into the illusionary space of the mirror. *Plate 10*

The preterite tense of the inscription *Johannes de Eyck fuit hic*, 'Jan van Eyck was here', would suggest that the instant of the event, as well as its location, is on display: perhaps this might be the *dextrarum junctio*, the joining of hands—of which the painting would constitute both a souvenir and a documentary proof. But instantaneity, in the sense of capturing the moment at which an event took place, is not in the nature of this painting. The bridal pair stand motionless before us; even Arnolfini's raised hand has nothing fleeting about it: it stands aloft in perfect stillness. We may as well admit that the couple look as if they had struck a pose and were obeying the portraitist's injunction to hold it. Even the little dog knows what the occasion requires and looks out at us, or rather at the painter, wide-eyed and motionless.

We learn from the post-medieval history of nature study that the first things that painters delineated with scientific minuteness were those that lent themselves to lengthy, patient and detailed study: the world of tiny living things, insects, birds or plants. To achieve such precise observation and recording of human facial features, in all their uniqueness, the owners of those features must have been prepared to stand still in their turn and lend themselves to optical scrutiny as if to a medical examination. Those portraits that are virtually heads, in which the painter concentrates on the face and, at most, on a small section of neck and shoulders, do not make it quite so apparent that the subject has put himself or herself so totally at the painter's disposal; but with full-length figures, whose bodies clearly reveal their inactivity, we become aware that the lives of these people must have come to a halt in order to be translated onto the more enduring plane of pictorial existence.

Such a picture is the precise opposite of a slice of life. The actors are not carrying on with their roles in life as if nobody were watching them; they have taken on an entirely new and passive role, that of the artist's sitter. Total stillness and silence must be maintained while he is at work. This naturally implies a distinctly unmedieval respect for artistic creation: these creatures no longer relate solely to God but, for the moment, solely to the painter. Only thus was the discovery of the visible world accomplished. The ideal object of depiction, for the stilled gaze, is stilled, immobilized life.

Whatever the precise ritual significance of the Arnolfinis' posture and body language in terms of contemporary custom, this represents no more than the raw material, the rationale, in which they are less than totally involved. Both stare into space; they are lost in an inner world of their own. The right hand knoweth not what the left hand doeth. This abstracted state must be seen as the direct cause of their passivity. At the same time, it is the dislocation between consciousness and posture that allows psychological truth to emerge. And so, in this special case of a marriage portrait, but also in more straightforward Eyckian portraits, not only is the physical self rendered in often microscopic detail but the sitter is simultaneously characterized as a psychological being. The unsparing reproduction of a person's outward appearance surprises us by bringing to light a dualism that is admittedly rooted in the medieval mind-body dichotomy but nevertheless has something entirely new to show us: the record of a mental existence, an inner state of being, that cannot be exclusively defined in terms of such concepts as faith or piety. Suddenly, in the profound silence of the room that sequesters this bridal couple from the world outside, another and far darker interior softly begins to open: that of human inner life.

Even when Jan van Eyck depicts a donor in prayer at the feet of a patron saint, like Jodocus Vijd on the Ghent Altarpiece, or devoutly kneeling at the very feet of the *99*

Plate 13
Frontispiece
Madonna, like Canon van der Paele or Chancellor Rolin, the earthly individual is never permitted to be entirely subsumed in his own piety. In none of these cases are the worshipper's eyes directed towards the object of his worship. These individuals, too, seem to look inward; they seem, as it were, to be going through the motions of prayer. Instead of prayer, what we see is something rather more neutral: a state of contemplation.

55
56
61
Plate 8
There are portraits by Jan van Eyck in which the sitter makes eye-contact: these include that of the *Man in a Red Turban* (or *Hood*) of 1433, in London, that of the goldsmith Jan de Leeuw of 1436, in Vienna, and that of the painter's own wife, Margareta van Eyck, of 1439, in Bruges. In each of these the sitter looks us, the viewer, straight in the eye, and must therefore have done the same to the painter. Undeterred by the fact that this feature appears in a number of Eyckian portraits of different sitters, some scholars have inclined to the view that the *Man in a Red Turban* in London is a self-portrait. As always, let us keep to what can be proved. We have seen on a number of occasions that Jan made it his practice to reproduce the things of the empirical world exactly as they presented themselves to his eye; and so, if he did paint a self-portrait, he must have shown himself in the attitude of self-scrutiny that seems implicit in the

54
Jan van Eyck (?),
Ince Hall Madonna.
Melbourne, National Gallery of Victoria

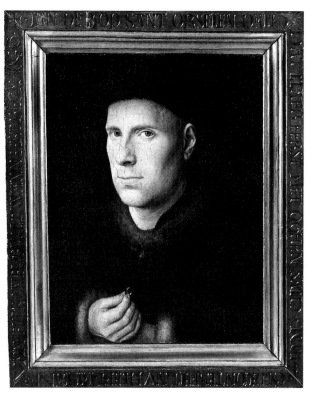

55 Jan van Eyck, *Man in a Red Turban*, 1433.
London, National Gallery

56 Jan van Eyck, *Jan de Leeuw*, 1436.
Vienna, Kunsthistorisches Museum

idea of self-portraiture. For the moment, that is all there is to say. Indeed, perhaps this motif of gazing out at the viewer is a less compelling sign of self-portraiture in Jan van Eyck's case than it is with other painters. For, as we have already seen, Jan does not choose to imply that his sitters have been discreetly observed; on the contrary, he makes it abundantly clear that they are keeping still for the painter's benefit and relating to him; and what simpler way could there be to do so than to look at him while he is painting them?

Jan has other ways of showing that his sitters are aware of their special status as subjects of portraiture. Jan de Leeuw holds up a ring, to show that he is a goldsmith; *57* and so does the unknown *Man with Ring* from the Bruckenthal collection (now in Bucharest). Baudouin de Lannoy grips his chamberlain's wand of office tightly, lest *58* anyone fail to take note of his position in the world. Others, like the mysterious *59* Timotheos and Giovanni Arnolfini, pose with a document or scroll. The hands—when *60* they are included, which is not always—are part of the presentation of the sitter; they are a new kind of attribute. And yet the gestures are never momentary ones: on the contrary, we tend to feel that the sitters are about to get pins and needles in their arms from holding up their assorted objects; sometimes, too, it looks as if the painter has moved the sitter's hand into the position that he wants for his picture.

With Jan van Eyck, the face and the hands are the speaking parts of the portrait; and in his earlier portraits at least there is little sign of an organic relationship between head, torso and hands. In the portrait of Timotheos, dated 1432, the torso is under-sized, and it is not until the Berlin portrait of Jan Arnolfini that the torso is fully developed, so that the arms are no longer compressed into too small a space within the portrait. Even here, however, they hang flat and parallel to the picture plane, whereas in the portraits of 1432–36 they serve to add a stronger element of depth to

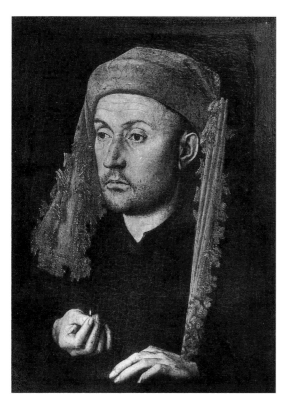

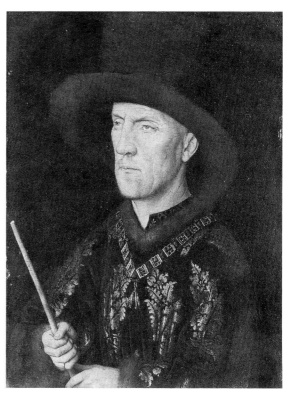

57 Jan van Eyck, *Man with Ring*.
Bucharest, Museum of the Romanian Republic

58 Jan van Eyck, *Baudouin de Lannoy*.
Berlin, Staatliche Museen Preussischer Kulturbesitz

the painting. The earlier the portrait, the more the visible hand is foreshortened, the sharper the crooking of the fingers, and the more cubic the half-clenched hand appears as a whole. By these criteria alone, the Bruckenthal *Man with Ring* belongs to the first period, before 1432.

In early works, the human face is intimately observed at close quarters, with incorruptible objectivity and impartial interest in every bump and hollow, every nuance of colour, every tiny crease, brow-wrinkle and beard-hair: *die stoppelen vanden barde wal grijsachtig…*, 'the stubble of the beard grizzled', Jan noted on his sketch for the portrait of Cardinal Albergati.[40] These portraits bear out Georg Christoph Lichtenberg's famous definition of the human face as 'the most entertaining surface on earth'.[41] Later, Jan came to take a more distant view, both literally and figuratively: he depicted people more summarily, and the sitters themselves became stiller and more retiring; the form broadened and flattened, and a deep tranquillity entered the painting.

We have sought to show that a portrait by Van Eyck is anything but a snapshot: it is not a slice of life, the extraction of a point in time. Jan must, however, have been clearly aware that a painting that concentrates on an individual's face *is*, literally speaking, the extraction of a detail view, and that it needs to make an artistic whole out of something that is objectively incomplete. To account for this incompleteness, he made the picture frame responsible for concealing the rest of the person. The individuals in Jan's portraits appear in the opening made by the frame, as if in a window. The frame cuts across and conceals the greater part of the body, but at the same time it makes the partial view into a pictorial whole—which the painter himself has deliberately created.

Jan did not put his portraits into any old frames. He designed and painted his

64

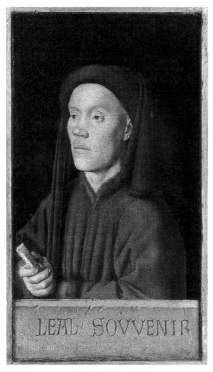

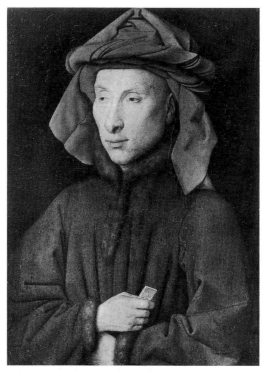

59 Jan van Eyck, *Timotheos*, 1432.
London, National Gallery

60 Jan van Eyck, *Giovanni Arnolfini*.
Berlin, Staatliche Museen Preussischer Kulturbesitz

frames himself to look like stone, with inscriptions either incised or added on metal plaques. And these inscriptions are as wordy as the portraits themselves are taciturn. All this is an illusionistic device. The frames exist in our world, the viewer's world, and the light that falls in our space falls on them; but through them we look into another space, the world of the painting, which has a specific lighting of its own.

The portrait of Timotheos, painted in 1432, has an additional stone parapet; the subject has stepped up behind it and holds his scroll out over it in his right hand. A similar pictorial idea was present in the portrait of Princess Isabella of Portugal, which Jan painted in 1428–29 as a member of the Burgundian embassy that travelled to sue for the Princess's hand with her father the King, and which he then sent back to Duke Philip. As Kurt Bauch has shown, a late copy of this portrait has survived, and we thus have an approximate idea of the look of a work painted by Jan van Eyck four years before the completion of the Ghent Altarpiece.[42] Inside the wooden frame there is a fictive stone frame, on the sill of which Isabella rests her hand in such a way that she seems to reach out into the viewer's space, taking a slight liberty with artistic boundaries. The right hand rests, parallel to the picture plane, on top of the fore-shortened left hand. Isabella's face is shown in the three-quarter profile that is a recurrent feature of Jan's portraits, and her eyes are on the painter, or the viewer. She is not standing in this window by accident, because she happened to be passing: she is holding a pose, and has been doing so for quite some time. The light is evidently supposed to be falling from outside, from the viewer's space: at least, so far as we can tell from the weak drawing. It illuminates the right side of the girl's face and casts a patch of light on the right-hand side wall of her niche. Whereas the Master of Flémalle likes to show us the shadows cast by solid objects, Jan shows us patches of light: the forms in which light, though insubstantial, depicts itself. The shadow in Isabella's niche is predominantly spatial shadow, as amorphous in itself as the patch of light.

59

62

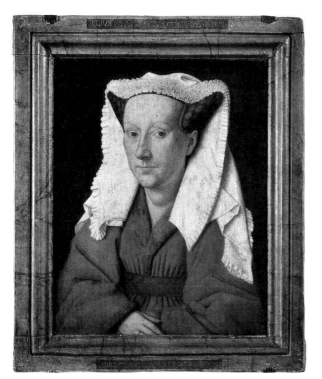

61 Jan van Eyck, *Margareta van Eyck*, 1439.
Bruges, Groeningemuseum

62 After Jan van Eyck, *Isabella of Portugal*.
Private collection

46
48 In the Master of Flémalle's portraits, light and shadow are primarily subordinated to the three-dimensional modelling of the heads. This can notably be seen in the way light falls on the half of the face turned towards us, banishing shadow to the periphery, where form recedes into depth. Light serves to enhance relief. In Jan's portrait of Isabella, too, it looks as if the light fell on the half of the face turned towards us; but in this respect his later works show a highly characteristic change. The lit side of the face is turned away from us, with the result that a considerable part of the near side lies in shadow. The nose no longer marks the watershed between light and shade; it forms a partial interruption of the illuminated zone, thus producing a much richer facial relief. However, what is essential is that shadow and light have freed themselves from their subordinate status as aids to modelling. The body's shadow merges imperceptibly into spatial shadow; and so the human face, in catching the light, never wholly detaches itself from its dark or shadowy background. Ultimately, it remains beyond our reach. This was the start of the evolutionary process that culminated in the chiaroscuro of Rembrandt's portraits.

In Jan's late work, contrasts of light and shade are more muted, eliminating even such faint hints of assertive dynamism as linger in the way the earlier portraits grow to meet the light. Clearly, Jan now finds such devices as sills, parapets and frames too obvious, and he abandons them in favour of a still more tranquil, distanced overall effect. In conjunction with the new-found spatial unassertiveness of the paintings, a subdued colour scheme causes the sitters to appear aloof and unapproachable. Although Jan takes anything but a flattering view of their features, his distancing vision gives them a serene, tranquil look that abstracts them from all constraints of time and space.

63 The criteria that I have just tried to outline enable us to sort the undated portraits into chronological order. The portrait in Vienna of the Cardinal of Santa Croce in

Gerusalemme, Niccolò Albergati, formerly dated 1431 because the Cardinal visited *Plate 9*
Bruges and Ghent in that year, really belongs a few years later.[43] The sitter had a
reputation for sanctity in his own lifetime; but this in itself is not a sufficient explana-
tion for the sense that we get from the Vienna portrait, of the serenity of a Prince of
the Church who stands far removed from the turmoil of this world: for that is not the
impression emanating from the preparatory drawing now in Dresden, which was the *64*
actual first-hand image. With its starker lighting, literally bringing to light the massive
folds of flesh, this is far more typical of the early 1430s. Since it is unlikely that a further
life-study was available, and since the Albergati of the painting nevertheless looks
older, more tranquil and more resigned, it cannot be far wrong to suppose that Jan
van Eyck's painting style had itself become more tranquil in the intervening time. The
painting also shows more of the height of the torso and concentrates less tightly on
the head. The painting is more Gothic, more donor-like, than the drawing.

The last painting to be discussed here, the *Man with Pink* in Berlin, has only to be *65*
juxtaposed with the Albergati portrait in Vienna to make us want to assume the
longest possible lapse of time between the painting of one work and the other. Not so
long ago, the Berlin painting was celebrated for its unsparing, photographic realism;
now it has fallen into disfavour, and has been struck off the list of authentic Van Eyck
paintings. A number of scholars decline even to acknowledge it as a copy of a lost
original by Jan van Eyck. Doubts first surfaced when an X-ray and chemical examin-
ation of the panel supposedly revealed a technique different from that known in Jan's
work. This was an imaginative boost to those art historians who had been unable to
make head or tail of the work's stylistic idiosyncrasies; they heaved a sigh of relief
and banished this inconvenient anomaly from the Eyckian *oeuvre* with a clear con-
science. The painting was even declared to be an archaizing invention painted in the
style of Van Eyck in 1500 or so, on the analogy of a number of paintings by Quentin

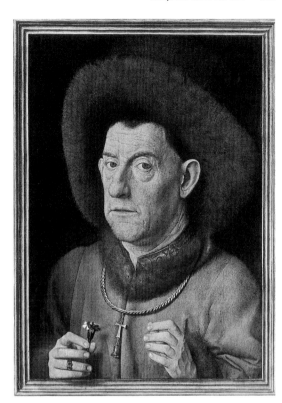

63
Jan van Eyck,
Cardinal Albergati.
Vienna, Kunsthistorisches Museum

64
Jan van Eyck,
Cardinal Albergati.
Dresden, Kupferstichkabinett

65
Jan van Eyck (copy),
Man with Pink.
Berlin, Staatliche Museen
Preussischer Kulturbesitz

Massys. I must confess that my eyes lack the acuity to find any of this in the *Man with Pink*; and I stick to the old-fashioned idea that this portrait of a member of the Antonite Order (founded by the counts of Holland in the late thirteenth century, and moribund long before 1500) is—in its invention, at least—an Eyckian creation; in which view I concur with Bauch, whose acute analysis of Eyckian portraiture is one of the most important recent contributions to Van Eyck studies.[44]

Turning to this work from the Eyckian portraits of the 1430s, which are the only ones known to us, we are disconcerted to find ourselves so indiscreetly and aggressively apostrophized by this ugly man in his outsize hat—not to speak of the faintly comic contrast between the pink itself and his age-worn features. The pose is more of an instantaneous one than any we know from other Eyckian portraits; this is the most 'speaking' likeness of all. Not only are both hands in play—something that happens nowhere else—but the lips are slightly parted, as if to speak. This last feature occurs, to my knowledge, only in one other portrait of the period, the Vienna portrait of Emperor Sigismund, a work whose provenance is controversial, but which undoubtedly dates from the early days of realism. There are some heads on the Ghent Altarpiece that might be cited as parallels; although their relevance is limited by the fact that they are not portraits.

Another highly unusual feature is the frame, which is not real but a painted, fictive one. Taken to its logical conclusion, this would mean that we are looking at a painting of a painting. One might imagine, for a moment, that the work in Berlin is a faithful replica of an Eyckian painting, in which the copyist has rendered the real frame of the original as a painted one. We know, however, from the little grisaille diptych of the *Annunciation*, that Jan van Eyck's illusionism did indeed extend to the use of a painted frame with shadow falling on it. So I am inclined to agree with Friedländer, who saw the Berlin portrait as a youthful work by Van Eyck, describing its curious blend of

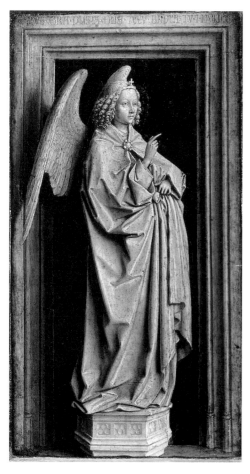
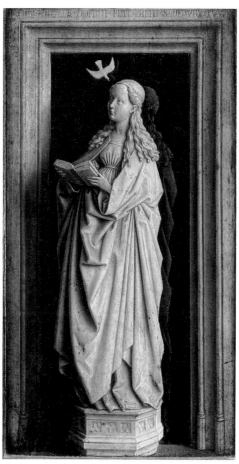

66
Jan van Eyck,
Diptych of the *Annunciation*.
Madrid, Thyssen-Bornemisza
Collection

spontaneity and immobility as follows: '[Its] expression seems rigid and archaic, like that of a deaf-mute who is straining vainly to speak'.[45]

The word 'archaic' is surely out of place, for in the first quarter of the fifteenth century this kind of realism must have been an unprecedentedly daring innovation, and one that remained without a parallel until Dürer painted his *Portrait of an Old Man*, now in Antwerp. Perhaps it would be a better description of the content and character of the work to say that the clash between the spontaneity of the sitter's gesture and facial expression, on one hand, and his apparent state of suspended animation on the other, looks like the result of a desperate effort on his part to hold still so that the painter can achieve his microscopic precision of rendering.[46]

From the moment of his very first appearance in the documentary record, Jan was a court painter, first in Holland, then in Flanders-Burgundy. Is it possible that his work at court has left no traces apart from the portrait of the Portuguese Infanta? This question has been repeatedly posed, and two pieces of work have been found that give us some, albeit vague, notion of the look of the original paintings of the period. They will be discussed here with all due caution.

One painting shows a *fête-champêtre* at the court of Philip the Good; it now hangs 67 in the Château de Versailles, and is undoubtedly a sixteenth-century copy of an early fifteenth-century original. To judge by the costumes, the courtly dress recorded by the Limbourg brothers in their calendar illustrations of the second decade of the century had gone out of fashion; and so the original must be assigned to the 1420s. Unless, that is, the difference in costume is not a chronological but a regional one. At all events,

the landscape across which the many episodes are strewn is still the 'wallpaper' landscape of the courtly style of International Gothic, *c.* 1400, with the ground rising uniformly to a high horizon: a landscape type that forms the basis of the Limbourgs' calendar landscapes, as well as that of the frescoes in the Adlerturm at Trento. The *May* and *June* scenes of the latter bear a close thematic relationship to the painting in Versailles: with their sociable promenades amid the greenery, they anticipate the later imagery of the 'Garden of Love'.

68

In the Versailles painting, we are immediately struck by the painter's marked predilection for figures viewed from behind. Of the thirty-six figures of court society in the foreground and middle ground, seven are straight back views, in which the face is not seen; six more display a pronounced 'lost profile'. In other words, there is a strong predilection for figures that are physiognomically mute, so that their costumes make a particularly strong showing. Back views provide us with repoussoir figures; that is, they conduct our gaze on into depth. On closer inspection, furthermore, we begin to see the formation of spatial cells: the nearer figures look away, while those further away face out towards us. The whole is held together by transitional groups, each consisting of two couples arranged in such a way that one member of each turns to look at the couple walking in the opposite direction. The result is a multiple flow of movement that gives a new lease of life to the old, cartographic, wallpaper landscape.

A purely iconographic explanation has been advanced for this, which is that the figures are not simply promenading but taking part in a stately dance, the *basse danse de Bourgogne*. Be that as it may, and however courtly the theme and the costumes, in stylistic terms this is a work that is beginning to grow away from the formal conventions of the 'soft' style, with its unwritten rules of seamless surface continuity and unbroken linear consonance. And so it is understandably tempting to ascribe the work

67 *Hunting Party at the Court of Philip the Good.* Versailles, Musée National de Versailles

68 *The Month of June.* Trento, Castello del Buonconsiglio, Torre del'Aquila

to Jan van Eyck, who is after all known to have been court painter to Philip the Good. No concrete links with Jan's authenticated work have yet been established; but, on the other hand, there is no extant work on a 'courtly' theme, identifiable as Eyckian on internal or external grounds, that is stylistically incompatible with this garden party scene. In our pursuit of the early Van Eyck, we may therefore leave this work to one side with a clear conscience.

The second example of Early Netherlandish secular painting, a work that has only recently come to light, is another work with a limited evidential value. It is a sizeable watercolour, once in the imperial collections in Vienna, but held by the Louvre since *69* Napoleonic times. It is not impossible that it is actually a fifteenth-century original; for those parts of it that do suggest a later date, in the landscape at any rate, are known to be the work of Joris Hoefnagel, one of the court painters of Emperor Rudolph II, who restored the work in contemporary style after it had badly deteriorated. The only aspects worth commenting on are therefore the overall composition, the figure drawing and the costumes.

What attracts our interest to this largely ruined work is the fact that it can be localized: three of the figures wear the chain and bell of the Antonite Order, the *70* dynastic order of the counts of Holland, whom Jan van Eyck is known to have served in the early 1420s. Otto Kurz, who has rescued the watercolour from oblivion, suggests that it can be firmly dated to the year 1417;[47] and the style of dress, or at least that of the male figures, is certainly compatible with that date. The feminine fashions are not so easy. The skirts elongated into a train, the *houppelande* costumes, are a product of the same stylistic impulse that produced the flowing draperies of the International Gothic; both appear in their purest form in the calendar scenes of the Limbourg

69
Jan van Eyck (?),
Fishing Party.
Paris, Louvre,
Cabinet des Dessins

brothers' *Très Riches Heures*. In detail, however, in the bunching of material and the thicker head-dresses, the fashions are those of the ensuing period, as typified in the dress worn by the bride of Giovanni Arnolfini. If this watercolour does date from 1417—and I believe that we must assume so, as it includes portraits of Count William IV of Holland and his son-in-law, both of whom died in that year—these court ladies must be regarded as early pioneers of a fashion that is generally regarded as typical of the 1420s and 1430s.

There is not much to say about the structure of the landscape, except that the male and female groups are separated by a stream which winds its way vertically down the centre of the picture. This is entirely in keeping with the steep, 'wallpaper' landscape conventions of the 'soft' style, which continued to prevail in secular court wall-hangings well on into the second quarter of the century. The grouping of the figures is looser on the left than on the right, and we notice that no attempt has been made to distinguish the women in the back row from those in front by making them smaller. In both groups, the figures stand very informally alongside and above each other; as the fishing proceeds, the only figures who face and look at one another are the two figures marked out as principals by their costumes. The rest look in every possible direction; their attention is not concentrated on anything but, in the etymological sense of the word, 'distracted'.

We notice that no one, except the three anglers, shows any interest in the sporting activity for which both groups have presumably come down to the river. In this, the watercolour strongly recalls the Dutch painters of the sixteenth and seventeenth centuries, who take some casual activity as the occasion, or rather the pretext, for a collective portrait of a number of persons who belong to some such social grouping

70

70
Court Hunting Party (detail).
London, Victoria and
Albert Museum

as a guild, a fraternity, or the audience at an anatomy lecture. In the present case, the gathering is a courtly and not a bourgeois one; otherwise, the analogy with the genre of the group portrait, so assiduously practised later in Holland, is perfect. As far as its poor state of preservation permits details to be discerned, this courtly group portrait even contained one or two figures who were looking out of the picture, directly at the viewer. This is one of the defining characteristics of the Dutch group portrait, according to Riegl's celebrated analysis: the need to involve the viewer, who acts as the unifying factor in a composition that lacks an inner unity of its own.[48]

The deliberate absence of composition detaches the individual participants in the group from each other and helps to point the contrast between the activity of the anglers, who are clearly menials, and the inactivity of those in the court party, who form the subjects of the portrait. This contrast reminds us of the dualism that we find in the Arnolfini portrait, between the instant that is portrayed and the state of immobility required by the pose; it is one strong argument for ascribing the invention of this, the earliest of all North European group portraits, to Jan van Eyck.

IV. The Ghent Altarpiece

Folding Plate We have hitherto been rather gingerly skirting the subject of the Ghent Altarpiece, the most powerful and complex of all works of Early Netherlandish painting. But now that we have formed an image of Jan van Eyck in the latter part of his life, and—in portraiture, at least—gained some idea of the qualities of his early work, we have no further excuse for postponing the encounter with what may well be the most intractable of all art-historical problems.

Most of the interpreters who have tangled with this Hydra of art history have emerged claiming a final victory; but this has not prevented the monster's severed heads from sprouting again, or more new solutions from being proposed. Only lately have wiser counsels prevailed, and new proposals have started to appear with question marks attached, to indicate the issues that remain open. I am convinced that we must above all resist the temptation to treat this matter like a mathematical problem or a game of patience that must eventually 'come out'. I had better say here and now that my game of patience does not come out. I think it would be irresponsible of me as a teacher to present the state of research as if there were nothing left to be done by the rising generation of art historians. I think it is not only more honest but also more dignified to point out the difficulties that remain to be overcome, and thus, perhaps, to draw attention to those places where laurels still remain to be culled.

How happy we should be, with other great works of world art, if we knew as much about them as we do about the Ghent Altarpiece, and if we had them in anything like the same state of preservation! The Altarpiece is signed and dated—at least as far as the year of completion is concerned—and stands in the very church and chapel for which it was intended.[49] However, the inscription tells us not only that Jan van Eyck completed the vast work in 1432 but that it was begun by his brother Hubert, a still greater artist; it does not go on to say when this was, or which parts of the Altarpiece are Hubert's, or who is to take the credit for the plan, design and programme of this multiple work.

All of this is essential knowledge, whether the attribution of greater merit to Hubert is fully justified or whether it represents no more than a grand gesture of *pietas* to a deceased artist. We know from other sources that Hubert died as early as 1426, only ten years after the Limbourg brothers; he was clearly the elder of the Van Eyck brothers, and so it is highly likely that he—and not, as posterity has supposed, Jan—was the initiator of the *Ars nova* of painting. In which case, to define Hubert's part in the Ghent Altarpiece would be tantamount to identifying the true creator of the new view of reality: the discoverer of the phenomenal, empirical, palpable world. The game is certainly worth the candle.

Theoretically, the investigation might have seemed plain sailing. The Ghent polyptych of *The Adoration of the Lamb* must be Hubert plus Jan. We know Jan well from other paintings. So all that has to be done is to subtract from the whole the known quantity, Jan, in order to isolate the unknown quantity, x. But, however it has been tried, this operation has refused to yield a result. It has been clear for some time now that all attempts to draw actual lines of demarcation—Hubert here, Jan there—are

doomed to failure. There are many places on the Ghent Altarpiece where several layers of paint overlie each other. Very often, the design and the execution do not tally. To varying degrees, the artist who completed the Ghent Altarpiece altered what his predecessor had begun, and this makes it impossible to make a neat distinction between their hands on adjacent portions of the final surface. The fact is that one square centimetre of painting may very well be the intellectual property of several artists.

The conclusions that had initially to be drawn from the visible surface became certainties after X-ray and chemical techniques of examination were applied to all the panels of the Ghent Altarpiece in the course of the major restoration of 1950–51. As the Altarpiece was known to have been extensively restored several times over the centuries, the first priority was to determine where the Eyckian surface actually lay, and what it looked like. To eliminate the subsequent, post-Eyckian additions, we shall therefore need to consult the findings of the Brussels restoration commission.[50]

The fact that the Altarpiece is now to be seen in the church that has always been its home tends to obscure the fact that over the centuries it has been moved a number of times; its position in Ghent is that of a wayfarer who has come home somewhat the worse for wear. In the sixteenth century it seems to have been subjected to a clumsy cleaning operation that destroyed the predella. By 1550 a thorough restoration was necessary, and this was undertaken by two distinguished painters of the day, Lancelot Blondeel and Jan van Scorel. Then came the Protestant iconoclasm, and the Altarpiece had to be hidden in the church tower; the Calvinists later banished it to the town hall. Eventually, after an absence of nearly twenty years, it returned to St Bavo.

After the French Revolution it was carted off to Paris, and it went back to Ghent only in 1816, after Waterloo. Hardly had it returned when a Vicar-General of the diocese sold the shutters to a dealer, and by way of an English collection they eventually found their way to the King of Prussia and thus to the Berlin Gallery. The *Adam* and *Eve* panels, which are separately hinged, went to the museum in Brussels. In 1919 the Treaty of Versailles restored the shutters to Belgium, and after a hundred years of separation they were reunited with the central panels, which had been badly damaged by a fire in 1822. In 1934 the Altarpiece suffered a grievous loss when the panel of the *Righteous Judges* was stolen; it has never been found.

The reunion of the Ghent Altarpiece panels in 1920 revealed differences between the state of preservation of the central panels and that of the shutters, and it became apparent that some of the restorations had been tantamount to partial repaintings. But at that time any demand for de-restoration would have been dismissed as the fantasy of an overwrought art historian. Then came the Second World War, and no time was lost in evacuating the work to the South of France, whence the Hitler regime shifted it to Neuschwanstein, and finally to a salt-mine at Altaussee. From this cache and bomb-shelter it was liberated by American troops and once more returned to Belgium.

It soon became horrifically apparent that conditions in that Austrian salt-mine had not suited the traveller at all. The varnish began to disintegrate, and crystals formed, threatening the paint surface beneath. The patient was on the danger list, and needed hospitalization and intensive care. So the painting was taken to Brussels, and there, in a laboratory equipped with all the latest technical aids, it was examined—literally—right down to the grounding of the panels. Then it was freed from its tainted varnishes and from some, though not all, of the post-Eyckian overpainting. The principle followed was that later coats of varnish were removed only where the restorers could be certain of finding enough of the old paint beneath for regeneration.

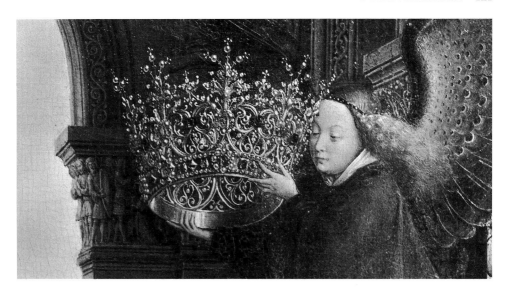

71
Jan van Eyck,
Rolin Madonna (detail).
Paris, Louvre

In this connection it is important to realize that varnish, in Eyckian painting, was more than a means of conservation: it acted as a coloured, translucent glaze, to produce part of the final colour effect. Where earlier restorations had destroyed this delicate, pellucid skin, there was no way of recapturing the original sense of relief. This was most notably the case, the restoration report tells us, in the mantle of the angel on the left, where the green of the brocade has turned flat and dull. By contrast, the brocade worn by the organ-playing angel retains all its splendour.

Naturally, much of the information deduced from scientific evidence in the Brussels report is not to be taken as a totally objective diagnosis but as a more or less subjective interpretation of specific data. Many observed facts lend themselves to more than one interpretation; and at times the authors of the report have succumbed to the temptation of presenting the view most congenial to the technical experts as if it were the only possible one. In such cases, the stylistic critic begs to differ.

Plate 22 Perhaps the major bone of contention between the technicians and the art historians is the crown at the feet of God the Father. X-ray photography of the area of floor on which the crown lies yielded the surprising information that the surface we see today conceals another and very different piece of painting. Painted directly onto the ground is a floor of alternating light and dark tiles; whereas what we see today is not a chequered pattern but uniformly dark tiling that varies in shade from dark olive green to brownish red. The present tiles are separated by not very accurately drawn lines in gold, and are painted on a thin silver leaf that covers the former chequered pattern. The same silver leaf underlies the step visible today, with its brown inscription; in the X-ray image there is a differently positioned inscription in black. As for the crown itself, there is nothing on the earlier layer of painting but a lightly incised drawing that seems never to have been coloured in.

71 Taking its stand on these facts, the Brussels commission concludes in its report that the crown we see today stems from Blondeel's and Scorel's restoration of 1550. The truth is, however, that—as a comparison with the crown of the *Madonna of Chancellor Rolin* makes clear—its form and design are Eyckian down to the last detail. To believe that this crown, as we now see it, was invented in an Eyckian style in 1550, we should need to credit those two sixteenth-century painters with an unexampled, selfless, truly archaeological gift of empathetic access to the Eyckian style.

Curiously enough, the Brussels report omits to mention that by 1458, at the very latest, there must have been a crown of some sort at the feet of God the Father. In that year, as we know from the *Kronijk van Vlaenderen*, the Ghent mystery players' guild saluted the entry of Duke Philip the Good into the city by performing a dumb-show or *tableau vivant*, entitled *Chorus beatorum in sacrificium Agni Pascalis* ('Chorus of the Blessed on the Sacrifice of the Paschal Lamb'), which was a fairly accurate enactment, on three levels, of the central panel of the Ghent Altarpiece.[51] In this, not only did God the Father, who wore an imperial crown, have a second crown at his feet, but beneath it was the very same inscription that we now read on the steps of his throne on the Ghent Altarpiece: VITA SINE MORTE IN CAPITE, IUVENTUS SINE SENECTUTE IN FRONTE... ('Life without Death on its head, Youth without Age on its brow').[52]

There is unlikely to have been a restoration of the Ghent Altarpiece between 1432 and 1458; and so the simplest explanation is surely that the crown in the *tableau vivant* was a copy of the painted crown that we see today. It is, of course, always possible that the paint surface now visible includes a few superficial overpaintings. How to explain the technical anomaly of the crown painted directly over the chequered tiles is a matter for the technical experts; but an anomaly of technique gives us no reason to doubt the authenticity of the crown itself.

Another point of disagreement is an architectural detail just below the Dove of the Holy Spirit, on the horizon of the *Adoration of the Lamb*. This is a portrait, as it were, of the tower of Utrecht Cathedral. The suspect feature in this case is that the tower is painted over the gold-leaf rays that emanate from the Dove, although gilding was usually the last thing added to a painting. Additionally, the painting of the Utrecht tower differs slightly from that of other buildings seen in the distance in the central panel; and in the X-ray it almost completely disappears, which means that it belongs to a later and more superficial stratum than the rest of the Paradise landscape. On the strength of this, Dr Coremans' restoration report describes the tower as an addition dating from the 1550 restoration; after all, one of the restorers, Jan van Scorel, was a citizen and a canon of Utrecht.

However, once we look at the architectural backgrounds in Scorel's own paintings, there is absolutely no stylistic affinity to be found; and it really ought to have been mentioned that this allegedly late addition to the Ghent Altarpiece is a close match for the Utrecht tower that Jan van Eyck himself painted in the background of the *Madonna of Chancellor Rolin*. In Scorel's time that particular work was in Burgundy, a long way from Ghent; and this would call for an additional hypothesis: that the Utrecht tower appeared in some other painting by Jan van Eyck, then extant, from which Scorel copied it. Once more, as with the inscription and the tombstone, we are invited to credit sixteenth-century people—and not even antiquarians, this time, but a painter—with a well-developed sense of historical perspective, and to suppose that Scorel, in his work as a restorer, subscribed to a quasi-Romantic ideal of stylistic authenticity. Here, too, we as art historians must appeal to the restorers themselves to suggest another possible interpretation of their technical findings.

In many other cases, scientific diagnosis and stylistic evidence go hand in hand and give each other a welcome degree of mutual support. The murky, flaccid passage of painting in the cloud underneath the Dove was readily identified as a later addition, beneath which was an aureole, painted in several concentric rings of different colours. As the clouds are already there in the copy by Michiel Coxie, made in 1557, this modernization of the aureole in a freer style of painting may quite legitimately be attributed to Scorel: another good reason, incidentally, for rejecting him as the painter

72
Ghent Altarpiece (detail),
Adoration of the Lamb,
Tower of Utrecht Cathedral,
with rays (arrowed)

73
Ghent Altarpiece (detail),
Angel of the Annunciation.
Infrared photograph

of the Utrecht tower and of God the Father's crown. In the case of the aureole, the work has been restored—correctly, in my view—to its original state.

Folding Plate Another important piece of de-restoration concerns the figure of the Virgin Mary in the *Deësis*. In an attempt to repair the damage caused in the 1822 fire, the Madonna's mantle had been painted over in a greenish blue; and the deterioration of the varnish had eventually obliterated the relief of the lower portion of the draperies. Here the underlying blue paint, and with it the relief of the drapery, was restored. Additionally, the chestnut brown of the spandrels was removed to reveal a light blue background.

74; Plate 24 A further de-restoration unfortunately had to be abandoned half-way; the cathedral chapter of St Bavo could no longer live without their Altarpiece. Beneath the Lamb now visible, there is a rather more graceful beast of which it was only possible to uncover the ears before the Ghent Altarpiece left the laboratory to take up its position in the cathedral once more. And so the Mystic Lamb in Ghent is the only one in the world with four ears.

73 Perhaps the most interesting discovery from an art-historical point of view was made in the *Annunciation* scene on the exterior of the shutters. On the polyptych as it finally left Jan's studio, the Annunciation takes place in a fairly shallow space that seems to retain the box-like, cramped quality of a trecento interior. The space is just high enough for kneeling figures; if Mary and Gabriel stood up, they would bump their heads on the ceiling. Infrared photography brought the surprising and—for the stylistic historian—welcome discovery that traceried arches were originally planned to appear on the near picture plane. This means that Mary and Gabriel were originally planned as figures in niches. This accords perfectly with the white colour of their garments: they must have been intended as grisaille figures, which would have made them a better match for the two Johns painted as fictive statues in the lower tier. The exterior of Rogier van der Weyden's Beaune Altarpiece provides a later example of an *Annunciation* in grisaille, with the figures in separate niches.

The conversion of two niches into a single interior clearly represents an important change of plan, which one is naturally at once tempted to ascribe to the younger artist. In which case, the technological deep-sea divers have at last brought to light a piece of history that lies between the commissioning of the work and its completion in the year 1432: a clue from which some tentative progress might be made.

One negative outcome of the Brussels examination has already been mentioned. The striking heterogeneity of the Ghent polyptych, the real and imagined inconsistencies in its composition and iconography, gave rise, over the years, to numerous and often highly ingenious theories and hypotheses to the effect that its two-tier arrange-

ment was the uneasy result of an operation whereby separately conceived, simpler altarpieces were combined into a highly complex, monumental structure ultimately devoid of inner unity. This supposition made it necessary to suppose that the tops of the panels were originally made in a different shape, notably with a higher central part above the *Adoration of the Lamb* that would have had to be removed when the altarpiece was extended. The Brussels commission, which was able to examine all the panels without their frames, has established that all of them have always been just the same size as they now are, thus disposing of this entire body of speculation, once and for all: a service for which scholarship cannot be too grateful.

In order to understand what follows, it is worth taking the time to survey the whole of this vast and many-sectioned work, piece by piece. Only this will enable us to understand the place of each of the twenty-four component images within the work as a whole. This guided tour will be rendered easier by the presence of inscriptions, on the frames or on the panels themselves, that supply a title for almost every image.

In the upper tier of the central part is a group of three enthroned figures: this is the combination that in Byzantine art we call the *Deësis*. The inscription worked in pearls *Plate 22* on the hem of the central figure's mantle identifies him in the words of the Apocalypse: REX REGUM ET DOMINUS DOMINANTIUM ('King of Kings, and Lord of Lords').[53] To the left of the Almighty—on his right hand, that is—the Virgin Mary sits reading a book; on her head is a crown, its circlet adorned with flowers and glittering stars. To the right is St John the Baptist, wearing a green mantle over his camel-hair habit; in his lap is an open book, and he raises his right hand in the act of speaking his famous words: *Ecce agnus Dei*, 'Behold the Lamb of God'.[54]

This monumental group is flanked by two panels of *Angels Singing* and *Angels Playing Musical Instruments*. On the frame of the left-hand panel are the remains of the inscription MELOS DEO LAUS ('Music in Praise of God'). On the right is a verse from *Plate 25* a Psalm, LAUDATE EUM IN CORDIS ET ORGANO ('Praise him with stringed *Plate 26* instruments and organs').[55] These angel panels, and thus the whole upper tier, are flanked in turn by *Adam* and *Eve*, who stand in narrow niches; above them, as sculptural ornaments in half-lunettes, are grisaille scenes of the *Sacrifice of Cain and Abel* and the *Slaying of Abel*. The nude figures of Adam and Eve are not shown enacting the Fall. Eve holds up the apple, but merely by way of an attribute: both conceal their private parts, so this must be after the Fall. This is not a depiction of any event but an image of our First Parents as the embodiments of Original Sin, timeless and statuesque.

The theme of the five panels in the lower tier is best described in the words used in the dumb-show based on the Altarpiece in 1458: 'Chorus of the Blessed on the Sacrifice of the Paschal Lamb';[56] although this in itself embodies an interpretation. By including the angels, the Ghent players formed the Chorus of the Blessed into seven groups, whereas the theologians distinguish eight varieties of celestial bliss.

The subject of the central panel is defined by two inscriptions in the picture itself. On the red antependium of the altar on which the Lamb stands, we read: ECCE AGNUS DEI QUI TOLLIT PECCATA MUNDI ('Behold the Lamb of God, which taketh away the sins of the world'), and also JESUS VIA VERITAS VITA ('Jesus the way, the truth, and the life'), both of which are quotations from St John's Gospel.[57] Below the altar, and close to the lower edge of the panel, is a fountain, with the following words carved on its rim: HIC EST FONS AQUE VITE PROCEDENS DE SEDE DEI + AGNI ('This is the fountain of the water of life, proceeding out of the throne of God and of the Lamb').[58] That is to say: the Fountain of Life is watered by the blood of the Lamb. A number of the angels who form a ring around the altar

74
Ghent Altarpiece (detail),
Adoration of the Lamb

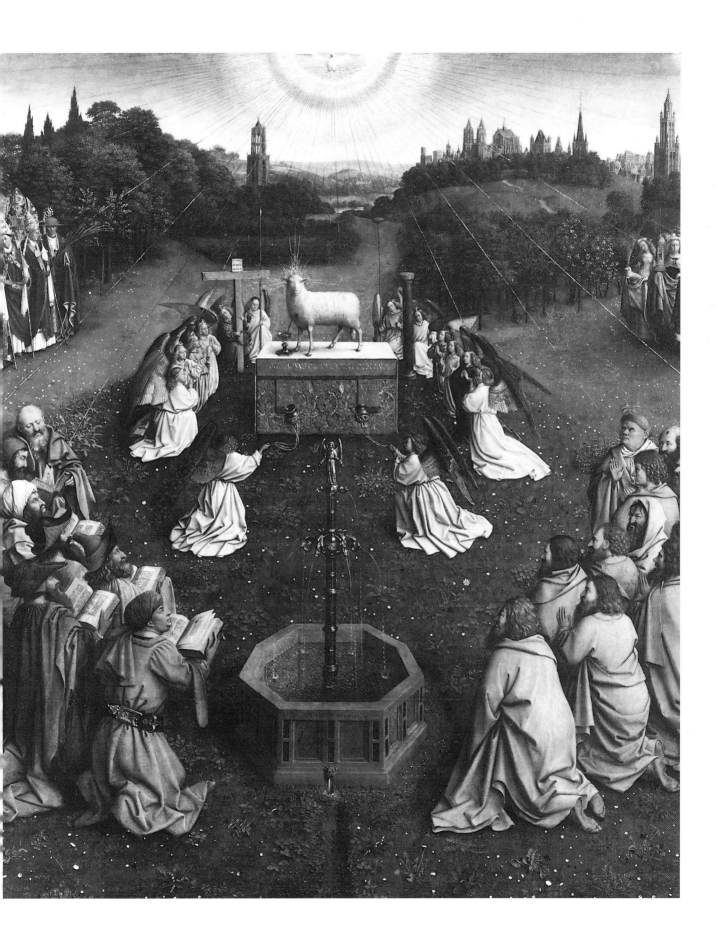

display the Instruments of Christ's Passion, and on the altar itself there is a chalice to receive the blood that flows from the breast of the Lamb.

A second semicircle of kneeling figures flanks the Fountain of Life on either side: bearded Apostles on the right, and on the left a group of men in rather exotic attire who must be the prophets of the Old Dispensation, holding open books. Behind the kneeling figures, two processions of figures have crowded to a halt: on the right are the representatives of the Church, led by their Popes and Bishops, and on the left those representatives of Jewry and Heathendom who have in their various ways foretold the Saviour's coming or confessed their allegiance to a single God.

Further towards the background, and smaller in scale, two further processions are to be seen, men on the left and women on the right. All carry palm fronds in their hands, which would suggest that they are martyrs. Saints they certainly are: Virgins on the right, Bishops and Confessors on the left.

The stage across which all these processions advance is paradisal meadowland, which becomes wooded in the middle distance and rises into hills along the elevated horizon. At the highest point of the central axis of the painting, above the Fountain of Life and the altar of the Lamb, soars the Dove of the Holy Spirit, emitting a semicircle of golden rays.

On the two wing panels to the left of the lower tier, two parties of mounted figures approach. Inscriptions on the frame identify them as CHRISTI MILITES, 'Warriors of Christ', on the near left, and IUSTI IUDICES, 'Righteous Judges', on the far left. Individually, they have never been reliably identified. On the wing panels to the right, the figures that approach are first HEREMITE SANCTI, 'Hermit Saints', and then SANCTI PEREGRINI, 'Pilgrim Saints'. The backgrounds consist of rocks and forests, affording occasional glimpses of the far distance. *Plate 27*

The exterior of the polyptych is also on two levels, but with the addition of a kind of attic at the top. In a pair of fictive niches in the centre of the lower tier, statues of John the Baptist and John the Evangelist receive the veneration of the donors, Jodocus Vijd, patrician of Ghent, and his wife Elisabeth Borluut, who kneel in niches of their own to either side. Above, we see an interior in which Gabriel offers his Angelic Salutation to Mary; through the arcade in the far wall, we see a view of a city. *98*

The lunettes above these two figures are occupied by half-length figures of the prophets Zechariah and Micah, whose prophecies flutter on long scrolls. Above the empty space of the room in which the Annunciation takes place, crouching in a pair of tall, narrow niches, are the Erythraean and Cumaean sibyls, with the scrolls of their own prophecies curling round behind their heads.

Struck by the profusion of imagery that makes up this vast and varied but not exactly regular work, the viewer will instinctively feel the need of some ordering idea, to link and condense all these images into some higher unity. In them, much that is well known appears in unexpected contexts, juxtaposed with many unfamiliar subjects. Even the viewer uninterested or unversed in iconography cannot help wondering about the iconographic programme that must surely underlie the work, and may even be prepared to postulate the existence of some learned *spiritus rector*, to whose spiritual direction the artist or artists must have deferred. However, all attempts to fit the disparate parts of the work into some overriding logical scheme have failed.

Eventually, and understandably, observers began to suppose that this welter of iconographic and formal inconsistencies was the result of some arbitrary change of plan. It was surmised, in fact, that after Hubert's death Jan found a number of unfinished altarpieces in his brother's studio and knocked them together as best he could into a kind of super-retable. Such speculations have been utterly exploded, as

Folding Plate

I have said, by the failure of the Brussels commission to find any sign whatever that the Ghent Altarpiece had been assembled from originally unconnected parts. It is no longer admissible to think of this miraculous work as having been arbitrarily and unthinkingly cobbled together.

Iconographically, the principal argument advanced against the existence of a unifying conception in the upper tier of the interior was the anomalous status of its principal figure, the enthroned Almighty. If we read the Ghent Altarpiece horizontally, then this is the Triune God: Father, Son and Holy Ghost in one person. And in this case the Baptist's gesture, 'Behold the Lamb of God', makes sense. But if we read vertically downwards, this same figure of the King of Kings is *only* God the Father; for the dove of the Holy Spirit can be seen on the wing, beneath his throne and above the altar of the Lamb, which represents the Saviour. (Raphael, in his so-called *Disputà*, which really depicts the *Triumph of the Holy Sacrament*, has brought these two alternative readings into perfect harmony: John the Baptist points to Christ at his side, and God the Father may be seen above them.) Does all this mean that the creators of the Ghent Altarpiece deserve censure on the grounds that their work is 'iconographically defective'?

There is one point on which all interpreters of the Ghent Altarpiece agree: that its iconographic programme is rooted in the liturgy of the Feast of All Saints. On All Saints' Day, the Epistle of the Mass consists of a number of passages from the Revelation of St John, including the vision of the great multitude which no man could number: *ex omnibus gentibus et tribubus et populis et linguis stantes ante thronum et in conspectu Agni* ('of all nations, and kindreds, and people, and tongues, standing before the throne, and in sight of the Lamb').[59] Note the twofold description of the scene: before the throne and in sight of the Lamb.

Another passage says of this multitude: 'These are they which came out of great tribulation, and have washed their robes, and made them white in the blood of the Lamb. Therefore are they before the throne of God... They shall hunger no more, neither thirst any more... For the Lamb which is in the midst of the throne shall feed them, and shall lead them unto living fountains of waters...'.[60] Here the image of the Fountain of Life follows immediately upon that of the throne of the Lamb.

A still closer literary parallel to the image before us is to be found in the *Golden Legend*, that constant stimulus to the late medieval pictorial imagination. The *Golden Legend* tells how the Feast of All Saints came to be instituted. It recounts a dream that came to the sacristan of St Peter's in Rome, after he fell asleep while making his rounds of the building. He saw God Almighty, 'King of Kings', seated on a throne, and to either side of him the angelic choirs, 'all the angels dwelling around about him'. At the right hand of God sat the Madonna, 'the Maiden of Maidens in a radiant crown'; and then came John the Baptist, 'clothed with camel's hair'.

Towards the throne came 'a countless multitude of virgins... a multitude of venerable elders; then came another man, wearing episcopal vestments, followed by a chorus of others similarly attired; but next there came a countless multitude of warriors. After these came an unending crowd of many nations'. Then the dreamer saw St Peter, who showed him Purgatory and commanded him to tell the Pope to institute a Feast of All Saints on that very day.[61]

Certainly, this dream includes some elements that appear in the vision of All Saints on the Ghent Altarpiece, notably the specified groups within the Communion of Saints (though not the *Righteous Judges* or the *Pilgrim Saints*). But it is important not to treat the parallels between the text of the All Saints legend and the composition of the Ghent Altarpiece as if the latter were an illustration of the former. This would be

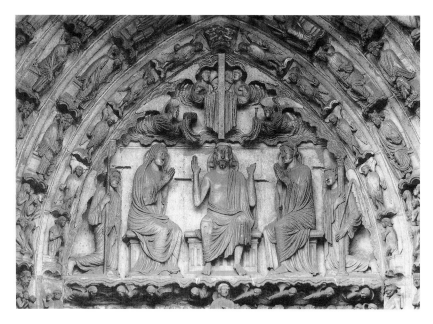

75
Deësis.
Chartres, Cathedral, south portal

wrong, if only because the text itself is based on a highly specific iconographic tradition.

When the dreamer in the *Golden Legend* saw Mary and John the Baptist as the Psychopomps, the leaders of a procession of the Saints or of the Blessed, he did so because in waking life he had often seen images of the Communion of Saints crowned with the *Deësis* motif, of Byzantine origin. Earlier than the eleventh century—that is to say, before the Byzantine *Deësis* reached the West—no sacristan of St Peter's could have had such a dream.

To object, as some scholars do, that on textual and doctrinal grounds John the Baptist has no right to a position of parity with the Virgin, is to misconstrue entirely the strength and the autonomy of the iconic tradition that had made this balanced juxtaposition of Mary and John, specifically as intercessors, into the norm. It is true that in this capacity they are most often shown standing to either side of the throne of the *Majestas*; however, seated intercessors do appear, as in the monumental figures on the south portal of Chartres—although in that case John the Baptist is replaced by 75 John the Evangelist. The same highly un-Byzantine form of *Deësis* reappears in an Eyckian composition that shows a number of thematic affinities with the Ghent Altarpiece: this is the *Fountain of Life*, the best copy of which is in the Prado.

Any remaining misgivings should be set at rest by the fact that Raphael, in his *Disputà*, was permitted to promote John the Baptist in exactly the same way, without suffering any censure on dogmatic grounds. Indeed, the fourteenth century affords us a seated *Deësis* of a far more remarkable kind: an altarpiece by Giovanni da Milano 76 in which the place of honour opposite Mary is occupied by Isaiah, identified by the words of his prophecy, *Ecce virgo concipet* ('Behold, a virgin shall conceive').[62]

We must accustom ourselves to the idea that in the late Middle Ages the deviser of an iconographic programme and the executant artist himself were licensed to vary an existing iconographic formula, such as that of the seated *Deësis*, by switching individual elements as circumstances demanded. In the present case the motivation is not difficult to find; for the cathedral that is now known as St Bavo was originally dedicated to St John the Baptist, and any change that redounded to the glory of the

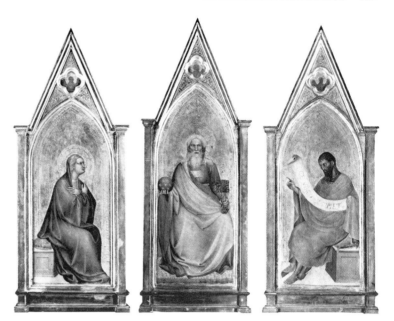

76
Giovanni da Milano,
Virgin Mary, God the Father and Isaiah.
London, National Gallery

church's own patron saint would have seemed entirely legitimate. The inscription calls him MAIOR HOMINE, PAR ANGELIS ('More than a man, equal to the angels').

It is far more difficult to explain the pose of the figure on the left, the Mother of God, within the *Deësis* context; and, curiously, little attempt has been made to do so. A Mary who is reading a book is a Virgin Annunciate; and in a true *Deësis*, in which Mary and John appear as intercessors, this would be completely out of place. The Annunciate type would be better suited to appear opposite the prophet Isaiah, as she does in Giovanni da Milano's triad; except that in trecento painting the Virgin Annunciate crosses her arms before her breast in a gesture of humility, and does not read. It was the Master of Flémalle who first transformed the Annunciate into a reader, not long before the Ghent Altarpiece was painted, thus disrupting the iconographic logic of the *Annunciation* very much as the Mary in Ghent disrupts that of the *Deësis*.

This figure of the Virgin must therefore be an adaptation—and one that is hard to justify in substantive terms—of the Master of Flémalle's Virgin Annunciate. In both works, she is deeply absorbed in her reading, and thus completely detached from the rest of the scene. The same thing happens in the *Deësis* of the Madrid *Fountain of Life*, the original of which must have been painted by Jan van Eyck during his visit to Portugal in 1428–29. Her self-contained, self-absorbed air in these works is entirely in keeping with Jan van Eyck's pictorial cast of mind, as known to us through his authenticated works. By contrast, when Mabuse paraphrased the Ghent *Deësis* in a head-and-shoulders composition three-quarters of a century later, he changed Mary back from a reader into an intercessor; and the same happens in another paraphrase of the Ghent *Deësis*, on the copes of the Burgundian ecclesiastical treasury now in the Schatzkammer in Vienna. But that is an enigma in itself, and one that still awaits its solution.

There is one further way in which the Ghent Altarpiece departs from the traditional configuration of the *Deësis*. We have yet to consider the crown at God's feet. It is clear that this is intended to create a transition to the *Adoration of the Lamb* in the lower register. In itself, it is an illustration of one aspect of the Deity, as characterized by the inscriptions on this panel: 'King of Kings, Lord of Lords'. The emblem of sovereignty,

37

79

Plate 22

77
Fulda Sacramentary,
Communion of Saints.
Göttingen, Universitätsbibliothek,
Cod. theol. 231, fol. 111a

worn by those who wield earthly power, lies at the feet of the One who is crowned with the papal tiara. The crown symbolizes the homage paid to him by the human race, whose members throng towards the altar of the Lamb in the image below. The question that imposes itself—not least because this crown has been thought of as a subsequent addition—is this: is it an extraneous device, added to tie together two originally quite unrelated tiers, or was it part of the plan from the start?

To see this question in perspective, we must first look at the history of the iconography of the Communion of Saints. The Feast of All Saints was instituted in Rome in 835; and, a few decades later, in a Carolingian manuscript from Metz, we find an illustration that refers to it. This is a miniature in the form of a diptych: on one side is the Lord in Majesty, *Majestas Domini*, above personifications of Earth and Sea, and on the other are five superposed rows of half-length figures of the Blessed, worshipping the Almighty. In a pair of tenth-century English miniatures, with stylistic roots in the art of Metz, the Communion of Saints is divided into six choirs: Angels; Prophets; Apostles, with the Virgin Mary at their centre; Martyrs; Confessors; and lastly Virgins.

A tenth-century manuscript from Fulda shows a completely different version of the Communion of Saints, in which the Lamb appears in place of the *Majestas*. Enclosed in a medallion, the Paschal Lamb receives the worship of the Saints, and its blood is caught in a chalice by Ecclesia, the personification of the Church. This celebrates the Church and the Communion of the Faithful as born from the blood of the Saviour and of the martyrs. And so, at the very outset of the iconographic evolution of our theme, the ambiguity in the text of Revelation, *ante thronum et in conspectu Agni*, 'before the throne, and in sight of the Lamb', seems to have imposed an alternative choice between depicting God in person and through the symbol of the Lamb.

In the Antiphonary of St Peter, Salzburg, the imagery of the Communion of Saints is transformed. To my knowledge, this is the earliest instance in which both indications in the text, 'before the throne, and in sight of the Lamb', have been followed at once. Here, too, Mary and John, clearly taken over from the Byzantine *Deësis*, appear

77

78

as the Psychopomps or leaders of the choirs of the Blessed. But the presence of these intercessors has caused a remarkable confusion or rather transposition of the three Persons of the Trinity. In a very un-Byzantine way, the Lamb takes over the centre of the *Deësis*. As for John the Baptist, in keeping with his accustomed role as Prodromus or Forerunner, his gesture is not one of intercession but of pointing to the Lamb. The central focus of the whole is the mandorla, borne aloft by angels, which is the most typical form of the vision of the Divine in Romanesque art. If we were to transpose the Lamb symbol and the *Majestas*, the arrangement would be approximately that of the Ghent Altarpiece.

The Gothic imagery of the Communion of Saints, which is mostly found in illustrations of St Augustine's *City of God*, is an attempt to resolve the awkward dualism of presenting both God Enthroned and the Lamb as objects of adoration, by reinterpreting the *Majestas*—in the spirit of Augustine's own Trinitarian doctrine—as a thorough-going Trinity. The Lamb is then represented by the figure of Christ and can be omitted. Assembled around the Trinity, the Communion of Saints becomes the Heavenly Jerusalem, a kind of *cour céleste* or celestial court: an image of contemplation, entirely devoid of drama.[63]

Seen in this evolutionary perspective, the Ghent Altarpiece represents a reversion to the biblical text of Revelation, which had supplied the iconography of the Feast of All Saints at its inception in the early Middle Ages. With this comes a revival of the idea of two thrones, one for God and one for the Lamb. For without depicting the Lamb it is impossible to include the motif of the Fountain of Life; and this, in turn, is indispensable if the deeper symbolism of the Adoration of the Lamb is to be expressed. The biblical text says, in a twofold image, that the Blessed, who stand before the throne of God, 'have washed their robes… in the blood of the Lamb', and that 'the Lamb shall lead them unto living fountains of waters'. This is precisely the message of the inscription on the rim of the fountain: 'This is the fountain of the water of life, proceeding out of the throne of God and of the Lamb'.[64]

The earlier, *cour céleste* images of the Feast of All Saints may seem superficially more unified and self-contained than the two-tier wall of imagery that is seen in the Ghent Altarpiece; but they have paid dearly, in terms of substance, for their pleasing appearance of unity. They have sacrificed the eucharistic content of the scene, the idea of salvation through the transmutation of the blood of the sacrificial Lamb into the water of life.

However, the Van Eyck solution is not merely a reversion to the original, eucharistic imagery of the Communion of Saints: it is more orthodox than that, and takes into account the immediately preceding version of the same theme, in which the throne of the Most High is used to express the idea of the Trinity. The only difference is that here the Trinity does not appear in a horizontal arrangement, parallel to the ground level of the *Adoration of the Lamb*, but vertically, as an overriding link between the two spheres. The connection is supplied by the Dove of the Holy Spirit, Third Person of the Trinity.

From an iconographic point of view, there is thus no reason to think of the two tiers of the Ghent Altarpiece in isolation from each other: examination has shown that each is incomplete without the other. Furthermore, existing iconographic analyses of the Ghent Altarpiece have tended to ignore the fact that the Altarpiece originally possessed a predella, said to have been painted in water-based colours, which was destroyed by fire in the sixteenth century. This represented Hell, the subterranean realm below the paradisal landscape of the *Adoration of the Lamb*; and this, again, made it necessary to round off the whole with a celestial culmination above.

This is not to say that everything concurs in perfect harmony. It is fallacious to suppose that the logic of iconography, or that of art, is a rational logic. We have only to remember that the literary source itself, the verbal imagery of the vision of Revelation, does not lend itself to rational interpretation, or to complete visualization. These ideas obey a dream logic, and only the art of the writer can make them coexist; in any attempt to realize them in pictorial terms, concrete objects tend to collide. A literal translation of the idea 'the throne of God, in sight of the Lamb' is bound to defeat our powers of visualization.

One other historical testimony reflects the inner cohesion between the *Deësis* above and the eucharistic allegory below: for the very same combination confronts us in another work by Van Eyck. The original of this has not survived, but the best idea of it is conveyed by a painting in the Prado, known variously as the *Fountain of Life* and *79* as the *Triumph of the Church over the Synagogue*. Because other copies of this work exist or have existed in Spain—and also on stylistic grounds—it is most likely that the lost original was painted by Jan in the course of his visit to the Iberian peninsula in 1428–29, and that it therefore predated the completion of the Ghent Altarpiece.

The setting of this work is unique in the whole of Netherlandish painting: a purpose-built structure on several levels, which would be easy to imagine as a décor for the *tableau vivant* staged in honour of Philip of Burgundy in 1458, as described in the *Kronijk van Vlaenderen*. At the top we see a variant of the Ghent *Deësis* group, in which St John the Baptist is replaced by St John the Evangelist; the Deity wears not a papal tiara but an imperial crown. At his feet is not a crown but the Lamb, below which an opening in the dais emits a stream of water with consecrated Hosts floating on it. This stream crosses a flowery meadow, on which groups of angels have seated themselves to play musical instruments, and emerges into the basin of a mural fountain that stands on a tiled apron or forestage. On either side of this fountain, a disputation is in progress between the representatives of Church and Synagogue, concerning the Mystery of the Eucharist.

79
Jan van Eyck (copy),
Fountain of Life.
Madrid, Prado

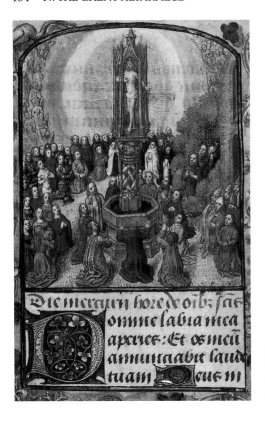

80
Honorius of Autun,
De omnibus sanctis (detail).
London, British Library,
MS Add. 17026, fol. 33

There is no Adoration of the Lamb by the Communion of Saints here; and so John the Baptist, as leader of the saints, gives up his place to John the Evangelist, as the supposed author of the Apocalypse. The central idea is the transmutation of Christ's blood into the water of life; and the Eucharist also appears in its other guise, as the bread of the Host—a group of ideas that found contemporary expression in paintings of the 'Mill of Hosts'. In a later manuscript from Ghent, we find the prayer *De omnibus sanctis* illustrated by another permutation of the same imagery: the Saints kneel concentrically around the Fountain of Life, which is not surmounted by the Lamb but by the Man of Sorrows, from whose wounded side the water of redemption flows. It has plausibly been argued that the popularity of the Fountain of Life idea in Flanders was connected with the local popularity of the cultus of the Holy Blood—the most celebrated of whose reliquaries is still in Bruges, enshrined in a specially built *Chapelle du Saint Sang*. In Ghent, the emblem of the mystery players' guild was a fountain (*fontaine*).

Two things clearly emerge from all this: the specifically Flemish quality of this extensive iconographic complex, with its symbols of specific eucharistic beliefs; and the necessity for a culminating group of three figures as part of the original iconographic programme, both in the *Adoration of the Lamb* and in the Madrid *Fountain of Life*.

A few lesser anomalies of iconography still call for mention. The ranks of the Blessed include two groups otherwise absent both from the imagery and the liturgy of All Saints: these are the *Righteous Judges* and the *Pilgrim Saints*. The elevation of the former to the ranks of the Blessed, and the special emphasis placed on the latter, probably derive from specific local circumstances. It has been suggested that the public office and patron saint of the donor, Jodocus Vijd, are relevant here: he stood

under the protection of the Righteous Judges in his capacity as councillor and lay justice to the city of Ghent, and under that of the Pilgrim Saints because St Jodocus enjoyed particular veneration as a patron of pilgrims.

Plate 25, 26 One feature of the altarpiece that more urgently clamours for interpretation is the pair of over life-size figures of Adam and Eve, who flank the groups of celestial musicians. In a work intended to celebrate the redemption of humanity by the sacrificial death of Christ, it was necessary to show the fundamental cause of that tragedy: the Fall of Man, which made redemption necessary. The naked figures of our progenitors, embodiments of the bitterest human self-reproach, had long been a familiar sight on the portals of Gothic cathedrals; but to find them in a church interior, above the altar itself, seems to have been a novelty.

When the altarpiece is closed, it displays the prologue to the drama of redemption: the scene in which the Saviour's coming, as foretold by the pagan sibyls and by the prophets of the Old Dispensation, is at last made known. Finally, in the lower register, the donors kneel in prayer before the two Johns: the Baptist, as the patron of the church, and the Evangelist, as the author of the vision that stands revealed when the polyptych is opened.

As has been said, we have found no indication that the iconographic programme of the Ghent Altarpiece underwent any radical change as work proceeded (whether or not in consequence of Jan's taking over the direction of the work). But this does not exclude the possibility that new stylistic and compositional ideas emerged during the execution of that programme, and that the original design was extensively reinterpreted. Indeed, the findings of the Brussels commission, based partly on X-ray evidence, not only permit but compel us to attempt an interpretation of the discrepancies between successive layers of the painting. In doing so, however, we must not jump to the conclusion that every change marks a move from Hubert's style to Jan's. Numerous *pentimenti* have been found on Jan's authenticated works, and it is entirely probable that in many places Jan has amended not only Hubert but also himself.

81 One such case is almost certainly to be found in the figure of Adam. Infrared photography has shown that Adam's left foot was not originally intersected by the frame, but that it originally rested, like Eve's, flat on the lower edge of the panel. This led the author of the Brussels report to suppose that the artist had originally intended to show only one leg, the right one, in exact analogy to the pose of Eve. He failed to observe that the position in which we now see the legs has been anticipated in a miniature by the Limbourg brothers, where—in the same way—it appears as the result of a low viewpoint. So this was probably a true *pentimento*, a change that Jan found necessary in order to avoid a rigidly symmetrical match between the postures of his male and female nudes.

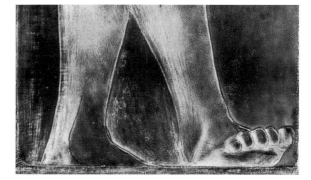

81
Ghent Altarpiece (detail),
Adam, feet.
Infrared photograph

However, the changes in the *Annunciation*, as revealed by infrared photography, are certainly something more than mere *pentimenti*. This scene was evidently first conceived in quite a different way; and it would therefore be quite possible to take the implications of this change of plan, the differences in attitude that it reveals, as the basis for a structural analysis of the work as a whole. In practice, however, this cannot be done; for the Brussels commission, in its published report, allows us to see through the present paint surface only at a few points that seemed to it to be particularly worthy of notice, and gives no information on other points of interest to us. I therefore think it wiser to proceed with the stylistic interpretation and structural analysis of the scene as if nothing were known of what has been found beneath it. Once we have formed a view of our own on stylistic criteria, we shall see how far this can be reconciled with the restoration commission's findings, and whether its conclusions confirm or contradict ours.

From Dvořák to Panofsky, all Van Eyck interpreters are agreed on one thing: the factor that makes it impossible to discover organic or harmonic unity in the Ghent Altarpiece lies in the frequent and often abrupt changes in its presentation of pictorial space. This puts the historian in a considerable quandary; for this work, generally supposed to represent the triumph of an *Ars nova* of painting, turns out to be the documentary record of a crisis in spatial perception. As Baldass observed in his important study of Van Eyck, the viewer who looks from below at the upper register of the interior is required to switch his vision from a low to a high viewpoint, then to a level one, and then back again.[65] The greatest spatial discrepancy is probably that between the *Adam* and *Eve* panels and the landscape of the *Adoration of the Lamb*. Adam and Eve are seen from below, *di sotto in sù*: in order to see the sole of Adam's foot, the viewer is imagined as standing close to the painting, at the altar table itself, with head thrown back. But in order to survey the columns of people who converge on the throne of the Lamb, we must adopt the viewpoint of an observer who commands a view from above, over the heads of the multitude and across the fields of Paradise. We are abruptly shifted from a worm's-eye view to a bird's-eye view.

The antithesis should not be taken too literally, however. This is not the contrast between two viewpoints at different heights in space. Of the two, only the low viewpoint is a fixed one. The landscape we see in the *Adoration of the Lamb* is like a panorama: it is based on the assumption that the eye is in constant motion, tracking over the scene, forward and back, from near to far. The eye feels its way into depth from one object to the next: or rather it does so from the flatness of the distance into an increasingly three-dimensional foreground. For in this landscape, as I have already pointed out in another context, there is a gradual transition from a level view in the far distance to a high viewpoint in the middle distance and foreground. This apparent change of viewpoint is certainly not—as Dvořák supposed—a stylistic discontinuity.

In discussing the Ghent *Adoration* and other, related spatial compositions, some have used the imaginary analogy of a stage with a front that folds down; it would be more apt to say that in the course of the introduction of space into the 'wallpaper' landscape the lower half of the scene began to detach itself from the wall and pivot out into the room, towards the viewer. In some Franco-Flemish miniatures of the early fourteenth century, the objects depicted seem literally to emerge from the framed pictorial field and swing out and up into our space. When the picture plane hinges upwards in this way, it turns into a sloping platform that will carry solid objects, such as figures and buildings. From the background, the surface flows towards us, out into space; and as it does so the solidity of the forms increases.

82
Limbourg Brothers,
Très Riches Heures,
The Meeting of the Three Magi.
Chantilly, Musée Condé,
MS 65, fol. 51v

Another factor requires to be taken into account. In Northern painting from the late thirteenth century onwards, with the growth of the impulse to treat individual figures and even whole scenes volumetrically, it became an overriding principle of composition to avoid, as far as possible, showing any figure or object parallel to the picture plane. The oblique position was regarded as the universal solution to the problem of penetrating into depth—which is also, on the picture plane, an upward movement. Artists discovered the inherent ambiguity of the diagonal: within the imaginary space of the picture, it leads into depth, away from the near plane; and at the same time it serves to organize the literal surface of the painting in a vertical direction.

82 This treatment of pictorial space finds its classic form in the pictorial compositions of the *Très Riches Heures* by the Limbourg brothers, with their unsurpassable refinement in the use of a diamond lattice pattern. Even later, when artists had gone over to a perspectival organization of pictorial space, this remained the favourite device of the French pictorial imagination: *vue angulairement*, 'seen at an angle', as the first French theoretician of perspective, Jean Pèlerin, called this pictorial type.[66] It may be worth recalling that the diagonal placing of carved figures on door jambs freed French Gothic statuary from its Romanesque thraldom to frontality and the block, and made it into free-standing sculpture at last.

Plate 24 In the composition of the *Adoration of the Lamb*, too, the diagonal plays a crucial role. Indeed, the central feature of the main panel may be accurately described as a diamond arrangement, albeit one with a truncated near apex; the upper apex is approximately marked by the beams that centre on the Dove. This configuration is disrupted, to some extent, by the procession of Virgin Saints, which is more nearly parallel to the picture plane.

In some important respects, the central portion of the *Adoration of the Lamb*—which we are examining, for the moment, in rather artificial isolation from the remainder of the panel—goes beyond the spatial structures used by the Limbourgs. First, recession in space is accompanied by a marked reduction in scale, which creates a greater sensation of depth; in terms of size, the angels mediate between the kneeling men close to the foreground and the two processions in the distance. The decisive innovation, however, is that the focus of the scene is set back: the eye reaches the principal motif, by which the grouping as a whole is defined, only after penetrating into depth and passing through a void. The foreground groups of kneeling figures turn their backs to us, and so our gaze is drawn straight in towards a point on which other forces converge diagonally from above. What is more, the centre of this centripetal composition is occupied by an entirely passive creature, which also forms a weak centre on grounds of sheer size. This lack of a strong central emphasis might well explain why some early restorer was moved to paint a larger, if less precise, version of the Lamb over the Van Eyck original.

The composition of the central part of the *Adoration of the Lamb*, as just described, with its organizing diagonals and its latticework of spatial tensions, is not continued in the rest of the panel. The oblique ranks of kneeling figures are crowded upon from both sides by dense masses, arranged more or less parallel with the picture plane, which to some extent modify the structure of the oblong panel itself. On the right, in particular, two parallel movements emerge, which operate at different levels of depth and are projected onto the picture plane one above the other. For the moment, I shall postpone discussion of the conclusions to be drawn from this anomaly, which must surely be more than a mere subjective impression. For the moment, I would point out only that these figures, moving parallel to the picture plane, appear to some extent as the vanguards of the processions that approach on the two pairs of wing panels.

When we turn our attention to these panels, one external factor demands immediate mention: the shutters are more than ten centimetres higher than the central panel. This has given rise to a great deal of baffled speculation, and was one source of the various conjectures according to which the central panel was cut down after it was painted. It would be pointless to pursue those speculations, since technical examination has shown that the sizes of the panels have not been changed. Nonetheless, it must go on record as a curious fact that in the central portion of the Ghent Altarpiece a wider frame has been needed, both above and below, to keep the two zones on the same level. No explanation attempted hitherto has been remotely adequate.

Though the horizon of the wing panels is lower than it is on the central panel, the landscape is thought of, in principle, as continuing behind the frames. On inspection, however, we find that the landscape in these tall, narrow lateral panels is completely different. The Elect are seen, not on a steeply sloping, grassy meadow, but on a shallow foreground stage, separated from the background by a rampart of rocky outcrops and wooded heights. Wherever there is a dip in this wall of rocks and trees, we can look into the far distance; but no middle ground is to be seen. Indeed, the whole *mise-en-scène* renders such a thing impossible.

Both wing panels on the right show rudimentary signs of a diagonal lattice pattern: it is present in the staggered arrangement of the figures, in the outline of the slope and in the path that snakes away into the distant forest on the panel of *St Christopher with Pilgrim Saints*; perhaps, too, in the way in which the procession of *Hermit Saints*, with its two female followers, emerges rightward from behind the cliff only to swing round diagonally to the left. On the whole, however, this is an orthogonal pictorial world,

in which the eye falls upon successive spatial layers of depth, and does not work its way into depth obliquely from one figure or object to the next.

This is a spatial vision that largely agrees with the pictorial space in Jan's known works. There, we see Jan consistently doing all he can to mask—indeed to eliminate—the middle ground. He makes the eye leap from near to far; all of a sudden, there we are at the horizon, and yet we have not moved. With Jan, the painter's eye is a static mirror; the viewpoint is fixed; and empirically, if not mathematically and perspectivally, the vision is a single one. Things that are far apart in the real world cohere when projected onto the plane of vision. Above all: to the eye, the picture plane has become an optical plane. None of this applies to the landscape in the central panel, with its tendency to swing out towards us.

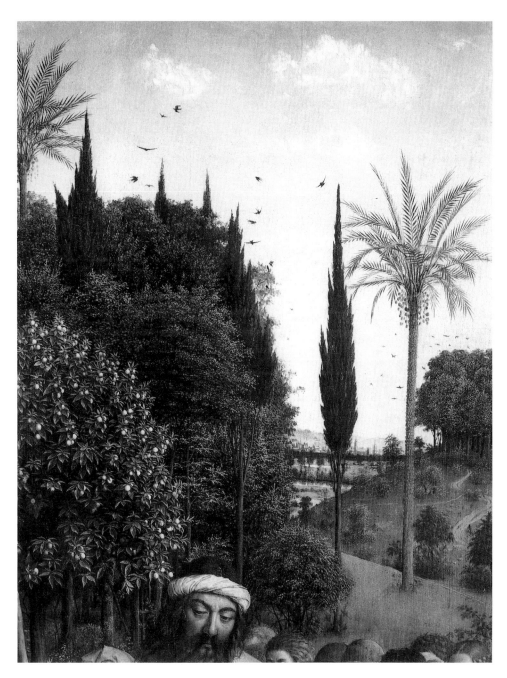

83
Ghent Altarpiece (detail),
St Christopher with Pilgrim Saints,
Landscape

This is a discrepancy in the handling of space that refuses to be explained away. Are we to equate it—as the inscription on the Ghent Altarpiece itself naturally tempts us to do—with a stylistic clash between two artistic personalities, those of Hubert and Jan van Eyck ? That is to say, are we to interpret our stylistic findings in such a way that the design (at any rate) of the central panel is attributed to Hubert, and the present form of the wing panels to Jan? To verify this hypothesis would require two specific findings: firstly, that the stylistic shift is visible not only in the perception of space but also in every detail of figure rendering, plant forms, pictorial construction, use of colour, and the like; and, secondly, that the results of our scrutiny of the painted surface agree with the facts as they emerge from X-ray and infrared examination.

We begin, quite unsystematically, with one of the discrepancies between successive layers of painting: the changes in the trees in the *Pilgrim Saints* panel. The orange tree *83* here is painted over a tree that is not only of a completely different species but also quite different in formal structure. Orange trees were a novelty in late medieval painting north of the Alps; and as this is not the only specimen of the Mediterranean flora that appears on the Ghent Altarpiece, it is tempting to suppose that this southerly cast to the landscape of Paradise stems from Jan van Eyck's journey to Portugal in 1428–29: all the more so because the orange tree, and also the date palm on the same panel, have clearly been painted over other and different landscape forms. Every single leaf of this orange tree is delineated in detail; in the date palm, too, which is much further away, we can count every leaflet of every frond. The trunks of the orange grove are pillar-like in their sculptural solidity and parallel growth; what was there before seems to have been more painterly, less static, and less solid.

The orange grove also stands out in strong relief from the surrounding foliage, which is much softer, more painterly, and painted in dabs of the brush: it is, one might almost say, more long-sighted. Its different appearance is surely as much the product

84
Ghent Altarpiece,
Adoration of the Lamb (detail)

85
Ghent Altarpiece,
Adoration of the Lamb (detail),
Virgin Saints

of personal vision as of any botanical difference. That is to say: the same kind of contrast of vision that exists between successive layers of the work can be detected in adjacent areas of the same final paint surface.

Nor is this restricted to contrasts between a North European and a South European flora. Thus, on the central panel of the *Adoration*, just to the right of the Virgin Saints, a clump of native plants, such as madonna lilies and irises, is depicted with such scientific precision and spatial depth as to stand out from the far more loosely rendered greenery all around.

Perhaps the greatest contrast is in the treatment of the turf. There are passages, both in the foreground and in the background, where the fact that the meadow is strewn with flowers is indicated by more or less amorphous dabs of colour; and interspersed with these—again, both near and far—we find individualized, identifiable, and volumetrically compact flowers and herbs. There is no sign that perspective is reducing the precision of what is seen. It often looks, in fact, as if something near-sighted and precise has been set down in the midst of something far-sighted and impressionistic; and from an evolutionary point of view the interesting thing about this is that the looser, more painterly approach seems to be associated with deeper, and thus earlier, strata of paint.

If we now turn to the figure painting, it is not difficult to discover similar stylistic contrasts; and, once more, the forms that represent a single style are not confined to a single area of the painting. We might expect the figures diagonally grouped on the continuous, steeply raked platform stage of the central panel to reveal no abrupt departure from the 'continuous' or 'soft' style of *c.* 1400, with its softly clinging draperies that serve to smooth over the directional contrasts created by each figure's existence in space. Sure enough, the angels to the right of the altar of the Lamb kneel in just the way that was customary in the days of the 'soft' style: the knees do not form a right-angle, and long, curving folds of drapery carry the lines of the figure round to merge into the horizontal of the ground. Similarly, the long mantles of the Virgin Saints make their procession seem to glide, almost float along. This gentle form of locomotion is, of course, entirely in keeping with the nature of these martyrs themselves.

The kneeling Apostles and prophets are made of sterner stuff. But here, too, I believe, there is an unmistakable effort to avoid harsh angles. The pyramidal form of the kneeling figures seen from behind is surely meant not only to lend them sculptural solidity but also to integrate them into the diagonal structure of the overall composition. Their kneeling posture is marked by a discrepancy between the oblique alignment of the bodies and the profile view of the heads. In the left-hand group, in *87* particular, the heads are held parallel to the picture plane, thus creating what seems to us a rather forced compromise between plane and volume. The same hesitation between three dimensions and two is to be found in the rendering of the draperies. Wherever the garment meets solid resistance, there is a zone of turbulence—a restless, painterly mass of folds—but no clear transition from one spatial direction to another.

A few steps to the left of these prophets stand some massive, almost monolithic figures with a clear, three-dimensional structure that recalls High Gothic sculpture. The stereographic rendering of such a figure as the bald man in the red cloak on the *86; Plate 24* far left dispels any idea of compromise with two-dimensional forms and relationships. This figure and the one who precedes him in the procession seem to us to typify the angular, 'discontinuous' style that we have identified as characteristic of Jan van Eyck's authentic works. The volume of each figure is emphasized by bunched folds close to its outline, and this gives both figures something of the monumental elo-

86
Ghent Altarpiece,
Adoration of the Lamb (detail),
Patriarchs

quence of Claus Sluter's *Prophets*. The massive dome of the bald man's skull, and the twin clumps of his cotton-wool beard, echo the tubular forms of the drapery folds. So keen is the painter to emphasize the sculptural solidity of the figures that he has inserted linear highlights—which are both non-naturalistic and unpainterly—at the points where the folds of the mantle would otherwise sink into shadow, in order to set each tubular fold spatially apart from the zone of shadow beneath or behind. This, too, is a feature that can be shown to exist in authenticated works by Jan.

This sculptural quality is less evident in the adjacent, blue-clad figure; but that is probably because it is in a far worse state of preservation. The right hand, jutting

57 obliquely into space and towards us, is identical to that of the Bruckenthal *Man with Ring*; the chunky form of the turban, too, unmistakably comes from an urge to create volume. Both figures have parallels in the two foremost, bearded *Hermit Saints*, and also in the giant St Christopher. In these, too, the relief of the drapery folds could be translated at once into monumental sculpture; and St Paul the Hermit's hands, with their bent knuckles, are angular in the extreme.

88; Plate 27 The long-bearded Pilgrim who follows St Christopher seems to me to be more problematic, however similar his draperies may be to those of the St Paul on the adjacent panel of *Hermit Saints*. Trapped by the left arm, the folds of his mantle do not have the same tubular solidity; nor does the sleeve stand out so clearly from the hip;

87
Ghent Altarpiece,
Adoration of the Lamb (detail),
Prophets

the painter seems to concentrate on making all the folds of the drapery curve round towards the figure's hand. The profile position of the head also gives us pause.

This is not to say that all the profile heads on the Ghent Altarpiece are to be assigned to one style, and the three-quarter heads to another, more 'discontinuous' or 'stereographic' style. But the way the long-bearded Pilgrim's head fits into his hood; the way his beard coalesces with the outline of his figure at the front, as does his hair at the back; and above all the slight grimace visible on his features, are all strikingly paralleled by the kneeling Apostles. Long-haired and long-bearded types also appear among the figures of the 'stereographic' style; but their physiognomy is quite different. The types of the Apostle painter look like primeval humans or woodwoses, wild men of the woods, with picturesquely tousled, straggling hair that robs the facial features of precision and gives the figures as a whole a rather dishevelled look. Often, the faces are distorted towards a point above the bridge of the nose, which suggests a scowl and imparts a slightly Mongoloid, slit-eyed cast to the features. 74; Plate 24

That this is not simply a matter of content, but of individual artistic vision and stylistic impulse, is plainly demonstrated by the *Hermit Saints* panel, with its very different rendering of much the same human type, the bearded anchorite. There, in the St Antony and the St Paul, the apparently well-groomed hair and beard reinforce the sculptural solidity of the head, and operate as a single mass, instead of flying picturesquely in all directions and obscuring the underlying sculptural form. Furthermore, these two heads, seen in three-quarter view, are clearly articulated in volumetric terms into neat verticals and horizontals; the grimacing heads, by contrast, seem to have been squashed flat—which is what gives them their slight air of caricature. This is not meant to represent a distinction of quality; what is most important is to make clear a difference in the formal ideal.

With all due caution, it is possible to draw some important conclusions from what has been said so far. First: the younger artist frequently used the same types as his predecessor, and thus clearly belonged to the same pictorial tradition—which goes some way to account for the fiendish difficulty of distinguishing between the two artists' contributions, and of defining these with any precision. Second: the younger painter received a number of panels intended for the Altarpiece in varying stages of completion, or rather incompletion, and carried them forward by making more or less radical changes to them: additions, revisions, overpaintings, and freehand embellishments.

No panel in the lower tier can have been far enough advanced to enable us to assign it, or even its invention, wholly to the elder artist. Only in the central scene of the *Adoration* itself, and in the two adjoining panels on the right, are there self-contained passages that are likely to have been designed and fully executed by the elder painter. Even here, however, the artist who completed the Altarpiece had no hesitation in adding figures and motifs of his own devising in prominent positions. Why he did so—whether these places were less well finished than others, or whether his changed sense of style made him regard what he found as in need of correction—we can no longer even guess. All possible degrees of combination of the two styles are not only possible but, on stylistic and radiographic evidence alike, highly probable: Hubert's design executed by Hubert, Hubert's design executed by Jan, Hubert's design replaced by Jan's design, Jan's design modified by Jan himself.

In the two wing panels on the left, too, there must be some of Hubert's work. This is clear from the X-ray of the *Knights* or *Warriors of Christ*: beneath the paint surface now visible, there is a landscape that precisely continues the grassy slope of the central panel. When the panel came to be finished, this zone of depth was overpainted with

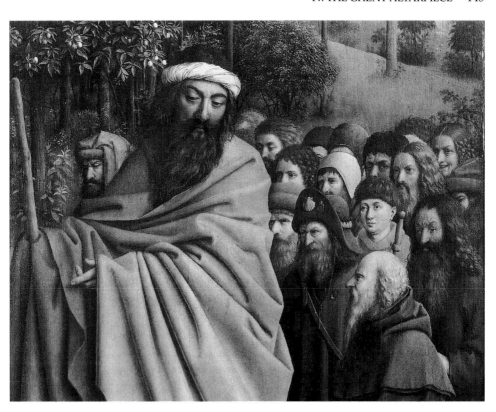

88
Ghent Altarpiece (detail),
St Christopher
with Pilgrim Saints

a higher, wooded landscape. As a result, we can tell that Hubert laid out a landscape, although not how it was composed. There are very many *pentimenti* in the detail of the cavalcade of the Warriors themselves, but the design and execution of this passage seem so homogeneous that a change of artist does not seem likely. In the panel of the *Righteous Judges*, too, it is hard to discover the hand of the elder artist anywhere, with the possible exception of the distant view.

To sum up, it might be said of the lower tier of the Ghent polyptych that in it we can discover Hubert's ideas only as staged, or rather orchestrated, by Jan. We may, however, safely credit Hubert with the idea of a panoramic landscape with luxuriant vegetation as a setting for the Adoration of the Lamb by the company of the Blessed.

In earlier Apocalypse illustrations, the throne of the Lamb had been nowhere, suspended in space. Some surviving images show the Lamb standing on a hill, but there the vision is a different one, that of Mount Zion. Hubert's source here was the passage in Revelation 7 that speaks of a great multitude, 'which no man could number', and which worshipped God and the Lamb. What Hubert did was to take the idea of worship literally, as it were, by transporting a brocade-covered altar, of the kind seen in church on high festivals, out into the open. For, in the book of Revelation, the text that gives rise to the iconography of the Feast of All Saints—the vision of the Elect thronging to the throne of God and in sight of the Lamb—is followed in a later chapter, after promise has become fulfilment, by a description of 'a pure river of water of life, clear as crystal, proceeding out of the throne of God and of the Lamb'. At this point, the setting is localized, albeit in a metaphysical or rather utopian sense: it is the Heavenly Jerusalem.

Throughout the Middle Ages, artists depicted the Heavenly Jerusalem, in accordance with the detailed account of it in Revelation 21, as a city with towers and battlements, garnished with precious stones. However, the artist of the *Adoration of*

the Lamb in Ghent has drawn his inspiration from the passage immediately following that just quoted, which reads as follows: 'In the midst of the street of it, and on either side of the river, was there the tree of life, which bare twelve manner of fruits, and yielded her fruit every month; and the leaves of the tree were for the healing of the nations… The throne of God and of the Lamb shall be in it [i.e., *in medio plateae*, in the midst of the street], and his servants shall serve him'.[67]

As so often happens, the verbal construct lacks any spatial logic; the Heavenly Jerusalem has just been described as a city, and now it is open country, with a river and the Tree of Life. The visual imagination, however, faces a choice, and has to decide; and in Ghent, for local and cultic reasons, the idea of the metamorphosis of the blood of sacrifice into the water of life has prevailed. The painter has chosen to depict an open landscape, of the kind previously confined to the imagery of the Earthly Paradise.

In late medieval art, the Earthly Paradise was most often shown as a walled garden, to which the Limbourg brothers added universal significance by making it circular, as an intimation of eternal recurrence. In the North Italian and German painting of the fifteenth century, this image of Paradise as a walled garden or *hortus conclusus* took on the dainty and pleasurable aspect of a rose-bower. Now, the landscape of Paradise on the Ghent Altarpiece is the exact opposite of a *hortus conclusus*: it does not even end at the frame, but extends beyond it into limitless space. Indeed, the meaning of the scene would be impaired if we were not conscious that all we see is only a section, a detail. The crowds who approach the altar from left and right—those whom, in the words of Revelation, no man could number—are only the vanguard of those who are still on the march, outside pictorial space. This landscape is not something added as a foil to the figure composition but a section of the infinity of space, and as such an integral part of the pictorial idea, which is that of universal thanksgiving for the redemption conferred by divine grace.

To us, today, the idea of a 'paradisal landscape' is something so much taken for granted that we cannot really imagine how much courage was required to break with a time-honoured iconographic tradition and to give the 'natural world' complete equality with the human figure, not only on an altarpiece but in the centre of it. In the early nineteenth century, when Caspar David Friedrich introduced a kind of religious landscape painting, one critic protested: 'It is an act of the grossest presumption for landscape painting to seek to creep into churches and crawl onto the altars'.[68]

There is no written evidence that the paradisal landscape of the Ghent *Adoration* evoked similar reactions among contemporaries; but there is indirect evidence, of a sort: for the leading artist of the post-Eyckian generation, Rogier van der Weyden, succeeded in founding a new tradition of religious—and, specifically, altarpiece—painting by reverting to pure figure compositions, with landscape and spatial depth excluded as far as possible. It cannot be a coincidence that the work regarded by posterity as the most significant product of the new painting, the Ghent Altarpiece, found practically no imitators, whereas the influence of Rogier's paintings can be traced through many dozens of paraphrases and repetitions.

In theological thought and literature, the idea of likening the Heavenly Paradise to a flowery meadow or a garden, and visualizing it as the 'fields of Heaven', was nearly as old as Christian art itself. What is more, in a twelfth-century homily on All Saints (*De omnibus sanctis*) by Honorius of Autun, there is a simile that anticipates the pictorial conception of the Ghent Altarpiece. Honorius says of the Communion of Saints: 'All have adorned the garden of God like divers flowers, and in word and deed they have given off the fragrance of eternal life'.[69]

89
Ghent Altarpiece (detail),
Adoration of the Lamb

However, it is often a long way from a figure of speech to a visible, concrete, outgoing image. It sometimes takes many centuries before verbal imagery can be translated into shapes and colours: until the mental notion can become a sensory vision. With notions of Paradise, as with others, the verbal image could never fertilize the pictorial imagination until the time was ripe.

The first signs of a pictorial response to the ancient metaphors of Paradise are to be observed in Italian trecento painting. In Robert of Anjou's poem of praise, Paradise is not illustrated by a symbolic representation of the Tree of Life but by a scene planted with trees and flowers that represent a markedly subtropical flora: orange, date and pomegranate can clearly be identified. Which goes to show that, if these same southern species adorn the Paradise landscape in Ghent, this is not only because Jan van Eyck happened to have visited Southern Europe: in what was then modern iconography, any ideal landscape of Paradise was already stocked with specimens of a Southern flora. What is more, the artist's experience of the phenomenal world, in the form of nature studies, had already established itself as a constituent of pictorial invention.[70]

In the study of nature, as in so many things, the art of the South had shown the way; but the results of that study were not, initially, put to artistic use. With painstaking objectivity, specialists in plant portraiture produced scientific illustrations for herbals, which were pharmacological reference books. In rendering the individual object, they made every effort to give an objective account of empirical experience. In art, however, and notably in the handling of religious themes, painters continued to invent and to compose from imagination. It was not until Pisanello that the two branches of visual activity coalesced, and empiricism became part of the artist's creed.

What the Italians lacked, however, when it came to the conversion of a 'Paradise tapestry' into a Paradise that could be a landscape setting for the Blessed, was something else again. It was not simply a matter of grasping the individuality of a plant as a single object, but of recognizing the formal identity of a space that was filled with light and air, rather than with solid bodies: the ambient space, without which nature as a coherent whole could never become visible. And this the Italians, as the true heirs of antiquity, could not do; they could not readily see a void as a positive form.

By contrast, for the artist who designed the central panel of the *Adoration of the Lamb*, the hollow space between the figures and between the groups of figures has a crucial part to play. The individual figure works only as part of a group; and the group in its turn is subordinated, along with other groups, to the vast expanse of the paradisal landscape. Everything is organized in a spatial configuration that forms a twofold polygonal ring around a centre that is occupied by the passive focus of an altar.

The ring of angels is scattered across the celestial turf, and the processions emerge, far back, from openings in the groves that crown the hills: everywhere, colourful figures are embedded in green. The setting thus does not have the neutral coloration used for landscape backgrounds in earlier—and often in later—art; this powerful green is the equal of all the other bright hues, and indeed dominates the colour scheme. Justified on grounds of meaning as the eternal green of Paradise, fed by the water of the mystic Fountain of Life, this green probably marks the first occasion on which the background of an altarpiece ever fully emancipated itself in terms of colour. There may well have been precedents for this in the secular art of the North, in courtly depictions of the Garden of Love and the like; in which case, the Eyckian renewal of religious art would seem to have enjoyed a kind of blood transfusion from secular art: a process of which traces are to be found elsewhere.

One of the symbolic interpreters of the art of the Van Eycks, Charles de Tolnay, summarizes the meaning of the *Adoration of the Lamb* in Ghent as 'Earth seen as Paradise'.[71] And this is quite right, to the extent that the painting can be described, in terms of its purely objective significance, as a sanctification of terrestrial nature. However, Tolnay's definition does not do justice to the work's evolutionary significance: indeed, he stands it on its head. It was Hubert's achievement that he took the space belonging to a fantasy of celestial bliss and clothed it in the attributes and qualities of an earthly landscape. He did not transfigure or spiritualize earthly reality, but transported the Heavenly Jerusalem into the world of experience: he naturalized Heaven.

Apart from noting the repeated shifts of viewpoint, we have not hitherto concerned ourselves with the stylistic features of the upper register of the Ghent Altarpiece. The fact that this has been possible is significant in itself. Clearly, there are few points of stylistic contact between the two tiers, such as might have prompted a reference to the upper register in the course of the discussion of the lower.

If we look at the Ghent Altarpiece in iconographic terms, we tend to see Above and Below as complementary; but as soon as we shift our focus to a stylistic one we are faced by a juxtaposition that clearly makes no artistic sense. Or, to put it another way: if we were to ask a modern viewer, who knew only the upper half of the Altarpiece or only the lower half, to imagine what the respective downward or upward continuation of the work looked like, that viewer would surely never produce the solution that we have before us in reality. No one would expect to find that in the heights, beyond the clouds that sail above the landscape of the *Adoration*, gigantic figures sit enthroned in tight-fitting altar niches; or that beneath a row of space-filling figures, close to the near picture plane, there is an extensive landscape in which an already much reduced figure scale becomes progressively smaller. An upward view of solid figures; and, beneath it, a horizontal view through an opening into unlimited space.

Again, even within the upper zone we are constantly perplexed by shifts of spatial vision and viewpoint. Despite all the uncertainties created in the lower tier by afterthoughts and alterations, a single landscape runs across all five panels; above, not only does the viewpoint change three or even five times, but there is no unified

ground at all. The figures of the *Deësis* are enthroned on a shallow platform; the wall behind them contains niches, and these are fronted by screens. The angels on the flanking panels are silhouetted against an airy background of sky. Lastly, Adam and Eve stand in rounded, shady niches.

The hardest thing to comprehend is the spatial organization of the *Deësis*. The only marks of spatial recession are the floor tiles and, more weakly, the stepped niches behind the three heads. If we trace back the receding parallels of the floor tile pattern, we are compelled to suppose that the back wall is some distance away; but if we look up to head level, we have the impression that the figures, and the back wall, are very close to the near picture plane. In the next century, when Mabuse copied the Ghent *Deësis*, he retained of his original only so much as was compatible with a pictorial space of uniform depth; and so his figures are head-and-shoulders only.

In tracing the transition from the wallpaper landscape to the purely projective pictorial space, we have already encountered the spatial inconsistencies of the Ghent *Deësis* more than once, both in the work of the Master of Flémalle and in the *Adoration* landscape of the Ghent Altarpiece itself. The pictorial space is once more of the 'hinged' variety, which starts in the upper half of the picture with frontally placed layers, parallel to the picture plane, and gradually swings out in the lower half to meet the viewer. This would incline us to the supposition that the layout of the *Deësis* was the work of the elder Van Eyck brother; especially as the two flanking figures, that of St John in particular, show a slight distortion in the transitional zone between frontal and oblique view.

In the execution of the figures, however, Jan van Eyck's stereographic manner is unmistakable. This is perhaps most clearly expressed in the way in which the seated posture of all three figures is convincingly manifested without a trace of a throne or anything else for them to sit on. The figures are seated by virtue of their block-like structure and of the architectural disposition of the drapery. Each, from its own resources, creates a kind of plinth-like substructure with the lap as its horizontal top, and this supports the torso.

The detail of the handling and of the colour is exclusively devoted to the illusion of three-dimensional form. The pearls, gems and golden bands of the tiara, or of the pectoral, are not there to supply an unspecific, purely optical glitter: their sculptural, volumetric and crystalline form is clearly worked out in terms of lighting. In the whole history of painting, there is no more magnificent example of light as an aid to *Plate 22* modelling than the crown that lies at the feet of God the Father; and to dismiss this triumph of Eyckian painting (as the Brussels commission did) as a post-Eyckian addition can be excused only as a bad joke or as paradox for paradox's sake. The light is so applied that it not only falls on the crown from the right but illuminates it from within; it is almost as if the Flamboyant fleurs-de-lys on the left were reflecting a light source concealed inside the crown. The concavity of the inner surface of the repoussé work is as clearly evoked as is the convexity of the outer surface on which the light first falls. Light and shadow insert themselves into the crown and superbly convey its hollow form; the elementary fact that light is the reverse of shadow, shadow the reverse of light, is brought home to us with paradigmatic clarity.

The angular, sharp-edged, solid figures of the *Deësis* hark back to the crisply creased three-dimensionality of High Gothic sculpture; but the background form, like the outline of the top of the altarpiece itself, is rounded and entirely un-Gothic. It looks, indeed, like a throwback to the Romanesque—a style used by both Van Eyck and the Master of Flémalle to convey a hieratic, Old Testament (partly, no doubt, because old-fashioned) quality.

Round arches and similar profiles are to be found in Romanesque reliefs on the Van Eycks' own home ground, in Liège and Maastricht. The *Madonna of Dom Rupert*, 90 which comes from the church of St Lawrence in Liège (although its closest stylistic relatives are in Maastricht), makes the same use of cavetto mouldings with a tight-packed central motif cutting across them. This relief is known to have been made as part of an altarpiece; and so the triconchal Ghent *Deësis* is a reincarnation of the Romanesque retable. This reveals a degree of historical interest, and also of historical objectivity, that is apparent elsewhere at the same period: a phenomenon of the dissolution of the Gothic style.

Remarkably enough, the central figure of the *Deësis* is itself a product of this same historical perspective. As is well known, there has been some controversy as to whether this is God the Father or God the Son. Our iconographic analysis has shown us that its significance varies according to the way in which we read it: either horizontally, as part of the *Deësis*, or vertically, in conjunction with the Dove and the Lamb of the lower register. However, its significance does not vary between Father and Son, but between the concept of the Triune God and that of God the Father. In appearance, the figure conforms to the type of God the Father with a long, full beard, in papal vestments, which had become the iconographic norm around 1400. At the same time, it owes something to another type of image of the Deity.

Towards the end of his life, Jan van Eyck painted a picture that is known to us, through a number of copies, under the title of *Salvator mundi*, Saviour of the World. It 91 is unusual in being cut off just below the shoulder line—a *Schulterbüste*—and in the regularity of the features, which is astonishing in the work of a pioneer of artistic realism; in their strict axial symmetry, they remind us of heads or figures based on geometrical constructions. Some years ago, the enigma of this *Salvator mundi* was solved at last.[72] In this work, whose inscriptions include some that are familiar to us from the Ghent Altarpiece, such as 'King of Kings' and 'The Way, The Truth and The

90
Madonna of Dom Rupert.
Liège, Musée Curtius

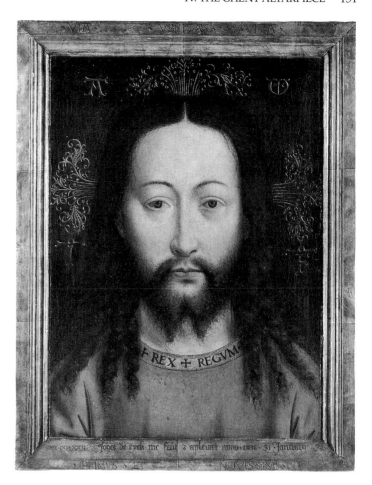

91
Jan van Eyck (copy),
Salvator mundi.
Berlin, Staatliche Museen
Preussischer Kulturbesitz

Life', Jan van Eyck has attempted a faithful copy of an ancient icon that was believed to be an *acheiropoieton*, a miraculous image not painted by human hands, and therefore an authentic portrait of the Saviour: a *veraikon*. Modern in his art, but medieval in his faith, Jan took a historically authenticated image of Christ as his source in just the same way as, in painting portraits of his own contemporaries, he took nature as his model. His intention was to replace an abstract, ideal type with a realistic image of the Saviour.

On the Ghent Altarpiece, he merges this eastern icon face with the traditional, papal type of God the Father, and thus creates an image of the Deity that uses its strange, exotic quality to convey to our minds something inaccessible and transcendental. It is an image that seems to reconcile palpable immediacy with a sense of mystery. Hegel said of it, in his *Aesthetics*, that it was worthy to be set beside the Olympian Zeus, perfect in its expression of eternal tranquillity, sublimity, power and dignity.[73]

The *Deësis* has been given a musical accompaniment. In transcendental visions since time immemorial, Heaven has opened to the strains of music. Indissolubly bound up with worship and the liturgy, music in medieval times was an essential attribute of the celestial spheres. It went without saying that, at the Feast of All Saints, Heaven joined in with the earthly hymn of praise. In Heaven, the musicians are the angels; and, as angels are winged beings, it was customary, until the trecento, for angelic orchestras to perform on the wing. Around 1400, in the Franco-Flemish region,

it seems to have become customary to paint singing and playing angels in chapel roofs, and these became vaults of heaven where angelic concerts were held. At the same time, angel musicians began to appear in the margins of French and above all Netherlandish manuscripts, fluttering around the text panel. Nor is all this interest in musical angels surprising, if we reflect that at precisely this time the Netherlands were in the forefront of the evolution of European music.

The angels on the Ghent Altarpiece are no longer required to fly, sing and play all *Plate 25, 26* at the same time. The music-making here is on a more professional level. The angelic concert proceeds in accordance with all the rules of church music; in fact, what we see is a Spiritual Concert, just as it would have been performed in a church, with all the instruments then customary. The angels have stepped in to fill the places of the choirboys and deacon musicians; and, as if to show how deeply they are absorbed in their work, they have laid aside their wings. Their exalted origins are sufficiently indicated by their earthly finery: brocade vestments and precious diadems, some adorned with crosses at the front. There is just one earlier instance of wingless angels, in the *Fountain of Life* in Madrid; and this too is the work of Jan van Eyck.

As in real life, the angels specialize: some are vocalists, some instrumentalists. Both of the angel panels in Ghent are based on well-known types of musical scene derived from psalter illustration. The angelic choir grouped behind a single music stand corresponds to the singing clerics who normally illustrate the beginning of Psalm 96, *Cantate Domino canticum novum*: 'O sing unto the Lord a new song'. The view and posture of the angelic organist in Ghent are almost identical to those assigned, in western manuscripts from the thirteenth century onwards, to King David, the proto- *92* type of Christian musicianship. Neither of the angelic concert scenes is thus an original compositional invention on the Van Eycks' part; but it is unlikely that these motifs, invented as psalter illustrations, had ever before served as the themes of panel paintings in their own right.

In each case, the image is organized around a piece of musical furniture. In the left-hand panel, the fact that the music stand is on a swivel enables the painter to show the base parallel to the picture plane and the desk top leading obliquely back into the space; the group of angels is then arranged in accordance with this oblique line. It is possible that this derives from a design by the elder Van Eyck. Some of the angel heads have the curiously narrowed, peering look in their eyes that we found in some of the Apostles of the *Adoration of the Lamb*, where it suggests the elder master's involvement. In the completed painting, however, the younger brother has left his stylistic imprint on the whole of the panel. What we see is a portrait group of angelic heads, but only one complete angelic figure: thanks to the side of the music stand, which looks like a choir-stall, the angelic chorus is made up of a single pillar-like figure, to which a variety of angelic heads have been attached.

In the right-hand angel panel, too, the pictorial field is dominated by a single figure, *Plate 26* that of the organist. The other members of the band, tightly crammed behind the organ, serve to fill the triangular space above the seated angel. To the Van Eyck brothers, on their pioneer voyage of discovery into the third dimension, a rank of organ pipes must have seemed like a ready-made perspectival construction. In this panel, however, the movement into depth is weakened and sidetracked into two dimensions by the way in which the diagonal batten of the organ case conducts the eye down to the line of the organist's back: the eye is once more held back from entering spatial depth and pulled forward to the near right-hand edge of the panel.

The idea of an analogy between the compression of a seated human figure and a diminishing series of organ pipes may well have played a part here. The pipes rise

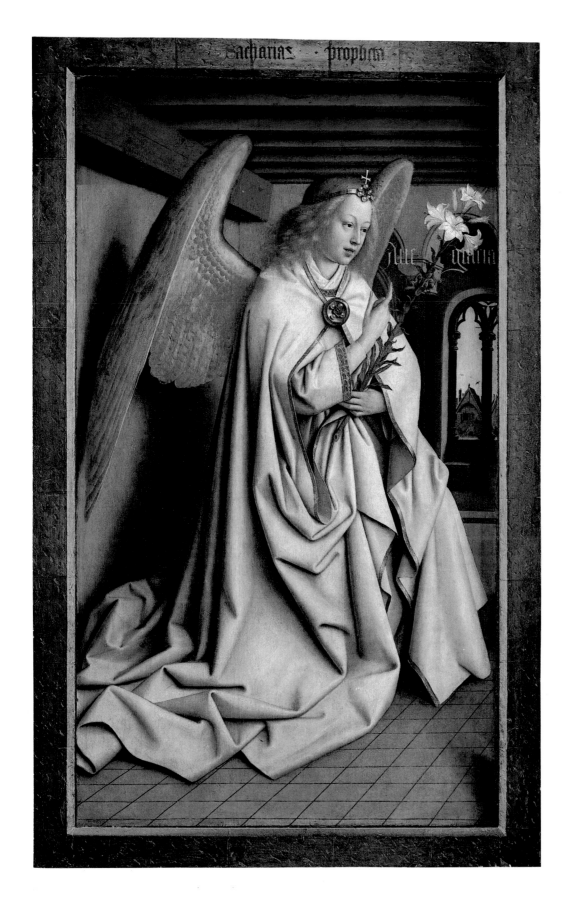

21 Ghent Altarpiece, *Angel of the Annunciation*

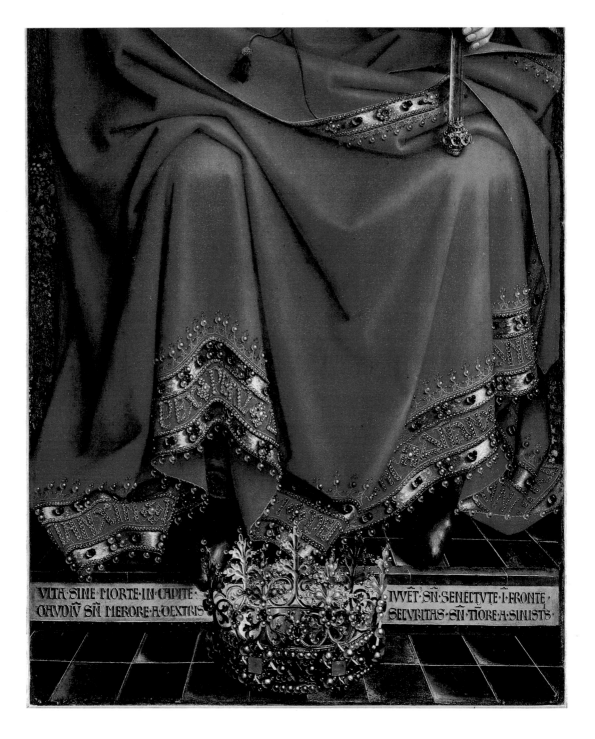

22 Ghent Altarpiece, *God the Father* (detail)

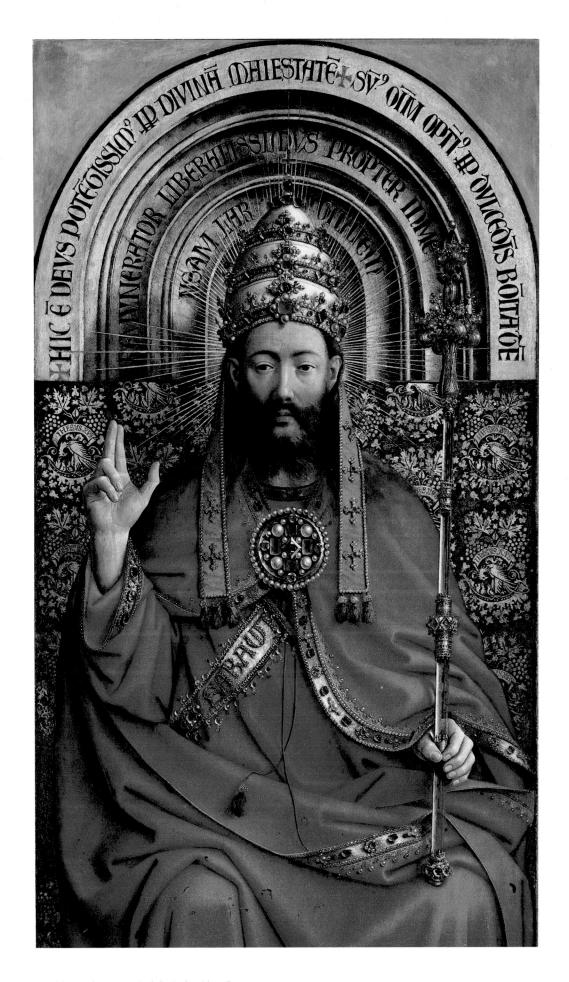

23 Ghent Altarpiece, *God the Father* (detail)

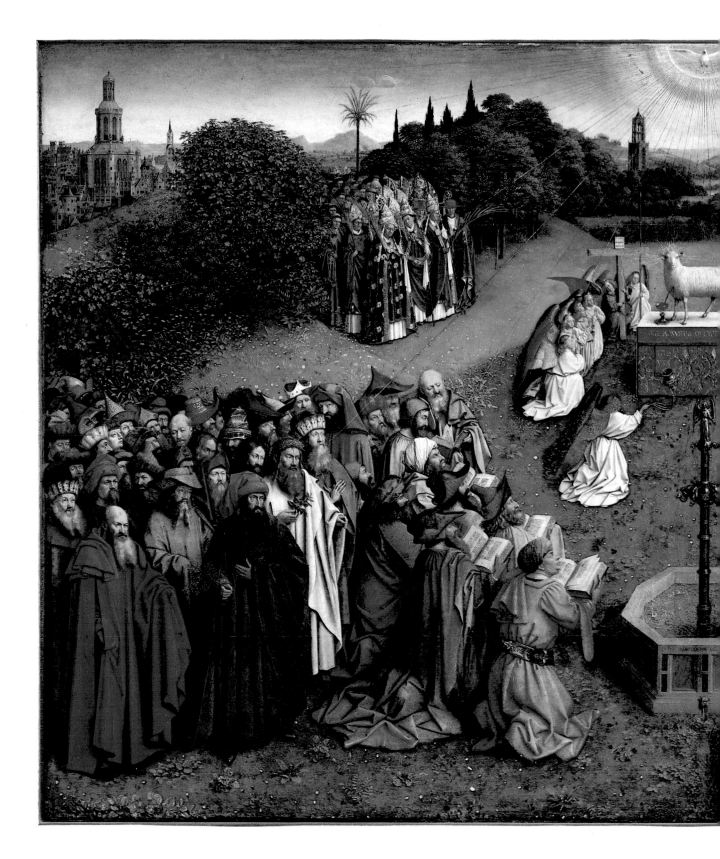

24 Ghent Altarpiece, *Adoration of the Lamb*

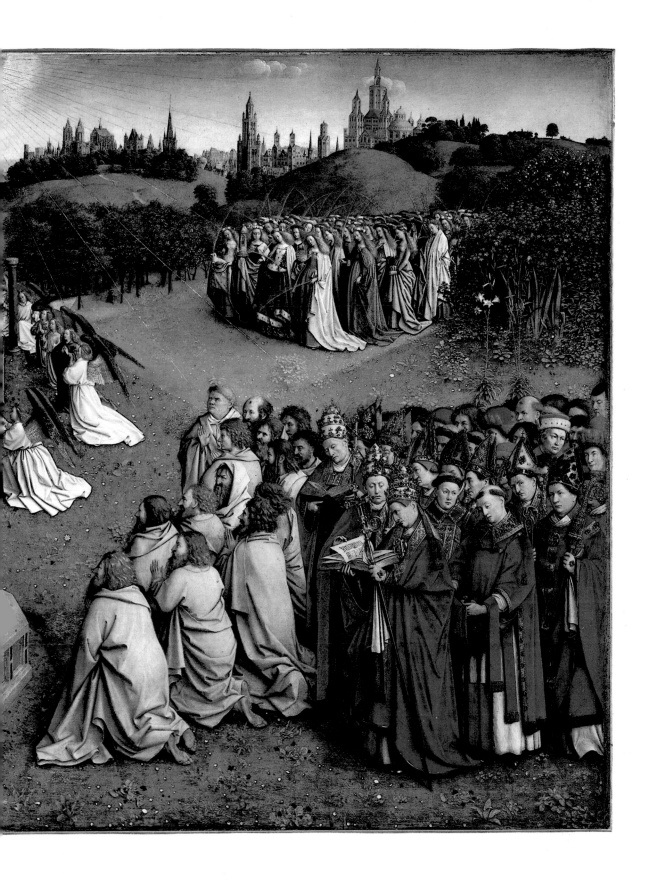

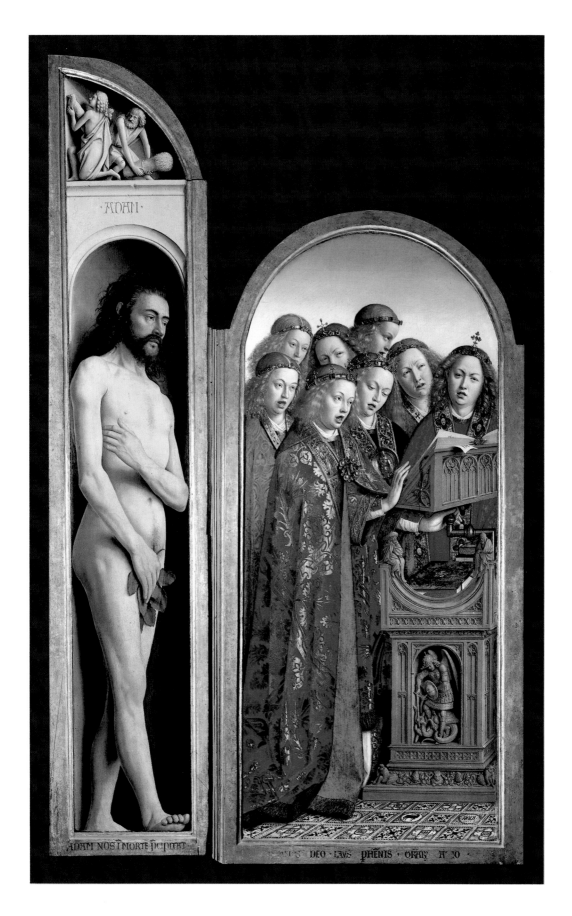

25 Ghent Altarpiece, *Adam and Angels Singing*

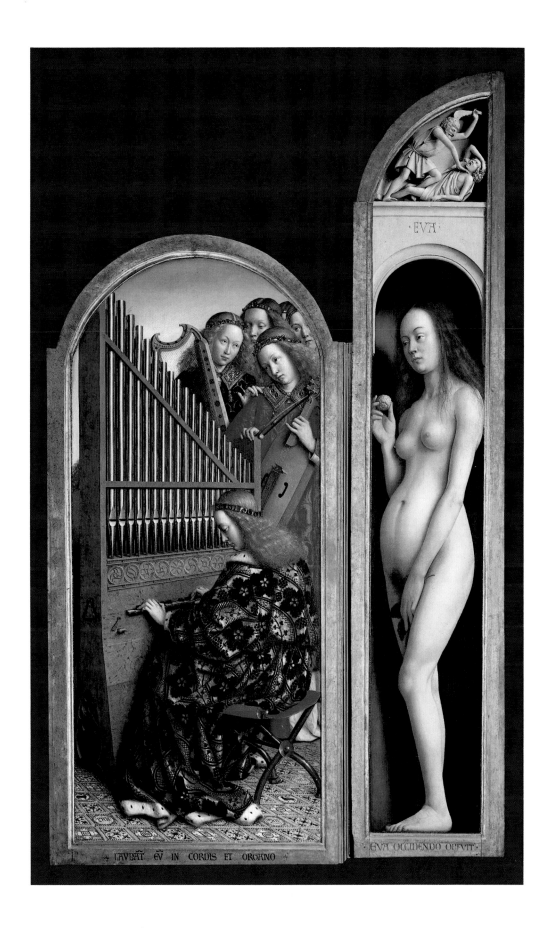

26 Ghent Altarpiece, *Eve and Angels Playing Musical Instruments*

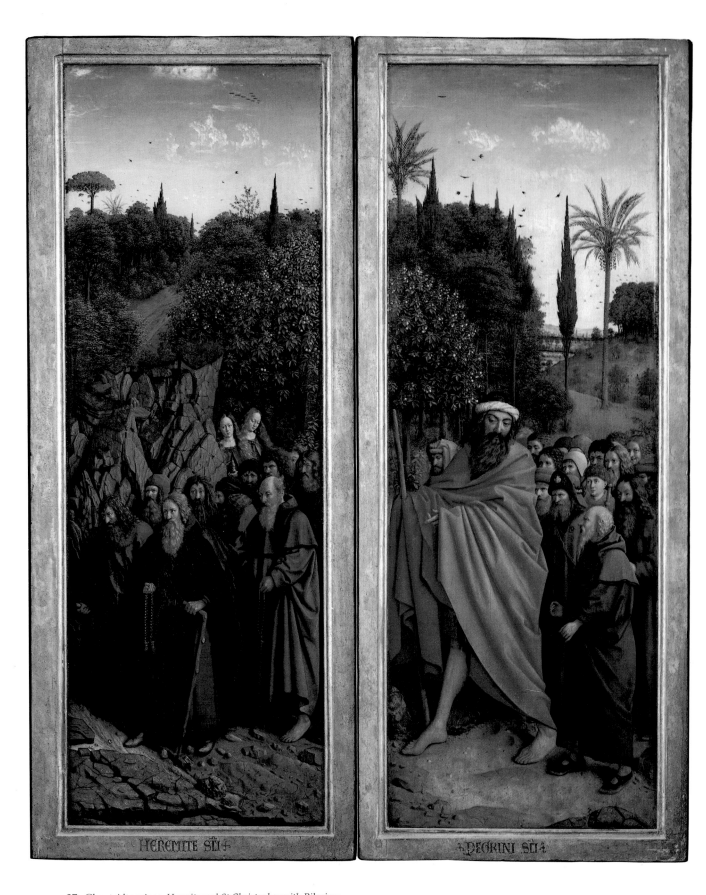

27 Ghent Altarpiece, *Hermits and St Christopher with Pilgrims*

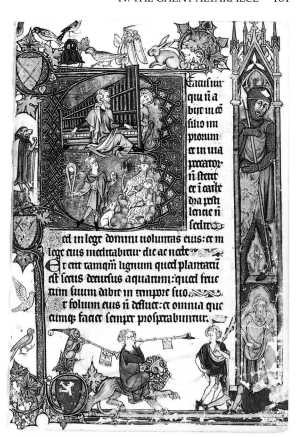

92
Hours of Yolande de Soissons,
King David at the Organ.
New York, Pierpont Morgan Library
M 729, fol. 16

progressively higher from the level of the seated figure's head. At the same time, the optical diminution symbolizes the progression of the musical scale, from low to high. The shape of an organ is surely the most suggestive visual expression of the structure of musical sound.

Countless thousands before Van Eyck must have seen organists from behind; and as I have mentioned, certain medieval illuminators had used this highly unusual view for images of King David the musician. In these spaceless scenes, the player's silhouette appears pasted flat on the organ case; as no air circulates between the two spatial layers, David's face has to be turned aside to appear in profile. It is not until the Ghent Altarpiece that player and instrument confront each other in space; and here, for the first time, use is made of lost profile or *profil perdu*, with its suggestion that the figure is turned away from us and caught up in the realm of music. Seen from the back, the figure invites us not only to leave the picture plane behind, and press on into depth, but to quit visual space altogether and enter the invisible world of sound. Mute, because faceless, it helps to evoke a realm inaccessible to the eye. So long as figures continue to act or face us directly, they remain unable to convey the phenomenon of music, which remains the province of the painters of still-life. Here, however, we become viewers and hearers at the same time, especially as the act of listening is personified within the picture itself by the angel instrumentalists who stand behind the organ, waiting for their cue to play.

Seen from behind, Jan van Eyck's organist polarizes yet another antithesis. The back, the least expressive view of the body in itself, becomes the richest in terms of painting, through the superbly decorative gold brocade in which it is clothed. This is

93
Ghent Altarpiece,
Sacrifice of Cain and Abel
and *Killing of Abel*

why, in that sphere of Heaven where Van Eyck's angels perform, a gold ground has become unthinkable. The organist angel has his back to the light, and the gold of the brocade shines out between the deep black forms of the floral pattern, so that it unites deep darkness with brilliant lustre. The centre of the panel reflects golden, immaterial light.

As we said in our account of the iconography of the work, the Fall marks the origin of the work of redemption, and thus has a logical place in any image of the Communion of Saints; but to find our First Parents set alongside the angels, and on a level with the *Deësis*, in the very register that corresponds to Heaven itself, has disturbed many interpreters and seduced them into all manner of conjectures, including the notion that these nudes were an arbitrary addition on Jan's part. One thing that is clear is that whoever painted these panels must have been aware that the presence of these over-life-size nude figures in so elevated a position would attract more than its fair share of attention. By the sixteenth century, if not before, the Ghent Altarpiece itself had become known as the 'Painting of Adam and Eve'.

It is noteworthy, too, that the *Adam* and *Eve* panels were the only ones to be separately hinged; they could be arranged not as a flat continuation of the rest but at an angle to the line of the Altarpiece itself, so that the two nudes would have looked even more oblique and foreshortened than they now do. This also meant that the spatial discrepancy between them and the five inner panels was accounted for by a literal change of viewpoint on the viewer's part. The two nudes would thus have stood, as it were, in lateral niches, rather like the figures on the jambs of a portal; and, for a centrally placed viewer, an oblique viewpoint would have been the only possible one. This incorporation of real spectator space in the pictorial calculation would be an entirely logical extension of the low viewpoint within the paintings; and this would give a deeper meaning to the motif of the sole of Adam's foot, in that the action of the figure in stepping forward above our heads would emphasize the movement of the panel itself towards the centre. Also, the grisailles inserted in the half-lunettes above *93* Adam and Eve would be more understandable if the altarpiece were thought of as a portal flanked by splayed jambs that contain figures of differing degrees of reality: a painting of a relief above; naturalistically painted, full-round figures below.

All this, I must emphasize, is not much more than a hypothesis, formulated with all due caution. If I present it nevertheless, I do so because the direct precursors of the Adam and Eve in Ghent, low viewpoint and all, are indeed illusionistically painted *13* statues. In one miniature designed by the Limbourg brothers, the city gate of Rome, through which St Gregory the Great leads his procession of intercession against the plague, is adorned with statues of Adam and Eve in poses identical to those shown

by Jan van Eyck. Elsewhere, the Limbourgs have placed the same Adam and Eve figures at the corners of a kind of loggia in which the Flagellation of Christ takes place. This latter image may be thought of as inspired by Italian work in the style of the ciboria of Arnolfo di Cambio; at all events, Van Eyck's nudes seem to have enjoyed a previous incarnation as statues. Their ancestry goes back, by way of such interme- *95* diaries as the Limbourgs, to such antique figures as the *Venus pudica*—whose arm *94* gesture is more faithfully echoed in Ghent by Adam than it is by his consort, the biblical Venus.

Anyone who has not acquired the habit of seeing individual works as links in a historical chain is certain to find the idea of these Van Eyck nudes as fictive jamb figures totally absurd; and it would indeed be a gross distortion of historical fact, and a misreading of the artistic phenomenon, to omit to add that, in this *Adam* and *Eve*, stone has undergone a metamorphosis into flesh and blood that Pygmalion himself could hardly match for thoroughness. Here in Ghent, the first human beings have been born anew.

In art, the secret of a new creation is the study of nature. The detailed shaping of these two human bodies, with their subtle differentiation between male and female musculature and flesh tones, would have been inconceivable without the most intensive study of the living model. The *Adam* figure, indeed, provides one conclusive proof that it is painted from life: the flesh tone of the head and hands is markedly darker than that of the rest of the body. Jan's Adam is the portrait of a man who has laid aside his clothes and stands before the painter in the pose of our earliest ancestor, and in his state of paradisal nudity. Head and hands, the only parts of the body exposed to the light in the normal life of western man, are tanned by comparison with the paler skin tone of the rest. With supreme and, one might almost say, brazen disregard for the demands of his iconographic programme, as well as for those of

 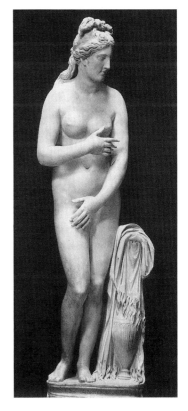

94
Ghent Altarpiece,
Adam

95
Venus pudica.
Rome, Museo Capitolino

illustrative decorum, Jan van Eyck records what his physical eyes see, without alteration or embellishment. Empirical truth means more to him than scrupulous fidelity to any iconographic canon or theologically sanctioned notion of what the first man looked like. Instead of the nudity of Paradise, Jan gives us the minutely observed nudity of a model who is playing the part of Adam. The creed of the new empiricism, *Natura sola magistra* ('Nature the sole teacher'), could not have been more radically formulated.

The interior of the Ghent Altarpiece suggests that the original compositional plan, had it ever been carried out, would have left us with a far more unified whole than that which now confronts us. As for the exterior, now that infrared photography has permitted us to look beneath the surface of the paint, we know that the entire surface was originally intended to be structured by a consistent fictive architecture: monotonous, no doubt, by comparison with what we now have, but undoubtedly more unified. All three tiers would have contained only niche-sized spaces; and the principal figures at least would have appeared in pure grisaille as fictive sculptures, a restrained prelude to the polychromatic splendours of the interior.

The inscription tells us that the completion of the Altarpiece by Jan van Eyck was due to the initiative of a Ghent patrician, Jodocus Vijd, and of his wife; and so it is certain that the coloured portraits of the two donors are the work of the younger Van Eyck. By the same token, of course, there is no telling what Hubert van Eyck had intended to have in his lowest tier.

The only part in which Hubert's handiwork can now be traced is in the *Annunciation*, where the marked discrepancy between the drapery styles of the two figures indicates a change of artist. The surface of the angel's garments is articulated like a sculptural relief; it is a good example of what Panofsky called 'Jan's stereographic style'.[74] Although Gabriel is primarily conceived as a draped figure, we are never left in any doubt as to the position of the body under the garments. The mantle falls and is caught up in such a way that we can tell where the left knee is and can imagine where the right knee rests on the ground: the mantle bunches, and the folds change direction in abrupt, angular creases. The figure as a whole has depth.

Plate 21

The same cannot be said of the figure of Mary. The folds of her dress run parallel to the picture plane, not only where the figure is meant to be seen in vertical extension—from the shoulders down to the knees—but also where the mantle must be thought of as lying parallel to the floor, that is to say, perpendicular to the picture plane. In the figure of Mary, as in the other, the weight of the body, and the contact between mantle and floor, disrupt and crumple the folds; but, instead of thrusting out towards the viewer, these yield sideways. There is an unresolved sense of tension between volume and plane, largely because the artist has not yet given up leading the eye continuously across the surface of the object. This is not, yet, a truly discontinuous style; and the folds still try, almost as in the 'soft' style, to make the transition to the floor on either side. When this figure was framed in a shallow niche, its spatial shortcomings would not have been so evident.

96

Even without knowing of the original plan to frame the figures in an arcade, Baldass saw and declared in his Van Eyck monograph that the interior shown in the *Annunciation* scene was a subsequent addition.[75] It was Jan who had the ingenuity to turn four adjacent niches into a single interior, into which we look past and between the uprights of the frame. These uprights interrupt our view and obstruct the light, and they therefore cast shadows on the floor within the room.

In spite of this illusionistic *tour de force*, however, the *Annunciation* on the Ghent Altarpiece bears all the marks of a compromise solution. The figures are far too large

for the space; they could not stand up without hitting the overhead beams. This is a box space, far more cramped even than that of the Mérode Altarpiece *Annunciation*, by the Master of Flémalle (of which we are reminded by one or two details of the furnishing). What is more, this chamber of Mary's does not even have a door through which the angel could have entered: a unique anomaly.

A number of commentators are inclined to interpret the change in this scene to a desire on Jan's part to experiment with the great iconographic innovation of the Mérode Altarpiece. By setting his *Annunciation* in an interior, they argue, he was bringing it up to date. It is an interpretation that has much to commend it. However, it must not be forgotten that, even if Jan did borrow some motifs and ideas from the Master of Flémalle, the spatial imagination manifested in the Ghent *Annunciation* is a totally different one. In the Mérode Altarpiece, the picture plane is packed full of the projections of various things that lie at quite different distances from it; in the Ghent *Annunciation*, Jan has dared to leave the centre of the picture virtually empty, and indeed—if we count by units of area—to fill two whole panels out of four with the representation of a setting without figures. No *horror vacui* here: on the contrary, Jan employs the force of suction created by a vacuum to draw our gaze, swift as an arrow, into the far distance.

Frontispiece This is the idea that found a more mature expression in the superb composition of the *Madonna of Chancellor Rolin*. Just as in that work, the path followed by the eye is a discontinuous one. A barrier has been introduced, above and beyond which the eye suddenly finds itself far in the distance. Past Mary and Gabriel, the motif of the view from a window is taken one step further still: the far wall of Mary's chamber opens through arches into an ante-room and only then, through its window, into space. At each stage, quite logically, the light changes. From the interior, lit from our real space, in which the brightest thing is the ivory white of the figures against the black of the cast shadows, the eye sinks into the half-light of the intermediate zone, before finally losing itself in the brilliance of the exterior view. The central role of lighting in creating the illusion of an interior means that the white garments no

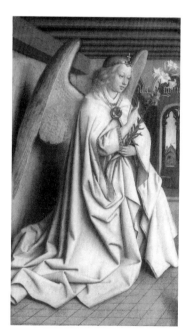
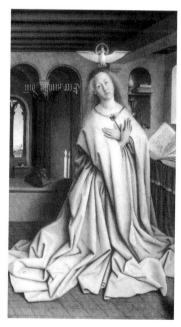

96
Ghent Altarpiece,
Angel of the Annunciation
and *Virgin Annunciate*

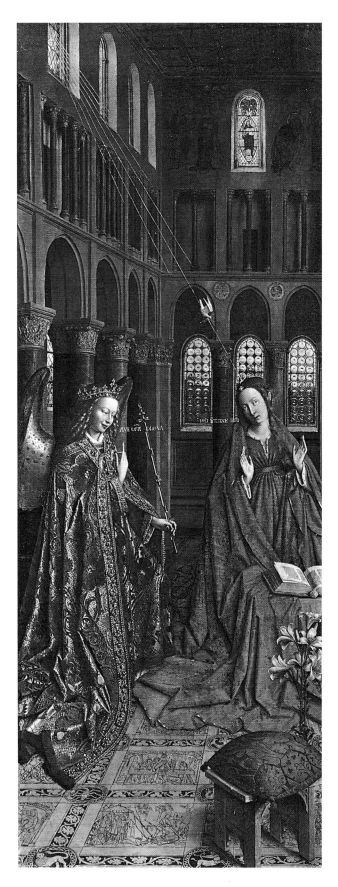

97
Jan van Eyck,
Annunciation.
Washington,
National Gallery of Art

98
Ghent Altarpiece,
Prophet Zechariah

longer look like a way of imitating sculpture but like purely painterly accents. With his magic of light and shade, Jan has succeeded in converting statuary niches into a true interior.

In the Ghent *Annunciation*, the inscription that gives Mary's answer to the Angelic Salutation is written upside-down: a peculiarity that reappears in another Van Eyck

97 *Annunciation*, now in the National Gallery of Art in Washington. It has been suggested that the response is written upside-down because it is intended for the Lord himself, or for the Holy Ghost, up in Heaven; but on the Ghent Altarpiece there is a more prosaic reason. The upside-down writing draws attention to the prophet Micah, who leans forward from his lunette—and looms out of pictorial space—above Mary's head, as if to see what is going on in the room below. The words *Ecce ancilla Domini*, 'Behold the handmaid of the Lord', are written upside down for the eavesdropper to read: another play on spatial illusion, intended to emphasize the compositional unity between the *Annunciation* scene and the upper register.

The most important confirmation of this unity is a formal one: the pairs of half-length and seated figures in the topmost tier, like the Adam and Eve on the inner side of the same shutters, are shown from a low viewpoint. This is notably evident in

98 the prophets' books: like Adam's foot, these project out of pictorial into real space.

What is depicted in this upper tier is indispensable to any encyclopaedic depiction of the Work of Salvation, *Teste David cum sibylla* ('witness David and the sibyl').[76] The medieval viewer knew these figures well from the mystery plays, where they form the cast of the prologue to sacred history; it is symptomatic that at this point the image gives way to writing, the signs that represent spoken thoughts.

Jan van Eyck has given his sibyls ethnically distinct costumes. The Erythraean sibyl is shown as an Oriental, crouching on the ground in a turban and a loose, sack-like overdress; the Cumaean sibyl is European, though she too has a certain exotic charm.

62 Now that we have seen copies of Jan van Eyck's portrait of Philip the Good's Portuguese bride, we know whose costume and appearance he used as his source: this is the Infanta in the role of pagan sibyl. We thus have a welcome *terminus post quem* for this figure, and for the work on this portion of the Ghent Altarpiece: 1428–29,

99
Ghent Altarpiece,
Jodocus Vijd (detail)

after Jan's return from Portugal. Implicitly, too, it supplies external evidence—had any been necessary—of Jan's authorship of this area of the work.

The attic storey of the exterior is painted in full colour; which helps us to see the white of the *Annunciation*, the subject to which the prophets and sibyls so clearly belong, not as the colour of stone but as a symbolic colour and as a tonal value. On the main level of the structure we are intended to receive the full illusion of life, just as we do on the interior panels of the altarpiece. Only below—in the plinth or rusticated basement, so to speak, that supports the weight of the lighter structure above—do we see niches filled by fictive statues: towering, monumental figures on plinths of their own. These painted figures of John the Evangelist and John the Baptist

100
Ghent Altarpiece,
Elisabeth Borluut (detail)

are totally sculptural. It is not only the colour that is stony: so is the substance of the figures. Hair and beards are chiselled forms; the fabric of the mantles falls into rectilinear folds, frozen into stone.

99, 100 At the feet of these cult statues, on the façade of the Ghent Altarpiece, the donors kneel in their identical niches, palms together, gazing into space, rapt in devotion. Immobile as the statues to which they seem to pray, they remain realistic portraits of living people. In terms of colour, their warm red contrasts with the stone of the statues and makes them the strongest accent on the whole exterior. The fact that these bourgeois individuals are commemorated, life-size, by the Duke of Burgundy's court painter, in the most monumental pictorial creation of Early Netherlandish painting,

typifies the historical position of that new art, with its unexampled blend of piety and secularization.

If we now look back over our lengthy analysis of this work, and ask what conclusions are to be drawn from it for the Hubert-Jan problem, we find that the following statements may be made without hesitation.

Even if there had been no inscription to confirm the presence of two artists, and to set scholars looking for the respective shares of the two Van Eycks in the Altarpiece, we should have been forced to assume, on stylistic evidence alone, that the directing mind had changed. The layer of the painting that enshrines the original design is only partly visible today; X-rays reveal more of it beneath the final painting. The execution of the original design had gone farthest in the *Adoration of the Lamb* itself, and in parts of the neighbouring wing panels, when the work was broken off and left unfinished. The cause of this must have been Hubert's death in 1426; after a gap of two or three years at least, Jan took up the work, and he completed it in 1432.

Jan's imagery and formal repertoire are very largely identical with Hubert's, and this makes it understandable that in some figure types and other details the two artists, or the two styles, are often indistinguishable; and that, especially where the design or the underdrawing is by the elder artist and the execution by the younger, their two contributions can never be neatly separated. Among the most momentous transitions of all, and at the same time one of the most elusive, is the stylistic shift from Hubert to Jan: for it primarily affects the way of seeing, not what is seen. It is only with Jan that the viewpoint becomes a fixed one, and painting becomes passive contemplation.

V. The Hubert van Eyck Problem and the Hours of Turin

In defining Hubert van Eyck's contribution to the Ghent Altarpiece, we are entitled to take into consideration the authorship of the overall design; even so, it is no easy matter to form a clear notion of Hubert's art on the basis of what can be attributed to him within that work alone. Quantitatively, the amount of finished painting by Hubert in that work is very modest, by comparison with that by Jan; and it is certainly not enough to justify the supreme artistic status that is proclaimed in the famous words of the inscription, *maior quo nemo repertus*. It does seem rather paradoxical that Jan, who is named there as *arte secundus*, should have expressed his respect for his elder brother, supposedly the greatest painter who ever lived, by taking the little that his brother had completed and overpainting, correcting and translating much of it into his own idiom. It is, of course, not known who composed the inscription, and it would be idle to speculate on the writer's motives in setting the dead master above the living one: above Jan, whose name was to be the only one remembered by posterity.

At all events, one thing ought to be clear: if there is any truth in the assertion of Hubert's overwhelming greatness, we are not going to find the direct evidence for it in the Ghent Altarpiece. The Ghent Altarpiece is and remains, so long as no other authenticated work is known, the only reliable basis for the recognition of Hubert's style; but only when this basis can be widened, by ascribing other works to him on stylistic grounds, does any prospect exist of bringing the figure of Hubert truly to life. And it transpires that there is a series of works whose stylistic physiognomy comes very close to that of the older stratum of work on the Ghent Altarpiece.

Plate 20 The best point of comparison is offered by the painting of *The Three Women at the Sepulchre*, now in Rotterdam. Since the twelfth century, the Women at the Sepulchre had been displaced, as the canonical image of Easter Day, by the *Resurrectio in carne*, the Bodily Resurrection. But some compositions in trecento painting combined the empty tomb with the *Noli me tangere* scene; and this is the iconographic tradition to which the Rotterdam painting belongs. In fact, it probably had a wing panel on the right showing the *Noli me tangere* itself. This is suggested by the golden rays of light that have emerged from beneath an overpainting on the right-hand edge: they presumably emanated from a Christ figure, which can be approximately reconstructed with the aid of a number of more or less free copies. The Christ of the Resurrection was visible on the periphery, in a scene closely allied in time and space; but he was not there in the centre of the picture.

The focus of the pictorial narrative is on the dialogue between the angels and the women concerning the miracle of the empty tomb; and the actual topic of conversation, the fact that the sarcophagus is empty, has surely never in previous art been made so succinctly and forcefully evident. The angel sits on the dislodged lid, as on a bridge over an abyss. It is as if a slot had opened up in the centre of the painting; and around

this void the whole scene organizes and groups itself, in a diagonal stacking arrangement based on the leitmotif of the diagonal of the lid. Parallel to this are other diagonal sequences, such as that of the guards, whose sleep affords the opportunity to place them immediately below and in front of the sarcophagus. This diagonal reaches the near edge of the picture at the fold of the foremost guard's turned-back cloak, which then leads the eye obliquely back to the top left by way of the Mary who kneels. The configuration established by the positions of the figures could almost be described as a diamond lattice pattern.

The lower corners are blocked by bits of rocky terrain that mark the edge of the stage: a device that is also used in the French manuscript illumination of the 'soft' style to enable the composition to develop simultaneously away into depth and up the picture plane, and above all to allow the movements of the figures to be traced continuously from far to near and back again into depth. In this Eyckian Easter image, rocky outcrops continue the upward impulse of both branches of the figure composition. The whole becomes a socket, a hollow, in which there nestles a distant prospect of a city.

This is the earliest instance, to our knowledge, in which the location of a scene—in this case Jerusalem—has been defined by the use of an urban skyline. What is more, this Jerusalem is no mere figment of the medieval imagination: at least two of the *101* buildings can readily be identified as portraits of real buildings in medieval Jerusalem, the Dome of the Rock and the so-called Tower of David, with its melon dome. Quite apart from its significance for the history of architectural portraiture, this is a highly interesting historical document: the painter of *The Three Women at the Sepulchre* must have been in a position to use his own or other people's observations, made on the spot in the Holy Land and recorded in a drawing. We shall come back to this trip to Jerusalem later: it has its relevance to the understanding of some details of the Heavenly Jerusalem on the Ghent Altarpiece. The *Three Women* painting contains other clues that point to travel: the parasol pine (which reappears high up on one of the wings of the Ghent Altarpiece, and which, like the cypress not far away, intersects the oblique line of a hill slope), and a number of oriental shields and weapons.

The peculiarities of the landscape forms, and the diagonal pattern of the figure composition, are powerfully reminiscent of the spatial structure of the *Adoration of the Lamb*; here, as there, the eye must traverse an obliquely rising scene for some distance

101 Hubert van Eyck (?), *The Three Women at the Sepulchre* (detail of Jerusalem). Rotterdam, Museum Boymans-van Beuningen

102
Ghent Altarpiece (detail),
St Christopher with Pilgrim Saints,
Landscape

103
Hubert van Eyck (?),
The Three Women at the Sepulchre.
Detail of Fig. 101

before coming upon the material and spiritual central focus of the picture. At all events, we are still far from the stacked layers of space, with no middle ground, that present themselves to Jan's stilled gaze. Nor, on the other hand, does *The Three Women at the Sepulchre* follow precisely the same style of representation of space and landscape as the *Adoration of the Lamb*. The size of the figures does not gradually diminish with distance; and the sarcophagus receives a surprisingly un-perspectival, parallelogrammic, unforeshortened rendering that contrasts with the comparatively clear perspectival recession visible in the altar and fountain of the Paradise landscape in Ghent.

 The greatest measure of stylistic agreement with the Ghent Altarpiece is in the details of the form of figures and landscape. To cite only a few examples: the two standing Maries have exact analogies in the procession of the Virgin Saints. The angel is a gentler brother to the Gabriel in Ghent, though his draperies are not given the same stereographic treatment. His sleeve, flowing into the line of the hand, is found in an identical form in the angel who swings a censer at the foot of the Altarpiece of the Lamb, and the indecisive billow and fold of the lower draperies reappears in the prophet figure to the left of the Fountain of Life. Another parallel is the pattern of folds in the figure of the Virgin Annunciate. Among the characteristic features of the landscape, we have already mentioned the parasol pine on the hillside; there is also the dabbed, far from solid-looking rendering of the bushes, for which a clear point of comparison is to be found in the upper left-hand corner of the Paradise landscape. Perhaps the most convincing analogy, however, lies in a background motif, that of a little path that snakes its way out of a wood and downhill, behind the angel's wings in the Rotterdam painting and in the upper right-hand part of the *Pilgrim Saints* panel in Ghent.

 It is worth stressing that this painting is not only the earliest depiction of the Easter story in a landscape setting, and not only the first in which the location is indivi-

85

Plate 21

103

102

dualized, but probably also the very first attempt to suggest the atmospheric light of Easter morning. The lighting is by no means entirely consistent: the buildings of Jerusalem are lit from the left, while the figures are lit from the right. Even so, there is an atmospheric sense of the roofs of the city emerging from the first grey light of dawn.

The status of *The Three Women at the Sepulchre* in Rotterdam as an early Eyckian work has never been questioned: in the conception of the landscape we have even detected some features that suggest a stylistic phase earlier than the presumably oldest parts of the Ghent Altarpiece. Are we so close to the preferred types and handling of that artist whom—in the context of the Ghent Altarpiece—we feel impelled to call Hubert that we can also ascribe *The Three Women at the Sepulchre* to him? It is a question that demands mature consideration. We shall suspend judgement until we have studied, and can take into the equation, another complex of early Eyckian works.

An equally problematic work is the *Annunciation* now in the Metropolitan Museum, New York, which some have associated with Hubert van Eyck, but which others have sought to ascribe to Petrus Christus: that is to say, to the Van Eycks' successor. This want of unanimity partly springs from its poor state of preservation. The panel has been heavily cut down at the top—there is no such thing as an Early Netherlandish painting that totally lacks a horizon—and the figures are in a precarious state, the paint having been so damaged that the drapery folds, in particular, can be spoken of only with the greatest caution. It is certain that the invention of this *Annunciation* scene belongs to an evolutionary phase in which artists had not yet learned to set that scene in an interior; the innovation of the Mérode Altarpiece was still unknown. In the New York *Annunciation*, as with Broederlam and with the Limbourgs, only the Virgin has an architectural setting: the angel kneels out of doors. The interior is incorporated in an architectural structure, seen from outside; although this is not a loggia-like annexe, as in Broederlam, or a chapel-like, roofed Gothic aedicule, as with the Limbourgs: Mary appears in the open doorway of a church, through which we glimpse the interior.

This is a transitional solution, for which a contrary example is to be found even among the early works of the Master of Flémalle. The oblique position of the façade, and the slight perspective distortion; the inclined, constantly rising stage on which the action takes place; the curved path that the angel seems to have taken, echoing the curve of a wall in the middle ground; the dabbed painting of the foliage, and the dotted highlights; the disembodied look of the hands; and—if we can trust what we see—the relatively unarticulated facial features: all these put us in mind of *The Three Women at the Sepulchre*, and of Hubert.

The third work that needs to be considered here is an immaculately preserved *Crucifixion* panel in Berlin. At first sight, there seem to be considerable differences between this and the works discussed so far. Its traditional row of three figures is large and stands in front of the landscape—instead of being part of it, as are the middle-sized figures of the *Adoration of the Lamb* in Ghent, of the Rotterdam *Three Women at the Sepulchre* and of the New York *Annunciation*. But this difference may perhaps be accounted for by the specific devotional type represented by this Berlin *Crucifixion*, a type in which it was an unwritten law that the figures must be in the foreground.

In spite of this requirement, which forces the painter to make the faces and the relief of the draperies more distinct, there is no sign of Jan's stereographic modelling; and it is not difficult to find many striking analogies with Hubert's contribution to the Ghent Altarpiece, and also with the two other works that are—let us say—under suspicion of being Hubert's. The faces of Mary and John, distorted with grief, are

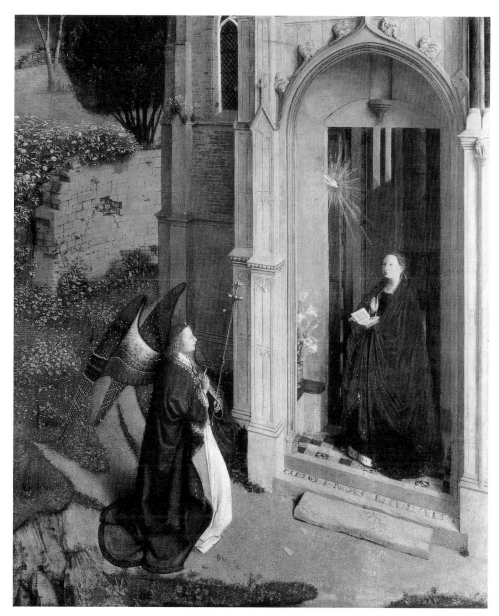

104 Hubert van Eyck (?), *Annunciation*.
New York, Metropolitan Museum of Art, Friedsam Collection

closely related to the grimacing types in the *Adoration of the Lamb*; and John's hair is painterly and shaded, not tight and sculptural. The fingers always follow a curved motion of the whole hand and are not bonily, angularly individualized. The landscape hangs behind the figures like a backdrop, but it is divided by a path, running obliquely into depth, which marks a diagonal on the picture plane. There is no break or hiatus between background and foreground, even though in this case the figures are not incorporated within the diagonal ground plan.

The landscape and townscape motifs in the background also invite comparison with those in the *Adoration of the Lamb* and *The Three Women at the Sepulchre*. Both views of Jerusalem have the same idiosyncratic orientalism, with its attempt to evoke historical and local colour by crowning Romanesque keeps, both square and cylindrical, with a variety of domes and conical roofs. Orientalism also affects the plant

omine dat cantatem nestram deus?
o preciose pietatis lampades iulianus
et martha quos unigeniti siu peregriná
tis in carne noluit esse pastores t hospi

kingdom: parasol pines and cypresses stand out against the sky, although juxta-posed—rather comically, to our eyes—with the sails of a Dutch windmill. Clearly, it was no violation of geographical truth, as then understood, to have the city with its oriental domes, parasol pines, cypresses and distant windmill overshadowed by an Alpine mountain range on the horizon.

Among the most original things about the Berlin *Crucifixion* is its colour. It had become a rule, in the traditional triadic schema of a *Crucifixion*, to set the figures of Mary and John against each other in a powerful contrast of red and blue. Without abandoning the traditional colour symbolism, the Berlin painting softens the contrast in a curious way. First, the strong colours worn by the figures do not stand out clearly as they do in earlier work—and as was later to be the case with Rogier—against a drab, neutral-toned landscape. What impinges on the landscape is the markedly lighter tone of the outer garments, a bluish white for the Madonna and a light, whitish wine-red for John. It is only in the undergarments, which create a kind of inner form, that the tone rises to a bright blue. In a word, the painter has provided a gradual transition from intense to dull; and this he has done with broken colours. What happens is not so much that the red is lightened by the fall of light on it, but that in a strange way the neighbouring colours affect it. It is as if the red of John's mantle carried a reflection of the bluish white of Mary's, and as if John's red were to cast pink shadows on Mary's white.

Light and shadow in medieval painting, and in many later schools, were created with black and white; light and colour were opposed. The supposition that bright colours interact entails an entirely different conception of the structure of colour, in which coloured light and coloured shadow proclaim an entirely new unity of all that is visible. The Berlin *Crucifixion* is, to my knowledge, the earliest example of painting in full colour with tonal effects: a technique that was later to find its purest expression in Holland. And with this we touch on the problem of the relationship between Hubert's works, whether authenticated or ascribed, and a group of paintings that anticipate the supreme achievements of seventeenth-century Dutch painting. It is to this group, which includes manuscript illuminations, panel paintings and drawings, that we must now turn.

The key position here is occupied by a number of miniatures painted, at a date that remains a matter of controversy, in a Book of Hours that once belonged to the Duke of Berry. Begun as early as 1390 or so, this manuscript has had a very eventful history. This is not the place to go into the still largely unresolved complexities of its genesis and subsequent fortunes; but a few basic facts are necessary for the understanding of the origins of the Eyckian style.

Even before the Duke of Berry died in 1416, the uncompleted *Très Belles Heures de Notre Dame*, as his inventory called it, had left his library and had been divided into two parts, which were thenceforth to be treated as separate entities, each with a calendar section of its own. One portion, on which work had been completed, came into the possession of Robinet d'Estampes, secretary to the Duke, and continued to be owned by his descendants for several centuries. After safely negotiating a number of perils, it finally came to rest after the Second World War in the—let us hope—safe haven of the Bibliothèque Nationale in Paris. Its illumination was the work of several generations of artists, all presumably employed by the Duke of Berry in Bourges.

The second and larger section of the manuscript, not much of which had yet been illuminated, found its way, probably by the second decade of the fifteenth century, into a Netherlandish workshop; we do not know for certain where this was, save that the principal illuminator who worked on it at this stage intended his work for the

105
Hours of Turin,
*The Sea Crossing of St Julian
the Hospitaller and St Martha,*
fol. 59v (destroyed by fire)

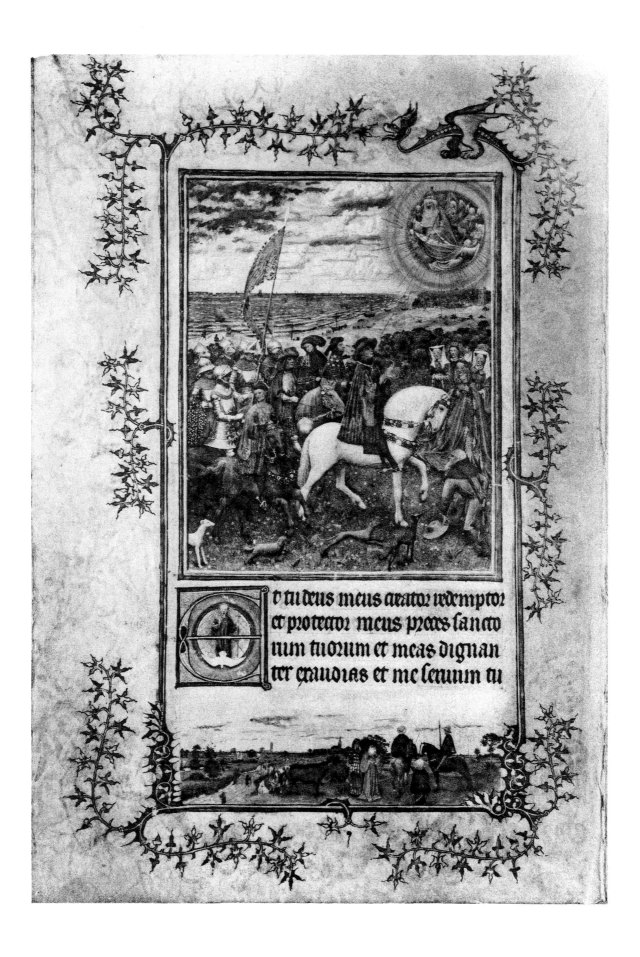

court of the counts of Holland. However, the book did not remain in the Netherlands; it found its way by a mysterious route to Northern Italy, and by the eighteenth century it is known to have been in the library of the Duchy of Savoy. Once more—and, as we must now say, fortunately—it was divided; half of it entered the library of Prince Trivulzio in Milan, and the other half went to that of Turin University.

The discovery of these two sections of the manuscript by French scholars at the beginning of the present century was one of art history's greatest sensations; for it was at once recognized that seven of the miniatures were by the Van Eycks.[77] The words that the Belgian scholar Georges Hulin de Loo wrote in his publication of the Trivulzio section, *Les Heures de Milan*, in 1911, remain as true now as ever they were: 'These seven leaves constitute the most marvellous group of paintings that have ever decorated any book, and, for their period, the most astounding work known to the history of art'.[78]

The joy that greeted their discovery did not long remain unclouded. In 1902, Paul Durrieu published a facsimile of the Turin portion; two years later, it was destroyed in a fire, and it is known to us only through the black-and-white collotype reproductions in Durrieu's facsimile. The other half changed owners again after the Second World War. It was purchased for the Museo Civico in Turin, to replace the treasure that had been so ill conserved before; so that the *Heures de Milan* are now the *Heures de Turin*. The name of 'Hours of Turin' is now used in reference to both the half that is lost and the half that survives; and so they are reunited in name, at least, though they can never be reunited in reality.

In the part that was lost in the Turin fire, there was one image for which no parallel exists in the entire history of manuscript illumination: it constitutes a *hapax legomenon*. It seems to have been adapted to the personality of the patron for whom the book was made, and perhaps to a specific biographical situation. The miniature shows a man (a sovereign prince, as we know from the text), giving thanks for an escape from peril on the sea. A cavalcade is seen on the seashore, awaited or welcomed by a lady and her suite. The leading horseman, who rides a white horse, has joined his hands in prayer and looks up to where God the Father appears in a circular aureole, surrounded by angels on the wing. The prince on the white horse wears the chain of the Antonite Order, the order of chivalry instituted by the counts of Holland and Hainault; and, appropriately, the ensign behind him holds aloft the banner of the house of Bavaria-Holland.

Durrieu, the only scholar who ever saw and closely examined the original, was inclined to identify this figure as William VI of Holland and IV of Hainault, of whom a chronicle records that he made a pious vow in the course of a sea crossing from England. Would the lady who awaits him therefore be his daughter and heiress, Jacqueline (Jacoba) of Bavaria? If this identification is correct—and there are other signs pointing in the same direction, elsewhere in the manuscript—the Eyckian miniatures in the Hours of Turin must have been painted earlier than 1417, fifteen years before the completion of the Ghent Altarpiece and a very few years later than the Limbourg brothers' calendar landscapes for the *Très Riches Heures*, which are pioneer achievements in themselves. On the face of it, this is an improbably early dating.

Before long, a reaction duly set in. The hypotheses proposed by Durrieu and Hulin, the discoverers of these Eyckian miniatures, seemed to make hay of all preconceived notions of stylistic evolution in the period in question; and there were a number of serious and thoughtful attempts, from various quarters, to disable their arguments and to ascribe the illumination of the manuscript to the reign of Jacqueline herself, i.e., the latter part of the 1430s. This would mean that these miniatures, which are

106

106
Hours of Turin,
Cavalcade on the Seashore
(*The Prayer on the Shore*),
fol. 55v (destroyed by fire)

107
Michelino da Besozzo,
The Coronation of Gian Galeazzo Visconti.
Paris, Bibliothèque Nationale,
MS lat. 5888, fol. 1

astonishing enough in any event, do not belong to the early part of the evolution that culminated in the monumental art of the Ghent Altarpiece but constitute reflections of that art: that they are not early works by the Van Eycks but manifestations of their influence on another artist—an artist, be it said, from Holland. The question is this: do the Turin miniatures help to lift the veil that conceals the origin of the Van Eycks' radically new painting; or do they compound this enigma, already puzzling enough, by adding another one, whereby in place of two Eyckian artists we have three? Seldom has so much depended on a satisfactory answer to the eternal art-historical dilemma: 'Belated, or premature?'

When the Hours of Turin was still in the Netherlands, its decoration or completion remained for some time in the hands of a whole workshop, whose members all spoke the Eyckian pictorial language with varying degrees of proficiency and frequently copied or paraphrased original Eyckian creations. Our primary interest here is in the master, the principal artist, to whom—with rare unanimity—scholars ascribe the seven leaves mentioned above: in Hulin's classification and catalogue of the ten hands (at least) that worked on the illumination of this important manuscript between 1390 and 1450, this person is called 'Hand G'. For the moment, let us refer to Hand G as the Master of the Turin Hours. Durrieu and Hulin regard him as identical with Hubert van Eyck, and they regard a number of the other Eyckian miniatures as early works by Jan van Eyck.

The group of seven miniatures, although unanimously regarded as the work of a single hand, is by no means homogeneous in formal terms. It falls into two categories that can be distinguished roughly as follows: in two of the miniatures the figures in the scene almost fill the whole pictorial field, and the landscape is incidental; the other five might be described as spatial or scenic images peopled with figures. No one would ever have objected to the early date of 1417 in relation to the figure-dominated scenes; but the early dating turns the other five into a mysterious and—in evolution-ary terms—an almost inexplicable phenomenon.

It may be appropriate, at this stage, to refer to a remark of Henri Focillon's: 'A monument that has been securely dated may be earlier or later than its date'.[79] Since

108
Hours of Turin,
Mystic Marriage of St Catherine
(Virgo inter virgines),
fol. 59 (destroyed by fire)

mnes sancte uirgines mentis
et corporis puritatem.

a dated work can be ahead of its time or behind its time, those who doubt the early dating supplied by historical and heraldic evidence require to be convinced that this is a work ahead of its time—as truly creative works normally are. We must also persuade the advocates of a late dating that as post-Eyckian works, products of the 1430s, these miniatures are even more anachronistic and incomprehensible than they would be if painted before 1420. After the Ghent Altarpiece, and before the advent of Joachim Patinier, pictorial compositions dominated by an interior or by a landscape are unknown and indeed hard to imagine; they can, on the other hand, be readily envisaged as contemporaries of the calendar landscapes and crowd scenes of the Limbourgs.

On the first of the two pages with large figures, now lost, the main image was that of Mary as Queen of the Virgin Saints, Maid among Maids, *Virgo inter virgines*; the *108* scene below, the so-called *bas-de-page*, shows a procession of maidens towards a hill on which the Lamb stands, its head crowned with rays of light. This page was the only one in which the artist of the miniature also painted the ornamental frame. He erased the conventional French border of leaves and thorns and replaced it with a decidedly more naturalistic, acanthus-like garland of tendrils, curling and uncurling in three dimensions, whose foliage encompasses fabulous beasts, but also an angel, a peacock and a monkey. Incidentally, an almost identical pattern borders the cope of one of the singing angels on the Ghent Altarpiece.

The main image is not simply a Madonna surrounded by virgin saints; it is, in fact, the *Mystic Marriage of St Catherine of Alexandria*, a scene witnessed by a band of holy virgins. For reasons as yet unexplained, a centralized composition on this very theme is a favourite subject in the 'soft' style of International Gothic, from Northern Italy to Bohemia and from Austria to France and Flanders. What is more, in this work the *107* ideal of feminine beauty—extreme delicacy and slenderness, slight, thin arms, girlish features with dainty mouths and chins—and the style of the figure and drapery painting, remain entirely wedded to the aesthetic canon of the beginning of the fifteenth century. Here and there, as the trailing skirts meet the ground, there are areas of turbulence; even so, the folds do not kink but slip sideways in a curve to maintain the continuity of form.

Most characteristic of all is the treatment of the seated pose. The eye is distracted from the horizontal of the lap, which would otherwise have required a degree of foreshortening, by a swathe of cloak that is draped across from the Virgin's left arm and falls to the ground only to loop round to the right again in a gentle, sickle-shaped curve. The seated figure grows gradually and consistently narrower from bottom to top, without ever really forming a lap. As a result, there is nothing for the Child to sit or stand on, and the Madonna pins his wriggling form to her side with one hand. Another typical feature of this period, with its persistent avoidance of fully three-dimensional form, is the shape of the Madonna's crown, which is a frontal diadem with an ornamental façade but no circlet.

Finally, it should be said that the girlish feminine type, with its tendency to a daintily pointed chin, seems to have been endemic in the Lower Rhine, Holland, Flanders, and even England at the very beginning of the fifteenth century; and that it is very unlike the rounded or fully oval face that we know from the authenticated works of Jan van Eyck. At best, a few of the slimmer virgins of the processional group in the *Adoration of the Lamb* might be adduced as analogies; but this does not help very much, as these are figures in which it is particularly difficult to decide whether they are by Hubert or by Jan.

We have just named the one group of figures on the Ghent Altarpiece that springs

109
Hours of Turin,
Discovery of the True Cross.
Turin, Museo Civico, fol. 118

os autem gloriari oportet in cruce dñi
nostri ihesu xpristi in quo est salus uita
et resurrectio nostra per quem saluati
liberati sumus. ps. deus misereatur

to mind—on grounds of content, if on no others—when we look at the *bas-de-page* of the page in question. In this miniature, the Lamb does not stand on an altar but on a hill, the Mount Zion of the Book of Revelation; this is an illustration of a different passage in the biblical text. But the grouping of the procession of virgins, with their slight, frail bodies clustering into a compact mass, exactly corresponds to that of the Ghent panel. Is this a 'first idea' for the corresponding part of the *Adoration*, or—if the early dating is rejected—is it an imitation, a comparatively free copy, of a detail from that monumental work? Where the latter option is concerned, one fact deserves particular emphasis: however similar the whole may be, there is not one single figure that is a literal repetition. If the vignette is a copy, it is a copy without any agreement of detail: a highly infrequent occurrence. On the Ghent Altarpiece, every saint bears the palm of her martyrdom, and some carry an additional attribute; in the vignette, the virgins seem to sing as they advance towards the Lamb on its hilltop, without palms or attributes, but with open books in their hands. On close inspection, this vignette turns out to be a highly independent version of the theme of the homage of the Virgins to the Lamb, and one whose similarity is largely rooted in the related thematic content.

I can touch on the other large-figured scene by the Master of the Hours of Turin only briefly, to point to the oblique, serried arrangement of the figures in the miniature of the *Discovery of the True Cross* in the presence of Constantine and St Helen. The diagonal structure here bears a particular relationship to the content. If we trace it across the picture plane from top left to bottom right, the eye is drawn gradually, via the stooping digger, to the surface of the ground itself. The motion from top to bottom is interpreted in two senses at once, as an organization of surface and as an indication of spatial position. *109*

The figures are still very largely two-dimensional; but the figure of St Helen herself, with the compact relief quality created by her drapery folds, represents an advance towards the articulated modelling of the Virgin Saints in Ghent; it is no longer quite so serenely curved as that of the virgins in the *St Catherine* miniature. By contrast, the weightlessness and instability of the male figure to the right of the Empress looks particularly old-fashioned and almost recalls the weightless figures of the late fourteenth century, the figurative canon of the Wenceslas Bible. The landscape, on the other hand, is surprisingly modern, especially the rendering of the sky, with its acutely observed differentiation of cumulus, cirrus and other clouds: a first portrait of the real sky.

The five other miniatures in this group bear witness to a supremely gifted painter's voyages of discovery in the realm of the phenomenal world, which lies before everyone's eyes, but which the many can perceive only after one individual has had the courage to demonstrate that it is worth depicting. The group includes two interiors, one ecclesiastical and one secular, and a variety of open landscapes: a seashore, as seen once from the land and once from the sea; a vista with a city on the horizon, by evening light; vignettes of extensive views across wide plains and river valleys. All these are images in which the experience of space comes first, and the theme becomes secondary. We see the interior of a church during a requiem mass, not a requiem mass in a church; a room with women busying themselves around a woman in childbirth, not the Birth of St John the Baptist in an enclosed space, and certainly not the scene of the Naming; a river valley with a castle on the bank, in which we almost overlook the Baptism of Christ, for the sake of which the scene was designed. On one occasion we see a wide expanse of lowland, caught in a tiny strip of painting, and have no idea what this scene could signify in the liturgical context of a Book of *Plate 16, 17*

110
Hours of Turin,
Betrayal of Christ,
fol. 24 (destroyed by fire)

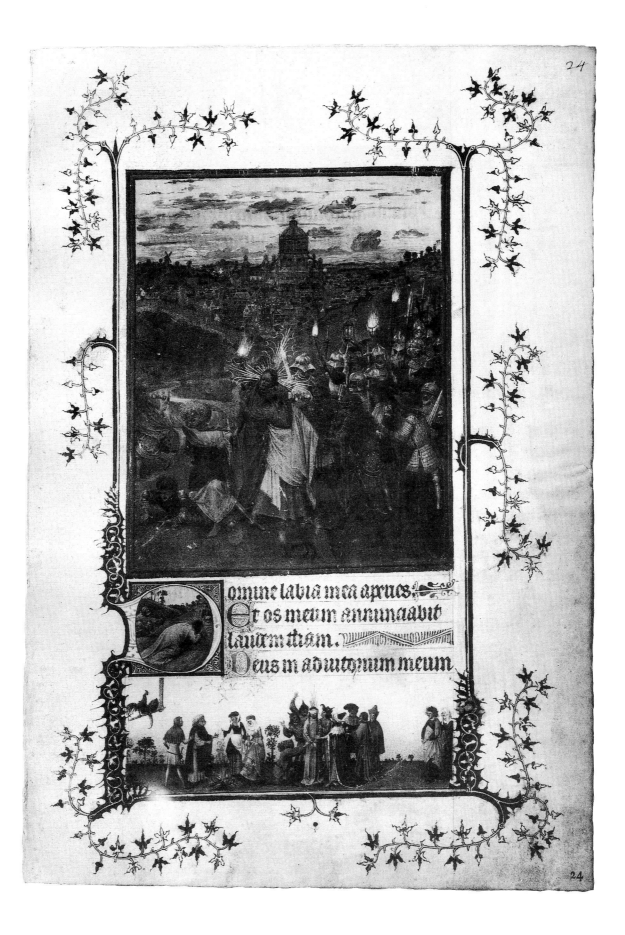

omine labia mea apcues.
Et os meum annunciabit
laudem tuam.
Deus in adiutorium meum

Hours; what is more—and whatever the iconologists may say—this does not detract in any way from the experience of this extraordinary little work of art.

Perhaps this artist's most astonishing and inexplicable stroke of daring was his depiction of the *Betrayal of Christ*, the Judas kiss by torchlight, which as far as we can see was the first night scene in post-antique art. The difficulty of appreciating this kind of atmospheric lighting with only a black and white plate available makes the destruction of this miniature in the Turin fire of 1904 a particularly painful loss.

110

The Limbourg brothers did make the attempt to depict nocturnal scenes; and, in one unforgettable miniature, they show the scene recounted in St John's Gospel in which, at night on the Mount of Olives, Jesus makes himself known to the soldiers who are looking for him, and they fall to the ground in terror. There are three weak sources of light in the picture: the stars scattered across the sky, Christ's radiant nimbus, and the flames of a few torches, together with a lantern that has fallen to the ground. Bright colours are eliminated; the night has extinguished them, and transformed them into gradations of dark blue-black and silver-blue, with a reddish gleam. And yet the whole is only a colour-free daylight scene; if we look closely, we can see all the bodies of the soldiers who litter the ground like casualties on a battlefield, in all their varied postures and forms.

In the *Betrayal of Christ* by the Master of the Hours of Turin, more torches burn than in the Limbourg scene, and the torchlight is reflected from the armour and weaponry; the sky is an evening one, its clouds illuminated by the light of the moon. And yet the impression of darkness, of nightfall, is complete. For the painter has understood that darkness cannot be suggested by imposing dark colours on a normally lit scene; he has realized that darkness is fragmentary visibility. There are many places within the picture where we sense the presence of objects or forms that we cannot make out, because they are swallowed up in darkness. This is a painter who knows how to paint what cannot be seen, not by making it visible but by suggesting to us that it is there; and this is one of the supreme *tours de force* in painting. Here, for the first time, light and darkness are concrete facts; or, to put it another way, things no longer exist—as they do in the Limbourgs' night scene—independently of their being seen. And so the episode of the *Betrayal of Christ* takes on the unearthly quality of night-time, when evil things are abroad that shun the light.

In the new painting of lighting effects, there are other things that become sayable for the first time. In the dark it is impossible to tell how many people are present; when we have the sense, as we do in this miniature, that there are more people in the scene than we can actually discern, we begin to sense the presence of a crowd, a mass, rather than of a sum of individuals. The artist of the Turin miniatures is a master of massed figure effects in his daylight scenes, too; here he has instinctively grasped the opportunity that reduced visibility offers to create a truly credible crowd scene.

As for the landscape and spatial construction of this miniature, it remains to be said that the townscape of Jerusalem nestles into the middle ground in very much the same way as the Jerusalem of *The Three Women at the Sepulchre*. The skyline is dominated by a centrally planned building broadly reminiscent of the Dome of the Rock, heightened into Gothic fantasy by the addition of a ring of flying buttresses.

101

As Jerusalem tucks itself into the landscape of the *Betrayal of Christ*, so does the sea into the coastline of the *Cavalcade on the Seashore*. The waves of the sea introduce a dynamic element, and we gain the impression that the sea is pressing towards the land from the horizon. This force transfers itself to the complementary form of the land, whose surface area widens continually from the horizon and from the right-hand side towards the foreground. It is important to see how the cavalcade stands

106

back from the lower edge, and how the dogs are inserted below as ancillary motifs, defining the forestage and running parallel to the motion of the figures above.

The structure of the other two open landscapes in the group is to some extent defined by the horizontal oblong of the *bas-de-page*. The Gothic, upright, rectangular form of the large miniatures presents the painter with the problem of reinterpreting the dimension of height, within the pictorial field, in terms of depth. In the vignettes, the format itself supplies a low horizon.

The result is an unprecedentedly modern-looking distant view, which makes the scene above look dated. In the *bas-de-page*, the horizon line is so low that the nearby horsemen intersect it and tower high in the air. The artist could have found no clearer way to demonstrate his repudiation of the customary representational mode: what is at the top of the picture—the horsemen—no longer has to be what is furthest from the near picture plane; things lower down, such as the church on the horizon, may be further away. Even the foreground is seen at a distance; and this pushes the horizon even further away. The distant view that is taken of the figures also partly accounts for the anonymous quality of the scene—with the result, in this case, that we are unable to determine its objective significance. We take these men and beasts for the natural denizens of this landscape, part of its life, and rest content with that. As in paintings by Philips de Koninck, the eye traverses a tiny scrap of painted surface and reads it as infinite space. In this tiny, early fifteenth-century miniature, the illusion of a limitless expanse of plain is no less perfect, and the sense of air and vastness is no less strong, than it is in the far larger canvases of the celebrated seventeenth-century Dutch landscape painters.

The remaining *bas-de-page*, too, can be classified as a landscape painting. True enough, in this tiny vignette of the *Baptism of Christ* the Baptism itself is impossible to miss, since Jesus and John are right in the foreground, outlined against the surface of the river; but the countryside that stretches out to the left and right of them seems to have been conceived, in total isolation from the figures, as the portrait of a landscape. Today, at all events, we find the figures slightly distracting; it feels as if a North European landscape of a river valley, with a castle on an island, has been labelled as the Jordan by the addition of appropriate *staffage* figures. In short, we suspect that the biblical theme has been chosen merely as a pretext for showing the peaceful expanse of a river landscape and the effect of the reflection of the castle in the water—an effect probably never before captured in a painting.

Not only is the castle reflected in the water: so is the sky. In earlier art, the earth of a landscape is allowed to slope steeply up to the top of the painting, until no air can be seen at all; now, not only is the horizon lowered, but with the aid of optical effects, and of a blurring of the borderline between the apparent and the real, the sky has been

111
Hours of Turin,
Baptism of Christ (*bas-de-page*).
Turin, Museo Civico, fol. 93v

brought down to earth. All this would have been impossible without one new factor in the picture, something never depicted before: light and atmosphere. Not only have the figures become an integral part of the landscape—even in colour, for John's mantle is a greyish brown, like the rocks—but all that is visible and concrete, including Nature itself in the landscape, has become part of something that is not concrete at all: and that is space. In the perception of colour, and in atmospheric refraction, dissimilar substances unite; the extreme case of this is the blue of the water, which is a reflection of the sky. With the arrival of atmospheric space as a unifying factor, the path is open to a true art of landscape: it is a path doomed to remain untrodden for several generations to come.

In the two interiors, too, the miniatures of the *Birth of St John the Baptist* and of the *Requiem Mass*, the Master of the Hours of Turin has broken entirely new ground; and this would remain just as true if the miniatures were assigned to the 1430s, as the work of a successor to the Van Eycks. For Elizabeth's lying-in room represents an entirely *Plate 16* independent approach to the problem of depicting an interior. It reflects premises and conclusions entirely different from those of either the Mérode Altarpiece or the Arnolfini portrait; and in many ways it is an even more revolutionary and forward- *Plate 3, 11* looking interior than either.

What is so unbelievably progressive here is the total subordination of the figure to the thing that contains it: the union of the dweller with the dwelling. The people, like their domestic animals, are there to serve the interior by animating it; the interior is not a spatial shell, built to measure as a housing for the individual figure, but the prime fact in its own right. By comparison with the room shown in the *Birth of St John the Baptist* of the Hours of Turin, even the Arnolfini bridal chamber is a box-like space; even (if I may exaggerate for once) an illusionistic foil to the figures.

Unlike the Arnolfinis, the principal figures here are not set far downstage: they lurk in the background and require to be sought out. Elizabeth is propped up against the tester of the huge four-poster bed, which forms a room-within-a-room in the far left-hand corner; and Zacharias is a tiny figure in a back room on the right, into which we look through its open door. In order to reach them, our eye must traverse—that is, must experience—the intervening space. In the process, we come across a dog and a cat, a chest and a cupboard, and two subsidiary figures, one of whom is seen from behind and therefore directs us further into the picture. It is true that in the *Annunciation* of the Mérode Altarpiece a sizeable piece of furniture stands right in the centre of the picture, just as this table-cum-cupboard does in the present case. But in the Turin *Birth of St John the Baptist*, the outlines of the neighbouring figures or objects do not fit so snugly round that of the table; air seems to circulate between them; the picture plane is not stocked with objects. We sense that the window is much farther away than the cupboard in the centre, and not directly above it, as it is in the Mérode Altarpiece. None of the figures looks as if it is about to bump its head on a beam; notice, for instance, how much headroom there is between the mother and the canopy of her bed.

All this is not just the consequence of progress in perspective construction: the Turin lying-in room is as completely innocent of the law of the convergence of all orthogonal lines as is the Mérode Altarpiece or the Arnolfini portrait. The Master of the Hours of Turin achieves a compelling illusion of interior space by contriving to convey both the idea of a void and the tonal muting characteristic of indoor scenes. The evolutionary position of this work is defined by the fact that it magically evokes an interior atmosphere without allowing us to trace how it is done, whether by analysing the fall of the light or otherwise; just as it is impossible to rationalize the

spatial construction. Effects of lighting are created—in the metal utensils over the door, for instance—while we remain unable to locate either the source or the path of the light. The window in the far wall is painted silver. To judge by the highlights on the jug on the table, the light must come from the viewer's side; and this is a reminder that we are still quite close to the time when the viewer was stationed outside and looked into a room from which the near wall had been removed.

If we can speak of a single viewpoint at all, it is well over to the right of the room; but we see none of the side walls: not on the right, because here we look straight ahead, parallel to the right-hand boundary of the space; and not on the left, because the encapsulated space of the four-poster bed conceals the wall. From the near left, the eye enters the picture along a zigzag path, following the lines of recession marked by the chest and the bed. This process of feeling our way along solid bodies to gain access to incorporeal space betrays the early date of the work—except for the crucial fact that we remain entirely oblivious of it, and experience the interior as we do an interior by Pieter de Hooch.

The dominant colour is the warm red of the bed; the few bright colours worn by the diminutive figures are no more than islands of colour, far outweighed by the red drapes and, even more, by the prevalent browns of the room. There are no cast shadows, but in places there are areas of shadowed space that contribute to the creation of a tonal interior mood.

Plate 17 In the other interior, that of the church in the *Requiem Mass*, the space is once more viewed (as is the birthplace of St John the Baptist) from an off-centre viewpoint. The lines of recession in the triforium, those of the bosses of the vault and—parallel to them—those of the catafalque lead obliquely into depth as a perspectival construction. The essence of a genuine interior can best be defined by saying that it is a picture in which nothing is to be seen but what an observer inside the space itself can see: that is to say, nothing of the exterior. This requirement obliges the artist to abandon a basic precept of medieval art—namely that what is seen must be a complete whole in accordance with the abstract concept of the work—and to acknowledge the possibility that a part of an object can be a formal whole. The Master of the Hours of Turin has looked for a compromise between the wholeness demanded by the medieval aesthetic, on the one hand, and his own new and empirical experience of space, on the other; and his solution bears the mark of genius.

He pretends that the Mass is being celebrated in the choir of a church whose transepts are still under construction. As a result, we see only a fragment of the church; but then this is all there is of it to see. The fragmentary nature of the object has its explanation in the object itself, not in the eye of the subjective observer. The artist carries his game with illusion even further and continues the building beyond the frame of the miniature. The cut ends of the ribs reveal that the near boundary of the pictorial space marks a cross-section; the bypassing of the frame marks its upper boundary as a section in the sense of a detail. What we see inside the frame is the interior; what we see outside it is the exterior.

As in the *Birth of St John the Baptist*, the interior effect, and the illusion, overwhelmingly depends on the muted tonality of the light and the visual unity between—in this case—the church and the congregation. The dark clothing of the mourners blends into the half-light of the tall interior, shielded from the daylight by silvery windows, and thus favours the anonymity of the figurative element. All the figures face the altar and the priest, and therefore turn their backs to us, thus introducing another element of muteness, a lessening of the distinction between figure and setting, between animate and inanimate substance. The touches of intense red, green and blue in the

112
Jan Vermeer,
The Little Street.
Amsterdam, Rijksmuseum

garments—even the catafalque is not black but blue—introduce an element of contrast with the monotonous stony grey of the architecture.

A word of warning is in order here against the false impression conveyed by even the best black-and-white reproduction, which brings the tonal values of architecture and figures unduly close to each other and suggests a much stronger chiaroscuro and more atmospheric colour than is really there; which is to say that it makes the miniatures look like seventeenth-century Dutch interiors—those of Emanuel de Witte, for instance. Even in the original, however, the colour of the figures, confined within a small area of the picture, fails to assert itself very strongly in competition with the seemingly ubiquitous grey of the building, which sets its seal on the whole picture as a unifying tone.

And so it is a fact that the Turin miniatures contain, in a nutshell, a considerable portion of the programme that was to be realized by Dutch painting in the seventeenth century. This is especially so if we take into account those inventions by the Master of the Hours of Turin that were executed by workshop hands and survive only in reproduction—such as the street scene in one calendar vignette, which, with its glimpses into and through a row of houses parallel to the picture plane, strongly reminds us of Vermeer's celebrated *Little Street.*

113

112

The personal style and the unique scenic imagination of the Master of the Hours of Turin are clearly recognizable in a number of panel compositions that have survived, some of them in the original and some as painted or drawn copies. One original consists of a pair of paintings, a *Crucifixion* and a *Last Judgement*, that have found their way from the Hermitage to the Metropolitan Museum in New York. Whether they were designed as a diptych or—if we give any credence to a report of

115; Plate 19

113
Hours of Turin,
Street Scene
(*bas-de-page*),
fol. 11 (destroyed by fire)

a lost central panel—as the wings of a triptych, is hard to determine. It is, however, important that the original frames have survived, since they are inscribed, in the Eyckian fashion, with Old and New Testament texts.

Plate 24 These are crowd scenes. The Ghent Altarpiece, too, shows us massed forces, in its endeavour to evoke the idea of a multitude 'which no man could number'; industrious persons have nevertheless insisted on counting heads, and have come up with a total of more than three hundred. With the New York diptych, we have the impression that such an attempt would be doomed to fail. This is a true *en masse* style, in which the crowd is not a mere accumulation of individual figures but the primary, collective entity, within which individual beings become details, impossible to distinguish fully.

The first signs of a specific style of crowd rendering *en masse* emerged in Italian trecento painting: in Florence, in Siena, and above all in Northern Italy. It was there that the type of the crowd *Crucifixion*, the 'Crucifixion in the Presence of a Multitude', first arose. French artists, and especially those in the Duke of Berry's cosmopolitan workshops, knew all about this by 1400, and about the two-tiered composition that was particularly suited to the filling of tall, narrow pictorial formats. In this compositional type, the three crosses stand on a raised plateau, surrounded by a tightly packed mass of soldiers, both horse and foot, and of spectators. Below this shelf—on the ground floor, as it were—is a second troop of horsemen, almost all seen from behind, who serve as a ring of repoussoir figures, all looking up at the place of execution. The figures at the bottom also mostly face away from us; only the group gathered around the swooning Mary is seen frontally. Even so, the grief of those closest to Jesus is reduced to a mere episode, lost in the mass spectacle that the Crucifixion has become.

In the New York *Crucifixion* there is no plateau or shelf, only a single, steep upward slope, such as we are accustomed to find in North European tapestries; the development into depth is a continuous one. At the same time, for this Northern painter, the upper and lower parts of the picture differ totally in expressive value. He separates the emotive group round Mary from the hostile crowd and moves it close to us, at the lower edge of the painting; first a back view, then the kneeling figure of Mary Magdalene, her head thrown back to gaze at the crucified Christ with her face in lost profile, wringing her hands. Above this group of slumped and kneeling figures, their faces partly or fully concealed, there rises a pair of standing figures in back view: soldiers in oriental dress, looking up at the cross. Only then do we encounter the mounted men, who seem to form a ring around the crosses: those nearest to us seen from the rear, those on the far side seen frontally. Above these, the terrain goes on rising, until the distant prospect of Jerusalem becomes visible over the brow of the hill. And even that is not the end. Above the battlements of the city, the eye plunges into the vast expanse of a distant river valley; on the skyline is a mountain range, its colour modified by aerial perspective. The crosses, however, rise still higher into the air and stand out against the partly clouded sky.

In following this trajectory, the eye falls on an inexhaustible profusion of details extracted from concrete reality. Burgundian and oriental costumes, oriental types, portraits of contemporary Netherlandish rulers, a variety of horses in widely differing poses, all manner of arms and armour and countless effects of light and shade, from the half-shade between the horses' hoofs, or the dark, bushy hair of the exotic types, to the blue of the mountainous horizon: it is a whole world in one painting, an *orbis pictus.*

The *Last Judgement* panel has more surprises in store for us. As on the Judgement portals of Gothic architecture, the individual episodes of a multiple narrative unfold

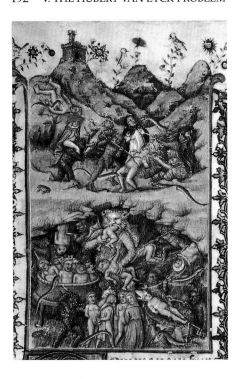

114
Zenobi da Firenze,
Inferno.
Cleveland Museum of Art,
MS 64.40, fol. 211

in superimposed layers; but here, in place of an additive arrangement of flat strips, every zone—from Heaven to the depths of Hell—is assimilated into a single, spatial cosmos. As on the Gothic portals, the large scale of the *Deësis* group makes it a fitting culmination for the whole; and, as on the portal of Bourges, Michael marks a powerful accent at the divide between Heaven and Hell, where he officiates not as the weigher of souls but as the vanquisher of all evil. And yet the biggest figure of all, staring out at us in hideous close-up, is below the Archangel's feet: the gigantic bat-winged skeleton whose bony arms and legs, outstretched parallel to its wings, arch over the Damned, their infernal torments and their tormentors.

Death has become the protagonist of the Last Judgement. Even though the motif of the Archangel who stands on Death's shoulders and raises his sword to strike is certainly intended to signify his victory over Death, the viewer finds it hard to believe that this youthful warrior can ever prevail against his monstrous adversary. The same applies in a wider sense: the punishments of the wicked are more convincingly rendered than the rewards of the virtuous. Beyond comparison, Hell is more vividly depicted than Heaven. The inventor of this Hell shows a mastery of the demonic that at once recalls Hieronymus Bosch, who lived many generations later; and indeed even that great specialist in Hell never did anything better.

In the pictorial evocation of infernal torments and the monsters of Hell, the Italians, inspired by Dante, had made an extremely auspicious start. Italian and Italian-influenced artists had initiated the North into the secrets of Dante's *Inferno*; but this *114* Latin Hell, with its anthropomorphic devils and its bombastic Hades/Satan, looks positively *gemütlich* by comparison with that in the New York *Last Judgement*. Horned devils have been replaced by a whole fauna of zoomorphic fiends. The artist's imagination has spawned a bestiary of Hell, ultimately derived from the magical world of medieval monsters, grotesques and drolleries, but roused to life by the breath of a naturalistic age. Based as they are on empirical nature study, these infernal creatures look entirely natural, and this makes them all the more terrifying.

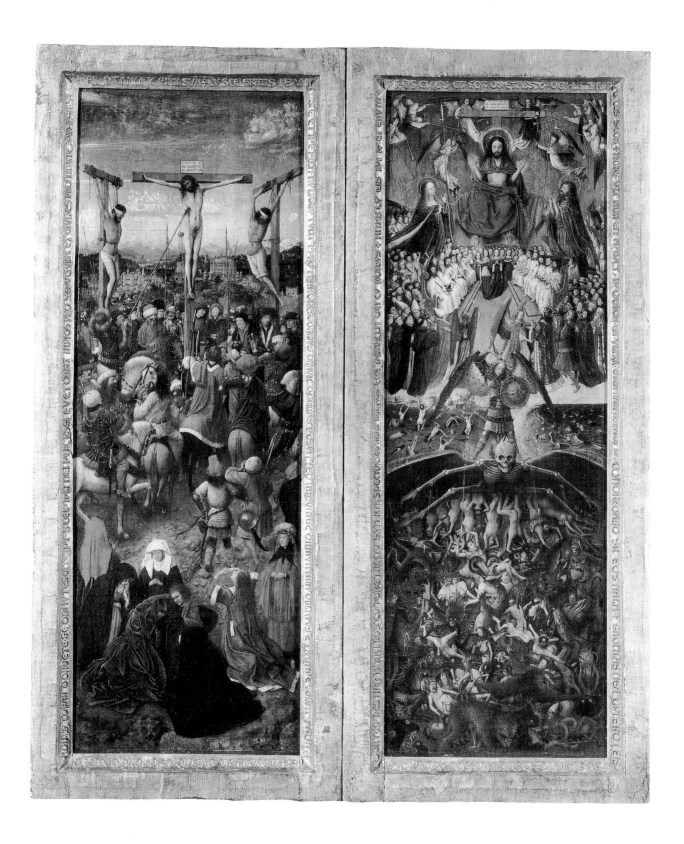

115
Master of the Hours of Turin
(Hubert van Eyck?),
Crucifixion and *Last Judgement*.
New York, Metropolitan Museum of Art

The tumult of this Hell has a very ancient Northern tradition behind it: for the new *en masse* style made it possible to revive the labyrinthine nightmares, the zoomorphic enlacements, of the Insular Style. And so the artist has succeeded in suggesting the state evoked by the words that appear on one of Death's wings: CHAOS MAGNUM, Great Chaos.

Written on the other wing is UMBRA MORTIS, the Shadow of Death. This too points to the nub of the artistic problem that has been solved here. Beneath the pinions of this skeletal figure lies the shadowy world of Death. We know from the *Betrayal of* 110 *Christ* miniature that the Master of the Hours of Turin could paint darkness; and here he has succeeded in evoking the illusion of near-impenetrable gloom, from which the various zoomorphic fiends and monsters emerge, and into which the bleeding bodies of their victims sink. Although light and shadow are not depicted as such, the artist observes and renders optical phenomena that can exist only for a pictorial imagination that thinks primarily in chiaroscuro terms. The artist who painted the scene of Hell in the New York diptych was the first ever to convey the physiognomy of the macabre, the fear of the dark as the refuge of all those evils that shun the light of day. This enabled him to capture the terror of night-monsters of which we see no more than their glittering eyes and the white of their fangs.

A reddish glow plays on the human bodies, but the fires of Hell are nowhere to be seen; and this sets the Eyckian Hell apart from that of Hieronymus Bosch. The Master 116 of the Hours of Turin has reserved the supernatural symbolism of fire for his depiction of the earthly world. In the distant prospect that opens between Heaven and Hell, the Resurrection of the Body is in progress; this is the moment when earth and sea give

116
Master of the Hours of Turin
(Hubert van Eyck?),
The Carrying of the Cross (copy).
Budapest, Szépmüvészeti Múzeum

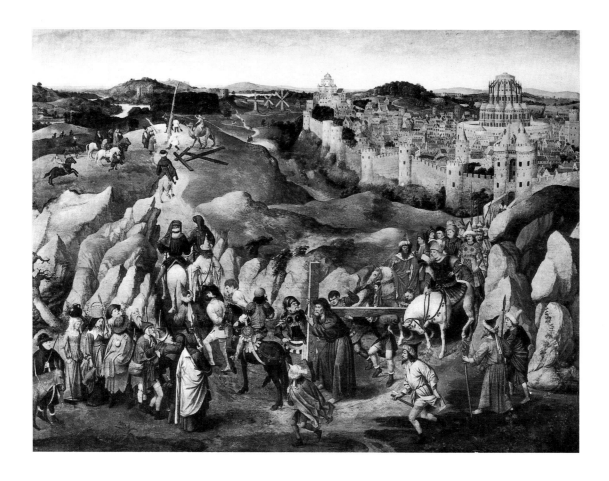

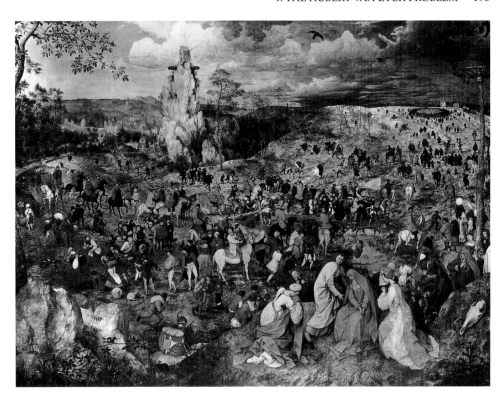

117
Pieter Bruegel the Elder,
The Carrying of the Cross.
Vienna,
Kunsthistorisches Museum

up their dead.[80] Here, probably for the first time, the resurrection on Judgement Day is visualized in terms of a cosmic landscape. The earth splits asunder; from a rough sea, human hands stretch up towards Heaven. Fire, too, plays its part in the turmoil of the elements, bursting out of the ground in the distance on the left and destroying the habitations of men.

In heaven itself, all is sweetness, gentleness and order. Neatly segregated, and escorted by angels, the clergy on the left and the laity on the right proceed to their eternal bliss.

It is a measure of the extreme originality of his pictorial imagination that the Master of the Hours of Turin is instantly identifiable as the author of a pictorial composition even when it survives only in copies or paraphrases. By common consent, he was the original creator of a large *Carrying of the Cross* composition that seems to have remained one of the most famous of all pictorial inventions until far on in the sixteenth century; numerous leading artists, Martin Schongauer and Pieter Bruegel among them, were inspired to paint their own free versions of it. A sixteenth-century painting now in Budapest probably gives the best idea of the original, although for an accurate reconstruction we need to refer to other copies as well. (For instance, the Budapest painting lacks Mary and her attendant figures, an iconographic impossibility; they will have been some distance back from the near edge of the picture, half-way between the procession and the city wall.)

Just as the Master of the Hours of Turin stages the Crucifixion as a crowd scene, so he transforms the *Carrying of the Cross* into a mass spectacle. The Italian trecento artists had been fond of peopling this subject with large numbers of figures; and their compositional ideas were developed in original ways by such artists as Jacquemart de Hesdin and the Limbourgs. These are always compositions in movement, unfolding within a landscape setting. In some of them the spectators in the crowd play a considerable part; but as yet no clear distinction is made between those actively

116

117

118

involved in the procession and the curious onlookers who line the route. This
distinction becomes clear in the *Carrying of the Cross* by the Master of the Hours of *116*
Turin. The onlookers have moved downstage; their back views, which act as repous-
soirs, form a framing curve, parallel to the motion of the procession towards the place
of execution.

In the right and left foreground are masses of rock that serve an important function
in the stage-management of space and motion. They mask the transition from back-
ground to foreground, and at the same time they serve as fixed cornerstones to set off
the activity of the mobile element, the procession, and define its route. To clarify the
compositional idea involved, perhaps I might use the analogy of a revolving stage
flanked by two static towers. The analogy is justified, because the interaction of time
and space, which is the essence of the use of a revolving stage, is also a decisive factor
in the pictorial composition. The background on the right, from which the procession
emerges, is also the past; the distant scene on the left is also the future. The present is
located just where the curve of motion meets the tangent of the near edge of the
pictorial space. Here, too, the artist has made sure that the motion does not falter: in
the gap between the two flanking groups of onlookers, there are figures who run along
beside the procession, to give the viewer the sensation of an event that is passing him
by. The presence of mounted figures at the head and tail of the procession helps to
suggest the distance that has to be covered.

Here, space is interpreted as a movement that emerges from depth and curves
round into depth again; it is a flowing, migrant space. Jerusalem seems to bulge
outward into the open country, just as in the *Cavalcade on the Seashore* of the Hours of *106*
Turin the sea surges landward to create the curve of a great bay. Perspective is not—as

118
Jacquemart de Hesdin,
The Carrying of the Cross.
Paris, Louvre

it later becomes with Jan van Eyck—a quality of seeing, but an activity of the seen. The style of the Master of the Hours of Turin is, if you will, a style of *becoming*, not a style of *being*.

With its sense of the passing of time, the great composition of the *Carrying of the Cross* is not only a record of an event but a pictorial chronicle: the march to Golgotha as a history play, with simple countryfolk in the cast. In keeping with his descriptive, historical approach to the theme, the artist combines oriental-looking buildings and costumes with landscape and folklore details from very much closer to home. In the light of the development of North European religious art in the early part of the modern period, it is not hard to understand why many of the most famous Nether-landish artists of the sixteenth century were fascinated by this work, and why they regarded a work that was already more than a hundred years old as highly modern. It approached sacred legend from the viewpoint of the common man; and this marks the inception of a form of artistic narrative in which an event could be approached solely through its effects—though this by no means excluded the possibility of endowing it with universal resonance. As the first fruit of a radical secularization of religious art, the *Carrying of the Cross* of the Master of the Hours of Turin carries within it the germ of both the 'cosmic landscape' and the 'panorama of folk life' of the sixteenth century.

A thousand threads link Eyckian art, including those three panels of the Ghent Altarpiece that depend most closely on Hubert's contribution, with that of the Master of the Hours of Turin. But how are these links to be interpreted? In my opinion, there are no less than four theoretical possibilities. First, the anonymous Master of the Hours of Turin represents an early phase in the art of Hubert van Eyck. Second, he is the young Jan van Eyck. Third, he is a personality in his own right, identical with neither of the Van Eyck brothers, and active before the painting of the Ghent Altarpiece. Fourth, he is a personality in his own right, but active after the completion of the Ghent Altarpiece: a follower of the Van Eycks. Historically, not all these four theses are equally plausible. We are dealing with a phase of transition between the anonymous history of art and the history of artists; and as in other cases this makes investigation not easier but harder, because less clear-cut.

Understandably, the question of the critical standing of the Master of the Hours of Turin has long been identified with that of the relationship between his work and that of the Van Eycks. This view, which confounds an issue of chronology with an issue of quality, has not exactly been conducive to rational investigation. Whether the complex of work associated with the Master of the Hours of Turin is dated early or late also determines whether we are looking at a pioneer achievement or the work of a follower; and this in turn calls in question the originality of the very nucleus of the Eyckian *oeuvre*. Not to put too fine a point on it: if the date is early, it is automatically assumed that the Turin miniatures are by one of the Van Eyck brothers. For, according to current ideas of artistic originality, to do otherwise would be to detract from the fame of the Van Eycks.

And yet we have no right to allow issues of quality, whether genuine or not, to distort our verdict on the evolutionary status of the Master of the Hours of Turin. External and internal evidence alike precludes the possibility of a late dating, the fourth of the theoretical possibilities mentioned above. On the strength of armorial bearings, emblems, and the identity of a number of the persons depicted, Durrieu, the discoverer of the Turin miniatures, proposed an early dating, not later than 1417; and this has largely been confirmed by the discovery of the Eyckian *Fishing Party* water-colour, with its depictions of a number of the same individuals, known to have died

119
After Jan van Eyck,
Mystic Marriage of St Catherine.
Nuremberg, Germanisches
Nationalmuseum

in 1417. However, this in itself introduces new complications. The most authoritative critics have considered Hubert to be the probable artist of the Turin miniatures; but for the contemporary group portrait of the Count of Holland's court, surely Jan has to be regarded as the most likely candidate. It is, however, pure gain to find our notion of an 'early Eyckian style' beginning to widen into a variety of facets.

We can, to some extent, enrich the detail of our view of the transitional period between International Gothic and the mature Eyckian style by enlarging it to include copies or drawings made from Eyckian originals. A number of years ago, I drew attention to a drawing of a lost Eyckian painting of the *Mystic Marriage of St Catherine*,[81] which challenges comparison with the *Mystic Marriage* in the Hours of Turin but simultaneously points forward to the *sacra conversazione* in Jan's *Madonna of Canon van der Paele*, of the mid 1430s. In several respects, including the solid masses of the figures, their weightiness, and the discontinuity of the drapery folds, the style of the composition recorded in this drawing (now in Nuremberg) is actually more progressive than that of the Turin miniature; but in the central figure herself there is a continuity of overall form that springs from the object itself and not from the way in which it is seen. Foreshortening in the lap has been avoided, partly by masking it with the figure of the Child; above all, however, the enthroned figure of the Madonna widens gradually towards the base, like an inverted funnel, instead of developing towards us, in a stepped block, as it does in the *Paele Madonna*.

A further step towards the conquest of the third dimension is taken in the figure of God the Father in the *Fountain of Life* in the Prado—a copy, as will be remembered, of an original painted by Jan in 1428–29. The enthroned figure still expands from the tip of the tiara to the ground in a compromise between two-dimensional outline and spatial form; but the descent is rhythmically punctuated by the stepped sides of the throne. Finally, the Ghent Altarpiece supplies the solution: no transitional surfaces link the successive zones of depth; the lap is orthogonally foreshortened; the seated posture appears as the forming of a block, not as a gradual widening. From all this, it

119

Plate 13

79

follows that the original of the Nuremberg drawing requires to be dated somewhere between 1417 and 1428.

The relationship between the two *Mystic Marriage* compositions is paralleled, I think, by that between two versions of the *Adoration of the Magi*, respectively recorded by drawings in Berlin and in Amsterdam. Both are described in the literature as inventions by the Master of the Hours of Turin: mistakenly so, in my view. Not only is the Amsterdam *Adoration* more advanced than the other in its repudiation of the visual habits of the International Gothic, and thus probably later in date, a product of the 1420s: the two compositions are fundamentally different in pictorial structure. Only the repertoires of types are related. In the Berlin drawing, the diminutive figures are impossible to separate from their landscape setting; but the artist of the Amsterdam drawing has succeeded in doing exactly this, without in any way impairing the narrative content of the figure composition. The probability is that these drawings reflect two distinct and contrasted artistic personalities.

Nor is that all. The central issue was first raised by Max Dvořák, with his usual uncanny instinct for the great inner connections of art history.[82] Once scholars became aware that the original underlying the Budapest *Carrying of the Cross* was a major work by the Master of the Hours of Turin, and moreover one of the most historically significant works in all Early Netherlandish painting, Dvořák was the first to spell out the conclusion: this is the origin of Dutch painting, the art of Holland, which reached its supreme flowering in the seventeenth century.

What he implied, but did not say in so many words, was this. The Ghent Altarpiece, the joint work of the Van Eyck brothers, and the authenticated works of Jan, have hitherto been regarded as manifestations of a pan-Netherlandish artistic impulse, not of a specifically Dutch one. How, then, are we to define the relationship between the Master of the Hours of Turin, as the progenitor of the art of Holland, and the Van Eycks, on whose shoulders there arose such pictorial traditions *outside* Holland as those of Bruges and Ghent? The stillness of Jan's art was influential in Bruges, in

120

121

120
Jan van Eyck (?),
Adoration of the Magi.
Amsterdam, Rijksprentenkabinet

121
Hubert van Eyck (?),
Adoration of the Magi.
Berlin, Kupferstichkabinett

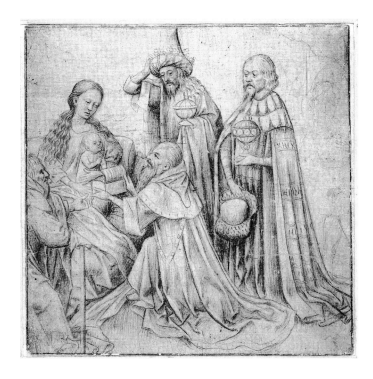

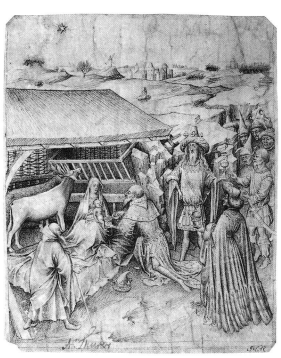

122
Gerard David,
St Michael.
Vienna, Kunsthistorisches Museum

the paintings of Petrus Christus, Hans Memling and Gerard David, until the end of
the fifteenth century; and the weirdly oriental-looking prophets and hermits of
the earliest strata of the Ghent Altarpiece—Hubert's types—survived in Ghent in the
Apostles of Justus van Gent and Hugo van der Goes. But if we look for an echo of
the work of the Master of the Hours of Turin, it is symptomatic that we find it in
fifteenth-century Holland, or else in the work of painters of Dutch origin, such as
Petrus Christus and Gerard David.

Petrus Christus painted a paraphrase of the *Last Judgement* of the New York
Diptych. Gerard David painted *St Michael* destroying fiends who have infested the *122*
folds of his cloak like vermin: an anticipation of Bosch that could only have sprung
from the imagination of the Master of the Hours of Turin; it was repeated in numerous
fifteenth-century Dutch and German illuminations, engravings and panel paintings.
Even more important, as early as the second quarter of the century, illuminated
manuscripts from Holland incorporate inventions by the Master of the Hours of Turin,
such as his *Betrayal of Christ* or *Adoration of the Magi*. All this supplies indirect
confirmation that the anonymous master himself was from Holland.

Even before scholars were aware of all this work in Holland derived from that of
the Master of the Hours of Turin, Dvořák had felt impelled to the conclusion—on the
strength of the anonymous master's specifically Dutch character, and in response to
a perceived need to set him apart from the Eyckian *oeuvre* in the narrower sense—that
his miniatures and related works should be dated to the 1430s and described as works
by a Dutch follower of the Van Eycks. Now that we know vastly more about the
transition from the 'soft' to the 'discontinuous' style, this escape route of Dvořák's is

no longer viable. To all that I have earlier said about the closeness of these works to the 'soft' style, I would only add a few words on the possible links between the art of the Master of the Hours of Turin and certain variants of the 'soft' style in the Lower Rhine area of Germany, as I consider that this gives a broader and firmer basis for the early dating.

123 The British Museum, in London, owns a silverpoint drawing of the *Betrayal of Christ* that is generally, and I think rightly, regarded as an original work by the Master of the Hours of Turin. If this is so, then this version of the theme must predate by several *110* years the version in the Hours of Turin itself. Both drawing and miniature contain one very conspicuous figure seen in rear view: in the drawing this is Peter, whom Christ restrains as he takes a swing with his sword at the prostrate figure of Malchus (replaced in the miniature by Judas). In both cases, despite the great difference in pictorial function, the articulation of the figure is so perfectly matched to the situation that there can be no question of supposing that one of them is simply copied from the other. Only the figure's creator could have adapted it to a second use with such total rightness.

Now, the repertoire of types in the London drawing is very nearly identical with that in a well-known group of Lower Rhenish paintings. To name just one feature: the figures of Christ's captors—uncannily weightless and nimble-footed, their oriental-looking, long-scarved headgear as spiky as their thin beards, ugly, wrynosed faces and pointed feet—reappear in the typical soldier types of the crowded *Crucifixions* of the Cologne, Lower Rhenish and Westphalian schools of painting. It is no coincidence,

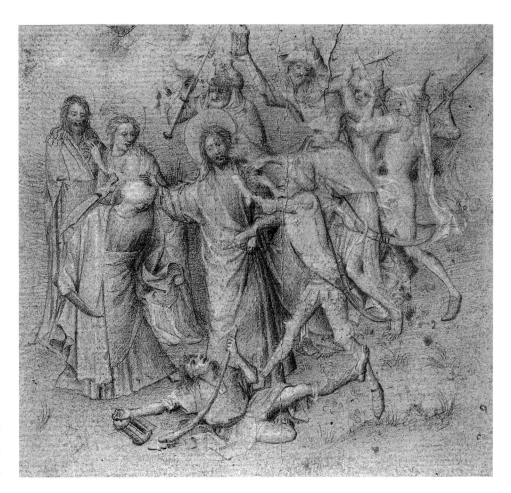

123
Master of the Hours of Turin
(Hubert van Eyck?),
Betrayal of Christ.
London, British Library

either, that the facial types of those same schools reappear in the preternaturally thin, girlish female types of the Turin miniatures, with their pointed chins. Even if there were no more to these analogies than a stylistic synchronicity—rather than, as I believe, a strong affinity of regional dialect—this in itself would mean that the youthful works of the Master of the Hours of Turin were painted close to 1400, and that the thesis of his historical position as a follower of the Van Eycks can finally be laid to rest.

When we ask ourselves whether it makes sense to equate the art of the Master of the Hours of Turin with the early work of either Hubert or Jan van Eyck, we need to bear the following in mind. Undeniably, the Master of the Hours of Turin represents the earliest manifestation of an artistic impulse specific to Holland. Now, to detect a specifically Dutch note in Jan's art, or in those parts of the Ghent Altarpiece that we feel justified in ascribing to Hubert, is incomparably more difficult; at least, no one has ever tried to do so, although there is clear proof that before 1425 Jan was in the service of the Count of Holland. Is it possible to imagine that an artist with as strongly pronounced a Dutch cast to him as the Master of the Hours of Turin could transform himself into an artist in whom—to put it in the form of an understatement—the characteristics of a pan-Netherlandish art predominate?

As should have emerged from our analysis of the Ghent Altarpiece, the outlines of Hubert's artistic personality are extremely hard to define; and so it seems best to juxtapose two clearly profiled artistic figures, the Master of the Hours of Turin and Jan van Eyck, and to look for signs of compatibility between the basic attitudes revealed in their work. If we do this, it immediately becomes apparent that each of the two bodies of work contains whole artistic genres that are absent from the other; there are portrait-like heads in the scenes depicted by the Master of the Hours of Turin, but no self-contained portrait, as with Jan; and, conversely, in all the known and confirmed work of Jan, there are no true depictions of events, and above all no representations of such mass spectacles as the Crucifixion or Carrying of the Cross.

Naturally, comparisons work best where there is a degree of thematic affinity. This appears only once, individual motifs apart: and this is the *Mystic Marriage of St Catherine*—or, to put it another way, the Madonna enthroned and surrounded by attendants, the so-called *Virgo inter virgines*. We have already attempted this comparison, as will perhaps be remembered, by considering a drawing in Nuremberg that we believe to be a copy of a *Mystic Marriage* by Jan van Eyck. This comparison is particularly rewarding, as the Nuremberg version—like the one in Turin—is comparatively early in date, probably no later than the early 1420s; so the differences in style emerge clearly, in spite of marked stylistic affinities based on date.

The compositional scheme that is first found in the Nuremberg drawing reappears in a mature version in the *Madonna of Canon van der Paele*, a major work of Jan's painted in 1436, in which the theme is converted into a related one, that of the *sacra conversazione*, in which the donor's patron saint ushers him into the Divine presence (the work was painted as a memorial). Here the specific iconography of the commission enabled Jan to abandon the already loose connection between the three structural pillars of the scene and to create a static image of totally isolated individuals. Jan's heirs in Bruges took from him a static, centrally composed scenic pattern on which they devised endless variations, and into which they had no compunction in reintroducing the theme of the *Mystic Marriage of St Catherine*. The immovable repose of an eternal order no longer risked being disturbed by any suggestion of a mystical ceremony.

In the *Mystic Marriage of St Catherine* of the Hours of Turin, it is difficult to isolate the saint's figure from the collective group of maidens; for an individual gesture, such

119, 108

as the putting on of the ring, simply becomes part of the life of the group. Jan presents us—throughout his works, and not only in the *Paele Madonna*—with the mute coexistence of a number of isolated beings, who relate to each other merely through a gesture, if at all; this is true even in the Arnolfini nuptial portrait, or in the *Annunciation*. Cocooned in passive contemplation, Jan's creations have become incapable of making contact. Each leads a life of his or her own in isolation. By contrast, in the scenic representations of the Master of the Hours of Turin, the individual figures, for all their agility, cannot disentangle themselves from their group existence within the bustling crowd.

This tendency towards a crowd style goes hand in hand with a long-sighted approach. The two phenomena are complementary; and so, with the Master of the Hours of Turin, it is no wonder that—just as the individual figure is seen only as a part of a crowd—all living creatures are experienced only as component parts of their environment and can be seen, ultimately, as not much more than a variety of landscape or architectural detail.

By comparison with the representational norm of medieval art, this long-sighted approach marks a distinct quantitative shift in—not to say a reversal of—the proportional relationship between the figure and its spatial environment. Italian trecento painting (with Siena as a possible exception), had abbreviated, and thus diminished, the setting by appending it to the human figure as a kind of attribute; the Master of the Hours of Turin, by contrast, as in the room setting of his *Birth of St John the Baptist*, tends to exaggerate the proportions of the spatial milieu at the expense of the figures. This lying-in room is as high-ceilinged as a palace chamber, not a bourgeois interior. The four-poster bed is as high as the ceiling, so that the mother who lies in it is hardly visible. Any artist who cared so much for the visibility and apprehensibility of interior space could not simultaneously concern himself with the three-dimensional, sculptural solidity of his figures. The active, bustling little figures of the Master of the Hours of Turin have little substance and consequently little stability. If one were ever to try to place them in relation to the hypothetical ground plan of the room, there would always remain a scintilla of doubt as to their exact position in space. (Two hundred years later, when Dutch painters once more set out to base their pictorial world on the rendering of a milieu, they had already absorbed both Renaissance perspective and the sculptural solidity of Caravaggio and Rubens, and as a result they were far better placed to achieve a convincing integration of figure and space.)

Where the Master of the Hours of Turin tends to exaggerate the available space, Jan van Eyck—in interiors, especially—gives his figures far too little of it: the figures dominate the visual field, and the pictorial format looks as if it had been made to measure to fit them. In his *Madonnas*, right down to the mid 1430s, Mary seems to fit into her throne-room as if it were a carrying-case. It may well be this quantitative limitation that enables Jan, with the help of his stereographic rendering of the figure and an instinctive, approximate use of perspective, to define the position of the spatial shell and of everyone in it, and thus to achieve a greater integration between person and environment. This clarification of spatial relationships is considerably helped by the fact that Jan's figures sit or stand absolutely still, and do not disorient the viewer by restless movement, as do the darting, mercurial beings of the Master of the Hours of Turin.

The main difference between the two approaches to spatial illusion lies elsewhere, however. Cramped though Jan's space may be, it remains something more than a piece of scenery for the figure to sit or stand in; this is primarily because there is a totally consistent and unified lighting context. In optical and colour terms, everything

in the picture is animated by a single source of light that we assume to lie outside the pictorial field. An interior, for Jan van Eyck, is a space lit from elsewhere—from outside the pictorial field, that is—by a source of directional light. By contrast, although the interiors of the Master of the Hours of Turin incorporate and use the atmospheric effects that arise from a finite supply of light—the illusion of chiaroscuro in the twilight of a church interior or of a living room—they give us no information as to the source or direction of that light.

This contrast between two distinct kinds of interior illusion might be exemplified by a comparison between two bourgeois domestic interiors, that of the *Birth of St John the Baptist* and that of the Arnolfini bridal chamber; but it is more important to clarify the distinction between the two artists' church interiors. This is because the very scholar who saw the relationship between Jan and the Master of the Hours of Turin most clearly—Hulin de Loo, the discoverer of what was then (1911) the Milan portion of the Hours of Turin—attributed one of these two works, the *Madonna in a Church* *Plate 5* now in Berlin, to the Turin Master and not to Jan.[83]

At first sight, it might even be believed that the two works show the same church interior, except that the scene of the *Requiem Mass*, with its tiny figures, is replaced in *Plate 17* the panel painting by a gigantic Madonna who looms as high as the triforium. On closer inspection, it is not only the figuration and the theme, but also the setting, that is very different. The setting for the *Requiem Mass* miniature is the choir of a cathedral, the crossing of which is still uncompleted. Within the choir, the unbroken perspectival recession of the arches leads the eye to the polygonal apse. In the *Madonna in a Church* we see first the nave, then the crossing, and only then, looking through and over the rood screen, the choir. The perspectival construction is only apparently coherent: in reality, the relationship between the parts of the building is not shown in full. We see first into the nave; then, under the pointed crossing arch, into the north transept and choir; and at the chancel arch our view is divided again—or rather it continues only above the barrier of the rood screen. The transition from foreground to background is ingeniously masked by the figure of the Madonna herself, who obscures the crossing pier; the middle ground is practically eliminated, and our eye passes over the crossing without our becoming aware of it. In terms of formal structure, the view through the near crossing arch has the same value and the same function as the distant view through the arcade in the *Madonna of Chancellor Rolin*, except that in the *Madonna in a Church* the distant view is not one of outdoor space.

The interior in the Hours of Turin is a complete choir, and thus readily constitutes itself as a formal whole; the world of the picture has an open form only at the sides. Incompleteness is inherent in the thing seen; its explanation lies in the object under observation and not in the observer's subjective viewpoint. In the *Madonna in a Church* we see nothing of the exterior whatever; what is before us is a visually incomplete object, a section of a cathedral with its perspectival recession shown in a discontinuous fashion. This is an interior in the modern sense; the *Requiem Mass* scene is not, although of the two works it shows the greater superficial similarity with a seventeenth-century Dutch church interior.

A second fundamental difference between these two Eyckian interiors lies in the handling of light and the overall coloration. The colour of the architecture in the *Requiem Mass* miniature is a stony grey, with whitish highlights only on the window reveals and some of the vault ribs. The windows are not coloured at all but represented by a reflective metal, silver. In the *Madonna in a Church*, all the lighting effects are achieved through colour. The fall of the light, the contrast between the brightness of the outside world (even though this is not visible) and the dimness of the interior, and

above all the various coloured effects created by the refraction of external light on its way in: all these are major factors in creating the illusion of an interior. They are the same principles on which the interior illusion in the Arnolfini portrait is based.

Perhaps this statement should at once be qualified. The Madonna in the Berlin painting stands out considerably less powerfully in the church interior than the Arnolfinis in their bridal chamber: spatial shadows swallow the cast shadows, and chiaroscuro values and overall tonality are more important than modelling through light and shade. This means that the painter of the Berlin panel, which was probably half of a diptych, also has a command of the same techniques of interior illusion that are used in the Turin miniatures. This may be seen as the foundation for the arguments of those who ascribe the *Madonna in a Church* to the artist of the Turin miniatures, identifying him as the early Jan; or who, like Hulin, assign both the *Madonna in a Church* and the Requiem Mass scene to Hubert.[84] I take the view that these arguments fail to give due weight to the achievements documented in Jan's 1434 portrait of the Arnolfinis; and so I see the *Madonna in a Church* as a late work by Jan, in which he harks back to the pseudo-interiors of the Turin miniatures: a synthesis of the near-sighted and the long-sighted conception of the interior.

Plate 11

It is characteristic of Jan, and of Jan alone, that the Madonna stands like an immense statue in her admittedly now quite airy shrine; for, to him, spatial integration is not primarily a matter of relationships of size (all his architectural settings are short of headroom) but of the existence of a measurable relation between bodily volume and spatial shell. The oversized figure of the Madonna is connected, of course, with her symbolic significance as Maria-Ecclesia; which supplies it with a justification that entirely transcends empirical fact. Ultimately, this is a pictorial tautology. In the artistic imagination of an incorrigible empiricist, the abstract idea of Mary as the personification of Mother Church has evoked the idea of a literal church building as a setting for the figure of the Queen of Heaven. And so Mary *as* Church becomes Mary *in* church.

Plate 14

There is one authenticated work by Jan van Eyck in which the setting has taken shape in a closely related way. This is the *St Barbara* drawing of 1437. In medieval art, the tower, which Barbara's father caused to be built in order to seclude her from the world, came to be treated as her attribute. Here it has been transformed back into the real and literal location of the beginning of her martyrdom. But Barbara is not to be found among the tiny figures on the building site where the tower is under construction. She has been taken out of that scene and appears on a platform-like forestage, large in size because close to the viewer, with the vast tower behind her as a distant view. The result, as in the *Madonna in a Church*, is the juxtaposition of a large figure and a lofty building, this time out of doors. The analogy goes further. The staging of the *St Barbara* scene also looks as if it derives from a work by the Master of the Hours

124

of Turin. There survives a copy of a *Tower of Babel* that must have been painted by the Turin Master; and it contains a number of individual motifs that reappear almost identically in the drawing of the building of St Barbara's tower. In this *Tower of Babel*, all the figures—including the giant Nimrod—are tiny; and in this respect Bruegel followed suit a century later. The motif that had constituted a self-sufficient landscape composition as the Tower of Babel—and Hulin called the Master of the Hours of Turin a born landscapist—becomes in Jan's painting, as the tower of St Barbara, a background motif replete with incident.

It must by now be sufficiently clear that I do not regard the difference between the group of works ascribed to the Master of the Hours of Turin and the known works of Jan van Eyck simply as a matter of chronology, but that I also, and most importantly,

see the evidence of two diametrically contrasted artistic personalities at work. One painter is a storyteller, with an inexhaustible fund of episodic detail; the other evokes a world in which all action is eliminated and nothing happens beyond the fall of the light and the interplay of colours. In the work of one artist, the landscape still moves; in that of the other, even the animate beings are mute and motionless. Hulin went so far as to conclude from this that one artist worked 'essentially from memory', while the other, Jan, worked *devant le modèle posé*, 'in the presence of the posed model'.[85] Hulin agrees with us in ascribing the contrasts between the two artists to profound differences in temperament; and he asks how anyone could ever imagine so enthusiastic and curious an explorer of every aspect of reality as the Master of the Hours of Turin ending up with so circumscribed a choice of subject matter as that of the known work of Jan. To assume that one changed into the other within the evolution of a single artistic personality would imply a constitutional change, a stupendous psychological upheaval. It would ultimately require us to believe in the freakish phenomenon of two artistic personalities within one and the same biographical individual.

If we are not to content ourselves with speculations of that kind, only two possibilities remain: are we to identify the anonymous master of Turin as Hubert van Eyck, or must we assume the independent existence of a separate artist, a third painter of genius, from Holland, who would probably have to be regarded as the teacher of both the Van Eycks? There can surely be little doubt that points of contact exist between the work of the Master of the Hours of Turin and those parts of the Ghent Altarpiece that can plausibly be ascribed to Hubert. It has several times been mentioned that the characteristic repertoire of male facial types, both bearded and beardless—with all those primeval, quasi-oriental, warped, grimacing faces—is largely the same in both. Difficulties arise, however, as soon as we pass on from facial types to the whole figure. The quicksilver movement, the darting restlessness, of the characters in the pictorial narratives of the Master of the Hours of Turin is nowhere to be found even on the earlier strata of the Ghent Altarpiece, let alone in the work of Jan. Is the difference between the procession of clerics who march onward to eternal bliss in the New York *Last Judgement*, vigorously alive in spite of their cramped quarters, and the sainted bishops and confessors of Ghent, tightly welded into a block—is this stylistic change to be explained as the result of changing times?

It would certainly be possible—especially if we were to include in the reckoning those figure paintings away from Ghent that are suspected of being by Hubert van Eyck—to build bridges between the Master of the Hours of Turin and the Hubert of the Ghent Altarpiece: intermediate stages between the crowd style, with its tiny figures, and the monumentality of the kneeling prophets of Ghent and their like. It would, for instance, be possible to set up a sequence of three *Crucifixions*, starting with the mass scene of the New York Diptych. The second in the sequence would be another *Plate 19* composition, known from copies in miniatures and panel paintings alike, which *125, 126* seems to mark the genesis of the traditional devotional pattern of the Crucifixion as the denouement of the Passion drama. The crowds have left the place of execution and are on their way back to Jerusalem, leaving the three principal characters behind in all their tragic isolation. Finally, in the Berlin panel, only these three are to be seen. *Plate 18* Leaving nothing behind but an obliquely sloping path, the crowds have melted into the scenery, and this in turn is crowned by a prospect of Jerusalem, just below the skyline. With the disappearance of all the *staffage* figures, the size of the principals has grown. This is the first large-figure *Crucifixion* of the early Eyckian style.[86]

Such, roughly speaking, is the evolutionary sequence that might have led to the Hubert style of the Ghent Altarpiece. I do not venture to present this as more than a

plausible hypothesis, or at best as a case resting on circumstantial evidence. In itself, such evidence supplies no more than grounds for suspicion; but it has a cumulative force from which, as is well known, a guilty verdict may be arrived at. In the present state of research, many questions must remain open: how, for example, does it come about that so distinctive an artistic personality as the Master of the Hours of Turin, whose traits are recognizable with ease, even in copies of his work, is so very difficult to extract from the Ghent Altarpiece—supposing the anonymous master to be identical with Hubert? If it were ever possible to prove beyond doubt that the Master of the Hours of Turin is identical with the Hubert van Eyck who died in 1426, Hubert would at last be released from his shadowy existence, and the ranking proclaimed in the inscription on the Ghent Altarpiece—greater than Jan—would to some extent become comprehensible. All this may go without saying; but it would be entirely wrong to describe the identification as finally proven, merely in order to avoid contradicting the words inscribed on the Altarpiece.

What, it may well be asked, is to become of the originality of Jan's achievement, if his entire vocabulary of types, his repertoire of motifs, all those unprecedented open-air and interior settings of his, turn out to be the intellectual property of an elder artist, whether that artist be Hubert or someone else? How is he then to maintain his rank among the pioneers of a post-medieval art?

I imagine that the answer would run roughly as follows. If Jan's crucial innovation consisted, as I have tried to show, in the stilling of the gaze into immobility; the withdrawal into an impartial confrontation with the object, free of emotional partici-

124
Master of the Hours of Turin
(Hubert van Eyck?),
Tower of Babel (copy).
The Hague, Mauritshuis

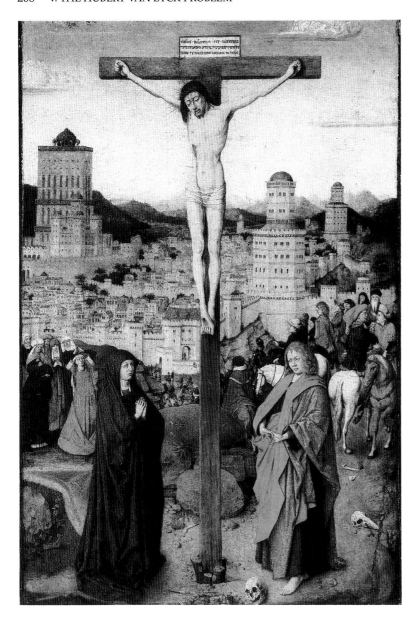

125
After Jan van Eyck,
Crucifixion.
Venice, Cà d'Oro

pation; the passivity of vision that ensured an objectivity never excelled, before or since—then this in itself was the core of Jan's artistic genius, from which all active formative intervention, and all narrative invention, were excluded. Originality no longer resided in the material, the What of the representation, but in the vision, the How; it became irrelevant whether the artist's raw material was a piece of nature or a piece of art, a reality that was already painted. Jan's revolutionary new vision was capable of assimilating inherited artistic material without any essential material change. Hence the many points of contact with the types, motifs and themes of earlier Eyckian art.

This is not to say that Jan's visual temper, his constitutional passivity of vision, did not influence the things that he saw and contemplated. The stilling of the motor energies present in the observing eye was matched by a corresponding immobility on the part of the object. Schopenhauer understood that 'pure contemplation, absorption

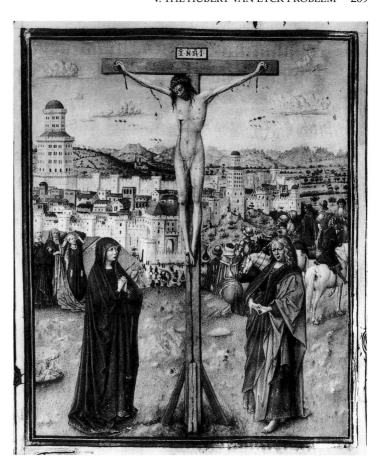

126
Hours of Turin,
Crucifixion.
Turin, Museo Civico,
fol. 48v

in seeing, loss of self in the object'—the forgetfulness of self that for him exemplified the supreme aesthetic principle of disinterested pleasure—must inevitably lead to still-life painting.[87] He had in mind the still-life painting of the seventeenth century, in which the Netherlandish painters, as he put it, expressed the bliss of will-less contemplation in the depiction of the most insignificant objects, and left 'a lasting memorial to their own objectivity and peace of mind'. With Jan, on the other hand, reality as a whole, including the animate beings in it, is a still-life world, in which silent tranquillity prevails. His painting conveys the antithesis of synaesthetic experience. It creates a world of imagery that is exclusively adapted to visual perception: the fiction of a world in which a human being is nothing but an eye. Whereas the miniatures of the Hours of Turin seem to anticipate the achievements of seventeenth-century Dutch painting, Jan's work has a prophetic message that is all its own, pointing forward to Vermeer and Cézanne, the two other great representatives of painting as an art of pure, will-less contemplation, of Being as a coloured still-life, of narrative-free, silent, unalterably mute imagery.

There was much in Jan's art that was ahead of its time. The fifteenth century could not rest content with a visual absoluteness that drastically curtailed thematic content. It was compelled to seek other models, and found them in the Master of Flémalle and in Rogier van der Weyden. Steeped in tradition though he was, Jan remains the great artistic anachronism of his age.

In conclusion, I want to stress once again that much of what I have said has only the value of a more or less well substantiated hypothesis; that there are some enigmas

that I cannot resolve; and that a series of questions must remain open. For some of them, no doubt, the time is not yet ripe. As Wilhelm Pinder used to point out, not all arts come to maturity at the same time. Not only every art but every academic discipline has laws and a time-scale of its own, and this is by no means identical with the real time in which its practitioners lead their lives. In science and the humanities alike, the live issue is not what happens to be in current demand but what is called for by the evolution of the subject concerned—its own historic hour. To find one's way into a work of art, one has to listen; it speaks to us only if we lend an ear. In the same way, it is only by listening to art history itself that we can ever know what questions can reasonably be asked—given the current state of research—and what cannot. Not only art but art history has an evolutionary dynamic of its own, often far removed from the supposedly pressing concerns of the day.

As a historical discipline, the history of art can absorb stimuli from outside, from iconology, from cultural sociology, from the sociology of art, or from whatever fashionable follies the future may bring; but it can never allow them to define the work that it has to do. Its vital nerve is maimed, if ever it feels obliged to serve the ends of any political, religious or social idea whatever. Those who refer everything to external causality will never see or understand the workings of inner necessity; and social relevance in historical scholarship is a contradiction in terms. Scholarship can bow to no worldly authority, not even to the best; it knows only one loyalty, to the common-wealth of minds.[88]

THE GHENT ALTARPIECE

All measurements are given in centimetres (height before width),
and refer to the individual panels without their frames.

With shutters closed: 375 × 260

Lunettes and upper tier:

Prophet Zechariah; Angel of the Annunciation	162.0 × 69.1
Erythraean Sibyl; View of City	204.8 × 33.0
Cumaean Sibyl; Wall Niche	204.5 × 32.3
Prophet Micah; Virgin Annunciate	161.5 × 69.6

Lower tier:

The Donor, Jodocus Vijd	145.7 × 51
St John the Baptist	146.0 × 51.8
St John the Evangelist	146.4 × 52.6
The Donor's Wife, Elisabeth Borluut	145.8 × 50.7

With shutters open: 375 × 520

Central panel:

Virgin Mary	166.8 × 72.3
God the Father	210.5 × 80
John the Baptist	162.2 × 72
Adoration of the Lamb	134.3 × 237.5

Left-hand shutter

Half-lunette and upper tier:

Sacrifice of Cain and Abel; Adam	204.3 × 33.2
Angels Singing	161.7 × 69.3

Lower tier:

Righteous Judges (copy)	145 × 51
Warriors of Christ	146.2 × 51.4

Right-hand shutter

Half-lunette and upper tier (from right to left):

Slaying of Abel; Eve	204.3 × 32.3
Angels Playing Musical Instruments	161.1 × 69.3

Lower tier (from right to left):

St Christopher with Pilgrims	146.5 × 52.8
Hermits	146.4 × 51.2

Editor's Note to the German Edition

This book is based on the author's own typescript of his course of lectures, made available by his son Michael Pächt, who has also designed and produced the book. In editing the text, it has been my aim to keep as close as possible to the original, and changes have been made only where they seemed unavoidable. The author's typescript makes no provision for notes, but I have added them in order to cite sources, and quotations have been checked, as far as possible. The inscriptions on paintings by the Van Eycks have been verified by reference to Elisabeth Dhanens, *Hubert und Jan van Eyck* (Königstein im Taunus, 1980), and those on the Werl Altarpiece by the Master of Flémalle by reference to Charles de Tolnay, *Le Maître de Flémalle et les frères van Eyck* (Brussels, 1939). The illustrations have been selected in accordance with marks in the typescript or as recollected; in the captions, an attempt has been made to reflect the author's intentions with regard to attribution.

Maria Schmidt-Dengler

Acknowledgements

I was delighted to be able to persuade Maria Schmidt-Dengler, a former student of my father's, to act as editor of this book. She constantly benefited from the scholarly counsel of Artur Rosenauer, Professor of Art History at the University of Vienna. I also very much want to thank Gustav Stresow both for his constant support and advice on all aspects of the design of the book. Finally I would like to thank David Britt for his intelligent and faithful translation of this complex text.

Michael Pächt

Notes

1. *Et omnia illa sunt ex mirabili et tam artificioso ingenio depicta: ut nedum picturam sed artem pingendi totam ibi videres…* Latin text quoted from W.H.J. Weale, *Hubert and John van Eyck*, London, 1908, p. lxxv.

2. G.E. Lessing, 'Vom Alter der Oelmalerey aus dem Theophilus Presbyter', in Lessing, *Sämtliche Schriften*, eds. K. Lachmann and F. Muncker, 3rd edn, Leipzig, 1897, pp. 163, 197.

3. E. Berger, *Beiträge zur Entwicklungs-Geschichte der Maltechnik*, Munich, 1897.

4. P. Coremans, ed., *L'Agneau Mystique au laboratoire*, Les Primitifs flamands. Contributions 2, Antwerp, 1953, p. 18.

5. G. Vasari, 'Antonello da Messina', in Vasari, *Le vite*, ed. G. Milanesi, 2, Florence, 1878, p. 566.

6. W. Schöne, *Über das Licht in der Malerei*, Berlin, 1954, p. 86.

7. L.B. Alberti, *Della pittura*, in H. Janitschek, ed., *L.B. Albertis kleinere kunsttheoretische Schriften*, Vienna, 1877, p. 138.

8. Quoted from E. Panofsky, *Early Netherlandish Painting*, Cambridge, Mass., 1953, p. 247.

9. M. Dvořák, 'Das Rätsel der Kunst der Brüder van Eyck', *Jahrbuch der Kunsthistorischen Sammlungen des Allerhöchsten Kaiserhauses*, 24, 1903, pp. 161–317. This article was later published in book form, eds. J. Wilde and K.M. Swoboda, Munich, 1925.

9a. Pächt borrowed the concept of the 'stilled' or 'immobilized' gaze (*die Stillegung des Blickes*), which plays a central role in his characterization of the art of Jan van Eyck, from W. Pinder, *Deutsche Dome des Mittelalters*, Leipzig, 1912, p. xiv. Pinder employs it in a description of the choir of St Lorenz, Nuremberg. (*Translator's note*: the English phrase 'Jan's stilled gaze' occurs in Pächt's *Burlington Magazine* review of Baldass; see note 85.)

10. Coremans (as note 4).

11. E. Panofsky, 'Jan van Eyck's Arnolfini Portrait', *The Burlington Magazine*, 64, 1934, pp. 117–127.

12. Coremans (as note 4).

13. G.J. Kern, *Die Grundzüge der linear-perspektivischen Darstellung in der Kunst der Gebrüder van Eyck und ihrer Schule*, Leipzig, 1904.

14. Weale (as note 1), p. xxviiiff.; Panofsky (as note 8), p. 247.

15. Jacobus de Voragine, *Legenda aurea*, ch. 153, ed. Th. Graesse, 3rd edn, Breslau, 1890, p. 685; reprinted Osnabrück, 1965.

16. In the passages in quotation marks here and on p. 58, Pächt is paraphrasing his own formulations from 'Gestaltungsprinzipien der westlichen Malerei', in Pächt, *Methodisches zur kunsthistorischen Praxis*, eds. J. Oberhaidacher, A. Rosenauer and G. Schikola, 2nd edn, Munich, 1986, p. 21. Originally published in *Kunstwissenschaftliche Forschungen*, 2, 1933, pp. 75–100.

17. Dvořák (as note 9).

18. Pächt (as note 16), p. 25.

19. Pächt (as note 16), p. 25.

20. Alberti (as note 7), pp. 64, 130ff.

21. Luke 1:29.

22. M. Schapiro, '*Muscipula Diaboli*: the Symbolism of the Mérode Altarpiece', *Art Bulletin*, 27, 1945, pp. 182–187. Reprinted in Schapiro, *Late Antique, Early Christian, and Medieval Art*, New York, 1979, pp. 1–19.

23. Panofsky (as note 8), p. 131.

24. A. de Laborde, *Les Manuscrits à peintures de la Cité de Dieu de Saint Augustin*, Paris, 1909, describes a number of illuminated manuscripts, with illustrations of the text passages concerned; but it has not been possible to locate the image mentioned here by Pächt.

25. Panofsky (as note 8), p. 125.

26. Protoevangelium Jacobi 19, 20; Pseudo-Matthaeus 13, in E. Hennecke, *Neutestamentliche Apokryphen*, 2nd edn, Tübingen, 1924, p. 92; M.R. James, *The Apocryphal New Testament*, Oxford, 1924, pp. 46f., 74. Jacobus de Voragine (as note 15), ch. 6, 'De nativitate', 3rd edn, p. 42.

27. E. Mâle, *L'Art religieux du XIIIe siècle en France*, Paris, 1898, p. 275ff.; *L'Art religieux du XIIe siècle en France*, Paris, 1922, p. 121ff., 139ff.; *L'Art religieux de la fin du moyen âge en France*, 3rd edn, Paris, 1925, p. 35ff.

28. O. Pächt, 'Die Gotik der Zeit um 1400 als gesamteuropäische Kunstsprache', in [Exh. Cat.] *Europäische Kunst um 1400*, Vienna, 1962, p. 56f.

29. M. Meiss and C. Eisler, 'A New French Primitive', *The Burlington Magazine*, 102, 1960, pp. 233–240.

30. Panofsky (as note 8), p. 172.

31. Dvorák (as note 9).

32. See Weale (as note 1), p. xlviii.

33. G. Santi, *Federigo di Montefeltro, duca di Urbino*, book 22, ch. 96, v. 120, ed. from Cod. Vat. Ottobon. 1305 by H. Holtzinger, Stuttgart, 1893, p. 189.

34. Hieronymus Münzer; see Weale (as note 1), p. xlviii.

35. Dutch original quoted by Weale (as note 1), p. 6.

36. Mâle, *L'Art religieux de la fin du moyen âge* (as note 27), p. 347ff.

37. Weale (as note 1), p. 6.

38. L. Baldass, *Jan van Eyck*, London, 1952, pp. 50 n. 2, 51f., 277 (cat. no. 7); M.J. Friedländer, *Early Netherlandish Painting*, I, *The Van Eycks - Petrus Christus*, Leiden and Brussels, 1967, p. 39f.

39. Panofsky (as note 11). See P. Schabacker, '*De matrimonio ad morganaticam contracto*: Jan van Eyck's "Arnolfini" Portrait Reconsidered', *Art Quarterly*, 35, 1972, pp. 375–398.

40. See E. Dhanens, *Hubert und Jan van Eyck*, Königstein im Taunus, 1980, p. 388.

41. See G.C. Lichtenberg, 'Sudelbücher', June 1776, F 88, in Lichtenberg, *Schriften und Briefe*, ed. W. Promies, 1, Munich, 1968, p. 473.

42. K. Bauch, 'Bildnisse des Jan van Eyck', 1961, in Bauch, *Studien zur Kunstgeschichte*, Berlin, 1967, pp. 79–122, especially pp. 85–91.

43. M. Meiss, '"Nicholas Albergati" and the Chronology of Jan van Eyck's Portraits', *The Burlington Magazine*, 94, 1952, pp. 137–145.

44. Bauch (as note 42).

45. M.J. Friedländer, *Die altniederländische Malerei*, I, *Die Van Eyck - Petrus Christus*, Berlin, 1924, p. 93.

46. P. Klein, 'Dendrochronologische Untersuchungen an Gemäldetafeln', *Berliner Museen, Beiheft Forschungen*, 1979, pp. 6–9. On the *Man with a Pink*: 'The earliest possible date of felling turns out to be 1468' (p. 8).

47. O. Kurz, 'A Fishing Party at the Court of William VI, Count of Holland, Zeeland and Hainault', *Oud Holland*, 71, 1956, pp. 117–31.

48. A. Riegl, *Das holländische Gruppenporträt*, Vienna, 1931. First published in *Jahrbuch der Kunsthistorischen Sammlungen des Allerhöchsten Kaiserhauses*, 23, 1902, pp. 71–278.

49. The Altarpiece now stands in the first bay of the north aisle.

50. Coremans (as note 4).

51. Latin text, *Chorus beatorum in sacrificium Agni Pascalis*, quoted in E. Dhanens, *Het retabel van het Lam Gods*, Ghent, 1965, p. 96.

52. Ibid. See Editor's Note on p. 214.

53. Revelation 19:16.

54. John 1:29.

55. Psalms 150:4.

56. *Chronique de Flandres*, quoted by Dhanens (as note 51), p. 96.

57. See John 14:6.

58. Revelation 21:6, 22:1.

59. Revelation 7:9. (*Translator's note*: the Authorized Version (King James) text, as used elsewhere in the English text, has been adapted here to fit the sense of the Vulgate version, used by the author.)

60. Revelation 7:14–17.

61. *Regem regum; omnes angelos in ejus circuitu commorantes; virgo virginum in dyademate praefulgenti; vestitus de pilis camelorum; innumerabilis multitudo virginum; multitudo venerabilium seniorum; deinde advenit et alius pontificali habitu decoratus, quem aliquorum chorus in habitu consimili sequebatur, postea vero processit innumerabilis multitudo militum. Post quos advenit turba diversarum gentium infinita.* Jacobus de Voragine (as note 15), ch. 162, 'De omnibus sanctis', p. 727.

62. Isaiah 7:14.

63. See Laborde (as note 24), plates LX, LXII, LXIX, etc.

64. Revelation 7:14, 17; 21:6; 22:1.

65. Baldass (as note 38).

66. Quoted by L. Brion-Guerry, *Jean Pélerin Viator; sa place dans l'histoire de la perspective*, Paris, 1962, p. 203.

67. Revelation 22:3.

68. Basilius von Ramdohr, quoted by L. Chr. Jensen, *Caspar David Friedrich*, Cologne, 1974, p. 101.

69. Honorius Augustodunensis (Honorius of Autun), *Speculum ecclesiae: de omnibus sanctis*, in J. P. Migne, ed., *Patrologia latina*, Paris, 1854, col. 1018.

70. Pächt is clearly referring here to an illustration in the so-called *Convenevole del Prato* (British Library, MS Royal 6 E IX, fol. 15v), which he mentions and illustrates in his article 'Early Italian Nature Studies and the Early Calendar Landscape', *Journal of the Warburg and Courtauld Institutes*, 13, 1950, p. 39 n. 2, fig. 9a.

71. *'La terre vue comme le paradis'*: C. de Tolnay, *Le Maître de Flémalle et les frères van Eyck*, Brussels, 1939, p. 28.

72. O. Pächt, 'The "Avignon Diptych" and its Eastern Ancestry', in M. Meiss, ed., *De artibus opuscula XL: Essays in Honor of Erwin Panofsky*, New York, 1961, pp. 402–421.

73. G.W. Hegel, *Vorlesungen über die Ästhetik*, part 3, section 3, ch. 1, Frankfurt am Main, 1970, p. 46.

74. Panofsky (as note 8), p. 227.

75. Baldass (as note 38).

76. The words of the *Dies irae*, composed by Thomas of Celano.

77. P. Durrieu, *Les Heures de Turin*, Paris, 1902.

78. G. Hulin de Loo, *Les Heures de Milan*, Brussels and Paris, 1911, p. 31.

79. H. Focillon, *La Vie des formes*, 3rd edn, Paris, 1947, p. 83.

80. See Revelation 20:13.

81. O. Pächt, 'A New Book on the Van Eycks', *The Burlington Magazine*, 95, 1953, pp. 249–253. A review of Baldass (as note 38).

82. Dvořák (as note 9).

83. Hulin de Loo (as note 78), pp. 34, 65.

84. Hulin de Loo (as note 78), pp. 34, 65.

85. Hulin de Loo (as note 78), p. 34.

86. The following note was found among Pächt's papers: 'The creator of the third Eyckian *Crucifixion* composition was the first to dare to present a discontinuity of the landscape background in a painting—an optical phenomenon that can only be the result of an abrupt drop in the terrain, and which our eye spontaneously registers as such. For this phenomenon to register, there must first be a total revolution in artistic vision… The third Eyckian *Crucifixion* composition presupposes the existence of the first two; but it manifests an entirely new logic of artistic vision. It is hard to imagine this shift taking place as part of the evolution of a single artistic personality.' [See Foreword, p. 10.]

87. See A. Schopenhauer, *Die Welt als Wille und Vorstellung*, I, book 3, par. 38, 3rd edn, Leipzig, 1859, p. 232.

88. R. Musil, *Der Mann ohne Eigenschaften*, ch. 13, in A. Frisé, ed., *R. Musil, Gesammelte Werke*, I, Reinbek bei Hamburg, 1978, p. 44.

Select Bibliography

The literature listed here is restricted to those major publications that mark an advance in the study of the art of the brothers Van Eyck and of the Master of Flémalle; it is arranged chronologically.

Paul Durrieu, *Les Heures de Turin*, Paris, 1902.

Max Dvořák, 'Das Rätsel der Kunst der Brüder van Eyck', *Jahrbuch der Kunsthistorischen Sammlungen des Allerhöchsten Kaiserhauses*, 24, 1903, pp. 161–317. In book form, eds. Johannes Wilde and Karl Maria Swoboda, Munich, 1925.

W. H. James Weale, *Hubert and John van Eyck: Their Life and Work*, London, 1908.

Max J. Friedländer, *Die altniederländische Malerei*, I, *Die Van Eyck - Petrus Christus*; II, *Rogier van der Weyden und der Meister von Flémalle*, both Berlin, 1924. Expanded edition in English: *Early Netherlandish Painting*, I, *The Van Eycks - Petrus Christus*; II, *Rogier van der Weyden and the Master of Flémalle*, both Leiden and Brussels, 1967.

Charles de Tolnay, *Le Maître de Flémalle et les frères van Eyck*, Brussels, 1939.

Ludwig Baldass, 'The Ghent Altarpiece of Hubert and Jan van Eyck', *Art Quarterly*, 13, 1950, pp. 140–155, 183–195.

Ludwig Baldass, *Jan van Eyck*, London and Cologne, 1952.

Erwin Panofsky, *Early Netherlandish Painting: its Origins and Character*, 2 vols., Cambridge, Mass., 1953; reissue, 2 vols., New York, 1971.

Raffaello Brignetti and Giorgio T. Faggin, *L'opera completa dei Van Eyck*, Classici dell'Arte, 17, Milan, 1968.

Martin Davies, *Rogier van der Weyden: an Essay*, London and Munich, 1972. With a critical catalogue of all works ascribed to him and to Robert Campin.

Charles Sterling, 'Jan van Eyck avant 1432', *Revue de l'Art*, 33, 1976, pp. 7–100.

Elisabeth Dhanens, *Hubert und Jan van Eyck*, Königstein im Taunus, 1980; original Flemish edition, Antwerp, 1980.

Hans Belting and Dagmar Eichberger, *Jan van Eyck als Erzähler; Frühe Tafelbilder im Umkreis der New Yorker Doppeltafel*, Worms, 1983.

Bibliography of Otto Pächt

Chronological list of writings on Early Netherlandish Painting and on Art c. 1400

'Ein neuer Ouwater?', *Kunstchronik*, 57 (N.S. 33), Leipzig, 1921–22, pp. 820–821.

'Die Datierung der Brüsseler Beweinung des Petrus Christus', *Belvedere*, 9/10, Vienna, 1926, pp. 155–166.

'M. J. Friedländer: Dieric Bouts-Joos van Gent, Berlin 1925 (Die altniederländische Malerei, III)', review, *Kritische Berichte zur kunstgeschichtlichen Literatur*, 1/2, Leipzig, 1927–28, 1928–29, pp. 37–54.

'Die historische Aufgabe Michael Pachers', *Kunstwissenschaftliche Forschungen*, 1, Berlin, 1931, pp. 95–132. Reprinted in Pächt, *Methodisches zur kunsthistorischen Praxis: Ausgewählte Schriften*, eds. Jörg Oberhaidacher, Artur Rosenauer and Gertraut Schikola, 2nd edn, Munich, 1986, pp. 59–106.

'Gestaltungsprinzipien der westlichen Malerei des 15. Jahrhunderts', *Kunstwissenschaftliche Forschungen*, 2, Berlin, 1933, pp. 75–100. Reprinted in Pächt, *Methodisches* (as previous entry), pp. 17–58.

'The Master of Mary of Burgundy', *The Burlington Magazine*, 85, London, 1944, pp. 295–300.

The Master of Mary of Burgundy, London, 1948.

'The Tower of Barbara and the Tower of Babel', in 'Festschrift for Johannes Wilde', London, 1951 (typescript copy in Courtauld Institute of Art, London).

'The "Carrying of the Cross", by Bernard van Orley', *Oriel Record*, Oxford, 1952, pp. 16–20.

'Catalogue of the Illuminated Manuscripts', in [Exh. Cat.] *Flemish Art 1300–1700: Winter Exhibition 1953–1954*, London, Royal Academy of Arts, 1953.

'A New Book on the Van Eycks', *The Burlington Magazine*, 95, London, 1953, pp. 249–253 (review of L. Baldass, *Jan van Eyck*, London, 1952).

'Panofsky's Early Netherlandish Painting', *The Burlington Magazine*, 98, London, 1956, pp. 110–116, 267–279 (first and second reviews).

'René d'Anjou et les Van Eyck', *Cahiers de l'Association internationale des études françaises*, Paris, 1956, pp. 41–57.

'Un Tableau de Jacquemart de Hesdin?', *Revue des Arts*, 6, Paris, 1956, pp. 149–160.

'Josua Bruyn, Van Eyck Problemen (De Levensbron – Het Werk van een Leerling van Jan van Eyck), Utrecht 1957', review, *Kunstchronik*, 12, Munich, 1959, pp. 254–258.

'The "Avignon Diptych" and Its Eastern Ancestry', in *De Artibus Opuscula XL. Essays in Honor of Erwin Panofsky*, New York, 1961, pp. 402–421.

'Die Gotik der Zeit um 1400 als gesamteuropäische Kunstsprache', in [Exh. Cat.] *Europäische Kunst um 1400*, Vienna, 1962, pp. 52–65.

'Zur Entstehung des Hieronymus im Gehäus', *Pantheon*, 21, Munich, 1963, pp. 131–142.

'The Limbourgs and Pisanello', in *Essais en l'honneur de Jean Porcher*, *Gazette des Beaux-Arts*, 6e pér., 62, Paris, 1963, pp. 109–122.

With J. J. G. Alexander, *Illuminated Manuscripts in the Bodleian Library, Oxford*, 1, *German, Dutch, Flemish, French and Spanish Schools*, Oxford, 1966.

'Künstlerische Originalität und ikonographische Erneuerung', in *Stil und Überlieferung in der Kunst des Abendlandes: Akten des 21. Internationalen Kongresses für Kunstgeschichte, Bonn 1964*, 3, Berlin, 1967, pp. 262–271. Reprinted in Pächt, *Methodisches* (see above, 'Die historische Aufgabe'), pp. 153–164.

'Typenwandel im Werk des Hugo van der Goes', *Wiener Jahrbuch zur Kunstgeschichte*, 22, Vienna, 1969, pp. 43–58.

'Meister Francke-Probleme', in [Exh. Cat.] *Meister Francke und die Kunst um 1400: Ausstellung zur Jahrhundert-Feier der Hamburger Kunsthalle*, Hamburg, 1969, pp. 22–27.

'Meister Francke-Probleme', in *Jahrbuch der Hamburger Kunstsammlungen*, 14/15, Hamburg, 1970, pp. 77–78.

With Ulrike Jenni, *Die illuminierten Handschriften und Inkunabeln der Österreichischen Nationalbibliothek*, 3, *Holländische Schule*, 2 vols., Österreichische Akademie der Wissenschaften, Veröffentlichungen der Kommission für Schrift- und Buchwesen des Mittelalters, series 1, vol. 3, Vienna, 1975.

'Die niederländischen Stundenbücher des Lord Hastings', in *Litterae textuales. Essays Presented to G. I. Lieftinck*, 4, Amsterdam, 1976, pp. 28–32.

'La Terre de Flandres', in *Pantheon*, 36/1, Munich, 1978, pp. 3–16.

With Ulrike Jenni and Dagmar Thoss, *Die illuminierten Handschriften und Inkunabeln der Österreichischen Nationalbibliothek*, 6, *Flämische Schule*, 1, 2 vols., Österreichische Akademie der Wissenschaften, Veröffentlichungen der Kommission für Schrift- und Buchwesen des Mittelalters, series 1, vol. 6, Vienna, 1983.

'Die Evangelistenbilder in Simon Benings Stockholmer Stundenbuch (Kgl. Bibl., A 227)', *Nationalmuseum Bulletin*, 7/2, Stockholm, 1983, pp. 71–92.

'Der Salvator Mundi des Turiner Stundenbuches', in *Florilegium in honorem Carl Nordenfalk octagenarii contextum*, Nationalmuseum, Skriftserie, N.S. 9, Stockholm, 1987, pp. 181–190.

Altniederländische Malerei: Von Rogier van der Weyden bis Gerard David, edited by Monika Rosenauer, Munich, 1994.

List of Works

*Works by the Brothers Van Eyck and the Master of Flémalle
mentioned in the Text*

*Measurements given here (in centimetres, height before width),
are for works reproduced in colour, and for other authenticated works.*

Aix-en-Provence
Musée Granet

MASTER OF FLÉMALLE
Madonna in Glory
48 × 31.6
Fig. 50

Amsterdam
Rijksprentenkabinet

JAN VAN EYCK (?)
Adoration of the Magi
Fig. 120

Antwerp
Koninklijk Museum voor
Schone Kunsten

JAN VAN EYCK
St Barbara
32.2 × 18.5
With original frame, 41.2 × 27.6
Colour plate 14, fig. 52

Madonna at the Fountain
19 × 12.2
With original frame, 24.8 × 18.1
Colour plate 15

Berlin
Staatliche Museen Preussischer
Kulturbesitz

JAN VAN EYCK
Madonna in a Church
31 × 14
Colour plate 5

Baudouin de Lannoy
26 × 19.5
Fig. 58

Giovanni Arnolfini
29 × 20
Fig. 60

JAN VAN EYCK (COPIES)
Man with a Pink
Fig. 65

Salvator mundi
Fig. 91

HUBERT VAN EYCK (?)
Crucifixion
43 × 26
Colour plate 18

MASTER OF FLÉMALLE
Robert de Masmines
28.5 × 17.5
Fig. 48

Kupferstichkabinett

HUBERT VAN EYCK (?)
Adoration of the Magi
Fig. 121

Bruges
Groeningemuseum

JAN VAN EYCK
Margareta van Eyck
32.6 × 25.8
With original frame, 41.2 × 34.6
Colour plate 8, fig. 61

Paele Madonna
122.1 × 157.8
With original frame, 140.8 × 176.5
Colour plates 12, 13, fig. 12

Bucharest
Museum of the Romanian Republic

JAN VAN EYCK
Man with Ring
17.5 × 15.5
Fig. 57

Budapest
Szépmüvészeti Múzeum

MASTER OF THE HOURS OF TURIN
(HUBERT VAN EYCK? COPY)
The Carrying of the Cross
Fig. 116

Dijon
Musée des Beaux-Arts

MASTER OF FLÉMALLE
Nativity
87 × 73
Colour plate 4, fig. 43

Dresden
Kupferstichkabinett

JAN VAN EYCK
Cardinal Albergati
21.4 × 18.1
Fig. 64

Staatliche Kunstsammlungen

JAN VAN EYCK
Dresden Triptych
27 × 21.5
With original frame, 33.1 × 27.5
Colour plate 7

Frankfurt am Main
Städelsches Kunstinstitut

JAN VAN EYCK
Lucca Madonna
65.5 × 49.5
Colour plate 6, fig. 7

MASTER OF FLÉMALLE
St Veronica and *Madonna*
Each panel 144 × 53
Fig. 1

Pietà of the Father
144 × 53
Fig. 19

Deposition (fragment)
133 × 92.5
Fig. 29

Ghent
St Bavo

HUBERT VAN EYCK
JAN VAN EYCK
Ghent Altarpiece
Closed: 375 × 260
Open: 375 × 520
Colour plates 21–27, fold-out plate,
figs. 10, 72–74, 83–89, 93, 94,
96, 98–100, 102

Liverpool
National Museums and Galleries
on Merseyside,
Walker Art Gallery

MASTER OF FLÉMALLE (COPY)
Deposition
Fig. 28

London
British Library

MASTER OF THE HOURS OF TURIN
(HUBERT VAN EYCK?)
Betrayal of Christ
Fig. 123

Courtauld Institute Galleries
(Princes Gate Collection)

MASTER OF FLÉMALLE
Seilern Triptych
Central panel 60 × 48.9
Shutters each 60 × 22.5
Colour plate 2

National Gallery

JAN VAN EYCK
Man in a Red Turban
25.7 × 19
With original frame, 33.3 × 25.8
Fig. 55

Timotheos
33.2 × 19
Fig. 59

Giovanni Arnolfini and Jeanne Cenami
81.8 × 59.7
Colour plates 10, 11

MASTER OF FLÉMALLE
Portraits of a Man and a Woman
Each panel 40.7 × 27.9
Fig. 46

Madonna with a Firescreen
63.5 × 44
Colour plate 1

Louvain
St Peter
Musée de l'Art sacral

MASTER OF FLÉMALLE (COPY)
Pietà of the Father
Fig. 18

Madrid
Prado

JAN VAN EYCK (COPY)
Fountain of Life
Fig. 79

MASTER OF FLÉMALLE
St James the Greater and St Clare
76.5 × 88
Fig. 9

Werl Altarpiece
Each panel 101 × 47
Figs. 11, 16

Annunciation
76 × 70
Fig. 30

Betrothal of the Virgin
76.5 × 88
Figs. 41, 44

Thyssen-Bornemisza Collection

JAN VAN EYCK
Diptych of the *Annunciation*
Each panel 39 × 24
Fig. 66

Melbourne
National Gallery of Victoria

JAN VAN EYCK (?)
Ince Hall Madonna
Fig. 54

New York
The Metropolitan Museum of Art,
Fletcher Fund

MASTER OF THE HOURS OF TURIN
(HUBERT VAN EYCK?)
Crucifixion and *Last Judgement*
Each panel 56.5 × 19.7
Colour plate 19, fig. 115

The Metropolitan Museum of Art,
Friedsam Collection

HUBERT VAN EYCK (?)
Annunciation
Fig. 104

The Metropolitan Museum of Art,
The Cloisters Collection

MASTER OF FLÉMALLE
Mérode Altarpiece
Central panel 64 × 63
Shutters each 64 × 27
Colour plate 3, fig. 37

Paris
Louvre

JAN VAN EYCK
Rolin Madonna
66 × 62
Frontispiece, figs. 51, 71

Louvre, Cabinet des Dessins

JAN VAN EYCK (?)
Fishing Party
Fig. 69

Rotterdam
Museum Boymans-van Beuningen

HUBERT VAN EYCK (?)
The Three Women at the Sepulchre
71.5 × 89
Colour plate 20, figs. 101, 103

St Petersburg
Hermitage

MASTER OF FLÉMALLE
Pietà of the Father
34.3 × 24
Fig. 20

Madonna with a Fireplace
34.3 × 24
Fig. 38

Turin
Museo Civico

MASTER OF THE HOURS OF TURIN
(HUBERT VAN EYCK?)
Hours of Turin
Page size 28 × 19

*The Sea Crossing of St Julian
the Hospitaller and St Martha*
Fig. 105 (destroyed by fire)

*Cavalcade on the Seashore
(The Prayer on the Shore)*
Fig. 106 (destroyed by fire)

*Mystic Marriage of St Catherine
(Virgo inter virgines)*
Fig. 108 (destroyed by fire)

Discovery of the True Cross
Fig. 109

Betrayal of Christ
Fig. 110 (destroyed by fire)

Baptism of Christ (bas-de-page)
Fig. 111

Street Scene (bas-de-page)
Fig. 113 (destroyed by fire)

Crucifixion
Fig. 126

Birth of St John the Baptist
Colour plate 16

Requiem Mass
Colour plate 17

Vienna
Kunsthistorisches Museum

JAN VAN EYCK
Jan de Leeuw
24.5 × 19
With original frame, 33.3 × 27.5
Fig. 56

Cardinal Albergati
34.1 × 27.3
Colour plate 9, fig. 63

Washington
National Gallery of Art

JAN VAN EYCK

Annunciation
93 × 37
Fig. 97

Index

Numbers in italics refer to the illustrations

Photo Credits